Understanding Heritage and Memory

This book is part of a series published by Manchester University Press in association with The Open University. The three books in the *Understanding Global Heritage* series are:

> *Understanding the Politics of Heritage* (edited by Rodney Harrison)

> *Understanding Heritage in Practice* (edited by Susie West)

> *Understanding Heritage and Memory* (edited by Tim Benton)

This publication forms part of the Open University course AD281 *Understanding global heritage*. Details of this and other Open University courses can be obtained from the Student Registration and Enquiry Service, The Open University, PO Box 197, Milton Keynes MK7 6BJ, United Kingdom (tel. +44 (0)845 300 60 90, email general-enquiries@open.ac.uk).

www.open.ac.uk

Manchester University Press

Manchester and New York

Distributed exclusively in the USA by Palgrave Macmillan

in association with The Open University

UNDERSTANDING
heritage and memory

Edited by Tim Benton

Published by

Manchester University Press
Oxford Road, Manchester, M13 9NR, UK
and Room 400, 175 Fifth Avenue, New York, NY 10010, USA
www.manchesteruniversitypress.co.uk

in association with

The Open University
Walton Hall, Milton Keynes
MK7 6AA
United Kingdom

First published 2010

Distributed in the United States exclusively by Palgrave Macmillan, 175 Fifth Avenue, New York, NY 10010, USA.

Distributed in Canada exclusively by UBC Press, University of British Columbia, 2029 West Mall, Vancouver, BC, Canada, V6T 1Z2.

Edited and designed by The Open University.

Typeset in India by Alden Prepress Services, Chennai.

Printed in Malta by Gutenberg Press Limited.

British Library Cataloguing in Publication Data: applied for

Library of Congress Cataloging in Publication Data: applied for

ISBN 978 0 7190 8153 8

1.1

Contents

Figures

Contributors

Professor Tim Benton is an architectural historian specialising in the history of modern architecture and design, in particular the work of Le Corbusier. His books include *The Villas of Le Corbusier and Pierre Jeanneret, 1920–1930* (Birkhäuser, 2007) and *The Rhetoric of Modernism: Le Corbusier as a Lecturer* (Birkhäuser, 2009). He has also worked on a number of major exhibitions, including *Art Deco 1910–1930* (2003) and *Modernism Designing a New World* (2006), both at the Victoria and Albert Museum.

Clementine Cecil is an independent UK journalist and former *Times* correspondent who is based in Moscow. She is one of the founders of the Moscow Preservation Society and is currently writing a book on constructivist architecture.

Dr Penelope Curtis is Curator of the Henry Moore Institute in Leeds. Her many publications on the history of twentieth-century art and sculpture include: *Sculpture, 1900–45: After Rodin* (Oxford University Press, 1999) in the Oxford History of Art series, Curtis, P. (ed.) *Taking Positions: Figurative Sculpture and the Third Reich* (Henry Moore Institute, 2001), *Barbara Hepworth: St Ives Artists* (Tate Publishing, 2002) and *Patio and Pavilion: The Place of Sculpture in Modern Architecture* (Ridinghouse, 2007).

Dr Rebecca Ferguson is a research fellow at The Open University, investigating the ways in which learners use asynchronous dialogue to build knowledge together. As a staff member on the Schome project, she also works in virtual worlds on the development of an education system for the knowledge age. Her avatars, Marie Arnold and Fox Phlox, have been working and exploring in Second Life and Teen Second Life since 2006.

Dr Karl Hack lectures in History for The Open University. Previously he spent 12 years in Singapore, where he was Associate Professor at the Nanyang Technological University, and carried out consultancy for heritage organisations, ministries and statutory bodies.

Dr Rodney Harrison is a Lecturer in Heritage Studies at The Open University, who has a broad range of professional experience researching and working in the heritage industry in Australia, the USA and the UK. He has published widely on the topics of community archaeology, museums, heritage and colonialism and is the author of *Shared Landscapes* (University of New South Wales Press, 2004), a critical exploration of the heritage of cattle and sheep ranching in Australia, and co-editor of *The Heritage Reader* (Routledge, 2008).

Dr Sabelo Ndlovu is a Lecturer in African Studies based at the Ferguson Centre for African and Asian Studies at The Open University, Milton Keynes. He has published extensively on the modern history and contemporary politics

of Zimbabwe and South Africa. His latest publication is *The Ndebele Nation: Reflections on Hegemony, Memory and Historiography* (Rozenberg Publishers & UNISA Press, 2009).

Dr Deborah Rose is the author of numerous prize-winning books. She is a Professor in the Centre for Research on Social Inclusion at Macquarie University, Sydney. She has worked extensively on Aboriginal claims to land, and her work in both scholarly and practical arenas is focused on entwined social and ecological justice. Her most recent book is *Reports from a Wild Country: Ethics for Decolonisation* (University of New South Wales Press, 2004).

Dr Daniel Weinbren works at The Open University. His publications include work on the history of war memorials, the Labour Party, the Humanitarian League, a pharmaceutical company and several armaments firms. Much of his recent work has been on friendly societies and other fraternal associations.

Dr Susie West worked in British field archaeology and regional museums before researching her PhD thesis in architectural history. She became a Senior Properties Historian at English Heritage, contributing to the public understanding of their historic properties. Much of her professional experience has been focused on the interaction between users and providers of heritage as a cultural resource, particularly in the museum and voluntary sectors. She joined The Open University in 2007 as Lecturer in Heritage Studies with a special interest in UK heritage practices and the English country house. Her publications include *The Familiar Past? Archaeologies of Britain from 1550* (co-editor with Sarah Tarlow, Routledge, 1999).

Preface

In recent years 'heritage' has become not only a topic of widespread public interest but also a central concern across a wide range of academic disciplines. This reflects the growth of official processes of heritage conservation into a multi-billion dollar industry throughout the second part of the twentieth century, alongside various developments relating to globalisation and the increased use of heritage in the manufacture of both national and community identity. *Understanding Heritage and Memory* asks us to engage with the many forms which processes of remembrance and forgetting take in contemporary global societies. The experience of individuals and groups is not uniform, and strategies have to be devised to accommodate difference while still attempting to celebrate national unity. *Understanding Heritage and Memory* asks some difficult questions about managing memory at the social scale, particularly where these memories are disturbed by past or present conflicts and fundamental differences in outlook. The book also investigates problems of conserving a necessarily changing landscape, the intangible heritage of living and evolving communities and the new problems posed by the conservation of ephemeral memory in online communities such as Second Life. In doing so, it engages with the loss of the former 'certainties' underpinning the conservation of canonical monuments and places in the West which has been a feature of various shifts in thinking about heritage over the past three decades.

This is the third of three books in the series *Understanding Global Heritage*, published by Manchester University Press in association with The Open University (OU), which seeks to make a distinctive intellectual and pedagogical contribution to the emerging field of critical heritage studies. Each book is designed to be used either as a free-standing text or in combination with one or both of the other books in the series. The books were developed by a dedicated team of OU scholars together with other published academics representing the range of heritage-related disciplines as part of the development of the OU course that shares the series title. They form the first interdisciplinary series of books to explicitly address the teaching of critical heritage studies as a unified discipline. As such, they aim to provide a comprehensive and innovative introduction to key issues and debates in heritage studies as well as to demonstrate the ways in which the study of heritage can be used to inform our understanding of the global diversity of human societies. The authors form a diverse team chosen to reflect the areas that inform heritage studies, including anthropology, archaeology, architectural history, art history, biodiversity and the natural sciences, geography, history, literature studies, religious studies and sociology.

The use of international case studies is an integral part of the structure of the series. These allow the authors not only to summarise key issues within each topic but also to demonstrate how issues are reflected in heritage practices in real-life situations. The international scope reflects the involvement of heritage in discourses of globalisation and the international nature of heritage practice: the issues discussed should transcend diverse national approaches to heritage, and the books should be equally valuable in the teaching of heritage studies in any English-speaking country throughout the world.

Each of the books aims to provide a sound introduction to, and detailed summary of, varied aspects of critical heritage studies as a global discipline. They do this through a consideration of official and unofficial heritage objects, places and practices. The books are concerned primarily with, on the one hand, the ways in which the state employs heritage at the national level and, on the other hand, the social role of heritage in community building at the local level. Using the concept of World Heritage they also explore the development of political notions associated with globalisation. This is accomplished by employing the idea that there exists an authorised heritage discourse (AHD) which works to naturalise certain aspects of heritage management while excluding others.

By leading with case studies which reflect on the ways in which wider issues are 'applied' to heritage and examine the theoretical and historical context of these issues, the books reinforce the relevance and value of critical heritage studies as a significant area of intellectual pursuit for understanding and analysing heritage and its contribution to matters of widespread public concern.

Rodney Harrison

Understanding Global Heritage Series Editor and Course Team Chair
The Open University

Abbreviations

AHD	authorised heritage discourse
ANC	African National Congress (South Africa)
ASNOVA	*Ассоциация новых архитекторов*, 'Association of New Architects'
CONI	Comitato Olimpico Nazionale Italiano (Italian National Olympic Committee)
DDR	Deutsche Demokratische Republik (The Republic of East Germany)
DNPWM	Department of National Parks and Wildlife Management (Zimbabwe)
DoCoMoMo	International Working Party for Documentation and Conservation of Buildings, Sites and Neighbourhoods of the Modern Movement
EUR	Esposizione Universale di Roma (Italy)
HLC	historic landscape characterisation
ICA	Institute of Contemporary Arts (UK)
ICOMOS	International Council on Monuments and Sites
INA	Indian National Army
MCP	Malayan Communist Party
MCS	Matobo Conservation Society (Zimbabwe)
MMOG	massively multiplayer online game
MPAJA	Malayan People's Anti-Japanese Army
NMMZ	Department of National Museums and Monuments of Zimbabwe
NSDAP	National Socialist or Nazi Party
NSW	New South Wales (Australia)
PAP	People's Action Party (Singapore)
PRO	Public Record Office (UK)
PWD	Public Works Department
STROIKOM	Soviet Building Committee
TICCIH	The International Committee for the Conservation of the Industrial Heritage

TNA	The National Archives of the United Kingdom
UMNO	United Malays National Organisation
UNESCO	United Nations Educational, Scientific and Cultural Organization
VR	virtual reality

Introduction

Tim Benton

Understanding Heritage and Memory investigates a number of ways in which the management of heritage across the world has become more complex in recent years. The consensus that existed in many professional circles in the 1960s about the aesthetic, historical and scientific values to be conserved at all costs, and how to set about achieving this, has come under increasing scrutiny. It is now generally recognised by the professionals charged with managing the heritage of most countries that heritage belongs to, and in a critical sense is defined by, individuals and communities in society. The multicultural nature of many societies and the acceptance of the co-existence of fundamentally different ideologies and ontologies have made these developments inevitable. The broadening of the categories of heritage to include a very wide range of artefacts, natural phenomena and practices has also weakened the control of archaeologists, art historians and historians over the definitions and scope of heritage. Increasingly close governmental attention has politicised heritage and created strong tensions in the heritage industry. While governments wish to promote a particular image of the nation, one calculated to encourage consensual citizenship, they wish simultaneously to respect and attract support from ethnic and cultural minorities. In addition, governments see heritage as a means of boosting tourist revenue and this leads to a consumer-oriented approach to heritage management. The significant inflation of heritage conservation and the increasing investment of public moneys in conserving an ever wider range of places and things, far from meeting a fixed demand, have created new desires and expectations. The heritage of everyone is now on the table for discussion. Furthermore, it is increasingly recognised that the driving force in motivating heritage conservation comes from what people think, feel and do (intangible heritage) rather than from the tangible remains of the past.

A symptom of the changing approaches to heritage is the importance now given to the role of memory in identifying what is important in society. Thinking about memory draws attention to the ways in which we all have a say in the management and maintenance of heritage. On this reading, heritage turns out to be what people remember as significant. The power of collective memory, where large or small groups within society share an idea of what happened in the past and why it was important, translates into patterns of tourism and demands on the heritage industry. More or less spontaneous gestures of public emotion, as often occurs after wars or public disasters, create needs that heritage can try to meet with the production of monuments and ceremonies. Unlike history, which attempts to be objective and disinterested, memory is essentially motivated; it meets the needs of

individuals or groups to make sense of the past in whatever way feels best to them. Individuals and groups of people remember the past in different ways and this creates significant problems for the management of heritage resources. To discuss heritage in terms of memory rather in terms of the value of artefacts significantly displaces the debate, compared to the early years of the heritage boom.

Multicultural societies present particular issues in the management of heritage. State policies oscillate between seeking to assimilate all groups within a single national culture and encouraging the celebration of plural traditions. At issue is not only which cultural traditions and their associated artefacts and places should be conserved, but which version of past events should be commemorated – a matter of particular potency in postcolonial societies in which the legacy of colonial government and struggles for independence continue to have an effect for subsequent generations. In countries where indigenous populations co-exist with dominant settler societies, the divergence of viewpoint towards the land, towards memory and heritage, might appear unbridgeable. Considerable progress has been made in the last decades in recognising the political rights of indigenous people to retain their traditions and ways of life, but not without structural tensions in the management of heritage.

Heritage conservation can be said to have begun with landscape; among the first sites to be conserved were areas of outstanding natural beauty. It was felt that these had to be protected from human intervention. But landscape never stands still, and the impossibility of preventing natural, as well as artificial, change has precipitated a significant re-evaluation of appropriate ways of thinking about landscape. Most of the countryside in developed countries has been managed and worked for millennia. Withdrawing agricultural industries from the land creates a new kind of change that cannot be corrected by going back to ancient forms of agricultural husbandry. Replacing agriculture with tourism creates yet more change. As a consequence, there is a move away from trying to be selective in heritage management to being inclusive. Instead of conserving outstanding examples of landscape, current practice is to attempt to characterise the whole surface of a country and make the best use of the whole land mass.

A significant aspect of the spread of the scope of heritage is the rapid expansion of the period to be conserved, to arrive at the very recent past. A 'postmodern' mentality which is profoundly sceptical about the certainties of truth and value finds it increasingly difficult to decide what could be excluded from heritage. This example only underlines the central theme of this book, however, which is that in the end what counts is not the age, or rarity or other extrinsic value of a thing or a practice but the feelings of those involved.

If people feel deeply about something, it will be commemorated in some way or other and thus become part of the nation's living heritage.

Understanding Heritage and Memory makes regular reference to Laurajane Smith's *Uses of Heritage* (2006) and her concept of the authorised heritage discourse (AHD). Smith defines the AHD as a set of texts and practices that dictate the ways in which heritage is defined and employed within any contemporary western society. This is an important concept, although it is true that in increasingly multicultural societies we also find plural AHDs, having agency in different countries, regions and communities. She also insists on the importance of intangible, rather than tangible, heritage in shaping public consciousness. But if for every example of tangible heritage there is a necessary intangible component of beliefs, feelings and practices which keep the heritage alive, it is also true that intangible heritage invariably tends to produce artefacts to commemorate and perpetuate them.

Chapter 1, 'Heritage and public memory' begins by considering some of the basic issues of private and collective memory, the roles of forgetting and distortion, the importance of practices of commemoration. Memory itself is intangible and in one sense inherently private. But most scholars accept that memory requires a social context to survive. Unless constantly refreshed by communicating to others (or even to oneself), memories fade away. We consider the idea that the loss of traditional forms of storytelling based on tight social structures has led to the felt need to associate public memories with particular places and things. We conclude with a case study of a public and intangible form of commemoration, in the form of architectural walks conducted in Moscow by the journalist Sergei Nikitin which, while purporting to be about the Constructivist architecture of the late 1920s, actually celebrate shared memories of life under Communism.

Chapter 2, 'The heritage of public commemoration' deals with a particular case of collective memory, in the commemoration of the world war of 1914–18. This catastrophe touched almost everyone in Europe and the European colonies and dominions. Although very few people are alive who have any memories of these events, commemoration continues to this day, and visits to First World War cemeteries and monuments have never been more popular. The chapter investigates some of the difficulties of creating war memorials, the tension between prompting horrific memories or seeking to soothe mourning relatives, remembering the calamity of mass slaughter or trying to celebrate patriotic virtues. The case study is about the Whitehall Cenotaph, which shows how a mass popular expression of feeling forced the government to accept as a permanent monument a hurriedly designed structure intended only for a single march past.

Chapter 3, 'Contentious heritage' asks how you can commemorate an event that is remembered in contradictory ways by different groups

in a multicultural society. The case of Singapore is instructive. Whereas the British administration, on resuming power in 1945, would have liked to celebrate the surrender of the Japanese and commemorate the war as a whole, the Chinese, Indian and Malay communities who made up the majority of the population had other scores to settle. For them, the British had let them down. Each community had radically different memories of war-time occupation and its own goals for postcolonial independence. These conflicts were played out in the production of a series of war memorials with very different qualities and meanings.

Chapter 4, 'Heritage and changes of regime' selects a paradigmatic example of how difficult it can be to manage collective memories: the case of regime change. What can be done with the buildings, artefacts and culture of a regime whose fundamental ideology has been condemned and overthrown? Individuals who survive from one regime into the next can adapt their views and profess new beliefs. But physical artefacts and buildings can only be changed in marginal ways. In this chapter we look at strategies for managing continuities after regime change, focusing mainly on Fascist Italy and National Socialist Germany.

In Chapter 5, 'Multicultural and minority heritage' we look at the various ways in which multicultural societies are organised and how different groups approach the problem of celebrating their identities. We consider the ways in which heritage has been challenged by multiculturalism, transnationalism and subaltern studies, and how in multicultural societies heritage may become a key site for the production of collective memory. The challenge of multicultural heritage for the nation-state and the relationship between local and global heritage initiatives is considered with reference to case studies in heritage management from Cape Town, South Africa and New South Wales, Australia.

Chapter 6, 'Heritage landscape and memory' focuses on human intervention in nature and the impossibility of halting change in landscape. Debates about how to deal with precious natural resources have come increasingly to focus on the concept of 'cultural landscapes', whose value resides as much in what people do as with the natural properties of the landscape. The case study in this chapter, by Sabelo Ndlovu, a historian of international politics, explores the complex meanings of the Matobo Hills, Zimbabwe, a World Heritage site. Postcolonial political significances intermingle with religion and ritual performed in the landscape.

Chapter 7, 'Intangible heritage' begins by charting the incorporation of intangible heritage into the policies and public statements of UNESCO. But accepting the concept of intangible heritage is different from dealing with some of the challenges it presents. Professionals find it difficult to respond to

something as subjective as what people think and do. The case study demonstrates how the beliefs and knowledge of Indigenous Australians are fundamentally different from the views of most heritage professionals.

As heritage turns to the very recent past in the digital age, new forms of commemoration are required. Chapter 8, 'Heritage and the recent and contemporary past' begins with a history of the move to conserve ever more recent works of architecture, in the context of what is described as the postmodern condition. The case study looks at the very recent construction of heritage in the virtual world of Second Life. Although this digital world might appear completely new, some of its forms of memorialisation are surprisingly conventional – the conservation of buildings, places and monuments stemming from the early years of Second Life.

Whether current practices and attitudes to heritage will survive very long depends in part on patterns of behaviour – how much time we all spend reworking the past and celebrating our shared memories – and partly on government policies. If heritage is perceived as a contribution to building consensus and a sense of shared identity, government will back it. If we, as individuals, continue to find value in re-living the past and moulding our memories to serve current needs, an increasingly complex pattern of heritage celebration will develop. Searching for a sense of identity and belonging in the world around us, past and present, is likely to remain an abiding interest in the twenty-first century, but the ways we rehearse and perform this quest are likely to change substantially as our interests evolve.

Works cited

Smith, L. (2006) *Uses of Heritage*, Abingdon and New York, Routledge.

Chapter 1 Heritage and public memory

Tim Benton and Clementine Cecil

In this first chapter we unpack some of the meanings of 'memory' and its implications for the study of heritage. The 'memory boom' has matched the 'heritage boom' in many ways as a topic of study. In both cases, there is an assumption that people have somehow lost touch with the past and that professional methods of historical analysis and heritage conservation have not filled the gap. Recalling memories in a social or cultural context is itself an example of intangible heritage and is often seen as contesting authorised heritage discourses (AHDs). Laurajane Smith coined the phrase 'authorised heritage discourse' to refer to the various ways in which dominant groups in society impose certain values and methods on the practices of conservation, thus including some groups in the heritage while excluding others (Smith, 2006).

To understand memory better, we look at various theories about private and public memory. What does it mean to talk of 'public', 'social', 'cultural' or 'collective' memory? How do the memories we experience individually relate to these 'public' memories? What is the relationship between memory and history? How does memory relate to places and things? These questions prepare the ground for a case study in which the historian and journalist Clementine Cecil looks at how a particular group of buildings in Moscow are remembered by groups of people taking part in cultural walks. This is a particularly vivid example of how public and private memories can work together.

Introduction

Why is **private** and **public memory** of particular importance to a discussion of heritage? Let us begin by rehearsing the factors that lead to objects, buildings, places or practices being selected for preservation and retention in memory and see where memory fits in. English Heritage is the principal officially sponsored organisation responsible for heritage management in England and Wales. In a policy document issued in April 2008, English Heritage lists four kinds of value relevant to conservation:

- Evidential value: the potential of a place to yield evidence about past human activity.
- Historical value: the ways in which past people, events and aspects of life can be connected through a place to the present – it tends to be illustrative or associative.

- Aesthetic value: the ways in which people draw sensory and intellectual stimulation from a place.
- Communal value: the meanings of a place for the people who relate to it, or for whom it figures in their collective experience or memory.

(Drury and McPherson, 2008, p. 7)

Considering these four factors, it is clear that the third is largely to do with the qualities of the object as it survives today, while the others relate to ideas about the past. We may want to know what happened and why (**evidential** and **historical value**), using more or less objective historical and archaeological methods, and preserving physical evidence is clearly important in this context. History and memory are closely associated and we discuss this further below. A simple distinction between them is that history aims at a measure of objectivity, based on evidence and reasoned argument, whereas memories come in all kinds of different forms based on subject position, from the individual flashback to the often retold story well known to a family or community. Whereas historic and **aesthetic value**s tend to be controlled by professionals, assessment of **communal value** resides in the opinions and feelings of members of the public.

Further into the English Heritage document, communal value is glossed in more detail:

Communal value

Communal value derives from the meanings of a place for the people who relate to it, or for whom it figures in their collective experience or memory. Communal values are closely bound up with historical (particularly associative) and aesthetic values, but tend to have additional and specific aspects.

Commemorative and *symbolic* values reflect the meanings of a place for those who draw part of their identity from it, or have emotional links to it.

The most obvious examples are war and other memorials raised by community effort, which consciously evoke past lives and events, but some buildings and places, such as the Palace of Westminster, can symbolise wider values. Such values tend to change over time, and are not always affirmative. Some places may be important for reminding us of uncomfortable events, attitudes or periods in England's history. ... In some cases, that meaning can only be understood through information and interpretation, whereas, in others, the character of the place itself tells most of the story.

(Drury and McPherson, 2008, p. 31)

The document goes on to discuss **social value**:

> Social value is associated with places that people perceive as a source
> of identity, distinctiveness, social interaction and coherence. Some may
> be comparatively modest, acquiring communal significance through the
> passage of time as a result of a collective memory of stories linked to
> them. They tend to gain value through the resonance of past events in
> the present, providing reference points for a community's identity or
> sense of itself. They may have fulfilled a community function that has
> generated a deeper attachment, or shaped some aspect of community
> behaviour or attitudes. Social value can also be expressed on a large
> scale, with great time-depth, through regional and national identity.
>
> The social values of places are not always clearly recognised by those
> who share them, and may only be articulated when the future of a
> place is threatened. They may relate to an activity that is associated
> with the place, rather than with its physical fabric. The social value of
> a place may indeed have no direct relationship to any formal historical
> or aesthetic values that may have been ascribed to it.
>
> (Drury and McPherson, 2008, p. 32)

It is worth reflecting on this official statement on the part of English Heritage.
It is evident that communal and social values are determined by people in a
community. National institutions are responding to the criticism of heritage as
purely a matter for professionals (such as historians, art historians,
archaeologists, conservators) whose authority is sufficient to select and
conserve artefacts or sites deemed to be of special value to the nation, based
on their '**intrinsic**' qualities. The word 'intrinsic' needs to be thought about
carefully. Aestheticians may debate about whether any values can ever be
wholly embedded in the form of an object. Without some echo and resonance
in human emotions, works of art cannot perform their function. We are using
the word 'intrinsic' in the relative sense, to indicate the many ways in which
the form of an object may stimulate the imagination. We use it to contrast with
'**extrinsic**' values, which refer to associations with historical events, famous
people or current practices. We might say of Stonehenge, for example, that the
standing stones themselves may inspire awe and an **aesthetic** sensation
'intrinsically', but that they may also have extrinsic values related to what we
know of their history, their original purpose and the use put to them by people
today. The 'intrinsic' values may derive from the bodily response we have to
large objects or to countless other ways in which we perceive the world and
derive pleasure from what we see and feel.

In what follows, we first investigate private and then public memory, before
turning to ways in which places and things perform a function in terms of
memory recall. This leads us into the case study, where Clementine Cecil

investigates the ways in which some people in Moscow have used buildings and places to rehearse shared and private memories.

Personal memory

We can all give some account of what memory is. We remember things that happened, although sometimes our memories may be contested by the memories of others or by physical evidence. Police witness statements are notoriously full of 'errors' and contradictions. These 'errors' may be due to the strong emotions caused by an event, which may have led us to interpret the event in a certain way, or they may be caused by changes imposed on the memories afterwards. **Personal memories** of traumatic events are particularly liable to modification. Often, these mistaken memories can be attributed to the need of the mind to 'live with' the memory, to extract something good and reassuring from past events and, above all, to make sense of them in terms of what has happened since.

There has been disagreement about how memory works. Sigmund Freud asserted that 'in mental life nothing that has once been formed can perish ... everything is somehow preserved and in suitable circumstances ... can once more be brought to light' (Freud, [1930] 1969, p. 6, cited in Forty, 1999, p. 5). This claim, supported by the practice of psychoanalysis, has been given powerful public exposure in the legal cases surrounding the 'recovery' of memories of parental abuse in childhood by adults undergoing analysis many years later. On the other hand, an influential experimental study, *Remembering*, carried out by Frederick Bartlett in 1932, is usually cited as supporting the idea that memories are highly contingent, subject to considerable variability and influenced by changing circumstances (Bartlett, 1932).

Recent research suggests that although most experience is recorded in some way in '**memory traces**', these are neither necessarily accurate records nor impervious to change (Winter and Sivan (eds), 1999, pp. 12–16). Indeed, it seems clear that memories are always selective interpretations of experience. It seems that the mind 'encodes' experience as retrievable memory traces. Part of this encoding involves making sense of the experience, in terms of what we know about the world. This basic knowledge is learned in childhood and is extremely common within a culture. Quite a lot of it is 'incorporated'; it becomes part of our unthinking habitual actions, like judging distance, riding a bicycle, reading and writing. Some of it is very widely shared by humans, while some is culturally specific and some is personal. The English social anthropologist Paul Connerton has argued persuasively that not enough attention has been paid to '**incorporated memory**' (Connerton, 1989). For example, he cites research in 1941 which demonstrated that southern Italian immigrants in New York retained a repertoire of hand gestures which were

essentially the same as those studied a century earlier in Naples, and that many of these specific gestures could be found in descriptions of rhetoric in antique texts (Efron, 1941, cited in Connerton, 1989, pp. 79–82). At a more personal level, many of the characteristics that make us recognisable – facial expressions, habits of movement or posture – can be thought of as incorporated memory. The place where these kinds of cultural or personal incorporated memory join up with traditional discussion of memory and heritage is ritual. In certain rituals, repeatedly performed by individuals, gestures and movements become part of a transmitted culture from generation to generation. Think of the practices of the dinner table, or of religious observation or the various codes of polite society. In rituals such as ceremonies associated with remembrance of wars, these movements and gestures are locked into memories of death and loved ones. Encoding experience as memory therefore needs to accommodate incorporated memory as well as other kinds of memory.

A second function of encoding is to prepare remembered experience for recall in linguistic form. It seems that in the very act of forming a memory trace the mind begins the process of turning the experience into the basis of a story. The third way that memory encoding works is to seize on the visual aspect of an experience. A memory attached to a strong and vivid image is usually more persistent and more likely to be recalled. This is confirmed by the well-known technique for memorising long passages of text, which consists in breaking up the text into short sections and associating each passage with a particular image. A well-known book by the scholar of Renaissance thinkers Frances Yates, *The Art of Memory*, explains how techniques like this, based on the methods taught by masters of rhetoric in antiquity, allowed priests to learn the whole of the Bible by heart (Yates, 1966). A common device was to imagine a building, with its columns, arches, niches and other details, and work through this mental image attaching short passages of text to each detail. We can all think of memories that seem to be attached to strong visual images. This relationship of memories to images, objects and places helps to explain the role of art, sculpture, architecture and landscaping in the creation of **monuments**. It helps the mind to retain memories of an event or a loved one **commemorate**d in a monument if the place is visually striking, irrespective of the meaning of the artefact.

How you remember something depends to a great extent on what you are going through at the moment of encoding. But if experience affects memories, memories also influence experience. As Connerton has noted:

> We experience our present world in a context which is causally connected with past events and objects, and hence with reference to events and objects which we are not experiencing when we are experiencing the present.
>
> (Connerton, 1989, p. 2)

We can think about this rather dense but very perceptive statement like this: our ability to cope with life and to recognise significance in things and events depend on accumulated experience which we carry in our minds in the form of memory. Memory and experience cannot easily be separated. It is practically impossible to experience something without being influenced by memories of previous experience, but the encoding of memory is also influenced by what is happening at the time.

Memories can also be altered by subsequent actions and thought processes. Memory traces vary in their density. The density of a memory can be increased by frequent rehearsal – typically in the form of stories told to others or rehearsed in the mind. Powerful and dramatic experience may lead to very strong memories, which may be difficult to control. Extreme cases are referred to as 'traumatic', when the mind may be unable to shut off vivid memories or, on the other hand, recall them at all.

Collective remembrance

So far we have been discussing personal memories. It might seem that memory is necessarily a uniquely personal mental act. A memory is a kind of thought and to talk about **collective memory** would be to imagine a group of people thinking the same thought, rather like a choir singing from the same hymn sheet. For this reason, some historians prefer to focus on the activities of remembering ('collective remembrance'), which is a social act (Winter and Sivan, 1999, p. 9). Collective memory would then consist of the similarities between the memories of a number of people, produced either by shared experience or by the common rehearsal of stories representing events of which people may have a more or less direct experience.

A poignant example of the relationship between private and public memory is the commemoration of the dead. We each have private memories of departed loved ones and may rehearse these in our minds privately. But commemoration of the loss of a loved one may also make use of physical artefacts, such as a photo album, taken down and looked at, usually in the company of other relatives or friends, or mementos on a mantelpiece. These objects and these practices, often occurring on special dates, can have a very powerful resonance. A more public form is the grave, monument or shrine.

For many years now, such a shrine has existed by the side of a road near the M1 junction 13 in Milton Keynes, England (Figure 1.1). From modest beginnings, this **memorial** now includes solar-operated lights, constantly renewed cut flowers, pot plants and a mown section of grass. What is moving

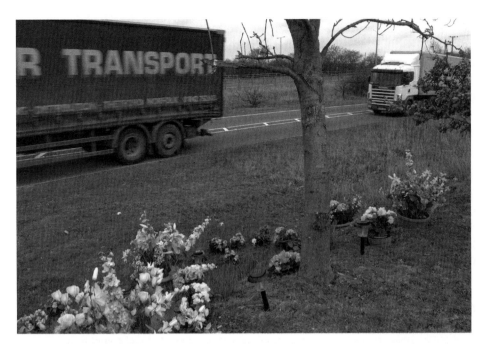

Figure 1.1 Roadside shrine on the A421, near the M1 motorway, Milton Keynes. Photographed by Tim Benton. Photo: © Tim Benton.

about this place is the care and attention dedicated to its upkeep. Although there are no official public ceremonies, and passing motorists will probably know nothing about the deceased and their family, this shrine constitutes a kind of public memory which can strike a chord. This is probably because it prompts observers' own memories of the loss of loved ones. It is one of the fundamental ways in which memories become collective; each one of us can associate ourselves with other people's experience.

Most theories of memory accept that memories that survive tend to be those shared with others in a cultural context. For example, we can be convinced that we remember something vividly from childhood which turns out to be based closely on stories we have been told and pictures in a family album, mixed in with recalled experience of our own. Memories seem to atrophy unless rehearsed and recreated to meet the needs of changing circumstances and cultural context.

Functions of memory

Recall of memories is necessarily highly selective and is usually motivated. In other words, we try to recall something specific for a reason, often in a social context. We may be prompted by others within a 'memory group' (a group of people who have shared some experience) or what the American historian Jay Winter calls '**fictive kinship**' **groups** (Winter and Sivan, 1999, pp. 40–60).

Many of the relatives of the dead and wounded after the First World War formed powerful bonds with others, in meetings, by correspondence or by participating in ceremonies and trips. Remembrance societies were formed in Australia, Canada and New Zealand, and the British Legion and other similar organisations were active in bringing veterans and the relatives together. Winter gives, as an example of a fictive kinship group, the Union of Disfigured Men, formed in France in 1921 to help the *gueules cassés* (those with 'broken' faces) to cope. In some ways, war memorials, and the ceremonies and private practices associated with them, perform a similar function, in helping individuals and families who do not even know each other personally at all to deal with grief in public ceremonies and rituals on the basis of their similar memories. An example of this is the significance of the annual two-minute silence and the rituals located at the **Cenotaph** in Whitehall on Remembrance Day. We will discuss this in detail in Chapter 2.

Maurice Halbwachs

The philosopher and sociologist Maurice Halbwachs argued that memory is always social. In his *Les Cadres sociaux de la mémoire* (translated as *The Collective Memory*) (1925), he distinguished between dreams and memories. The context for this was Halbwachs's desire to separate himself from the views of his first master Henri Bergson (Douglas, 1980, p. 12). Bergson believed that consciousness included both rationality and pure intuition, the latter being knowable only by the individual and subject to no rational control. Halbwachs was prepared to accept that dreams were of this kind, fragments of experience, whereas memories only exist when shared with others. He believed that memories are always located in some kind of spatial and social framework. Childhood memories, he argued, are invariably located in a recognisable place and social context, and it is recurring familiarity with places, as well as people, that keep memories alive in the mind. His book was criticised because it seemed to fly in the face of psychological research and suggested that consciousness at even the intimate level is socially determined. It also appeared to raise the spectre of the 'spirit' or group consciousness of a 'race' or '*Volk*' which was abused in the 1930s in the interests of racialist dogmas. He responded to this in a later book, *La Mémoire collective* (*The Collective Memory*, Halbwachs, 1980) in which he made it clear that the social dimension of memory can consist of very small groups (family, community, work groups) and is not therefore determined by generalised entities such as class consciousness, **race** or the dominant culture of the state.

In *The Collective Memory* Halbwachs accepts that experience leaves traces in the mind which are more or less clearly formed, but that these only become recognisable as memories within particular groups. For example, a cohort of schoolchildren may have vivid memories of a school teacher because these

memories are frequently rehearsed in and out of class, whereas the teacher has more trouble recalling one annual cohort of pupils from another because he or she is not part of a social group linked to that particular class. The 'affective communities' which sustain remembrance may be enduring groups, such as the family, or short-term associations, such as a group of people on holiday together, or any friendships or work associations. The shared experience, according to Halbwachs, forms the basis for remembering. Halbwachs pushes his idea to the point of suggesting that purely individual memory never survives.

The relationship between personal and collective memory is a difficult one to explain. This is how Halbwachs attempts it:

> While the collective memory endures and draws strength from its base in a coherent body of people, it is individuals as group members who remember. While those remembrances are mutually supportive of each other and common to all, individual members still vary in the intensity with which they experience them. I would readily acknowledge that each memory is a viewpoint on the collective memory, that this viewpoint changes as my position changes, that this position itself changes as my relationships to other milieus change.
>
> (Halbwachs, 1980, p. 48)

We might inflect his ideas to infer that 'collective memory' can be defined as the overlap between the individual recollections of a number of people who have shared experience and some kind of social and affective association which nurtures and supports the recreation of memory. Collective memory is not an entity, therefore, like a myth or religious belief, but a number of different recollections which share fundamental characteristics and which have been to an extent created by mutual interaction.

Whatever you may think of Halbwachs's reasoning, modern scientific evidence does support the idea that memory is greatly influenced both by the physical and social context of the experience remembered and by the affective milieu within which the memory can be recalled. His book left an important trace on later writing on collective memory.

Halbwachs also makes a helpful distinction between autobiographical memory and historical memory, the latter consisting largely of learned information about the past (whether at the personal or national level). Autobiographical memory constantly makes use of historical memory, to make sense of recollection. For example, we use dated events to put our memories into order. Often these events themselves help to fix certain memories. For example, Halbwachs describes being taken to see the huge **catafalque** of the Romantic novelist and poet Victor Hugo displayed in the

Arc de Triomphe in Paris on 31 May 1885 (when Halbwachs was 8). Hugo
had spent several years in exile under the Second Empire for his republican
views:

> I see myself at my father's side, walking towards the Arc de Triomphe
> de l'Étoile where the catafalque had been erected; I see myself the
> next day watching the funeral parade from a balcony at the corner of
> the rue Soufflot and the rue Guy-Lussac.

> (Halbwachs (ed.), 1980, p. 56)

Hugo was the hero not only of the ruling Republican Party but also of the
extreme left. A mass turn-out had welcomed Hugo back to Paris in 1870, at
the end of the Second Empire. Halbwachs's father had no doubt been
emotionally involved with the ceremony, and a mass literature of tributes,
illustrations and photographs recorded the scenes of what was the biggest
public ceremony of Halbwachs's early years. No doubt people in the family
household and at school talked about this for years. This is an example of the
kind of process that Halbwachs believed to be typical of the reconstruction of
memory. The important point is that individual memories are never
completely isolated from society, places or things, or from the supporting
evidence of history.

There are many other ways of describing 'collective memory'.
Anthropologists would place emphasis on oral transmission and storytelling.
Cultural studies, informed by an interest in reception and transmission of
culture as much as its production, has coined the term 'cultural memory', in
which the stress is on the performative. Mieke Bal summarises this position:

> We also view cultural memorialisation as an activity occurring in the
> present, in which the past is continuously modified and re-described
> even as it continues to shape the future. Neither remnant, document,
> nor relic of the past, nor floating in a present cut off from the past,
> cultural memory, for better or for worse, links the past to the present
> and future.

> (Bal, 1999, p. vii)

The activity that keeps memories alive – remembering – is itself often a social
activity. We will see in Chapter 2 that Jay Winter regards this 'collective
remembrance' – notably associated with war memorials and ceremonies – as
the mechanism which links private experience and memory to collective
memory. An example of this, to which we will return in later chapters, is the
staging of ceremonies on specific days to commemorate wars and the
casualties of war.

In the USA federal holidays are held both for Veterans Day (11 November)
and Memorial Day (last Monday in May). These patriotic events, staged by
the American Legion, encourage young and old to reflect on the spirit of

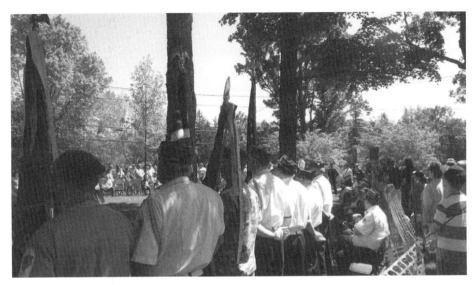

Figure 1.2 Memorial Day celebration in Williamstown, Massachusetts, 2009. Photographed by Tim Benton. Photo: © Tim Benton.

sacrifice of members of the armed forces and include speeches, the firing of salutes, the sounding of the 'Last Post' and a march past (Figure 1.2). There is a very explicit rehearsal of memories of old and more recent conflicts.

Remembering and forgetting

Just as important as remembering is forgetting. Unless we were able to forget most of what happens to us, we would not be able to operate. The English art historian Adrian Forty, in an interesting introduction to a book entitled *The Art of Forgetting*, quotes the French philosopher Michel de Certeau who believed that 'memory is a sort of anti-museum; it is not localizable' (Forty, 1999, p. 7). It is forgetting which allows people to live their lives and overcome **nostalgia** for the past or a crippling sense of loss. The art historian Jas Elsner was even fascinated by the traces of 'public forgetting' that can be found in monuments (Elsner, 2003). For example, he studied Roman monuments where figures represented in stone were later removed when they fell from favour. The gap left in the stone relief was itself a prompt to a kind of memory of forgetting. Similarly, the half-destroyed medieval sculptures on many British churches represent both a kind of forgetting of the reverence for saints in the Roman Catholic faith and a remembering of this officially forgotten past.

It has been argued that forgetting is particularly characteristic of the artistic and literary phenomenon known as Modernism (De Man, 1970). In the course of the early twentieth century many artists and writers became convinced that

a clear break had to be made with the past. The repetition of old styles of expression, traditional practices and conventions, and even bodily comportment and fashion, had become detached from the reality of modern life. They should all be discarded to make way for something completely new, based on the reality of modern existence. The tendency, within Modernism, to forget the past has been exaggerated, but there has certainly been a perception that the living continuity with the past has been damaged and needs to be repaired. The heritage movement has therefore often seen itself in opposition to Modernism, although Modernist buildings are now subject to conservation.

Memory and distortion

Michael Schudson identifies four types of memory distortion: **distanciation**, **instrumentalisation**, **narrativisation** and **cognitivisation** (Schudson, 1995, p. 348). Distanciation describes the process of progressive blurring of memory and loss of emotional intensity in recollection that occurs with time. We talk of memories 'fading'. The popular saying 'time heals all wounds' has some truth in it. There are prominent exceptions: memories of tragedies, grievances and vendettas can last for generations and, if nourished by frequent repetition and participatory rehearsal, can grow in intensity over the years. For example, the battle of the Boyne (1690) and the battle of the Somme (1916) remain defining memories for Protestants in Ireland.

Instrumentalisation describes the way that 'the past is put to work' (Schudson, 1995, p. 351). Memories are inevitably influenced by the present. For example, a traumatic event occurred in German-occupied Rome in 1944, during the Second World War, when 335 people were shot by the Germans in reprisal for the killing by partisans of 32 German soldiers. The German military commander ordered that the reprisals were to be carried out within 24 hours, without any public warning, presumably to avoid the risk of public protests. Alessandro Portelli, an Italian sociologist, interviewed a number of people who lived through these terrible events, and most of them remembered something quite different (Portelli, 2003). According to this 'collective memory' the Germans called on the partisan perpetrators of the attack on the Germans to give themselves up and only after several months carried out the reprisal, in which 'innocent' people were killed. It was the fault, then, of the cowardly (Communist) partisans not to accept responsibility for the 'bomb outrage'. This distortion of 'the facts' can be explained by postwar Italian politics in which the threat of Communism seemed very present, and the role of the Communist partisans in the war put many Italians at risk of German reprisals.

Narrativisation describes the way memories are turned into interesting stories. Just as the stories told by tribal elders have a dramatic form, sometimes including dance, personification and symbolism, any recalling of memory tends to adopt a narrative structure. Inevitably, memory stories simplify,

dramatise and reorganise events to make an impact and, literally, 'be memorable'. This is true as much about how we remember things as individuals as about collective memory. The gap between private and collective memory and fictional recreations of past events, in novels, films and television, is not as great as we sometimes think. The role of a film such as *Braveheart* in stimulating and focusing feelings of Scottish identity did not depend on its historical accuracy but on the imaginative world it created which chimed with many people's feelings.

The ugly word cognitivisation describes the need we all have to make sense of our memories. This is particularly true at a social level:

> Memories are prepared, planned and rehearsed socially as well as individually. Experiences attended to by powerful social institutions are likely to be better preserved than experiences less favoured by rich institutional rememberers.
>
> (Schudson, 1995, pp. 358–9)

Memorialisation, and the ceremonies that surround memorials, are a very clear example of cognitivisation, fixing meanings over time by attaching them to physical monuments or places, and by repetition and restructuring in rituals of remembrance. This process is often contested, however, and memorials frequently feature as sites of conflict if the fixing of collective memory is made too narrow to accommodate the memories and understanding of the past of individuals or **subaltern** groups.

Memory and history

The differences between 'collective memories' and history are comparable, in some ways, to the differences between **tangible** and **intangible heritage**. Just as AHDs may try to fix the meaning and values of the physical legacy of past generations, the work of historians, whatever their differences, tends to impose an authoritative interpretation of past events. Intangible heritage practices may contest these AHDs just as 'collective memories' may challenge history. Clementine Cecil's case study is just such an example, where the official view of a brief period of Moscow's architectural history in the 1930s is contested by individuals who impose their own memories on the city.

Memory has become itself a dominant theme in historical studies. As the truth of history has been increasingly criticised, memory has been put forward as a more human and sensitive way of understanding the past:

> Memory appeals to us partly because it projects an immediacy we feel has been lost from history. At a time when other such categories – Man, History, Spirit – have lost much of their shine, memory is

ideally suited for elevation ... If history is objective in the coldest, hardest sense of the word, memory is subjective in the warmest, most inviting senses of the word.

(Klein, 2000, pp. 129–30)

Historians are trained to identify difference in explanation, to compete with rival historians by contradicting, invalidating or supplementing their accounts. And yet, taken together as a discipline, history tends to produce a particular kind of account of the past, one typically based on documentary evidence, looking for verifiable facts rather than unsubstantiated opinion or emotion.

The historian Raphael Samuel saw the increasing specialisation of history, and the tendency to reject many of the most popular forms of inquiry as inadequate – biographers, **antiquarian**s, local historians, oral historians – as signs of the separation of history from real life:

History, in the hands of the professional historian, is apt to present itself as an esoteric form of knowledge ... The historical discipline encourages inbreeding, introspection, sectarianism.

(Samuel, 1994, p. 4)

Samuel wanted to restore history as a 'truly social form of knowledge; the work, in any given instance, of a thousand different hands' (Samuel, 1994, p. 8). And indeed many historians do practise forms of inquiry far removed from the narrow specialisms Samuel condemns.

Nevertheless, many historians still juxtapose memory and history as mutually exclusive ways of interacting with the past. The kind of history Raphael Samuel sought to develop was

an organic form of knowledge, and one whose sources are promiscuous, drawing not only on real-life experience but also memory and myth, fantasy and desire; not only the chronological past of the documentary record but also the timeless one of 'tradition'.

(Samuel, 1994, p. x)

Documentary evidence and 'facts' are often unavailable to explain certain kinds of event. For example, the feelings of an artist or the motivations of a person undergoing extreme stress or emotional ecstasy can only be hinted at by empirical observation. But the memories of eyewitnesses or the imagination of someone trying to make sense of an event may provide a more convincing account than anything based on hard evidence. For this reason, memory – and especially collective memory – is often seen as an antidote to history, especially in situations where the documentation lies on the side of an oppressive class and the memories are on the side of the oppressed or marginalised.

Places of memory

The influential French historian Pierre Nora launched an ambitious project to document and analyse 'places of memory' precisely because he believed that modern circumstances, and the practice of 'scientific' history, had destroyed memory as it exists in more organic communities:

> The equilibrium between the present and the past is disrupted. What was left of experience, still lived in the warmth of tradition, in the silence of custom, in the repetition of the ancestral, has been swept away by a surge of deeply historical sensibility. Our consciousness is shaped by a sense that everything is over and done with, that something long since begun is now complete. Memory is constantly on our lips because it no longer exists ... *Lieux de mémoire* [places of memory] exist because there are no longer *milieux de mémoire* [social and cultural contexts of memory].
>
> (Nora and Kritzman, 1996, p. 1)

Nora juxtaposes a traditional rural society, in which memories and traditions are continually recreated and shared through ritual and poetry, with a modern, industrialised and urbanised society in which this comforting presence of the past has to be recreated in other ways. Instead of living memory, he argued, modern societies create an industry of memory substitutes – history and the heritage industry – to document, collect and store fragments of the past in the vain hope of calling up the lost experience which once attached to them. Nora, too, juxtaposes memory and history:

> Memory and history, far from being synonymous, are thus in many respects opposed. Memory is life, always embodied in living societies and as such in permanent evolution, subject to the dialectic of remembering and forgetting, unconscious of the distortions to which it is subject, vulnerable in various ways to appropriation and manipulation, and capable of lying dormant for long periods only to be suddenly reawakened. History, on the other hand, is the reconstruction, always problematic and incomplete, of what is no longer ... At the heart of history is a criticism destructive of spontaneous memory. Memory is always suspect in the eyes of history, whose true mission is to demolish it, to repress it.
>
> (Nora and Kritzman, 1996, p. 3)

Connerton also makes this distinction between the life of the village, where everyone knows everyone else's business, and that of the modern city, where we are surrounded by strangers:

> Most of what happens in a village during the course of a day will be recounted by somebody before the day ends and these reports will be

based on observation and first-hand accounts. Village gossip is composed of this daily recounting combined with lifelong mutual familiarities. By this means a village informally creates a continuous communal history of itself; a history in which everybody portrays, in which everybody is portrayed, and in which the act of portrayal never stops.

(Connerton, 1989, p. 17)

Nora distinguishes three kinds of memory: archival, memory as individual duty and alienated memory. The ironic and paradoxical observation that memory can be archival stems from the fact that Nora believed that historians have appropriated memory. But memory also lies with the individual, to take possession, alone or in groups, of memories which connect the public sphere and private experience. Any attempt to take possession of the past as memory has to struggle with the sense of discontinuity with the past created by modern conditions and emphasised by history. This creates a sense of alienation which can be countered by seeking ways of making the past vivid again by dramatic reconstructions or by visiting sites where significant things happened and filling the senses with the sight, sounds and smell of a particular place. The essays that fill the volumes of *Les lieux de mémoire* approach the problem of finding a more direct route to the past in different ways. Some of them study myths of identity, such as the privileged place of the Gauls as founders of the race (despite the historical importance of many other population groups, including the Franks), French attitudes to foreign migrants or the continuing conflict between left and right in remembering French resistance during the occupation in the Second World War. In each case, the aim is to focus on issues that are deeply felt by ordinary people and that had not been sufficiently studied by historians.

Nora's theoretical premises and methods have been criticised. Winter points out that ritual and literature are far from dead in modern societies and that the link between real experience and collective memory is performed by collective remembrance and by the relationships of grandchildren and grandparents (Winter and Sivan, 1999, p. 2):

The linkage between the young and the old – now extended substantially with the life span – is so central to the concept of memory that it is surprising that Nora doesn't simply urge us to leave our libraries and just look around, at our own families. A vital, palpable, popular kind of collective memory is, then, alive. Its obituary, written by Nora, is premature and misleading.

(Winter and Sivan, 1999, p. 3)

But Nora's enterprise is still of interest, in drawing attention to the importance of familiar places as carriers of meaning.

Memory, places and things

The relationship between memories and places or things is highly complex. What is the relationship between our understanding of the past and the objects that can be said to incorporate, or stimulate, memories of the past? There are many arguments for associating memory with objects. Marcel Proust tells us that the smell and taste of a madeleine biscuit prompted a suite of memories. We can all think of cases where visiting a place, coming across an object or hearing a piece of music stimulated memories. People often visit places connected with their childhood or with a loved one with the specific intention of reviving lost memories. The French novelist Albert Camus recounted visiting the cemetery in Brittany where his father was buried. Albert, born in Algiers, never knew his father, who died of his wounds in the battle of the Marne in 1914. Visiting the cemetery at the age of 40, Camus was overwhelmed with grief at realising that his father had died at the age of 29, and was younger than he was. Seeing the headstone prompted him to recall his memories of a childhood without a father (Winter and Sivan, 1999, pp. 52–4). The cemetery, and the poignant headstone of his father, enabled Albert's unhappy childhood memories to be precipitated, as it were, into emotional release.

Similarly, experiments have shown that students sitting an examination calling for a good recall of information will perform better if the examination is held in the same room that the learning took place (Winter and Sivan, 1999, p. 15). Psychologists refer to this as the 'extrinsic context' of an experience and its memory, and it is extremely important for an understanding of how heritage practices and memory may fit together. A place can prompt memories associated with an original experience in the same place. But a place where memories have been rehearsed – for example, a room where you heard someone recount their own memories – can also prompt the recall of these memories. Monuments and heritage sites can work in this way as memory prompts. Similarly, places and things associated with events of which we have no direct experience can come to prompt powerful personal memories, composed in part of stories (or history) we have learned but moralised and internalised by the imagination as if part of our own experience. The recent boom in visiting monuments and war graves commemorating the Great War is just such an example, nourished by historical accounts of the war, television documentaries and a sense of loss that many people have, precisely because the direct human ties with the 1914–18 war have almost entirely passed away. We will return to this in Chapter 2.

This brings us to an important question, which Jas Elsner expresses succinctly: 'Can we say that memory inheres in the materiality of a monument?' (Elsner, 2003, p. 209). In other words, is there anything in the form of an artefact which can carry meaning as memory, irrespective of what the viewer knows about the artefact's origins?

Recent historical analysis has attributed a particular place for physical artefacts in the definition of public memory:

> The most common strategy for justifying the analogical leap from individual memories to Memory – social, cultural, collective, public or whatever – is to identify memory as a collection of practices or material artifacts. This is the new structural memory, a memory that threatens to become Memory with a capital M ... The items adduced as memory are potentially endless, but certain tropes appear time and again. The most obvious are archives and public monuments from statues to museums, but another, more picturesque body of objects qualifies as well ... Ideally, the memory will be a dramatically imperfect piece of material culture, and such fragments are best if imbued with pathos.

(Klein, 2000, p. 136)

As American historian Kerwin Lee Klein points out (Klein, 2000), one advantage of transferring public memory on to the objects and practices that sustain them is that this makes them subject to historical inquiry.

So, memory can certainly be stimulated by attachment to things. The problem is, does this work the other way? Do certain objects or places have embedded within them forms or symbols capable of stimulating the imagination of all or many of those who see them? The Italian architect Aldo Rossi certainly thought so, describing historic cities in terms of the collective memory of its people (Rossi, Eisenman, Graham Foundation for Advanced Studies in the Fine Arts, 1982). The many authors who have taken the lead of Maurice Halbwachs or Pierre Nora have tried to find different ways of understanding the relationship between places and things and memories, both private and 'collective'.

This is a very complex question, which we cannot fully explore here. Can we say that art can work without some reference to lived experience and thus to memory? This has been one of the underlying debates over the topic of abstraction in art. Some critics insist that art works directly on the sensations through the impact of colour, line and form. The comparison with music is often made in this argument. There is a large body of experimental evidence to confirm that people do respond in a similar way to certain juxtapositions of line, colour and shape, or to certain patterns of rhythm, timbre and tonality in music. These arguments were particularly potent in the development of the ideas of Modernism. Artists and architects were concerned to discover a universal language of artistic expression which required no reference to the past and no specialist knowledge to be appreciated. The study of physiological sensations seemed a promising route to such a universal language. The Russian Constructivist architects who will be the subject of the case study, for instance, believed strongly in the power of certain shapes and forms to convey

emotion and meaning directly. Most critics nowadays agree, however, that all aesthetic responses, including those derived from abstract art and music, depend on a certain level of shared cultural experience (and therefore memory). Some artworks require a great deal of specialised experience to appreciate fully. Others require only the culturally conditioned experience of growing up, learning about the world and remembering strong emotions triggered by experience. This basic experience can be forgotten. For example, there are cases of 'colour amnesia', in which a person may forget how to identify particular colours and colour contrasts. Thus, the example of 'memento mori' illustrated at the start of the chapter (Figure 1.1) will not be perceived in exactly the same way by any two people and will be understood differently by someone who has never before seen a roadside memorial to a fatal traffic accident. But to a high proportion of British motorists, the shrine will evoke roughly similar feelings. Similarly, inscribed signs, such as a heart and initials cut into a tree, communicate very widely across a culture without the need of any direct association with the people concerned.

As we saw at the beginning of this chapter, it is an axiom of the heritage industry that buildings, as well as objects, places and things, enshrine memory. Just as it is argued that there is no such thing as heritage, only intangible heritage practices, it is more common to argue now that memories require remembering – active human interaction – to survive from generation to generation. We should try to leave this question open at least to the extent that the following chapters provide some evidence for the symbolic and figurative potential for monuments to prompt personal and collective memories.

Remembering Russian Constructivist architecture

The case study by Clementine Cecil looks at how enthusiasts in Moscow have created a culture of remembrance around certain buildings designed in the 1920s and early 1930s in the Modernist style known as Constructivism. How do people try to reconstruct a sense of their identity after political and economic changes as overwhelming as those of the Russian Revolution of 1917–18? One theory, in Bolshevik Russia, was to 'give the people their colonnades', in other words to build in the style of the palaces of the deposed tsars, as a symbol of the victory of the proletariat or a kind of distribution of prize money, giving everyone a taste of aristocracy. To many young avant-garde architects, just after the revolution, this situation was intolerable. They wished to devise a totally new architecture to represent a totally new society.

Modernism in architecture was a movement that had an impact across much of Europe in the years just before and especially after the Great War and took slightly different forms in different countries. The fundamental argument

for Modernism was that the world had been changed completely by industrialisation, urbanisation and the availability of new materials such as concrete, steel and plate glass. In these conditions, so the argument ran, it was a fault of reasoning to continue to design buildings in the conventional styles as if constructed in traditional materials and building methods. If the construction of buildings could follow the example of industry and dramatically reduce costs by standardisation, simplification and elimination of labour-intensive ornament, the problems of society could be solved by providing cheap and hygienic housing and public buildings. In the new Soviet state these arguments were overlaid with a specific approach to celebrating a new anti-bourgeois aesthetic intended to dignify the industrial proletariat. Architecture, design and even art should reflect the processes of industrialisation by which the state would rapidly modernise itself. Russian Modernism therefore adopted the generic label Constructivism, which implied an emphasis on an aesthetic based on the elements of industrial construction – steel girders, concrete beams and large windows.

Among a number of competing groups of architects, painters and designers, grandiose theories and plans were developed. The Productivists went so far as to argue that art itself was a capitalist bourgeois concept and should be abandoned in favour of work aimed directly at furthering an understanding of the revolution. Instead of making easel paintings or designing buildings, artists should work at the level of the factory, the street and the printing press. The most politically engaged of these groups devoted themselves to Bolshevik propaganda, staging popular festivals and decorating Proletkult propaganda trains with semi-abstract designs. At the other extreme, some artists and architects developed the idea of a revolutionary art of a more formalist kind. The ASNOVA (association of new architects), founded in 1923 under the leadership of N. Ladowski, took on the leadership of this tendency. They thought that the principles and message of the revolution could be inscribed into architecture by the use of radically new forms, made possible by the new materials, and expressing the dynamism of the proletarian movement. These architects looked to European Modernism for their inspiration, although they created a uniquely Russian style which was in turn highly influential in European avant-garde circles.

Much admired in the West was the research into new forms of housing carried out by the STROIKOM (state building committee). One of the products of this was the Narkomfin building, a highly influential communal housing block designed by I. Milinis and M. Ginzburg (Figure 1.3). Mosei Ginzburg was one of the theoreticians of Russian Constructivism and author of a book *Style and Epoch*, which was one of the few architectural books quickly translated and read in the West. This was partly because Ginzburg shared most of the assumptions of European writers, such as Le Corbusier, whose *Towards an Architecture* had been published in 1923, or Walter

Figure 1.3 Mosei Ginzburg, Narkomfin collective housing
block, 1928–32, Moscow. Photographed by David Martyn.
Photo: © David Martyn.

Gropius, whose book *International Architecture* was published in 1925.
Narkomfin, like many Soviet housing schemes, went much further than
its western counterparts, however, in radicalising the nature of
communal living. A communal kitchen provided meals for the inhabitants,
and child-care facilities allowed parents freedom to live a life
unencumbered by children.

Among the associates of ASNOVA and generally regarded as one of the best
of the new generation, was Konstantin Melnikov. He was selected as the
architect to build the Russian pavilion at the 1925 exhibition in Paris, which
gave him a great deal of international exposure. There is a photograph of him
in the Canadian Centre of Architecture which shows him and his wife dressed
in the latest French fashions, standing in front of the house and studio he

Figure 1.4 Konstantin Melnikov and his wife standing outside their house, Moscow, c.1927–9. Unknown photographer. Collection: Centre Canadien d'Architecture/Canadian Centre for Architecture, Montréal.

designed for himself in the centre of Moscow (Figure 1.4). The very fact of designing his own Modernist house was shocking within the group of Russian Modernists.

Despite his weakness for bourgeois luxuries, Melnikov designed buildings for workers' associations, including the Rusakov Club (1927–9) (Figure 1.5) and the Kautschuk Club. In these buildings Melnikov exploited the structural possibilities of reinforced concrete to create bold, machine-like forms expressive of a revolutionary proletarian society.

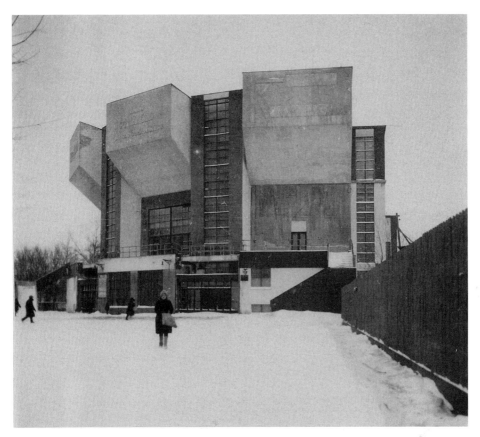

Figure 1.5 Konstantin Melnikov, Rusakov Club, 1927–9, Moscow. Photographed by Robert Byron. Photo: © Robert Byron/Conway Library, Courtauld Institute of Art, London.

Case study: official and unofficial Moscow

Although the interest of architectural historians, both in Russia and outside, has begun to produce a steady stream of publications on the architecture of the Russian Constructivists (Anderson, 2008), official attitudes in Moscow and majority public opinion remain indifferent. The crucial point of study in this case study is the dichotomy between official and unofficial versions of Moscow's history. Moscow is the showcase city of Russia, as it was of the Soviet Union, and it therefore has an official role and a corresponding official image. The hegemony of this official image is well illustrated by the repression of Soviet avant-garde architecture during the rise of Josef Stalin in the 1930s, as well as by the redefinition of the city's image since the fall of Communism. The presence of such a strong official image necessarily creates a counter-culture: an expression of an alternative experience of the city. I will explore this through the Moscow Cultural Walks (*Moskultprog*) conducted by

architectural historian and journalist Sergei Nikitin, which have contributed to the rediscovery and re-evaluation of Russian avant-garde buildings in the first years of the twenty-first century.

Moscow was re-attributed its capital status in 1918 following more than two centuries of St Petersburg's predominance as capital city. This was soon followed by a city plan to redefine the city's image, to provide factories and housing and to offer the people an image of a bright new future. Closely involved with this initiative were the Rationalists and the Constructivists, the two main artistic movements of the Russian architectural avant-garde, together with architects unaffiliated to any group, such as Konstantin Melnikov and Yakov Chernikov. They created completely new types of buildings, and developed radical new urban planning proposals. Actual construction on any significant scale began in 1925, when the first experimental and office buildings began to appear. The 'golden age' of the Russian avant-garde was 1927–9. In these three years virtually all the best-known buildings were built or planned: Mikhail Barshch's and Mikhail Sinyavsky's planetarium (1929), the Zuyev Club (1926) by Ilya Golosov (Figure 1.6), all of Melnikov's workers' clubs as well as his own house (all in 1927–9), the Narkomfin housing block by Ginsburg (1928–32) and Ivan Nikolaev's communal house for students (1928–30). The triumph of the avant-garde was such that it even inspired Aleksei Shchusev, a well-known and acclaimed pre-revolutionary architect, to design Lenin's Mausoleum and the Narkomzem building on Sadovoye Koltso (Garden Ring Road) (1928–1933) in the Constructivist spirit.

When they first appeared, the simple forms of the avant-garde buildings made them look like spaceships dropped among the Moscow sprawl, much of which still consisted of wooden houses. Not only were these engineers and architects creating much needed factories, but they were also providing an image of a bright, clean, technologically advanced future that broke with the past in every way imaginable.

However, it was not long before a different official image was needed, in step with the times. As the country became wealthier following the upheaval of the revolution, the First World War and the civil war, and with the introduction of the New Economic Policy in 1921 which re-introduced elements of market economy to the socialist system, the radical and revolutionary buildings of the avant-garde came to be seen as symbolic of a time of insecurity (Paperny, 2002). Within the Party, Trotsky and his ideas for world Communism were sidelined, and Stalin focused instead on Communism within the boundaries of the Soviet Union. The borders went up, and a period of relative stability ensued which was reflected in the arts by the rise of Socialist Realism. In April 1932 all architectural groups were banned and a single Union of Soviet Architects was created with the task of defining a new Soviet architecture.

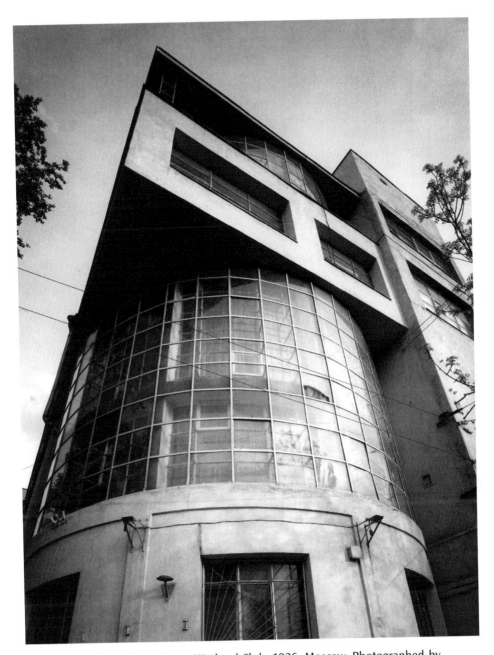

Figure 1.6 Ilya Golosov, Zuyev Workers' Club, 1926, Moscow. Photographed by Richard Pare. Photo: © Richard Pare.

Constructivism and Rationalist architectures were condemned as 'foreign imports' and not indigenously Russian. Neo-classicism was adopted as the official style.

Melnikov, unattached to any group, became a scapegoat in the hunt for the new architectural style. He was publicly denounced at conferences and in the press, and lost the right to practise. He lived in effect under house arrest at his own house, designing on paper but not in practice, until the end of his life.

Architecture students were taught that the buildings of the avant-garde were a failure, and a common exercise was to design projects to 'classicise' the buildings. Over the following decades many of the buildings of this time were clothed in classical details to hide their Modernist roots with their negative connotations. Buildings such as Narkomfin, which was originally lifted off the ground by thick concrete columns (*pilotis*) in line with Le Corbusier's 'five points of architecture', had its ground floor filled in with walls, and other buildings were simply neglected. While a negative attitude to Modernism was, and is, widespread throughout the world, within the Soviet Union the negative response was fuelled by a political agenda which rendered it not merely passive neglect but active repression.

This attitude persisted officially throughout Soviet times. In the 1960s General Secretary Krushchev publicly denounced several avant-garde buildings, although in academic circles their rehabilitation had already begun: Selim Khan-Magamedov began to publish articles on the avant-garde in the 1960s, as well as an important book on avant-garde Soviet architecture (Zhuravlev and Khan-Magomedov, 1968) and these were closely followed by Vigradia's Khazanova's important studies of the period.

In 1987 the State Administration for the Protection of Monuments awarded thirty avant-garde buildings 'monument' status and in 1989, to mark the one-hundredth anniversary of the birth of Konstantin Melnikov, seven more buildings were added to this list. Even this has in most cases not ensured their maintenance or protection and most are listed with local status, the lowest status for a monument in Russia. Laws are hard to enforce when they are not widely recognised or supported, and it is only recently that official attitudes towards the buildings of the avant-garde have begun to change. Why has this shift occurred? Two associated reasons are the fall of Communism and the newly politicised perception of the avant-garde. A third factor is the passing of sufficient time for the perceived **inherent** value of the buildings to be appreciated. Colin Amery, former head of the World Monuments Fund in the UK, noted in an introduction to a lecture on threats to Moscow's architectural heritage at the Royal Geographic Society in February 2006 (*Destruction of Moscow*, by Clementine Cecil and Alexei Leporc) that this last process usually takes seventy years, which is about the age of these buildings.

Today, Moscow is a city in transition. The Communist regime was toppled in 1991 and since then the former Soviet Union has undergone dramatic changes. This is reflected in the fabric of Moscow – evident from the amount of construction and demolition that is taking place. According to statistics from

the Moscow Architecture Preservation Society, Moscow lost over 2000
buildings between 1996 and 2006, some 400 of them architectural
monuments. The new city fathers, led by Yuri Luzhkov who became city
mayor in 1992 and at the time of writing still holds that office, have given the
city a new set of symbols suited to its new image. The first major new symbol
was the Cathedral of Christ our Saviour, demolished by the Communists in
1935 and recreated by Luzhkov in 1995. Another new addition is the palace of
Tsaritsyno, a late eighteenth-century palace commissioned by Catherine the
Great and never finished. It stood as a romantic ruin in a park in south
Moscow until 2005, when the mayor ordered work to start on 'completing' the
palace, which entailed giving it a roof and interiors that it had never had. This
building is comparable to other new Moscow restaurants modelled on a
fantasy past. One of these, Turandot, on Tverskoi Boulevard, is on the site of
an eighteenth-century listed building that was illegally demolished in
February 2004. It is patronised by Mayor Luzhkov and important state guests
are received here. An elaborate fantasy in the spirit of the eighteenth century,
the new building was created by the restaurant owner Andrei Dellos, who is a
trained theatrical designer. He said in an interview with the *Financial Times*
in December 2005 that he was giving the Russians an opportunity to
experience 'a place where they could dream'. Judging by the clientele of the
restaurant, he is giving very wealthy Russians a place to dream. For the rest,
they have lost a building but they have not gained an experience, as it is
inaccessible to them. The imbalance between official versions of history and
the experience of the ordinary Muscovite is addressed by Sergei Nikitin's
Moscow Cultural Walks, or *Moskultprog*. This alternative perception of the
city replicates the dynamic of the Communist era.

Throughout Communist times a powerful sub-culture ran parallel to official
culture, giving vent behind closed doors to strong political and cultural
criticisms of the regime. *Moskultprog* offers a public forum for remembering
that private experience of protest. Participants continue the dissident activity
of Communist times and give the memories of these times an important place
in Moscow's cultural landscape. They are also continuing the campaigning
that was started in the 1950s by supporters of the avant-garde.

The Moscow Cultural Walks

Moskultprog started in 1997 when Nikitin began to take some of his friends on
tours of his favourite parts of Moscow. Some of the early walks concentrated
on buildings of the avant-garde, as a period that had been severely neglected
since the 1930s. Nikitin's friends began to ask their friends along, and soon
the walks had turned into events attended by up to 200 people.

Each year Nikitin organises a cycle of eight to ten walks during the 'season',
that is, late spring to autumn. The groups meet on Saturday or Sunday

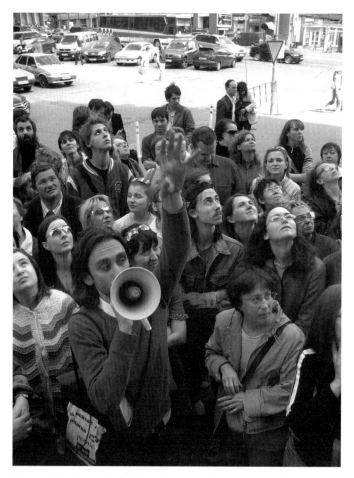

Figure 1.7 Sergei Nikitin with megaphone, interacting with members on one of his walks in Moscow, 2007. Unknown photographer. Photo: © Sergei Nikitin.

mornings in a designated metro station. Both the home-made advertising Nikitin uses for the walks and the underground venue contribute to the feeling of collusion in a sub-culture. Nikitin arrives armed with a megaphone – a classic tool of the revolutionary – and leads the way outside (Figure 1.7). The very act of gathering in a large group is an act of rebellion in Moscow where recent laws come down hard on civilian protest. The police often interrupt the walks but rarely manage to stop them.

Nikitin researches the areas before the walks and makes contact with locals who have particular insights into the architecture or history as well as others with specialised knowledge. Continuity is valued highly in this city of rapid change, and the descendants of architects or local people who have lived in an area for a long time are valued as much as architectural celebrities.

On the walks, history is formed from group memory. In September 2004 I attended a walk called 'Communal flats and sunshine in Moscow's Meshchanski region' (Figure 1.8). This was conducted by well-known radio broadcaster Sergei Buntman, who was born and brought up in the area. He was supported by theatre critic Valerii Zolotukhin, literary historian Leonid Vidgof and Sergei Nikitin.

The walk begins outside the Forum cinema on Sadovoye Koltso (Garden Ring Road). All attendees are encouraged to contribute, and the walk opens with several people sharing information about the cinema, which recently closed following a fire. Built in 1910, the Forum was one of the first in Russia, and had a cloakroom and an orchestra and choir, like a real theatre. Premieres took place there and, as Buntman comments, 'At that time it was absolutely necessary to go to premieres, in the very first days; that is what my Papa taught me: they could just take the film off repertoire after a few showings.'

The social history shared and revealed on the walks is as potent as the architectural history, if not more so, for it gives meaning to the buildings. Buntman points to the street corner and says, 'And another one of our myths – on the intersection of Ulitsa Shchepkina [Shchepkin Street] and the Sadovoye Koltso was a kiosk, first wooden and then stone. Here Yevtushenko's [Yevgenii Yevtushenko, poet] mother sold newspapers.' Someone else shouts 'Yes, and she sang in the choir in the Forum, that's right.'

The group has by now established itself by pooling memories and articulating common values and interests. Now, whether a building is demolished or reconstructed, whether a street is altered, or the function of a building changed, the group has memorialised it and given it a new significance as a vessel for memories, allowing change to occur without trauma. The shared experience of the walks has given people a space in which to come to terms with the transformations.

We cross the road via a pedestrian underpass, and someone tells us when it was built. The significance of this apparently banal detail is recognised by the group. The hierarchical power structure of Russia and the former Soviet Union is reflected in the urban planning. Pedestrians are at the bottom of the hierarchy and bow to the car. Cars – owned by wealthy people who do not need to get their shoes muddy – have dictated the development of Moscow since they became widely available after perestroika. The pedestrian is therefore forced to take indirect routes to get across busy streets, via crossings. Most of these are underground – the individual has been pushed underground. On the walk, simply by establishing the history of this pedestrian crossing, the experience of the pedestrian is acknowledged and valued.

As we leave Sadovoye Koltso and enter the quiet back streets, we encounter a different zone of the city, where the buildings are less imposing and there is less emphasis on official image. The noise of the cars recedes; we can hear

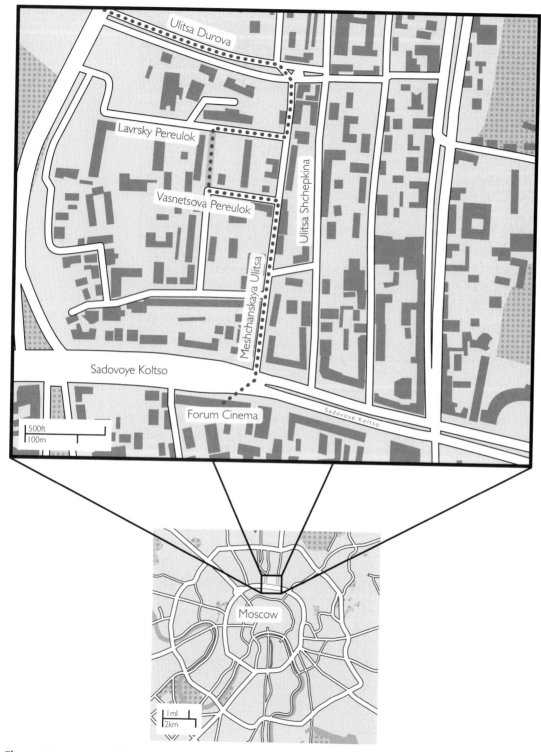

Figure 1.8 Route of 'Communal flats and sunshine in Moscow's Meshchanski region' walk.

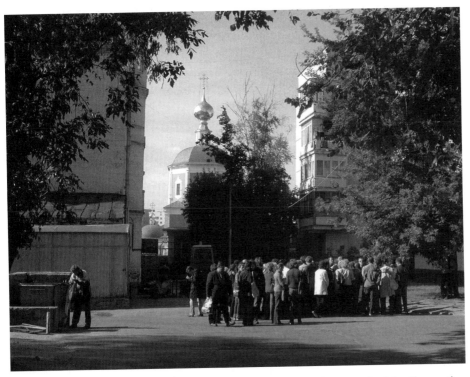

Figure 1.9 Sergei Nikitin walking tour in Moscow, 2007. Photographed by Clementine Cecil. Photo: © Clementine Cecil.

ourselves speak. We pass Sergei Yurev's house where Lev Tolstoy was known to come as a guest to discuss philosophy after tethering his horse to a lamp-post outside. Next door is the building where we are told Buntman passed his childhood. For the group, these two pieces of historical information have equal value, knitting personal experience with more established history. The group warms up, and in a quiet courtyard reminiscences come pouring forth. Buntman tells stories about the communal flat where he lived, and others join in with stories from their own past. They point into emptiness, where there once stood a building in which they lived. The younger people on the walk are transfixed by the evocation of the ghosts of buildings and by the portrait that is being drawn of the lives of the earlier generation. For young people one of the main motivations for attending the walks is the desire to grasp the history of a city that is changing so fast. In this way, built heritage that is no longer standing lives on through memory and continues to inform the experience of the city, in a different, though equally potent, way from existing built heritage. For those who did not live there, the building that exists now only in memory becomes a part of their associations with that place.

It is a hot day. After a long session of reminiscence the group breaks up to wander along empty sun-filled streets, the air humming with memories. We

come together again at the foot of a brick art nouveau building, where Nikitin talks in architectural historical terms. The walks usually last three or four hours until, satiated, the group disperses. Walks take place even if the weather is bad – in snow, rain or intense heat – showing how much they are valued by those who attend. At *Moskultprog* a community of people of all ages and backgrounds has formed. I talked to one elderly lady who said she preferred to come to the walks than go to her dacha (country cottage) outside Moscow, even during planting season. For her, it was a chance to take in another version of her city's history, one closer to her own, that valued and validated her experience.

The walks do not go unobserved: Nikitin is a journalist and he uses the press as an extension of his megaphone. He sees the presence of television cameras as a mark of the walks' success, for they validate on a more official level the private experiences shared by participants. This is an example of a grassroots sub-culture that enters official culture and subverts it by expressing a different set of values.

Nikitin is aware of the sensitivity of the issue of heritage, of the emotions it touches and its political associations. He is not interested in political debate: he believes that a political polemic would restrict experience during the walks. Rather, he concentrates on creating an atmosphere of openness, discussion and playfulness on the walks:

> It depends a lot on the style, the style was always very important to me. There is a pogrom, rumbling style – to shout and heckle the authorities, but I prefer a more scholarly approach, entertaining scholarship.
>
> (Interview with Sergei Nikitin, Moscow, 13 November 2004)

In the same interview he says:

> I have many times received amazing letters saying what a wonderful atmosphere – I had forgotten about this atmosphere – it's the atmosphere of the 80s, or 60s – it depends on when the person was young, and they compare that to our project.

Both the 1980s and the 1960s were periods when private alternative cultural scenes flourished. The 1980s was a time of stagnation under Brezhnev when very little changed. For people who lived that experience, the accelerated change that has hit Moscow since the fall of the Soviet Union is a shock:

> As Moscow is being pulled down and rebuilt once again to conform to the latest vision of the past and its future, its inhabitants hold on to the specific truths that make up the unseen history of a city.
>
> (Dimbleby, 2008, p. 169)

Nikitin recreates the freedom of the atmosphere of the 1980s, in which participants are able to establish a new relationship with the city.

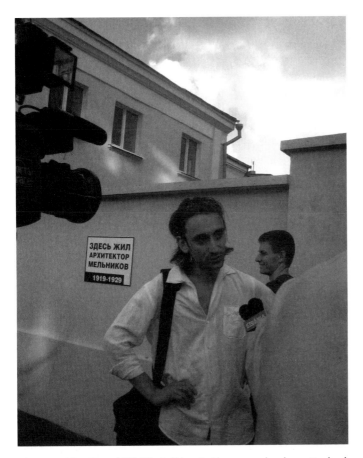

Figure 1.10 Sergei Nikitin talking to the press, having attached the plaque dedicated to Konstantin Melnikov on to the wall of a building in which the architect once lived, Moscow 2005. Photographed by Clementine Cecil. Photo: © Clementine Cecil.

Afterwards an account of the walk is written up and placed on the website, with photographs. The website is widely used by individuals for research purposes, and print journalists who attend the walks often use material in their articles. Thus oral, group history becomes written history.

The walks are also popular with television as they are visually impressive. Nikitin has a strong sense of theatre and likes to invite musicians to participate, and to sing on the walks. He also organises related events that are directed specifically at the press and that can be described as direct action. For example, in summer 2006 Nikitin made a cardboard placard printed with the words 'Architect Melnikov Lived Here 1919–1929'. He invited the press and attached the placard to the wall of a building where Konstantin Melnikov once lived (Figure 1.10). The building is now a glamorous restaurant. With this simple action Nikitin was attempting to overcome the prevailing indifference to Moscow's heritage and specifically to its avant-garde legacy.

Nikitin has made a significant contribution to the debate concerning ways of persuading the authorities of the importance of the buildings of the avant-garde. Academics and bureaucrats campaigning for increased recognition of the buildings respect and value his playful approach and his good relationship with the media. His walks are a means of reacting to the destruction of the city, trying to preserve things that are important to people's memories, and actions such as the Melnikov placard event rile the public and the authorities, through playful activity, to reconsider the values they have imposed on a certain period of history.

Reflecting on the case study

The Moscow Cultural Walks, and Nikitin's strategies in organising them, embody many of the practices of collective memory that we have looked at in this chapter. The evocation of the past is de-centred: many voices are encouraged to contribute, rather than the single authoritative voice of the architectural historian. No one meaning is attributed to the buildings visited and, although their architectural qualities are discussed, equal value is given to the memories and stories coming from the group. Following the tactics proposed by Pierre Nora, buildings and places are used to stimulate memories and to encourage 'forgotten' memories to re-emerge. That this takes place within a group – self-selected for having some interest in the neighbourhood – reinforces the social role of memory. The walks also point up some of the problems of memory in a period of radical ideological changes. Many Muscovites no doubt had their criticisms of the Soviet regime, but they also have a nostalgia for aspects of the life they led. Trying to come to terms with difficult but very poignant memories is a fundamental task for contemporary societies.

Places of memory

We might ask ourselves why buildings themselves are important in this rehearsal of private and shared memories. Would not a meeting in a café or in someone's room serve just as well? People tend to imprint memories on places, and buildings – which bear witness to the passage of time in the wear and tear on their façades – can help to trigger these hidden memories. Furthermore, the ideas embedded in the design and use of buildings – in this case the hopeful utopianism of the late 1920s – can carry a very strong emotional charge for those who saw those dreams dashed over the years. So, although there is nothing stopping people exchanging memories and stories, or carrying on the traditional activities which constitute their real heritage, we find again and again the need to attach these to specific places and things. Whether contemporary societies have got it right by institutionalising much of

this in museums and heritage sites is a question we will be asking throughout this book. But what is clear is that intangible and tangible heritage are locked together through the processes of recollecting and sharing memories.

Conclusion

We began this chapter by locating associative heritage values, and public and private memory, within the values of **official heritage** practices. It should be clear by now that considering the way that private and public memory works, as opposed to the methods of the historian or the conservationist, raises a number of important issues. If heritage professionals are to retain a hold on our imagination, it behoves them to be extremely sensitive to the intersection between what we as individuals cherish, in our recall of the past, and what professional experts consider to be valuable. That public and private memory is changeable, subject to many internal and external pressures and inherently difficult to interrogate, makes this a tough challenge. We will discover, in the next three chapters, that our troubled past, and the very different perspectives we may have of it, either as groups or as individuals, builds tensions which both nourish and threaten consensus.

Works cited

Anderson, R. (2008) 'Taking stock: documenting Russia's modern heritage', *Future Anterior: Journal of Historic Preservation History, Theory and Criticism*, no. 5, pp. 81–6.

Bal, M. (1999) 'Introduction' in Bal, M., Crewe, J.V. and Spitzer, L. (eds) *Acts of Memory: Cultural Recall in the Present*, Hanover, NH, Dartmouth College University Press of New England, pp. vii–xvii.

Bartlett, F.C. (1932) *Remembering: A Study in Experimental and Social Psychology*, Cambridge, Cambridge University Press.

Connerton, P. (1989) *How Societies Remember*, Cambridge, Cambridge University Press.

De Man, P. (1970) 'Literary history and literary modernity', *Daedalus*, no. 99, pp. 384–404.

Dimbleby, L. (2008) *I Live Here Now*, London, Firework.

Douglas, M. (1980) 'Introduction' in Halbwachs, M. (ed.) *The Collective Memory* (trans. F.J. Ditter and V.Y. Ditter), New York, Harper and Row, pp. 1–21.

Drury, P. and McPherson, A. (2008) *Conservation Principles Policies and Guidance for the Sustainable Management of the Historic Environment*, London, English Heritage.

Efron, D. (1941) *Gesture and Environment*, New York, King's Crown Press.

Elsner, J. (2003) 'Iconoclasm and the preservation of memory' in Nelson, R.S. and Olin, M. (eds) *Monuments and Memory, Made and Unmade*, Chicago, University of Chicago Press, pp. 209–31.

Forty, A. (1999) 'Introduction' in Forty, A. and Küchler, S. (eds) *The Art of Forgetting*, Oxford, Berg Publishers, pp. 1–18.

Freud, S. (1969) *Civilization and its Discontents* (trans. J. Riviere), London, Hogarth Press (written 1929, first published as *Das Unbehagen in Der Kultur*, 1930).

Halbwachs, M. (1980) *The Collective Memory* (trans. F.J. Ditter and V.Y. Ditter), New York, Harper and Row (first published as *La Mémoire collective*, 1950).

Halbwachs, M. and Coser, L.A. (1992) *On Collective Memory*, Chicago, University of Chicago Press (first published as *Les Cadres sociaux de la mémoire*, 1925).

Khan-Magomedov, S.O. (1987) *Pioneers of Soviet Architecture: The Search for New Solutions in the 1920s and 1930s*, New York, Rizzoli.

Klein, K.L. (2000) 'On the emergence of memory in historical discourse', *Representations*, no. 69, pp. 127–50.

Nora, P. and Kritzman, L.D. (1996) *Realms of Memory: Rethinking the French Past – 1 Conflicts and Divisions*, New York, Columbia University Press.

Paperny, V. (2002) *Architecture in the Age of Stalin: Culture Two*, Cambridge, Cambridge University Press.

Portelli, A. (2003) 'The massacre at the Fosse Ardeatine' in Hodgkin, K. and Radstone, S. (eds) *Contested Pasts: The Politics of Memory*, London and New York, Routledge, pp. 29–41.

Rossi, A., Eisenman, P., Graham Foundation for Advanced Studies in the Fine Arts and Institute for Architecture and Urban Studies (1982) *The Architecture of the City*, Cambridge, MA, MIT Press.

Samuel, R. (1994) *Theatres of Memory: Volume 1, Past and Present in Contemporary Culture*, London and New York, Verso.

Schudson, M. (1995) 'Dynamics of distortion in collective memory' in Schachter, D.L. (ed.) *Memory Distortion*, Cambridge, MA, Harvard University Press, pp. 346–64.

Smith, L. (2006) *Uses of Heritage*, Abingdon and New York, Routledge.

Winter, J. (1995) *Sites of Memory, Sites of Mourning: The Great War in European Cultural History*, Cambridge, Cambridge University Press.

Winter, J. and Sivan, E. (eds) (1999) *War and Remembrance in the Twentieth Century*, Cambridge, Cambridge University Press.

Yates, F.A. (1966) *The Art of Memory*, London, Routledge & Kegan Paul.

Zhuravlev, A.M. and Khan-Magomedov, S.O. (1968) *Sovetskaia arkhitektura*, Moscow, Znanie (see Khan-Magomedov for revised English edition).

Further reading

Forty, A. and Küchler, S. (eds) (1999) *The Art of Forgetting*, Oxford, Berg Publishers.

Gillis, J.S. (1996) *Commemorations: The Politics of National Identity*, Princeton, NJ, Princeton University Press.

Hodgkin, K. and Radstone, S. (eds) (2003) *Contested Pasts: The Politics of Memory*, London and New York, Routledge.

Radstone, S. and Hodgkin, K. (eds) (2003) *Regimes of Memory*, London and New York, Routledge.

Urry, J. (1996) 'How societies remember the past' in Macdonald, S. and Fyfe, G. (eds) *Theorizing Museums*, Malden, MA and Oxford, Blackwell Publishing, pp. 45–68.

Winter, J. and Sivan, E. (eds) (1999) *War and Remembrance in the Twentieth Century*, Cambridge, Cambridge University Press.

Chapter 2 The heritage of public commemoration

Tim Benton and Penelope Curtis

A place where collective and private memory converges most directly is the war memorial. 'The commemoration of the dead of the First World War was probably the largest and most popular movement for the erection of public monuments ever known in Western society' (King, 1999, p. 147). War memorials offer a test of the working of what Laurajane Smith (2006) calls the authorised heritage discourse (AHD) because they can be seen as a calculated way to promote consensus around a particular set of patriotic values and reinforce a sense of shared identity. In other words, as Smith would argue, the AHD frames the way we think about and discuss war memorials in the service of nationalist goals. Alternatively, they can be seen as a means for individuals and small groups to express their feelings, or at least take part in a shared social action. We will look at examples of both here and seek to draw out the necessary connections between collective and private memory.

In the first part of the chapter we will look closely at two examples of British national commemoration, each formed as much by public engagement as by politicians, architects or sculptors. Trafalgar Square in London became over the years a site both of commemoration of the state and resistance to it. Penelope Curtis, Director of the Henry Moore Institute in Leeds and a leading expert on British sculpture, traces the evolution of the Whitehall Cenotaph as the most important commemoration of the Great War. In the second half of the chapter we will turn to the form of war memorials and the role that artists and sculptors play in representing feelings about loss and mourning. This book is about material as well as intangible heritage, and the monuments themselves present problems of adaptation and change over time that need to be understood and dealt with.

Introduction

In so far as we can speak of 'collective remembrance' and its relationship with heritage and national identity, wars – and the sacrifices on which they depend – play a crucial role. A sense of Britishness has been moulded by past victories – Agincourt, Trafalgar, Waterloo, the battle of Britain – as well as by bitter experiences such as the battle of Hastings, the evacuation of Dunkirk and the surrender of Singapore or the Blitz. Scottish identity has been marked both by the victory over the English at Bannockburn and by the bloody defeat at Culloden. Australian and New Zealand identity has been grafted on

to the terrible Gallipoli campaign in the Great War. These events are rehearsed in plays, novels, films, television documentaries and annual ceremonies and practices. They may affect different groups within society in radically different ways. Where Republican Irish sympathisers march in Belfast every year to commemorate the Easter Rising in 1916, the decisive step in the liberation of Ireland from British rule, Protestant Loyalists remember the first day of the battle of the Somme on 1 July 1916, where the 36th (Ulster) Division was virtually wiped out on the first day of the action (Graham, Ashworth and Tunbridge, 2000, p. 37). In fact, 250,000 Irish men and women served in the British army during the Great War and the losses were very high. Only recently, however, as a result of the slow healing of the wounds provoked by the Troubles in Northern Ireland, has it been possible for the Irish nation to give prominent public expression to remembering the Irish dead in the Great War. In 1998 Queen Elizabeth and Mary McAleese, President of Ireland, were both present at the opening of the Irish Peace Park at Messines, where the 16th (Irish) Division suffered its worst casualties. This is a vivid example of how **commemorative** monuments and ceremonies are subject to movement in political attitudes and emotions.

Many public institutions in the UK – schools, universities, railway stations, town halls and office buildings – commemorate in some way those who died in the two world wars, and virtually every village and town has a war memorial. Many of these are simple stone cross memorials on a plinth, with the words 'Our Glorious Dead', and often the names of the dead from the community. In the relatively homogeneous communities of the countryside and small towns, these monuments may be both reassuring and part of a shared culture. The problem of representing death on the larger stage of the nation or empire posed different problems.

Remembering wars is a particularly powerful means of confirming national identity. That which palpably threatens the stability of a nation can be seen to align the interests of the individual with those of the state, overriding class and sectarian differences. For this reason, some authors see war memorials as a kind of state propaganda, a ready opportunity to use a deep sense of loss as a weapon to construct consensus around the patriotic values of courage and sacrifice and the rightness of the cause (King, 1998, p. 148). Indeed the iconography of many war memorials can be read in this way, transposing military conflict into the struggle between good and evil (St George and the dragon, for example) and emphasising the purity, innocence and desirability of 'Peace', or 'what we are fighting for', invariably represented as a naked or scantily clad woman. War remembrance plays particularly powerfully across gender difference.

The examples we look at here, however, often indicate that state organisations had great difficulty controlling the memorialisation of war. The historian Alex King argues that the reason for this was that there was no consensus

about why so many young people had died and what an appropriate representation of these losses should be:

> However, commemoration did achieve a very considerable degree of social unity in action. It could do so because all the controversial activity centred on a carefully preserved area of the unsaid, the inexplicit. It was an area which could be approached from many points of view, an area for common action, rather than for the expression of common values.

(King, 1998, p. 164)

The most successful practice of annual remembrance in Britain and much of the empire and dominions was, precisely, a space, the two-minutes silence, in which people could at one and the same time feel a solidarity of shared action and a complete privacy in its content and meaning. So it is hardly surprising that some of the most successful monuments were also those that were least explicit.

The war memorial in Leeds is a graphic illustration of some of the issues surrounding commemoration after the First World War (Figure 2.1). Although more than 10,000 Leeds men were killed in action, in a city of half a million people, only 210 relatively wealthy people could be persuaded to subscribe to a memorial, and the sum produced was only a fraction of what was hoped for. The 15th Battalion of the West Yorkshire Regiment, part of one of Kitchener's 'Pals' regiments recruited at the outset of the war, was slaughtered on the first day of the battle of the Somme, with all its officers and all but seventeen men killed or wounded, from a total of 900. Perhaps it was the trauma of these terrible losses, coupled with a sense of grievance about the futility of the war, that dissuaded a popular engagement in commemoration. Nor did the population take the monument to its heart. It was later moved from its original position in the City Square to a less significant position near the Town Hall, and the crowning bronze figure of Victory was removed to Cottingley Crematorium where it was progressively destroyed by vandalism. The new statue of Victory is a recent reconstruction. We will return to this monument later.

Over 86 years after its inauguration this monument still serves its official function as a place for the annual ceremonies and the laying of official wreaths, but there is little evidence of strong popular reverence for it. There appears to be more active participation in a nearby plaque commemorating the names of seventeen Leeds men awarded the Victoria Cross for bravery down the years. Here, in a lead-lined tray, can be seen many small wooden crosses with messages from family members. This appears to be the place where individual crosses are dedicated to family members, with recently written notes, whereas the main monument operates mainly as a place for official organisations – the British Legion, the police and army – to lay their annual wreaths.

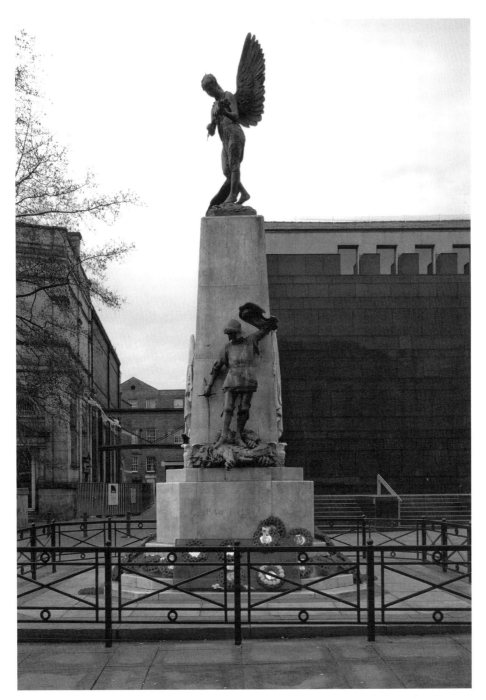

Figure 2.1 H.C. Fehr, Leeds War Memorial, 1922. Photographed by Tim Benton.
Photo: © Tim Benton.

Trafalgar Square as site of empire

To set the Great War monuments into a historical perspective, it is useful to look at an earlier attempt to create a British site of national celebration of victory in war. As late as the Napoleonic wars, which stretched British endurance to the limit, governments were unsure how to proceed and broadly limited themselves to celebrating national heroes. In 1837 a huge equestrian statue of Lord Wellington was commissioned, to stand near the Mansion House in the City of London, and the next year Mathew Cotes Wyatt began work on the 60 ton bronze figure of Wellington on his horse Copenhagen on the eve of the battle of Waterloo (finally installed in 1846). This was located on top of the Green Park arch but was so controversial that it was removed in 1883, on the occasion of the relocation of the whole arch in order to smooth traffic flow, and was eventually relocated in Aldershot.

A problem with celebrating British victory over Napoleon's armies, in the person of Lord Wellington, was that the man was very much still alive in the 1830s and leading the opposition in the House of Lords. Admiral Nelson was much easier to deal with, since he had died a hero's death at the battle of Trafalgar in 1805. Of the various monuments raised to celebrate Nelson, the most famous is the column, built by public subscription in the newly planned Trafalgar Square. The Wellington statues helped to stimulate the forming of a committee in 1838 to create a great monument to victory at sea. Funds were raised and a competition held, leading to the choice of the architect William Railton, out of a field of 124 entrants (Mace, 1976). Instead of focusing on the personality of the hero, Railton designed a Corinthian column 174 feet high, on which the stone statue of Nelson could barely be seen.

Giant columns had been used in antiquity to celebrate military campaigns. For example, a column was set up in Trajan's forum in Rome to celebrate the Emperor's victories in the Dacian wars. Continuous carved reliefs that spiral up the column tell the stories of these campaigns in graphic detail. This form was copied in the column erected in the Place Vendôme in Paris by Napoleon to celebrate the battle of Austerlitz (1806–10). This was always regarded by those on the left as an aggressive symbol of despotism, and was demolished during the Paris Commune in 1871 by a group led by the painter Gustave Courbet. Nelson's column, designed when the Neo-classical revival was still at its height, breaks the tradition in that it represents a classical Corinthian column without any reliefs or decoration added to it. Only around the base on which the column sits are four of the 'stories' of Nelson's victories told in large bronze reliefs. Of these, two show Nelson as triumphantly victorious (Ternmouth's scene from the bombardment of Copenhagen and Watson's *Battle of St Vincent*), while two show him as a sacrificial victim (Woodington's *Battle of the Nile*, where Nelson received a severe shrapnel wound, and Carew's *Death of Nelson*). Those who bother to look attentively at these will

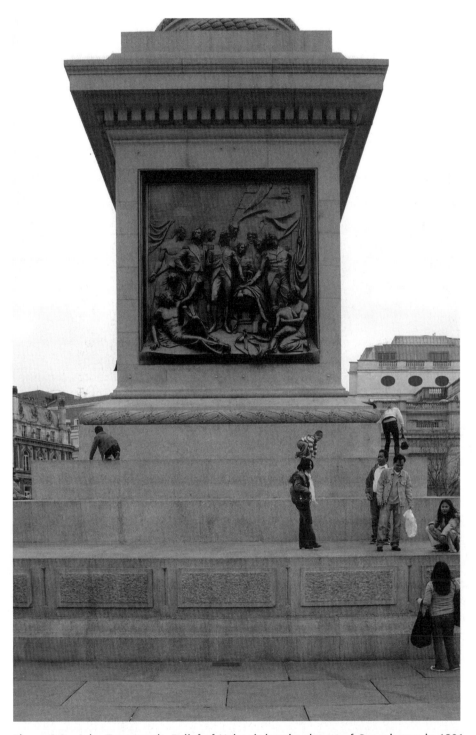

Figure 2.2 John Ternmouth, Relief of Nelson's bombardment of Copenhagen in 1801, *c.*1846, Trafalgar Square, London. Photographed by Tim Benton. Photo: © Tim Benton.

understand that naval warfare was indeed brutish and horrific. They will also pick up the suitably uplifting message that common sailors and commissioned officers fought side by side and suffered the same hardships, united by their respect for their leader and their country. For example, the relief showing the bombardment of the city of Copenhagen shows a bare-chested sailor standing shoulder to shoulder in a line of officers which also includes a youthful midshipman (Figure 2.2). Nelson's empty sleeve demonstrates his personal courage, while two wounded figures take solace from his example. The distance between this image and the reality of Nelson's navy, with its press gangs and brutal punishments, has to be stressed.

Perhaps the best-loved aspect of the Nelson memorial is the latest addition, the lions modelled by the renowned Victorian animal painter Sir Edwin Landseer to replace four unsatisfactory stone beasts which were part of the original project. The new bronze lions were not finally installed until 1863 and add greatly to the character of the square. The British associate lions with the authority of the Crown and state and their presence reinforces the sense of Trafalgar Square as a site of empire. But it is also important to reflect on the role of national monuments, at a much more mundane level, as generators of new and private memories. Tourists need to be photographed alongside something recognisable, to mark their passage through the memorable world. At this level, the pigeons, lions, fountains, column and surrounding buildings all have a role to play. The lions fit well into the use of the square, since children can climb up on them, and the sculptures have a naturalistic quality to which people respond well. The fountains feature in many acts of popular celebration. Feeding the pigeons was, for many people, the most memorable aspect of their visit to Trafalgar Square until the decision was taken to ban the practice and cull the pigeons using trained falcons.

The menu of commemorative devices

Most monumental sculpture, even works commemorating events of great national importance, are roundly ignored by the public. The authorities often have difficulty capturing the public's imagination with public monuments. For example, of the four plinths erected in Trafalgar Square, only three have permanent monuments on them. The equestrian statue of King George IV (by Sir Francis Chantrey, 1829–41) can at least be recognised as 'Monarchy', but few people will know what to make of the standing figures of Major-General Charles James Napier (by George G. Adams, 1856) or Major-General Sir Henry Havelock (by William Behnes, Figure 2.3), whose large bronze statues occupy plinths on the southern side of the square. The latter played an important role in putting down the 'Indian Mutiny', an event which caused consternation in Victorian Britain. Inflamed by stories of outrages performed on defenceless women and children by the rebellious sepoy troops,

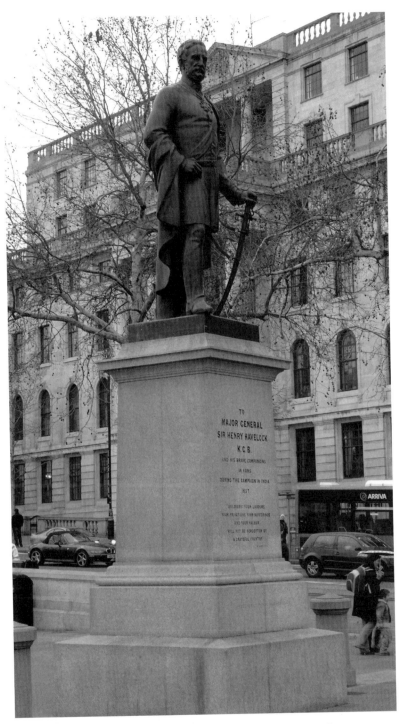

Figure 2.3 William Behnes, Monument to Major-General Sir Henry Havelock, 1861, Trafalgar Square, London. Photographed by Tim Benton. Photo: © Tim Benton.

Havelock's forces carried out ugly reprisals throughout the affected areas, slaughtering thousands of Indian villagers in the process. Perhaps this was the reality of a colonial situation in which a relatively tiny number of British soldiers and officials attempted to control a teeming subcontinent with an army largely composed of local recruits But this was not a reality the Victorian population wished to see represented, and so Havelock is not even shown in military uniform.

In an attempt to dignify Havelock as a popular hero, part of one of his speeches is inscribed on the plinth: 'Soldiers, your labours, your privations, your sufferings and your valour will not be forgotten by a grateful country.' The Office of Works censored the next line in his speech: 'You will be acknowledged to have been the stay and prop of British India in the time of her severest trial' (Mace, 1976, p. 122). To stress the role of military domination and reprisals would detract from the myth of the 'Jewel in the Crown' – a peaceful empire of people consenting in a process of civilisation and production of wealth. Of course, Trafalgar Square is meant to give a particular view of empire. It is not a place to remember the dirty work abroad that was considered necessary to maintain Pax Brittanica in the empire. Monuments have a particular role to play in both remembering and forgetting important parts of national history.

Napier also served in India, where he conducted a daring campaign leading to the annexation of Sind (in modern Pakistan) in 1843. But he was chiefly respected in Britain for dealing with Chartist disturbances in the north of England, despite having some sympathies himself with the Chartist cause. Napier was a Liberal, but also a fiercely patriotic professional soldier who wrote a manual on the use of volunteers and militia in the suppression of civil unrest (*A Letter on the Defence of England by Corps of Volunteers and Militia*, 1852, cited in Mace, 1976, p. 116).

What is the role of these statues in the modern city? The former mayor of London Ken Livingstone proposed moving the statues of Napier and Havelock to a site on the river, saying:

> I think that the people on the plinths in the main square in our capital city should be identifiable to the generality of the population. I have not a clue who two of the generals there are or what they did.

> (quoted in Kelso, 2000, p. 3)

But this may be partly to miss the point. As Paul Kelso, in an article in the *Guardian* in 2000 reported,

> Ronald and Carol Tynan, visiting from Ohio in America, wouldn't change a thing. 'I've got no idea who these guys are but they look great,' said Carol. 'Why take 'em down? They're beautiful, very impressive.'

> (Kelso, 2000, p. 3)

These statues communicate at the level of their stiff Victorian clothes and lofty demeanour. At this level they contribute to the sense of place, imparting an atmosphere of dignity, of the passage of time, of a past wealth and confidence, which helps to explain something of the character of Victorian London. In this sense, works of art and architecture can convey meaning quite separate from their intended meanings.

Hardly any of the historical events associated with Napier or Havelock, or indeed the whole history of settlement, colonialism and empire, could now be celebrated as simple patriotic duty. Here, as so often, history is the enemy of heritage. Many perspectives have to be taken into consideration by the historian. To ask whether the full reality of colonialism could be represented on the public stage in the form of monuments is to expose the strict limitations of commemorative monuments, however ready British people might be to look again at this period.

The tradition of protest

Trafalgar Square is an interesting example of how official policy and popular practice can stand in mutually sustaining opposition. Almost as soon as the square was laid out at the beginning of the nineteenth century it became a site for demonstrations of protest. Part of the point of demonstrating against the policies of the day in Trafalgar Square is that the place is seen, precisely, as representative of authority. Memories, in Trafalgar Square, are as likely to be triggered by thoughts of relatively recent demonstrations, based on personal experience, traditional stories or television programmes, as by the physical monuments. Denise Scott-Brown, one of the architects of the extension to the National Gallery, on the north-west side of the square, actually claimed that a feature of their building – the large window over the entrance facing diagonally towards the square – was intended to reach out to the square, like a mother holding out her arms to the young people meeting in protest (Benton, 2000, p. 70). Scott-Brown, the wife and architectural partner of Robert Venturi, was born in South Africa, and spent many years in London during the time when there was a permanent anti-**apartheid** vigil outside South Africa House on the south-east side of the square. This is a good example of how personal experience and associations interact with buildings to leave a trace in the built environment. If we are to talk of cultural memories, they will be made up of these kinds of elements too. The history of public protest in Trafalgar Square is an important part of public history as well as private memories. The Museum of London maintains an archive documenting these demonstrations and this alternative history sits alongside the history of empire in a necessary dialogue. Without the one, there would not be the other.

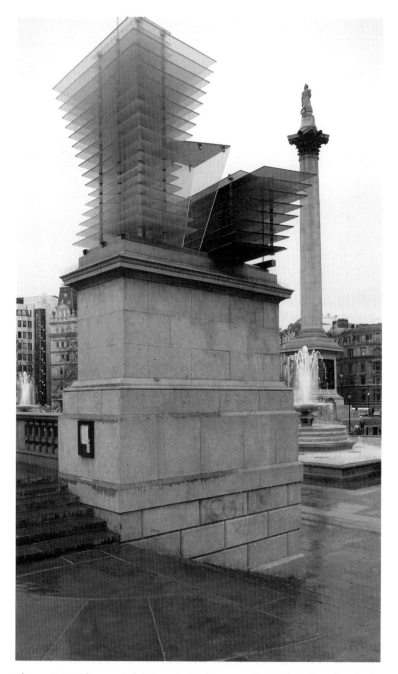

Figure 2.4 Thomas Schütte, *Model for a Hotel*, 2007–9, fourth plinth, Trafalgar Square, London. Photographed by Tim Benton. Photo: © Tim Benton. © DACS 2009.

Public debate about the role of public monuments in Trafalgar Square has been stimulated in recent years by the programme of contemporary sculpture launched by the Royal Society of Arts in 1998 to occupy an empty plinth. This plinth was originally designed by Sir Charles Barry in 1841 to hold an equestrian statue. A succession of works by British and foreign sculptors succeeded in capturing the interest of the public. Marc Quinn's realistic sculpture *Alison Lapper Pregnant* (Alison Lapper is an artist born without arms and with shortened legs) (September 2005 to October 2007), was better received than Thomas Schütte's *Model for a Hotel* (November 2007 to May 2009) (Figure 2.4). This construction of coloured Perspex was originally titled 'Hotel for the Birds', but the title had to be changed because of the newly introduced ban on pigeons.

In 2001 a substantial remodelling of Trafalgar Square was carried out, to make the square more accessible from the National Gallery but also to introduce new lighting and public surveillance systems intended to discourage bad behaviour. As Sue Malvern has written:

> The whole course of the project, the subsequent remodelling of Trafalgar Square as a public space (the most extensive since it was first established) and the reinstallation of a programme of contemporary sculpture for the still-vacant pedestal has shifted the meanings of Trafalgar Square in ways that are possibly the most significant in its history as a public space.
>
> (Malvern, 2007, p. 132)

From constituting a site of memory (that of the empire and resistance to government policy), the square is being recast as a safe place for cultural tourism. The new tradition for generating controversy around the fourth plinth has been continued by the sculptor Antony Gormley, whose project was to allow 'ordinary people' to occupy the plinth: 'The proposal is, for 100 days from 6 July [2009], to occupy the fourth plinth with 2400 people, 24 hours a day, one person at a time, one hour each' (Gormley, 2009).

Commemoration and the Great War (1914–1918)

Although the Crimean and Boer Wars produced new kinds of journalism, images and monuments, it was the Great War which presented the problem of remembrance in a new form. This was partly because of the scale of loss, which scarred every village, school and factory in the land, and partly because it was difficult to take comfort from victory. Nevertheless, it was essential to stand behind victory and the just cause, or the bitterness of loss would be unbearable. Furthermore, the sheer horror of trench warfare could not be communicated to civilians who had been deprived of real information throughout the war. As in cases of private trauma, remembrance and

commemoration of conflict take unpredictable forms, in which amnesia and the repression of feelings play a significant role.

In the next case study Penelope Curtis looks at the one object that was adopted nationally as the proper place of mourning for the dead of the First World War. This is an edited extract from a longer piece published in *Imperial War Museum Review* (Curtis, 1994).

Case study: reading the Cenotaph, London

The British Peace Celebrations Committee met for the first time on 9 May 1919, with no idea when the Germans would sign the Treaty of Versailles. At its next meeting on 18 June the 'War Cabinet recorded their respectful dissent from the Prime Minister [Lloyd George]' – who thought the celebrations should be spontaneous – and agreed that the following telegram be 'dispatched to the dominions':

> Subject to Peace being signed, it is proposed to hold Peace celebrations Saturday 2 August and three following days ... [and that a] notice will be circulated inviting the public not to indulge in premature celebrations of peace should the Germans sign.

> (PRO, 1919, WORK [WORK] 21/74)

The varied proposals for the celebrations recorded at this meeting include no mention of any cenotaph. The King was to take the military salute opposite the Queen Victoria Memorial on Pall Mall (as indeed he was still to do), and this memorial, and Nelson's, which was to be decorated, were the only monuments to be singled out (WORK 21/74, 7 July 1919).

Peace was signed at the end of June and Lord Curzon hurriedly convened a third meeting for 1 July, at which it was decided to bring forward the celebrations to 19 July. Curzon then introduced Lloyd George's suggestion that, following the French example, a catafalque feature in the Peace March, and put the matter into the hands of First Commissioner of Works Sir Alfred Mond. By 8 July Sir Edwin Lutyens's name had appeared in *The Times* as the architect of a 'temporary but fitting monument' (Homberger, 1976, p. 1429). It seems that Lutyens had been called to Downing Street in June and made a first design on the same day. Mary Lutyens quotes a letter from her father dated 7 July 1919 in which he reports that Lord Curzon 'has approved my structure in Whitehall – but wanted it if possible less catafalque so I am putting a great vase or basin on it – to spout a pillar of flame at night and I hope smoke by day'. Lutyens told Lloyd George that it should be called a cenotaph rather than a catafalque, apparently remembering a stone seat that he had designed for Gertrude Jekyll which had been nicknamed the 'Cenotaph of Sigismunds' (Lutyens, 1980, p. 164).

The temporary structure

The temporary structure (not, as yet, known as the Cenotaph) by Lutyens was used on the Peace March of 19 July 1919, and was saluted by Pershing, Foch, Haig and Beatty (representing the American, French and British armies and the Royal Navy) (Figure 2.5). Field Marshall Sir Douglas Haig appears to have been persuaded with difficulty to participate; he had earlier said

> I have no intention of taking part in any triumphal ride with Foch, or with any pack of foreigners, through the streets of London mainly in order to add to L.G.'s importance and help him in his election campaign.
>
> (Homberger, 1976, p. 1429)

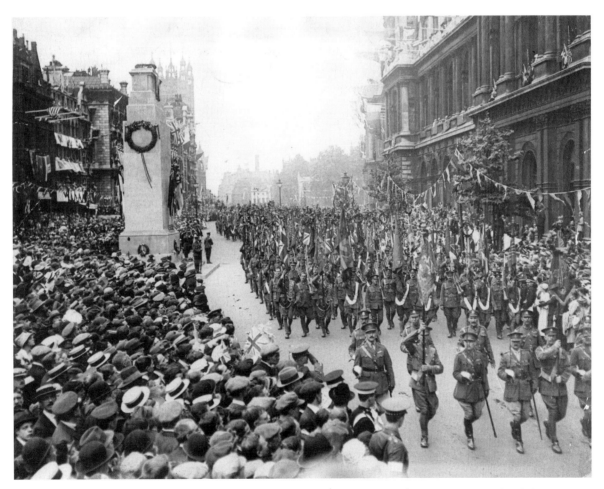

Figure 2.5 Peace March, before the temporary wooden and plaster cenotaph designed by Sir Edwin Lutyens, July 1919. Unknown photographer. Photo: © Getty Images.

Lutyens was not invited to the ceremony. This was not exceptional, for at the unveiling of monuments it was still rare for the artist or architect to be acknowledged. The commemorated and the inaugurators had more relevance. It was only as public sculpture lost its commemorative role that the artist came to the fore – the monument coming to signify him rather than the absent. Moreover, this event was not an unveiling as such, for the Cenotaph was more of a stage prop within the ceremony. Ironically, though it was without doubt the Peace March and the illustrious salutes which sanctioned and caused the realisation of the Cenotaph as a monument, it was the success of its design which made Lutyens' name as an architect. The absence of a real inauguration ceremony for the Cenotaph meant that its ownership was never formally transferred from the initiating body to the collectivity. The terms of ownership were never, and have never been, defined.

An Office of Works memorandum of 24 July explains that

> Sir Edwin Lutyens' beautiful design was carried out entirely by Sir Frank Baines' staff, including all the structural details, which was actually designed by them. Day and night work was continuous as only five days were available ... The refinements were such that even the separate stones were coloured to give the effect of masonry.
>
> (WORK 21/74)

Three days after the Peace March, a memorandum to the General Officer Commanding stated:

> It had been decided to allow the Memorial to the Dead in Whitehall to remain in position for another week at least as a very general desire from the public to that effect has been expressed. Many people will be coming from the country to see it as the outward symbol of the national gratitude.
>
> (WORK 20 1/3)

Two days after that Frank Baines wrote:

> It will be difficult to arrange to remove the cenotaph at the end of this week as the public are placing more and more wreaths around the base.
>
> (ibid.)

Next day, Earle wrote to the first Commissioner:

> The public would go on placing floral tributes on this monument months hence, and it is rapidly becoming a war shrine. In view of the extremely temporary character of the erection, I think that it should be removed some time ... next week ... at the same time as the other decorations in connection with pageant.
>
> (ibid.)

At the time it was not seen as in the natural course of things that the Cenotaph should be made permanent, and although such suggestions were made almost as soon as the temporary erection had served its purpose, Bonar Law still urged caution. We read in the minutes of the War Cabinet of 30 July:

> Mr Bonar Law suggested it might be wiser to leave the decision for about a month. In his view, it was too soon after the Peace Procession to judge whether the public opinion, which was now so strongly in favour of the Cenotaph, would continue to be so.
>
> (WORK 20/139)

Expediency was certainly put forward as an argument for the Cenotaph's retention, the first commissioner declaring that immediacy would 'prevent a great deal of controversy' (ibid.).

The temporary becomes permanent

It seemed that the Cenotaph would not go away, and on 23 July First Commissioner of Works Sir Alfred Mond suggested to the War Cabinet that it consider making the memorial a permanent one because of public interest and favourable press opinion. He added that Lutyens himself had expressed 'his readiness to design one on the same lines, with more elaboration'. As points in favour he cited the following:

1 It will be the historic spot.
2 The monument itself is dignified and simple and the position is a central and fine one.
3 The public has become accustomed to seeing the monument on its present site.
4 The erection of a monument on these lines in a permanent form will solve the difficult question of a War Memorial which is bound to become the subject of public interest.

As points against, he put forward:

1 Busy thoroughfare.
2 The monument, although appropriate for the occasion, may not be regarded as sufficiently important and may be of too mournful a character as a permanent expression of the triumphant victory of our armies.
3 There will probably be a demand for a greater and more imposing monument in any event.

4 Flowers and wreaths difficult to control – might develop into an unseemly untidiness.

5 Grounds belong to Westminster Borough Council. [Westminster Council agreed to the site, 13 August 1919.]

(WORK 20/139)

Mond added, 'the proposal to erect a replica of the present design on some other site would seem to me scarcely worthy of consideration. The whole point would be lost' (WORK 20 1/3).

In later years the Office of Works received an inquiry as to whether the site on which the Cenotaph stood had been consecrated. This inquiry caused some consternation in the Office; although it had been assumed that the site had been consecrated, it was realised that this of course was not the case. The 'consecration' of the Whitehall site by the Peace March may therefore be seen to have been as important as the seemliness of the structure (if not more so) in the story of the Cenotaph. As we see in a memo from the Office of Works:

> The great argument in favour of leaving the temporary erection up is that on sentimental grounds the ... ground has been consecrated ... [it would be] highly undesirable to let traffic again move over [it] ... I suggest that the First Commissioner should ask Edwin Lutyens whether he could get drawings sufficiently forward for a permanent memorial to commence some time in early October, so that the site is never again given over for normal traffic.

(WORK 20/139)

In a Parliamentary answer to the same effect, Captain Ormsby-Gore considered that to move the Cenotaph to Parliament Square would be 'a profound mistake. Artistically it would be a blunder. From the point of view of association it would be a crime' (Hansard, 1919, col. 1201). 'It is recognised universally as the right thing in the right place', wrote a commentator: 'It is "The Whitehall Cenotaph" and it cannot and must not be anything else' (Tipping, 1919, p. 131).

It was not only the site that was seen as sacred. On 13 November the curator of the Imperial War Museum asked Earle if he might have for the museum the sarcophagus that had been on the top of the Cenotaph:

> This erection of plaster will mean a very great deal to the general public. ... All the allied troops in London have saluted this piece of plaster and thousands of men and women have paid reverend respect.

(WORK 20 1/2)

The curator was not alone in regarding as precious the material of the temporary Cenotaph. On 23 January 1920 the chairman of St Dunstan's

Blinded Soldiers' Hostel thanked Earle for the wood 'of which the Cenotaph was composed':

> My original intention was: if the request was granted, to use the wood for making photo frames, but it is obviously not suitable for this. ... Whatever is done will be done on straightforward principles, and that only the wood actually used for the Cenotaph will be employed.
>
> (WORK 20 1/2)

This is the logic of the religious relic, whereby fragments of objects or body parts believed to belong to saintly figures are believed to be able to perform miracles. The concept of sanctity is also implicit in the need, as it was perceived, to shield the public from the sight of the dismantling and disappearance of the temporary Cenotaph while the permanent one was being erected.

The Office of Works required the hoarding to be sufficiently high to cover the Cenotaph completely. 'No demolition will take place or flowers be removed until this scaffold is completed and the Cenotaph hidden from public view' (ibid., 8 January 1920). Though decisions had been delayed, they could not be delayed much longer: 'The whole question of the removal of the Cenotaph should, I think, be decided at an early date as the effect of weather is now showing markedly' (ibid., 2 December 1919). Lutyens had told Mond on 29 July that he would like the monument 'to be where it now stands', and had added, 'Many have suggested to me to place bronze figures representing sentries around the monument. This I would greatly regret' (WORK 20/139). The following day Mond replied that he had 'induced the cabinet to approve. ... Opinion was generally expressed that it should be altered as little as possible' (ibid.).

The Cenotaph, if erected at all, had to be erected in the form used for the Peace March. It was now seen as inalterable. Lutyens – or any architect – would not be given the chance to reconsider or improve on it:

> No doubt he could redesign with success. But that is not what is wanted. It would no longer be the Peace Day Cenotaph, and it is permanence of the Peace Day Cenotaph that is demanded. We want it as we have seen it, merely its plaster transmuted into stone, its emblems into bronze.
>
> (Tipping, 1919, p. 133)

Nor could functions or symbolism be altered. Bonar Law explained, in a letter in the *Pall Mall Gazette* to the Comrades of the Great War (12 November 1919), that 'the Cenotaph is intended to represent an imperial grave of all those citizens of the Empire' and that it would be unsuitable to convert it into an actual grave (WORK 20/139).

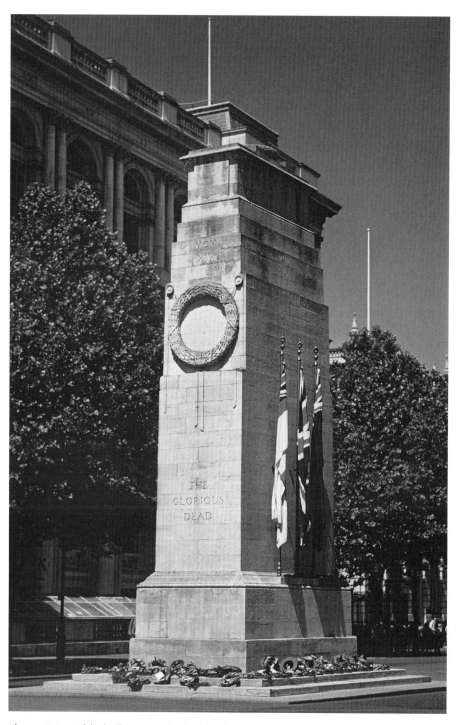

Figure 2.6 Whitehall Cenotaph, designed by Sir Edwin Lutyens and constructed in 1920. Unknown photographer. Photo: © Image Source Pink/Alamy.

On 23 October 1919 the War Cabinet 'sanctioned [a] permanent memorial at [an] approximate cost of £10,000' and decreed that it 'should be a replica exact in every detail – no alterations, additions or fresh inscriptions' (WORK 20 1/3). The inscription – 'The Glorious Dead MCMXIX' – was not altered, despite suggestions for 'more suitable' religious or poetic quotations being proposed by a variety of people, including the Archbishop of Canterbury (WORK 20/139). Lutyens did make slight alterations – 'almost imperceptible, yet sufficient to give it a sculptural quality and life, that cannot pertain to rectangular blocks of stone' (WORK 20/139).

On 14 October 1919 Austen Chamberlain wrote to Mond, with a certain grudging resignation,

> I do not at all like finding you the necessary £10,000. However, as you say, the War Cabinet has decided that the present temporary Cenotaph should be replaced by a permanent replica, and a public announcement has, I think, been made to this effect. In the circumstances, therefore, I shall make no objection to this expenditure.
>
> (ibid.)

The assistant secretary of the Office of Works noted on 19 December 1919,

> The House of Commons has now voted the money required for the re-erection of the Cenotaph on its present site. This decision is backed by the overwhelming mass of public opinion.
>
> (WORK 20 1/3)

The work of building the Cenotaph was carried out by Holland and Hannen and Cubitt Ltd, for an estimate of £5,890 submitted on 16 April 1920. Their estimate was the lowest of eight submitted. They contracted to finish work by 23 July 1920 (WORK 20 8/5). Derwent Wood modelled the wreaths. The present Cenotaph is 35 ft high, with a base measuring 15 ft x 8 ft 6 in., and cost £7,325 (WORK 20/139, 'The story of the Cenotaph as told by Sir Edwin Lutyens') (Figure 2.6). Lutyens required no payment, writing to Earle on 19 September 1919, 'As an architect I don't want to be an undertaker and I am too jolly grateful not to be whitening in France myself' (ibid.).

The inauguration

On 28 September 1920 Earle received a letter from Balmoral Castle:

> The King originally said that he would not unveil the Cenotaph, but as, apparently, there is a general desire on the part of the public that His Majesty should perform the ceremony he would now accept to undertake the task.
>
> (WORK 20 1/3)

In October the various possible constituents of the inauguration ceremony were under discussion. Again it was not so much a question of an inauguration as of the establishment of a formula for Armistice Day. Nevertheless, the Cenotaph (in its temporary form) had already been used at Armistice Day 1919, and what marked 1920 was the presence of the permanent structure ready for unveiling. On 15 October the Cabinet agreed that the burial of the unknown 'British warrior' in Westminster Abbey should take place at the same time as or just before the unveiling (WORK 20 1/3). On 2 November the Cabinet Memorial Services Committee decided that the service should begin with a hymn, followed by the Lord's Prayer, unveiling, two minutes' silence and the 'Last Post'. They would recommend 'simultaneous observance throughout the Empire'. Fifteen thousand applications for tickets had been received (ibid.).

Draft recommendations for the observance of Armistice Day include the following (these date from 1924, but are included as a typical example, the minutiae of the celebrations varying little, if at all, from year to year):

> That the two minutes' silence at 11 am should be observed throughout the Empire and that the Secretary of State for the Colonies and India should be requested to invite the co-operation of the Dominions, Colonies and India as in previous years. Local Authorities in the United Kingdom would be requested, through the press, to suspend all vehicular traffic between 11 am and 11.20 am, but rail and water transport would not be suspended.

(WORK 21/113)

Recognition

The Cenotaph surprised all observers by its immediate popularity. The quantity of wreaths laid at its base was an obvious outward sign of this popularity, and in the early months it was feared that they hampered the traffic flow. When the Office of Works was finally ready to shroud the temporary Cenotaph in preparation for the permanent version (8 January 1920), it was seen to be necessary that 'a notice should be immediately inserted in the press' that no flowers were to be laid after 18 January (WORK 20/139). This is testimony to the actual function that the Cenotaph was then enjoying in public life. Between September 1923 and May 1932, 11,097 wreath frames were collected for re-use (WORK 21/74, 9 June 1932). The raising of hats by men when passing the monument was quickly established as a standard procedure. It must have declined a little in the interwar years, for when on 16 June 1923 six MPs wrote to *The Times* on the question of the Cenotaph's illumination,

they took the opportunity to record their wish that 'the very general practice of saluting the Cenotaph may be extended' (WORK 20/139). However, the *Glasgow Herald* maintained,

> Though quibblers contend that London's lack of respect for her great memorial is amply demonstrated by a growing disinclination to bare the head in passing, the reverence is undiminished.

> (ibid.)

> It is the only monument in London which passers-by naturally and of their own accord salute.

> (WORK 21/74, February 1924)

And the *Scotsman* considered that, even in 1933 (13 May),

> The Cenotaph still retains its impressive symbolism. The constant pile of wreaths and the continual saluting of it by passers-by on foot or in vehicles, testify to the hold it preserves.

> (WORK 21/74)

As the site was 'sacred', so the public expected decorous behaviour there. In February 1924 a complaint reached Ramsay MacDonald that the writer had been shocked at 10:15 that morning to 'see men removing and piling up on a barrow the faded tributes' (WORK 21/74). The writer's shock derived from the fact that the unseemly business of removing the flowers had been carried out in public sight. The Office of Works clearly considered itself obliged to assure the writer that, in future, the 'removal of the wreaths will be completed by 9 am' (ibid., 3 February 1924). The Office frequently had to contend with members of the public shocked to find that their wreaths had been removed, the shock in such cases being more than purely emotional. They frequently interpreted the action of the authorities as virtually iconoclastic and appear to have regarded the site of the Cenotaph as inviolate. This raises once again the question of the ownership of the Cenotaph; many people clearly felt that it belonged to them, to the nation, and not to a government department. As the symbolic nature of the Cenotaph grew, and as it gained meaning for individual members of the public, it came to be an increasingly difficult site to regulate. A whole framework for the maintenance and regulation (both practical and symbolic) of the Cenotaph had to be instituted (a responsibility which, *faute de mieux*, devolved on the Office of Works), and this framework frequently clashed with public expectations.

A more recent highlighting of the standardised expectations of behaviour suitable for the Cenotaph is revealed in the case of the duffel coat worn by Michael Foot (then leader of the Labour opposition) at the Remembrance Day ceremony of 1981. The attack was opened by a fellow Labour MP, who described Foot as looking like an unemployed labourer. The *Daily Telegraph*

followed, with the opinion that his casual wear made him look like an 'old man', a 'bored tourist' and a 'tramp'. The affair degenerated into a trivialising game, exposing stereotyped images of Labour MPs, lecturers, the unemployed and the working class rather than any analysis of the Cenotaph's place in public life. The real issue emerged as being Foot's right to speak for the working class, while a concomitant of this (though not explicit) was the Tory claim to the national past. The catalyst of the debate was Foot's perceived perversion of the norms of remembrance as enshrined in the Cenotaph ceremony, which raised (and raises) the troubled question of the Cenotaph's ownership.

Appropriation

A mark of the Cenotaph's successful establishment as a symbol enjoying widespread currency is the fact that diverse groups and individuals have used it as a focal point for aims other than those for which it was 'intended'. On 3 July 1922 the first commissioner was troubled by individual 'appropriation' of the monumental site:

> In view of criticisms as to wreaths being placed on the Cenotaph, whether for political or other purposes, but totally unconnected with those who died in the Great War, I consider that we should lay down a rule that no offerings are to be placed on the Cenotaph except in memory of those who lost their lives in connection with the Great War.
>
> (WORK 21/74)

At the Armistice Day ceremony of that year 25,000 unemployed ex-servicemen paraded past the Cenotaph with their service medals hanging from red banners and pawn tickets pinned to their lapels.

In May 1933 a wreath laid at the Cenotaph by Rosenberg, Hitler's ambassador to Britain, was thrown in the Thames. The culprit, a Captain Sears, was fined. The wreath was replaced, but without its swastika. The Office of Works received letters in support of Sears.

Later, in 1933, the Office of Works defined its policy in an attempt to defend itself over another complaint: 'One of the statues staff examines every morning the wreaths ... and has instructions to draw attention to any inscription likely to cause offence' (WORK 21/74, 18 May 1933).

In 1939 the Office received a warning that wreaths had been 'laid in memory of persons killed in the International Brigade of the Spanish Republican Government ...' and that the British Battalion of the International Brigade returned from Spain had organised a march of 300 members to the Cenotaph which was stopped by police. For Geoffrey Hutchinson, writing to Sir Philip

Sassoon on 13 January 1939, 'Similar incidents at the Cenotaph in Liverpool' suggested that 'an organised system of propaganda' was in operation (WORK 21/74).

In 1946 the British League of Ex-Service Men and Women 'applied for permission to lay a wreath in memory of the British Armed Forces killed by Jewish Terrorists in Palestine'. The Office reported, on 5 December 1946, that the 'Home Office say that the league is an active Fascist organisation' and that 'its object may be to get undesirable publicity and to turn the action into a political demonstration' (WORK 21/74).

Reproduction

As early as August 1919 the Office of Works was receiving requests to reproduce the Cenotaph, either in miniature or on a large (if not full) scale. A Mr Ouzman asked Mond for the 'sole right to reproduce the Cenotaph in miniature', adding, 'we employ a large percentage of disabled men'. The Falcon Pottery of Stoke-on-Trent sought permission to reproduce it in porcelain; Samuel Wright for his 'small syndicate to manufacture small scale models in fibrous plaster'; Raphael Tuck to sell postcards of the Cenotaph; Alfred Bucklands to reproduce bronze medals; Dimes to reproduce small silver models (WORK 20/205).

The Office of Works commented on one request, on 12 July 1921:

> The writer of the letter should, I consider, be requested to communicate with Sir Edward Lutyens who has already expressed strong objections to the reproduction of his design in any form.
>
> Models seen from time to time are certainly hopeless travesties of the Cenotaph and it is questionable how far the objections of the architect will prove effective in preventing the manufacture of correct or incorrect models.
>
> (WORK 20/205)

The Cenotaph soon became the model, in form and name, for war memorials throughout Britain and the Commonwealth. A request (25 June 1920) from a Mr W.A. Elliott of Brandon, Isle of Man, is telling: 'We are told that throughout England most communities are erecting Cenotaphs. I would be pleased to get some particulars as to their character' (WORK 20/205).

A firm of solicitors from Bangor asked the Office of Works if the design 'is the property of the Office of Works? Is it available for use elsewhere?' (ibid., 26 November 1919). Between November 1919 and April 1921 various requests were made to reproduce the monument (WORK 20/205). For example, Stoke-on-Trent informed the Office of its 'resolve to erect a cenotaph similar to the one at Whitehall' and asked for dimensions and

particulars. This request, along with others (for example, from Listowel, Ontario, from the West African Frontier Force, Gambia, from the Agent General for Queensland, and from London, Ontario), was referred by the Office to Lutyens. The Governor of Hong Kong wrote asking if the permission of Sir Edwin Lutyens for the use of the design could be obtained. A letter that Lutyens wrote to Earle (19 June 1925) about a request to erect a replica on Rhode Island suggests that he was not opposed to the reproduction of his design: 'We should of course have no objection to a replica, provided you are willing to grant the request', and he approved the request of London, Ontario, at a fee of £110.47 (ibid.).

The BBC had requested permission each year to broadcast the ceremony, but had been repeatedly turned down. In 1928 the request was granted ('BBC assure us that there will not be the slightest sound'). In 1929 they were joined by British Movietone News, and by 1932 there were ten official cinephotographers, along with twenty-nine still photographers and fifty-four press representatives. The framework for the most effective dissemination of the Cenotaph and all that it was meant to stand for was now firmly in place (WORK 21/113). And reproduction of the Cenotaph still continues. The British Legion has introduced a faithful reconstruction of the Cenotaph, surrounded by a field of poppies, on their website in the virtual reality world Second Life (for a discussion of heritage on Second Life, see Chapter 8). It forms the centrepiece of an electronic Garden of Remembrance which the British Legion hopes will stimulate a new generation to reflect on the human cost of war.

Extension

Decisions reached after the Second World War that the Cenotaph should commemorate another generation's war dead further invested this modest 'vessel' with significance. It became a symbol of extraordinary range.

In June 1946 it was agreed that the Sunday before 11 November should be known as Remembrance Sunday (WORK 20/206, 16 June 1946). In July 1946 it was agreed that the inscription 'XXXIX–XLV' be added to 'The Glorious Dead MCMXIX' (ibid., suggestion of 14 June 1946). The Cenotaph was re-unveiled by George VI on 10 November 1946 – its third inauguration (WORK 20/139, 'The story of the Cenotaph').

The Cenotaph continues to be an extraordinarily extensive symbol and, though the power of its symbolism is less affective to the public at large today, its nominal significance has not altered. The Armistice Day ceremonies continue with little superficial change, and the regular day-to-day maintenance of the Cenotaph is carried out along with that of the capital's other statutes. In 1968 the Cenotaph underwent a programme of restoration (WORK 20/267).

In 1919 a Parliamentary question from Sir F. Banbury had been asked rhetorically: 'What is the object of erecting a Cenotaph?' And the answer provided was 'I presume the object is twofold: first to allow the relatives to place wreaths at the foot of it; and secondly, that future generations shall know what has taken place now' (Hansard, 1919, col. 1204).

In 1967, when asked for the official definition of the Cenotaph, the Office of Works offered the following: 'The Cenotaph is a public statue authorised by section 2 of the Public Statues (Metropolis) Act 1854' (WORK 20/267).

Reflecting on the case study

Of all the monuments in Britain, the Cenotaph might appear to be the most 'official', calling for an acceptance of the authority of the state and the desirability of sacrificing young lives to a patriotic cause. And yet this case study shows that, despite its appeal to collective patriotism, the Cenotaph became what it has become from the multiplication of private acts of grief. Although the first Peace March was organised and orchestrated by the government and the armed services, the mass expression of grief that 'sanctified' the site was a popular expression of feeling. Governments have trouble controlling the commemoration of war or other causes of popular grief. The death of Diana Princess of Wales in 1997 prompted a similarly uncontrollable situation, fuelled by media coverage, when hundreds of thousands of wreaths were laid in an unplanned expression of popular feeling. The case also demonstrates how the Cenotaph itself gained in effectiveness by eschewing explicit religious symbolism, representational sculpture and even the explicit symbolism of a tomb. The tomb of the unknown soldier, inaugurated simultaneously at Westminster Abbey, has its own poignancy, but the Cenotaph is effective because it allows everyone to construct their own scenario of grieving. The annual public ceremonies and the private acts of commemoration give the Cenotaph its real meaning.

We can now turn to the problems facing architects and sculptors in trying to symbolise and express the emotions of loss and grief after the Great War. We will find that every attempt to use representational sculpture ran into some kind of difficulty. The monument to Earl Haig demonstrates the impossible problem of matching people's memories of a real man and representing a national figure by whose authority millions of men were sent to their deaths. We will see that sculptors had a wide range of options open to them in representing the horrors of war. The Monument to the Machine Gunners' Corps and the Royal Artillery Memorial (discussed on pp. 80–3) appear to reflect the wishes of the soldiers themselves, but they adopt radically different strategies of representation.

Earl Haig's monument, Whitehall: an impossible task?

A few yards away from the Whitehall Cenotaph, in front of the Horse Guards, a more difficult task was proposed, to set up an equestrian monument to the man who most perfectly symbolised both the moral and spiritual rightness of the cause and the obstinate inflexibility that persisted in hopeless attacks. This is not the place to argue for or against Field Marshall Haig's conduct of the war or his characteristics as a man. What is important here is that almost every detail of the monument triggered violent disagreement which reveals the underlying tensions of the situation. Where the abstraction and, in the first instance, the temporary nature of the Cenotaph allowed it to be almost instantly adopted as a sacred shrine, the sculptor of the Haig monument faced impossible contradictions in the brief. Whereas the public in Germany appeared to greet the erection of major monuments to its military commanders with considerable enthusiasm, the British public was far less certain. For example, a large sculpture of German Field Marshal Paul Von Hindenburg was set up in the middle of Berlin while the war was still raging, and replica castings were marketed 'for any room, as an enduring memory of the great time of the World War' (Winter, 1995, p. 83). The British view was that celebrations of this sort, both public and private, smacked of militarism. War was something to be endured rather than glorified.

The following analysis is based on a published research paper by Nicholas Watkins (Watkins, 2002). The decision to commission a monument to Earl Haig was taken shortly after his death in 1928. Earle decided that Haig, a cavalry officer, should be represented on horseback and sited as close as possible to the Cenotaph. Alfred Hardiman was one of only three sculptors selected for a closed competition, all of them ex-servicemen. Hardiman's winning maquette was intended 'to give an impression of the Field Marshal's calm and imperturbability by contrast with the restiveness and impatience of his horse'.

Hardiman was provided with a number of photographs of Haig on horseback (Figure 2.7). To give Haig greater presence, Hardiman dressed him in a cape and stylised the horse in the sturdy image of antique and Renaissance models. The naturalistic horse of the photographs has been transformed into a heraldic icon, the head tightly drawn back on the neck, one leg raised as if on a dressage event, the moulding of the body generalised and unspecific (Figure 2.8). When the maquette was published, the reaction was puzzled and generally hostile. As Lord Mildmay of Flete said, in a letter to *The Times*,

> Why must we in our search for symbolism go back to a travesty of the Elgin marbles for our ideal horse, and present a horse which no real horseman would be paid to ride and which Lord Haig would not have looked at.

> (Letter to *The Times*, 7 September 1929, quoted in Watkins, 2002, p. 6)

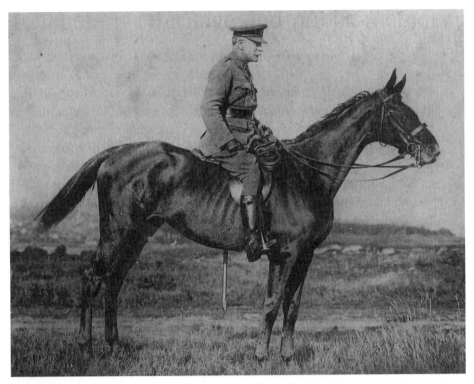

Figure 2.7 Earl Haig on horseback at the Front, 1917. Unknown photographer. Leeds Museums and Galleries (Henry Moore Institute Archive).

Hardiman's argument was that only by artistic stylisation could the real symbolic power of the supreme commander of British forces be made visible. But Haig's widow pointed out

> The King has in his stables the horse Douglas rode in France, through the streets of London, and at the first trooping of the colours. It was at his funeral and Douglas looked so fine on it. Surely that is the horse he ought to have [been on] ... Slack reins too, so unlike Douglas. He had such wonderful hands.
>
> (Lady Dorothy Haig to Sir Lionel Earle, 26 July 1929, WORKS 20/185, quoted in Watkins, 2002, p. 6)

Good horsemanship and an appreciation of thoroughbred quality were seen as essential features of Haig's Britishness. Haig's niece Annabel Morse thought her uncle had been portrayed like 'some Teutonic commander' (Annabel Morse to the First Commissioner of Works, 27 July 1929, WORKS 20/185, quoted in Watkins, 2002, p. 7). What is at issue here is a conflict between the commemoration of a real man (and horse), in the memories of those who saw him ride through London in the victory parades or at the trooping of the colour, and the attempt to create a national symbol.

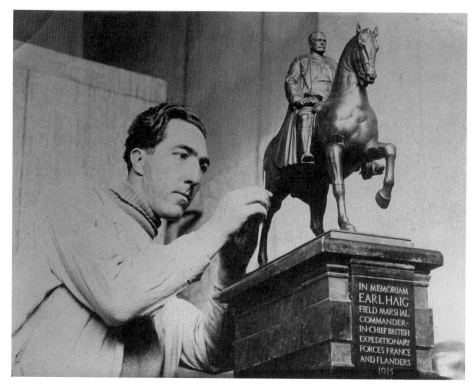

Figure 2.8 Alfred Hardiman, First study for the equestrian portrait of Earl Haig, 1929. Leeds Museums and Galleries (Henry Moore Institute Archive). Used with the permission of the Hardiman estate.

Lady Haig, supported by the national press, pushed her campaign against Hardiman's model to the point of commissioning at her own expense a more realistic statuette of Haig on his horse by S.W. Ward Willis. Faced with this pressure, Hardiman was told to try again, and he produced a second, more realistic model (Figure 2.9).

With the exception of the committee of assessors, who accepted this version with some detailed points for consideration, it was met with unremitting criticism by all who saw it. The figure of Haig was criticised as too passive, and Hardiman collaged a new head onto the photograph. Hardiman, who had worked on the second maquette under protest, offered only half-hearted defence of it. Faced with this situation, he was given carte blanche to produce a third and final model which would somehow meet all the accumulated criticism. This was finally ready for inspection in February 1935.

The statue that was eventually unveiled returned to many of the features of the first model, with the addition of an even higher level of monumentality and abstraction (Figure 2.10). The hind legs of the horse are drawn back into a completely unrealistic rocking-horse pose, as if bracing the rider for a leap forward. Nicholas Watson draws attention to two precedents for the

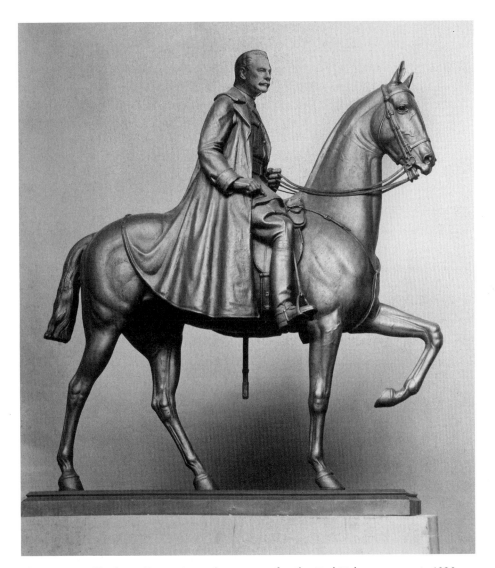

Figure 2.9 Alfred Hardiman, Second maquette for the Earl Haig monument, 1930. Leeds Museums and Galleries (Henry Moore Institute Archive). Used with the permission of the Hardiman estate.

arrangement of the hind legs, in the adjacent statue of the Duke of Cambridge and the dramatic sculpture by G.F. Watts entitled *Physical Energy*, in Kensington Gardens (Watkins, 2002, p. 8). This forward drive, echoed by the cape draped over the horse's rump, is opposed by an inclined base on the plinth and by the strong verticality of the rider, accentuated by the line of the cloak falling directly from the head to behind the stirrups. The monument was generally considered as falling between two stools: neither a realistic representation of a well-known man and his horse nor a convincing artistic statement of high Christian principles and steadfastness.

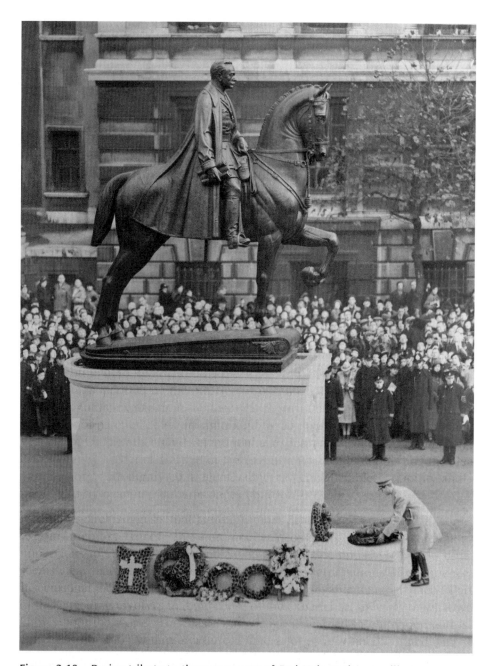

Figure 2.10 Paying tribute to the monument of Earl Haig at the unveiling ceremony, 1935. Leeds Museums and Galleries (Henry Moore Institute Archive). Used with the permission of the Hardiman estate.

By 1935 attitudes to the Great War were changing. Politicians, writers and historians were beginning to blame the generals for the mistakes that had been made. When the memorial to the missing at the Somme was inaugurated in

1932 in Thiepval, the national mood was far from triumphalist (Stamp, 2007). The enormous structure, composed of interlocking arches, was covered on every surface with the names of over 73,000 British troops (from a total of around 420,000 British and Dominion casualties in the battle of the Somme) whose bodies were never found. To the thousands of veterans, able-bodied as well as maimed, who were suffering unemployment in the Depression, the value of expensive war memorials at home and abroad seemed questionable. Could not the £117,000 have been better spent regenerating British industries? Nevertheless, Thiepval, along with other war memorials in France, has never ceased to exert a powerful fascination. Annual visitors to Thiepval reached just over 100,000 by the end of the 1930s but fell significantly in the 1950s and 1960s, to spring back to an average of a quarter of a million today (2009).

Response to war memorials follows a pattern that matches many people's experience of grieving, but extended over a longer period. The Scottish author Ian Hay (pseudonym of Major John H. Beith) described this process, in his book about the Scottish National War Memorial on Calton Hill, Edinburgh (1931):

> At last came Victory, resounding and complete ... exultation; and blind determination to make a hero of everybody who had contributed thereto. Then followed one vast reaction. Everybody announced that the War must now be forgotten. We had to get back to business. War books were unsaleable, War topics taboo. Having talked about nothing but the War for five years, we decided never to talk about it again. And now, twelve years later we are talking about it more than ever. But the note is different. War has become a monstrous, unspeakable thing, and all the nations of Christendom are today combined in earnest, eager debate to drive it forever from among men.
>
> (Stamp, 2007, p. 157)

This pattern was repeated after the Second World War, with the new feature that, since the 1990s, both world wars and subsequent wars have begun to occupy a place of fervent curiosity in the public mind as a particularly powerful aspect of the **heritage boom**. We might try to map these phases in managing memory of the war against different forms of representation. 'Making heroes' matches a celebration of physical and spiritual qualities in recognisable personalities, whether generals such as Napier, Havelock and Haig, or the common soldier. 'Getting back to business' is a characteristic mixture of repressed grief and determination to focus on something positive. In the Freudian analysis, grieving involves replacing the defunct loved one with a new object of desire. Letting go of the love object can only be achieved by accepting the reality of loss. Realism in representational terms is one method of facing up to the horror of warfare and the reality of loss. Realistic depiction of warfare may also feed a more distant curiosity about what happens in war.

Popular war films, such as *A Bridge Too Far* (1977), *Gallipoli* (1981) or *Saving Private Ryan* (1998), allow a generation remote from the two world wars to experience the horror of warfare vicariously. These films also work to modern agendas. *Gallipoli* played a significant role in interesting a new generation of Australians in the ANZAC myth: the idea that modern Australia and New Zealand came of age in this campaign, sacrificed by callous British generals and redeemed by the discovery of uniquely Australian virtues of courage, endurance and mateship (Rowlands, 1999, p. 133). It is not important that British troops suffered twice the casualties of the Australians and New Zealanders at Gallipoli, or that many more Australians died on the Western Front than in the Dardanelles. It is the disaster of Gallipoli, remembered every year in Sydney at dawn on 25 April, which stands as a symbol of Australian and New Zealand identity, more even than Armistice Day on 11 November. The war memorials in Canberra, Melbourne and Sidney are bigger and more elaborate than anything in the British Isles.

These considerations point up once more the differences of viewpoint that different fictive kin groups may have about warfare and loss, and how these viewpoints can change radically over time. For monuments to continue to appear relevant to succeeding generations they must either be sufficiently abstract to allow for different interpretations to be laid on them, or sufficiently imaginative to inspire curiosity and sympathy despite changing circumstances.

The spiritual or the realistic: two paradigms

Symbolism offers a means of referring to things or ideas indirectly, by way of a visual sign or icon. Some symbols refer to ideas or things in an abstract way, using conventions that are either traditional or fixed by rules. Others point to ideas using representational means (they contain realistic visual clues). Most symbols mix both systems of reference. Think of traffic signs. A sign may be completely abstract, such as the 'No entry' sign which uses the generalised convention of the colour red – carrying the implication of negation – combined with a formal device that you have to learn from the Highway Code. The icon of a man shovelling earth is fairly self-explanatory. War memorials employ symbols such as a cross formed by an inverted sword (associating military combat with death and **resurrection**) or doves (representing peace) or they may refer to mythical or historical events.

The London sculptor H.C. Fehr, creator of the Leeds War Memorial we looked at earlier, avoided any direct reference to modern warfare in his sculptures, representing war and peace on opposite sides of a stone obelisk framed by heraldic owls of Leeds. An obelisk (a vertical slab of stone such as those used by the ancient Egyptians and transferred to Rome and other cities) allows sculptors to create a dignified form without specifically Christian symbolism. The figure of 'Peace', in a seductive costume and holding a dove, represents

not only the hope for future peace but also a personification of the nation and the symbolisation of a happy future after war (Figure 2.11). Her modern face and sensuous body attempt to capture something of the soldier's sweetheart or sister – 'what we're fighting for'. The act of warfare, on the other hand, is transposed into the age-old symbolism of the struggle between good and evil in the form of St George and the dragon (Figure 2.12). Fehr obviously considered that the citizens of Leeds had no wish to be reminded of the horrors of trench warfare.

Some of the complex functions of the war memorial can be understood from this example. A distinction is usually made between memorials – intended to sustain the grieving process in the individual – and monuments, which may be celebratory of national aims. The needs of the state and the individual are uncomfortably brought together. An important issue is that war memorials are not tombs. The British and New Zealand governments decided that the bodies of British and empire soldiers should stay where they lay in France and Belgium (Winter, 1995, pp. 22–8). The USA and Australia repatriated the remains of their fallen and France, after a protracted battle, allowed the identified bodies of French soldiers to be returned to their towns and villages. British war memorials, therefore, mark a place where commemoration occurs far from the place of death.

Memorials may help individuals to mourn in a number of ways. They may prompt cathartic emotions of pity or loss. By representing a 'beautiful death' – a naked youth untouched by wounds – they may offer a peaceful and calming image of the loved one. A classical style, in sculpture or architecture, was often seen as a means of sublimating death in this way (Carden-Coyne, 2003). By contrast, memorials may provide realistic detail of death and destruction which might enable a grieving relative to accept the reality of loss. They may provide symbols of hope and a better future. They may provide a justification for death, allowing a sense of moral justice to ease the pain of separation. They may simply provide images of dignified and stoic acceptance of death, typically in the figures of soldiers standing guard around a monument. Any of these strategies, and others beside, might work for some people, some of the time, but they cannot all co-exist. The most powerful agency of memorials is the shared participation in what Jay Winter calls 'fictive kin groups' (Winter, 1995). 'Fictive kin groups' are formed by the bond between those who have shared a traumatic experience. Sharing grief is itself a healing process. 'Memorials become monuments as a result of the successful completion of the mourning process' (Rowlands, 1999, p. 131). Monuments may have the role of reinforcing a consensual sense of national unity, but in so doing they may well contradict the memorialising function which sustains the grieving processes.

We can list some of the representational strategies used in war memorials. A common image is that of the calm, resigned soldier, often represented with his rifle inverted in mourning. Showing soldiers in action was controversial.

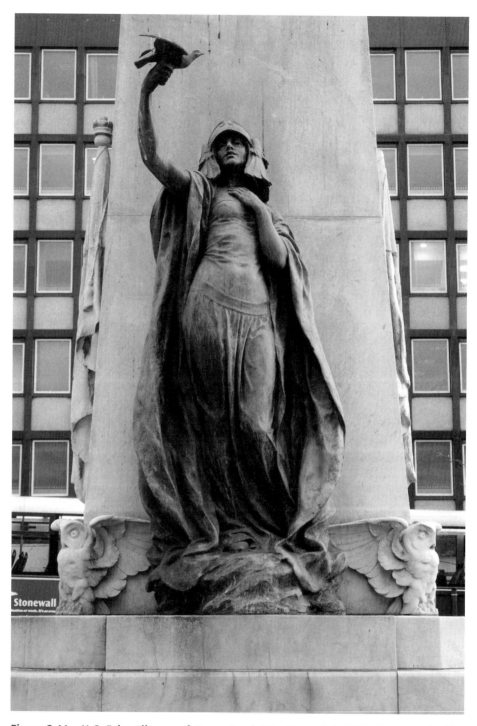

Figure 2.11 H.C. Fehr, Allegory of Peace, Leeds War Memorial, 1922. Photographed by Tim Benton. Photo: © Tim Benton.

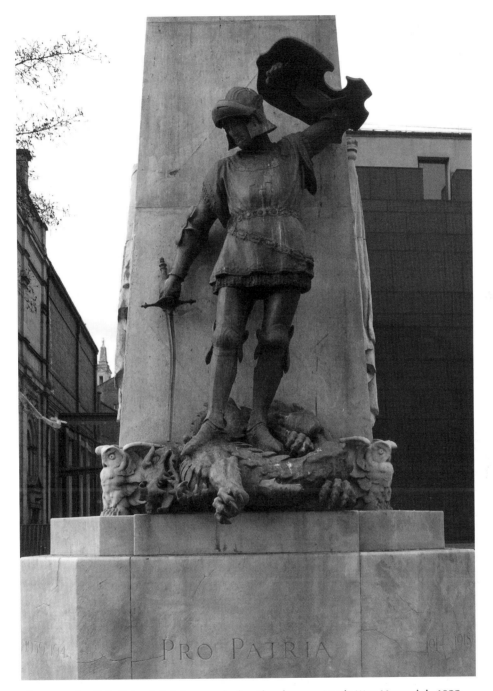

Figure 2.12 H.C. Fehr, Saint George slaying the dragon, Leeds War Memorial, 1922. Photographed by Tim Benton. Photo: © Tim Benton.

For example, on the Bradford War Memorial bronze figures of a soldier and sailor advancing with fixed bayonets were considered by the Lord Mayor as 'quite out of place' (Boorman, 2005). It seemed that any direct reference to reality was too painful.

The mechanisation of warfare in the 1914–18 war, and in particular the devastating use of machine guns and artillery, made the sense of loss more difficult to bear. The anonymity of mechanised death and the obliteration of bodies gave this war a new dimension. The fact that thousands of men's bodies were never recovered means that their memories are attached only to names inscribed on monuments such as the Menin Gate or the Thiepval monument. Machine gunners and artillerymen also suffered terrible casualties. How could these victims, also fearsome purveyors of death, be properly remembered? As it happens, two monuments at Hyde Park Corner, commissioned by the artillerymen and machine gunners themselves, clearly expose different strategies from those we have looked at so far. Penelope Curtis analyses the significant differences in the way these two sculptors approach the problem of commemorating the war.

Royal Artillery Memorial and Monument to the Machine Gunners' Corps

Not far from Whitehall stand a pair of monuments which make for an interesting comparison with the Cenotaph. Designed predominantly by sculptors, they were commissioned by regiments rather than by government. While acknowledged to be official monuments, and occupying a site only a little less prestigious than that of Whitehall, these addressed a more specific audience of combatants and their relatives.

The Royal Artillery Memorial (1921–5) by the architect Lionel Pearson, with sculptures and reliefs by Charles Sargeant Jagger (Figure 2.13), stands across from F. Derwent Wood's Monument to the Machine Gunners' Corps (Figure 2.14) on the traffic island at Hyde Park Corner. Jagger's forceful composition is much larger and more complex than Wood's; the customary stone plinth emerges to take the form of a raised howitzer gun, while its side panels are cut in shallow relief and show camouflaged soldiers, struggling with the mud and dying in the trenches (Figure 2.15). At each of the four sides is a bronze soldier, dark and deathly against the pale stone; three are 'on duty', protected by their heavy greatcoats from the rain and the blast of the guns, while the fourth is a 'gisant' or recumbent figure, horizontally laid out in death. The dead man's face is partly shrouded in respect. The gun itself, a massive 9.2 inch howitzer, dominates the piece. The monument is full of realistic details which would speak vividly to those who had experienced war as a gunner. For example, one of the reliefs shows men struggling to move a gun under fire in heavy mud. It is the rain, the mud and the arbitrariness of death which fill veterans' stories.

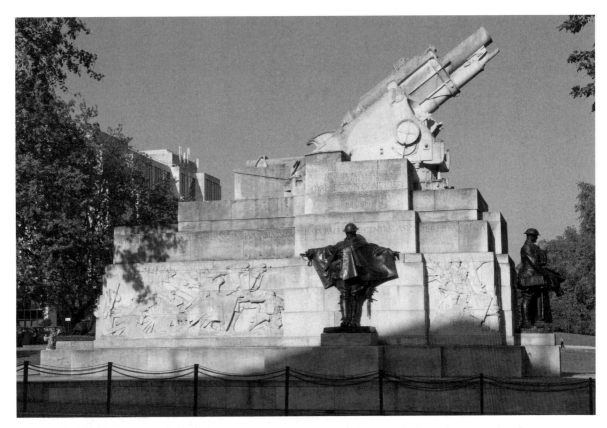

Figure 2.13 L. Pearson and C.S. Jagger, Royal Artillery Memorial, 1925, Hyde Park Corner, London. Photographed by Tim Benton. Photo: © Tim Benton.

While Jagger's sculptures and reliefs are brutally realistic, Derwent Wood's is idealistic. Rather than being dressed for modern warfare his 'soldier' is naked and languidly holds an enormous (and completely outdated) sword in his left hand. His right hand rests just as loosely on his hip. At his feet, however, are two machine guns, each adorned with wreaths, in strange but pressing combination with the nude male above. While Jagger's memorial is a highly effective mixture of documentary detail with passages of bravura, and could be seen by any soldier as historically 'accurate', Wood's is more ambiguous. It is surely arguable, however, that Wood's memorial is just as original, if not more so, in its high degree of abstraction, and perhaps even bolder than Jagger's, in terms of the portrayal of its subject. If it is a commonplace that Jagger was revered as a soldier-sculptor, Wood cannot be accused of academic distance. He was just as familiar with the horrors of the war from his work with soldiers in the Department of Masks for Facial Disfigurements which he founded in the Wandsworth General Hospital.

Figure 2.14 Derwent Wood, Monument to the Machine Gunners' Corps, 1925, Hyde Park Corner, London. Photographed by Tim Benton. Photo: © Tim Benton.

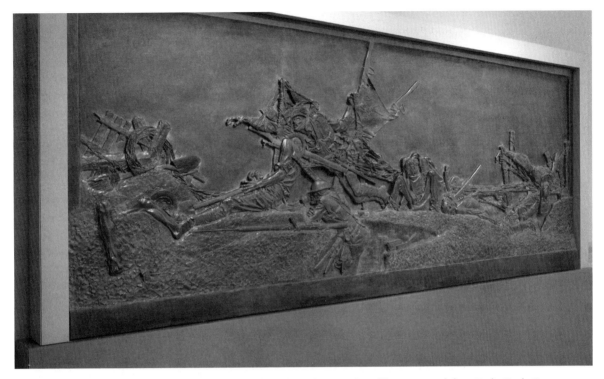

Figure 2.15 C.S. Jagger, Bronze maquette for relief on the Royal Artillery Memorial at Hyde Park Corner, London, 1921–5, Tate Gallery, currently on display at the Victoria and Albert Museum. Photographed by Tim Benton. Photo: © Tim Benton.

In fact, initially Jagger's memorial was poorly received by the press in general and by art critics too. Soon after it was erected *The Times* launched a campaign to move it to Woolwich, away from its prime central London site, but it was supported by those who had commissioned it. The 'David' on the Machine Gunners' Corps Monument was not without its own controversies – chief among which was its legend 'Saul has slain his thousands but David his tens of thousands' – but similarly it was most strongly supported by the soldiers it represented. Thus these two memorials – formally each so different – are similar in the support they inspired from their soldier clients.

Commemorating criticism

Another device of grieving is anger: searching for revenge against the injustice that has been committed. Immediately after the war Abel Gance made a film *J'accuse* (1919) which shows the dead of the First World War rising up and marching on the ruling classes, demanding revenge (Winter, 1995, pp. 15–18). The tradition of expressing anti-war sentiments was given added impetus after Erich Maria Remarque's novel *All Quiet on the Western Front* (*Im Westen nichts neues,* 1929) was made into a box-office hit film

a year later by Lewis Milestone. The poetry of Siegfried Sassoon and Wilfred Owen also fuelled dissatisfaction. Although this kind of response rarely expresses itself in war memorials, for obvious reasons, there are exceptions.

In 1923 a war memorial plaque was inaugurated on the south wall of the Library at Leeds University by Vice-Chancellor Michael Sadler, commissioned with the aid of a donation by Mrs Frances Cross. It was intended to commemorate the dead and wounded of Leeds University in the Great War. The plaque, designed and carved by Eric Gill, represents Christ driving the money lenders from the temple (Figure 2.16). Sadler tried to persuade the University Council that the subject represented 'the penalty for the covetous ambitions of Germany in provoking the war' (Kent, 1990, p. 17). But Gill himself published a pamphlet about the relief in which he made it clear that the subject had two meanings. Christ's violent expulsion of the money lenders from the temple justified war in a noble cause. Gill refused, however, to lay the blame particularly on the Germans. The figures represented are a pawnbroker, his wife and clerk, a politician and two other financial experts. Gill goes on:

> The nationality of the various persons has not yet been definitely ascertained. The artist suspects it to be varied. There are 'moneychangers' in all civilised countries, and modern war, in spite of the patriotism of millions of conscripts and their officers, is mainly about money – for the 'white man's burden' consists chiefly in the effort to bestow the advantages of 'civilisation' upon those 'unenlightened natives' who happen to be living where gold or oil is available.
>
> (Eric Gill pamphlet 'A war memorial', 23 May 1923, quoted in Kent, 1990, Appendix C)

Figure 2.16 Eric Gill, 'Christ expelling the moneylenders from the temple', 1923, war memorial of the University of Leeds. Photographed by Tim Benton. Photo: © Tim Benton.

For Gill, the war was a conflict between Justice and cupidity, but cupidity clearly existed on both sides. Many returning veterans expressed outrage at the profiteers who had made fortunes from the war. It is significant that the representatives of cupidity are recognisable British characters – the pawnbroker and his fashionably dressed wife – and that their clerk's books are labelled 'LSD' (pounds, shillings and pence).

It is not surprising that most people could not relate to this monument. One comment from a woman who had lost her husband and son in the war was that the work had 'no appeal to her sense of overwhelming loss' (Kent, 1990, p. A.4). The *Leeds Mercury* summed up the pros and cons in exemplary fashion:

> For:
>
> There is a war on, and there always will be, between Justice and cupidity
>
> This is the whole point of the last war
>
> The Lord instituted the war against cupidity and the memorial is a memorial to the war he began
>
> Against:
>
> The memorial commemorates hatred
>
> It does not honour our men's valour
>
> It does not comfort the grief-stricken
>
> It seems to savour of class-war and prejudice against the well-to-do.
>
> (*Leeds Mercury*, 24 May 1923, quoted in Kent, 1990, Appendix H, p. 9H)

Conclusion

We have looked at a number of very different ways in which memorials and monuments might serve both the needs of grieving individuals and the interests of the state in building a sense of national unity. It has been argued that these two functions sit very uncomfortably together, and that different groups of people, at different times, need very different things from war memorials. It should also have become clear that war memorials have played a very significant role in twentieth-century heritage. As in the case of all heritage objects, the practices and performances of people making use of the objects constitute the real heritage. This is clearly the case here, where even the history of the Cenotaph, as a state monument, was driven by popular needs rather than government decisions. The role of sculptors and architects has also been examined. We have seen how difficult it was to create monuments that were accepted and

appreciated by the public. We have seen brutally realistic representations of warfare, classically idealistic representations and abstract ones. We have even seen a monument that criticises the causes of war. Each memorial is an attempt to come to terms publicly with the tragedy of mechanised warfare.

Public mythology and private emotions come together in the war memorial, and these are necessarily bound up with the processes of remembering, forgetting and recreating interest. In this sense they represent a paradigmatic example of our relation to the past, a metaphor for heritage in general. We will develop this argument in the following chapters.

Works cited

Benton, T. (2000) 'When is it right to be wrong?', *Harvard Design Magazine*, no. 12 (fall), pp. 66–71.

Boorman, D. (2005) *A Century of Remembrance*, Barnsley, Pen and Sword Books.

Carden-Coyne, A. (2003) 'Gendering death and renewal: classical monuments and the First World War', *Humanities Research*, no. 10, pp. 40–50.

Curtis, P. (1994), 'The Whitehall Cenotaph: an accidental monument', *Imperial War Museum Review*, no. 9, pp. 31–41 (first published in Brisley, S. and Balcioglu, M., *The Cenotaph Project*, Derry, Orchard Gallery).

Gormley, A. (2009) The People's Plinth (26 February) [online], www.guardian.co.uk/commentisfree/2009/feb/26/trafalgar-square-fourth-plinth (accessed 12 June 2009).

Graham, B., Ashworth, G.J. and Tunbridge, J.E. (2000) *A Geography of Heritage: Power, Culture and Economy*, London, Arnold.

Hansard (1919) Parliamentary Debates (9 December), cols 1201–5.

Homberger, E. (1976) 'The story of the Cenotaph', *Times Literary Supplement*, pp. 1429–30 (12 November).

Kelso, P. (2000) 'Mayor attacks generals in battle of Trafalgar Square', *Guardian*, p. 3 (20 October).

Kent, G.R. (1990) *The Writing on the Wall: Leeds University War Memorial Controversy*, Leeds, PhD thesis, Leeds Polytechnic.

King, A. (1998) *Memorials of the Great War in Britain: The Symbolism and Politics of Remembrance*, Oxford, Berg Publishers.

King, A. (1999) 'Remembering and forgetting in the public memorials of the Great War' in Forty, A. and Küchler, S. (eds) *The Art of Forgetting*, Oxford, Berg Publishers, pp. 147–69.

Lowenthal, D. (1985) *The Past is a Foreign Country*, Cambridge, Cambridge University Press.

Lutyens, M. (1980) *Edwin Lutyens: By his Daughter*, London, John Murray.

Mace, R. (1976) *Trafalgar Square, Symbol of Empire*, London, Lawrence and Wishart.

Malvern, S. (2007) 'The fourth plinth or the vicissitudes of public sculpture' in Gerstein, A. (ed.) *Display and Displacement: Sculpture and the Pedestal from Renaissance to Post-Modern*, London, Courtauld Institute of Art Research Forum and Paul Holberton Publishing, pp. 130–50.

Rowlands, M. (1999) 'Remembering to forget: sublimation as sacrifice in war memorials' in Forty, A. and Küchler, S. (eds) *The Art of Forgetting*, Oxford, Berg Publishers, pp. 129–46.

Smith, L. (2006) *Uses of Heritage*, Abingdon and New York, Routledge.

Stamp, G. (2007) *The Memorial to the Missing of the Somme*, London, Profile Books.

WORK, The National Archives (TNA): Public Record Office (PRO) WORK (various folders and dates).

Tipping, H.A. (1919) 'The Whitehall Cenotaph', *Country Life*, vol. XLVI, p. 131.

Watkins, N. (2002) *A Kick in the Teeth: The Equestrian Monument to Field Marshall Earl Haig, Commander-in-Chief of the British Armies in France 1915–1918 by Alfred Hardiman*, Henry Moore Institute Essays on Sculpture, Leeds, Henry Moore Institute (a fuller version may be found on the website of the Henry Moore Institute, www.henry-moore.ac.uk).

Winter, J. (1995) *Sites of Memory, Sites of Mourning: The Great War in European Cultural History*, Cambridge, Cambridge University Press.

Further reading

Johnson, R. and Ripmeester, M. (2007) 'A monument's work is never done: the Watson Monument, memory and forgetting in a small Canadian city', *International Journal of Heritage Studies*, vol. 13, no. 2, pp. 117–35.

King, A. (1998) *Memorials of the Great War in Britain: The Symbolism and Politics of Remembrance*, Oxford, Berg Publishers.

Phelps, A. (1999) 'Locating memorial: the significance of place in remembering Diana', *International Journal of Heritage Studies*, vol. 5, no. 2, pp. 111–20.

Winter, J. (1995) Sites *of Memory, Sites of Mourning: The Great War in European Cultural History*, Cambridge, Cambridge University Press.

Chapter 3 Contentious heritage

Karl Hack

Reactions to war monuments depend in part on the different experiences and practices that individuals associate with them. This is especially so in multicultural and multi-ethnic communities such as Singapore and Malaysia. Both of these contain three major ethnic groups (Chinese, Malay and Indian). In this chapter Karl Hack, a historian, focuses on two case studies of contentious memorialisation: one of the Second World War in Singapore; and another of the Malayan Emergency in Malaysia. He demonstrates how these postcolonial states rejected the commemorative strategies of their pre-independence British colonial masters. Each developed instead its own particular way of using commemoration for nation building, with the two states' approaches having contrasting impacts on marginalised groups, and on the affective power of commemoration. As such, this chapter links to previous chapters on war commemoration and to following chapters, which deal with contentious heritage in postcolonial states (notably with states which, unlike Malaysia and Singapore, had large settler populations).

Introduction

> ... the most obvious sense of heritage as performance is that of commemoration, ranging, for instance, from the national rituals associated with events like Armistice Day, to ... family anniversaries ... the doing of commemorative events or performances engenders strong emotions as collective memories.
>
> (Smith, 2006, p. 69)

War memorials and the rituals that surround them bear out Laurajane Smith's observations, above: that heritage can be experienced as 'performances'; that such performances evoke 'strong emotions'; and that together public monuments and performances are designed to reflect and in part manufacture 'collective memory', right up to the national level.

First, war memorials – such as the Whitehall Cenotaph and the Malaysian and Singapore national monuments discussed below – do derive much of their meaning as focuses for self-consciously constructed 'performances'. These range from the laying of a wreath by a solitary widow, to televised national ceremonies. Indeed, if heritage were conceptualised only in the traditional sense of buildings, artefacts or practices with '**time-depth**' (belonging to the period to which they refer), then war memorials would scarcely qualify, since they are erected after the events they refer to. True, some are located at

battlefields, or over the bodies of victims. But equally true, many are detached in space and time from the events they commemorate. Their link is often more imaginative than physical. They provide a backcloth for commemorative 'performances'. Indeed, the monuments themselves resemble performances, in that they are words and forms carefully scripted after the event. Thus this chapter encourages you to look at how particular forms of monuments and performances came to be adopted in postwar and post-independence Malaysia and Singapore, that is, in postcolonial states with little or no white settler history or legacy but rather with richly multicultural Asian populations.

Second, such 'collective memory' of suffering and loss can stir powerful emotions, ranging from private grief to patriotic fervour. This chapter focuses on the way different communities in Malaysia and Singapore had very different – and to some extent irreconcilable – memories and emotions concerning 1941–5 and its aftermath and the Malayan Emergency of 1948–60. The chapter encourages you to look at the consequent tensions between the needs of individuals and particular groups on the one hand, and of the state for citizenship and nation building on the other.

This leads to the third, and for this chapter most important, point, that some monuments are constructed specifically to link private and community grief to a sense of wider community, and ultimately to a sense of 'the nation'. Thus the Whitehall Cenotaph was designed to give a focus to a *national* commemoration of the dead of the whole of the UK after the First World War. This chapter looks at the tensions and difficulties experienced when – as in Malaysia and Singapore – sharply contrasting memories made agreement on the form, role and significance of *national* monuments and performances particularly difficult.

This chapter thus deals with all three aspects of commemoration, namely: performance, emotion and the attempt to establish national focuses. It specifically looks at what happens when creating something *national* is made even more problematic than was the case in Chapter 2, with its focus on the Whitehall Cenotaph. The two case studies below provide stark illustrations of this problem of constructing 'national' focuses for 'collective memory' when different ethnic, linguistic, cultural and political groups have contrasting memories.

It may help to think of the two societies and states we examine here in terms of Ashworth, Graham and Tunbridge's (2007, pp. 72–87) classificatory scheme (further discussed in Chapter 5). They divide multicultural societies into:

- **Assimilatory** – a single core with alternative heritage marginalised, seen as temporary, or attacked.
- **Melting pot** – attempting to blend different heritages into something new as in some settler societies, but often with significant issues concerning minorities that resist incorporation.

- **Core+** – which allow space for alternative heritage in addition to a pre-eminent national core.
- **Pillar** – society seen as composed of autonomous, equally valid cultures and heritages collectively supporting the state, as in the Belgian model or, when degraded, as in pre-1990 South African apartheid.
- **Salad bowl** – where each type of society and heritage floats freely and state policies may support such variety, for instance by funding separate sites, or by encouraging diversity to be reflected in the management of individual sites. Some modern European states which have become increasingly diverse – such as the United Kingdom – incline towards this approach.

In this scheme Malaysia and Singapore are obviously not assimilatory, melting-pot or salad-bowl societies. Both care deeply about constructing a core heritage and identity, while wishing to engage with the multiple ethnic identities that persist in their states. Hence Ashworth, Graham and Tunbridge (2007) label Malaysia 'core+'. In Malaysia the Malay culture, language and religion flavours the state and the state-sponsored 'Malaysian' identity, but the '+' cultures of Chinese and Indians are given add-on status and tolerated, even to some extent included in televised montages of 'national' culture, costume and dance. In Singapore, by contrast, the state fosters an ethnically non-specific core, using English as a neutral lingua franca for a meritocratic society in addition to continuing to support local languages and cultures in the school system. As we shall see, however, though both can be termed core+ societies, their policies contrast, resulting in different outcomes. In short, while such models do help us to think about contentious heritage in multicultural societies, we also need to study precise historical context and policy decisions in order to understand outcomes.

The rest of this chapter examines the workings of heritage in these two states through case studies of commemoration in the areas represented by modern Malaysia and Singapore.

Actors

This chapter is particularly concerned with how the state interacted with key stakeholders in these two states' war heritage: veterans and the groups that represented them; veterans' families; and organisations and individuals seeking to influence collective memory. Here you might recall the Whitehall Cenotaph and British Armistice traditions discussed in Chapter 2. These were the result of *interaction* between state action, and the needs, suggestions and actions of individuals and groups. Take the idea of bringing back an 'unknown soldier' to be buried in London. This was first suggested by an army chaplain who recalled a cross to an unknown soldier in France, and was then adopted

by the army and state. Jay Winter argues that such suggestions often came from fictive kinship groups, groups of people united not by blood or politics but by experience (Winter, 1995, 1999). He argues that these emerge when people live, work, argue and endure together, for instance in particular regiments.

We might tentatively extend Winter's notion to groups who suffer together on the home front, though only if as a result they also form organisations, or at least spawn groups of activists who champion their memories. Such organisations might also act as 'fictive kin', though in reality civilian victims of war are often less organised than veterans.

Over and above fictive kin groups, people and organisations take on the role of '**memory activists**'. These campaign for forms of commemoration that accord with their own or their group's interpretations of the past. It was the identification with, and development of, the Cenotaph and surrounding ceremonies by fictive kin groups, 'memory activists' and others that gave the Cenotaph added potency. But what happens, as was the case in Singapore and Malaysia, when the state tries to use heritage for purposes of national unity, in situations where memory activists and fictive kin groups hotly dispute what most deserved to be remembered? This is what we will explore in this chapter.

Bear in mind, as you read what follows, that forms of commemoration, as monuments and 'performances', evolve in a conversation between different actors: the state, fictive kin groups and memory activists, families and individuals, and the 'artist', such as Edwin Lutyens (for the Whitehall Cenotaph). There is also the problem of how far these two states – which both wanted to harness or limit alternative heritage interpretations – were able to deal with 'dissonant' or 'subaltern' heritage values that continued to be held by groups outside the ruling elite. How far were they successful in imposing and having accepted their own version of an authorised heritage discourse (AHD) that dampened difference and upheld a national story (Smith, 2006, p. 299)?

Contexts

You should also consider the need for a specifically historical analysis, including analysis based on primary documents (images, media, government documents) from the time, and for establishing contemporary context. If you were to try to analyse commemoration without understanding its historical context you might remain unaware of the ways in which it draws on, suppresses and distorts past events. You might also remain unaware of how the historical and political characteristics of a country and key individuals shape possibilities. To analyse commemoration without also knowing the history it commemorates – and the history of how commemorative practice has been shaped – is to make bricks without straw.

The best way of illustrating this is to outline the nature of Malaya (enlarged as Malaysia after 1963) and Singapore and their populations (a mix of Malays, and of generations of immigrants from China and India), as well as the nature of the conflicts whose commemoration we shall be examining.

Both areas were under British protection in 1941, when Japanese troops landed in the north of Malaya, before storming down the peninsula. Around 130,000 British empire troops – mostly British, Australian and Indian – fought until overwhelmed by superior Japanese airpower, sea power, tanks and generalship. The British made little use of local forces, with the notable exceptions of a couple of thousand Malay Regiment soldiers and several hundred Chinese volunteers (sometimes called 'Dalforce'). Both units showed impressive but futile valour in the final days of battle. Singapore fell on 15 February 1942, with 100,000 British-led personnel becoming prisoners of war (POWs). For the subjects of this chapter – the Asian population – the prime memories of the conflict were mainly, therefore, not those of battle but of three and a half years of Japanese occupation.

Malaya and Singapore were run as part of Japan's empire from 1942 to 1945, with Singapore given Japanese temples, language lessons and a Japanese name – Syonan-to (Light of the South). At one level, therefore, the populations of these territories did undergo similar experiences. Regardless of **ethnicity**, few people would not have learned a little Japanese, grown or eaten tapioca and other foods, and come across celebrations such as those for the Japanese emperor's birthday.

Despite these similarities there were differences in how various people in Malaya and Singapore experienced the war, stemming in part from the existence of a '**plural society**'. In other words, there were ethnic-linguistic-cultural groups who met in the marketplace but generally did not mingle or marry, and who generated no overarching new culture. There were also groups with mixed ethnicity, such as the Peranakans (Chinese-Malay) and Eurasians. But the vast majority remained locked in distinct communal contexts. Pork-eating, Chinese-speaking immigrants did not, generally, inter-marry or share a great deal culturally with pork-avoiding Muslim Malays. On the Malayan peninsula most immigrants were assumed by the British to be temporary sojourners in a Malay land, which was divided into nine Malay sultanates. Membership of a cultural group, whether you were Chinese, Malay, Indian (or indeed Eurasian), could have a major impact on your experience, and memory, of the war.

To the south, Singapore, joined to the mainland by a causeway, was a very different, urban and Chinese-dominated place. Since Sir Stamford Raffles had negotiated a British claim there in 1819 it had grown into one of the world's premier ports, and this had meant even greater immigration. Chinese, from rickshaw pullers and dock workers to rich 'towkays' (businessmen),

comprised more than 70 per cent of Singapore's population, with sizeable minorities of Malays and Indians, and myriad other small groups besides.

Hence Malaya and Singapore were very different. Demographically, Malays were the largest single group on the peninsula, with Chinese just behind and a minority of Indians. On Singapore, there was a large Chinese majority. Geographically, while the Malayan peninsula was 80 per cent jungle and mountain-covered, with towns and plantations restricted to the costal plains, Singapore island contained a modern city (Hack and Blackburn, 2004, pp. 12–28).

It is hardly surprising that the varied communities of the Malayan peninsula and Singapore – most notably the Malays, Chinese and Indians – had significantly different experiences of occupation. These were exacerbated by Japanese policy. The Japanese came to South-East Asia after several years' campaigning against mainland China, notably from 1937. They were predisposed to fear Chinese opposition, even before some Chinese fought against them in Malaya. The Malayan Communist Party (MCP) subsequently led a mainly Chinese guerrilla force after Singapore's surrender, known as the Malayan People's Anti-Japanese Army (MPAJA), or 'mountain rats'.

Perhaps unsurprisingly, Chinese experienced the harshest treatment, especially in a 'sook ching' (purification) or screening exercise of February to March 1942. Male Chinese were examined, and thousands were taken away and shot as suspected of harbouring anti-Japanese views. The Japanese later confessed to killing 5000, while local Chinese claimed that 30,000 were killed in Singapore and 20,000 in Malaya. By contrast, Malays were often left alone in their rural kampongs (villages). For Indians, some carried on quietly, but others joined the Japanese-sponsored Indian National Army (INA). Originally raised from captured Indian soldiers, this was sent to help the Japanese fight their way from Burma towards India in 1943 to 1944 (Hack and Blackburn, 2004, pp. 142–82).

Hence you could find, in postwar Malaya and Singapore, Chinese Communists who had fought the Japanese from jungle bases, Malays who had continued on smallholdings or in administrative posts, and Indians who had joined the Indian National Army (INA), as well as Indians who had remained in plantations or offices. Beyond this the permutations, between and within communities, were myriad.

Postwar and then post-independence Malaya and Singapore were therefore to inherit two serious obstacles to constructing *national* forms of war commemoration. First, their multi-ethnic societies contained groups with radically different memories of the war. Second, they needed to adapt or replace pre-existing colonial forms of remembrance so as to meet their citizens' needs and their own desire to create nations where plural societies had existed. In short, both states saw heritage as having a role in building a new, consensual

form of national identity. Both had an interest in constructing a postcolonial authorised heritage discourse to support their new nations.

Malaya achieved independence in 1957 and was renamed Malaysia in 1963, with the incorporation of Singapore. In 1965, Singapore seceded to become an independent state. The rest of this chapter looks at case studies of contentious war commemoration in these two territories. It does not attempt to be comprehensive. For instance, it does not mention Singapore's myriad gun emplacements and memorial plaques, or the Changi Museum and Chapel (which honours mainly European wartime POWs). You can access websites on many of these. Instead, the case studies focus on the difficulty of constructing *national* monuments for mainly Asian citizens. They look at the ways in which the monuments raise issues of performance, emotion and 'collective memory', and they include consideration of the planning stage of the monuments. This should remind you that the national monuments that were constructed were not the only possible end-results. It would be naive to analyse the monuments that were built as if they were the only possibilities. It is important to consider the alternative suggestions that existed, and why they did not see the light of day.

Case study: Singapore's contested war heritage

In order to understand post-independence memories we need to start by asking what was the colonial model of commemoration that new states inherited. In Malaya and Singapore this centred on cenotaphs that echoed the one at the core of the empire, in Whitehall (see Figures 2.5 and 2.6 in Chapter 2 for Whitehall, and Figures 3.1 and 3.2 here for Asia).

The obvious point about Figures 3.1 and 3.2 is that they are British in conception. The stepped platform, the central structure, the inscriptions to 'Our' or 'The' Glorious Dead, are repeated. In November 1920 it had been recommended that there should be simultaneous ceremonies all over the empire every 11 November. Hong Kong asked permission to copy Lutyens's Whitehall Cenotaph as a focus for its ceremonies. These monuments, then, were reproduced, together with the surrounding ceremonies, as modular units of empire symbolism and sentiment.

The Singapore Cenotaph differed in form from the Hong Kong Cenotaph; it was not, for example, as closely modelled on the Whitehall Cenotaph as Hong Kong's. Nevertheless, its central column echoed the construction of the Cenotaph in London. Before we go on to look at how the Singapore monument was used we should reflect on an important aspect of the Whitehall Cenotaph, which is that it owed its form and persistence as much to individual, and group, needs and initiatives as to state planning.

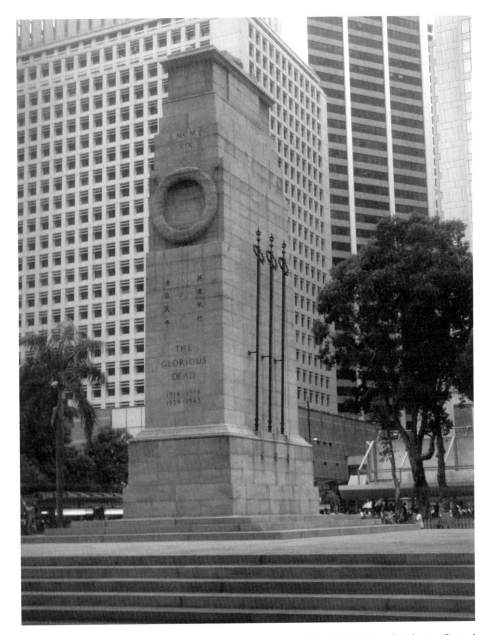

Figure 3.1 The Cenotaph, Hong Kong, 1923. Photographed by Karl Hack. Photo: © Karl Hack. There were ceremonies here every last Monday in August after 1945, to mark the liberation of Hong Kong from Japanese rule at the end of the Second World War.

What are we to make, then, of the replication of a British empire mode of war commemoration in an Asian colony? For this is what Singapore was: from 1946 until its entry into the newly formed Malaysia in 1963, Singapore was a Crown colony, with increasing measures of self-government. Its incorporation

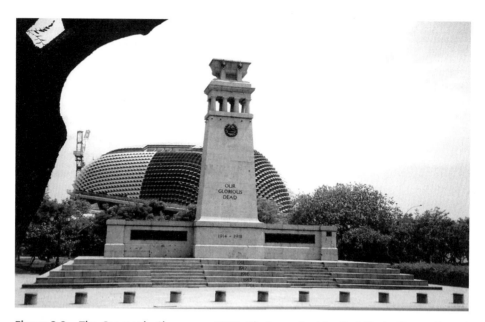

Figure 3.2 The Cenotaph, Singapore, 1922. Photographed by Karl Hack. Photo: © Karl Hack. This structure, initially dedicated to 124 men from Singapore who lost their lives in the First World War, was begun in 1920, and unveiled in 1922 by the then Prince of Wales (the future King Edward VIII). It stands on Queen Elizabeth Walk, which before land reclamation ran along the seafront, with the padang (green space) and City Hall to its front. Until the 1950s, ceremonies were held here every 11 November.

into Malaysia – joining port and hinterland – seemed logical, but ended in acrimonious divorce on 9 August 1965, after which the island became independent.

So while in London the Cenotaph reflected a widespread desire to commemorate the war and its sacrifices, the version in Singapore was imposed by a colonial administration and was shortly to come up against a very different approach to war memory dictated by Singapore's post-independence ruling party.

The struggle between imperial and local needs

The island's People's Action Party (PAP) first formed a government in 1959, one that enjoyed a wide measure of internal self-government. Even before full independence in 1965, the PAP promoted the idea of building a meritocratic, united 'Singaporean' nation from its disparate Chinese majority and its Malay, Indian and Eurasian minorities. In 1947 Singapore had a population of 938,079 including: 727,863 Chinese, 114,654 Malays, 71,289 Indians, 8718 Europeans, 9012 Eurasians and 6453 'others' (Colony of Singapore Report, 1948, p. 19) It was determined to lead people away from poverty and from

ethnic divisions that fuelled race riots in 1950 and 1964. One means of bringing this about was to dampen down communally distinct memories of the war and to foster postcolonial 'nation building'.

The PAP also faced the question of what to do with the legacy of colonial commemoration: the Cenotaph, Remembrance Day celebrations and new layers added by the postwar colonial government. After the Second World War ended in August 1945, an 11 November Armistice Day ceremony continued to be held at the Singapore Cenotaph, renamed Remembrance Day. The dates of the Second World War were added to the Cenotaph. However, neither the form of monument nor the ceremony addressed the needs of the local population: both were the products of western fictive kin groups and bereaved family, not of Asians. The Remembrance Day ceremonies dwindled into events for the small expatriate community, whose prime focus increasingly became the Commonwealth cemetery at Kranji, to which we will return.

What aspect of the Pacific War would the inhabitants of Singapore most seek to remember? Would it be the military campaign, the Malay Regiment and Chinese volunteer units (Dalforce)? If so, this would also be to remember British failure. One possible message for Singaporeans, therefore, would be to avoid relying on Britain or anyone else. Since the 1990s this has been integrated into education and government messages through the slogan 'We must ourselves defend Singapore'. This is in turn related to the introduction of two years of National Service for every male from 1967 onwards, following Singapore's expulsion from Malaysia in 1965, and then an announcement in 1967 that British forces might soon be withdrawn. Now that Singapore was to be protected by neither Britain nor Malaysia, it was essential to have a substantial military force. With a small population with a historical aversion to military service, National Service seemed the only way. One method of persuading the population to accept this was constantly to remind them of the terrible cost – in the 1941–5 period – of relying on others for their defence.

Another message from defeat might have been that communal division could be the fatal flaw in defence. This was because the British-led imperial force that was defeated was about half British and Australian combined, and half Indian troops from abroad. Local forces were few.

There was also the question of what dates to use to commemorate the war, after the British re-occupied Singapore in September 1945. Some (including the Malayan Communist Party (MCP)), wanted to mark the date of 15 February. But the British did not favour commemoration of the date on which their forces had surrendered. The British favoured two alternatives: one for commemoration and one for celebration.

The first, for commemoration, was simply to continue using 11 November. This meant that the Second World War would be bundled up with other wars of the empire, with memory focused on those who had sacrificed their lives in

victorious conflicts. But that date alone was not sufficient. Given the terrible cost of British defeat in Malaya, they needed a date that more powerfully and specifically evoked British success and return in Asia.

The second date, 12 September, marked the day in 1945 when Lord Louis Mountbatten (Supreme Commander, South-East Asia Command, 1943–6) had formally accepted the local Japanese surrender at Singapore's City Hall. This gave a suitable date to 'celebrate', even if the restoration of British prestige was not enhanced by the circumstances of Japanese surrender, caused not by military victory in Malaysia but by the atomic bombs dropped on Hiroshima and Nagasaki. The 12 September 1945 was, therefore, carefully choreographed, with a march past the City Hall, the arrival of the Japanese delegation, and Mountbatten distributing honours. The date of 12 September subsequently became the officially preferred day for marking the end of the Pacific War, and a holiday for many workers.

By contrast, the date of 15 February was intended to be left for private reflection, except that the MCP still had other ideas. Through its labour unions the party announced a day of mourning and a procession for 15 February 1946. During the war the MCP's 'mountain rats' (MPAJA) had worked with the British. After the war, Britain had recognised the MCP and had committed to introducing elections. The MPAJA in turn had laid down its arms, and its MCP members had turned to union work. British authorities now interpreted the plans to mark 15 February – the anniversary of British surrender – as an attempt to embarrass them. The event was banned. But to the MCP the date was vital. For them, it marked both the beginning of Japanese occupation, and also the date from which MPAJA fighters, not British-led troops, became the main resistance to the Japanese. The organisers therefore went ahead. Police fired on the crowd. One protester was killed and another died of injuries afterwards. Several Communist and labour leaders were banished, and the MCP responded with increased violence. After a spiral of Communist intimidation and tighter British labour laws an emergency was proclaimed in Malaya in June 1948. This 'Malayan Emergency' officially lasted until 1960.

Despite Britain's negation of 15 February as a date for public commemoration and the MCP's retreat to the jungle in 1948, the focus of war heritage nevertheless changed. By the early 1950s anti-colonial agitation was increasing. There were protests by students and workers, sometimes spurred on by Communists, and the British recognised that holding ceremonies at the Cenotaph, minutes' walk from Chinese residential districts, could backfire.

An alternative focus for commemoration already existed at Kranji, in the north-west, and in the 1950s the focus of British-led ceremonies was moved here from the Cenotaph. The site of a former military hospital cemetery, this is where most war dead were buried from the 1940s onwards (eventually, the war graves concentrated there numbered 64 from the First World War,

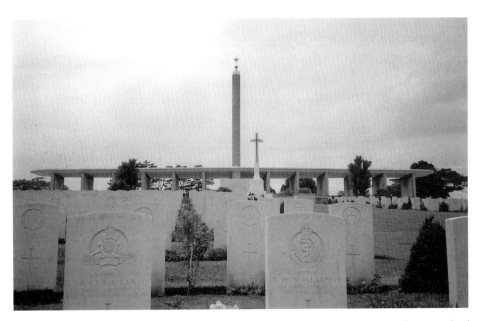

Figure 3.3 The Commonwealth War Memorial, Kranji, Singapore, 1957. Photographed by Karl Hack. Photo: © Karl Hack.

4458 from the Second and 850 unidentified graves). The main monument (Figure 3.3) is adorned with the names of about 24,000 servicemen for whom there is no known grave. Smaller memorial stones are dedicated to units such as the Singapore Volunteers. To the front are individual gravestones. Officially opened on 2 March 1957, Kranji is maintained by the Commonwealth War Graves Commission and remains the focus for ceremonies for those who died fighting under British control. Ceremonies generally include a two-minute silence, wreath laying and attendance by representatives from the nationalities concerned.

Kranji emphasised loss, sacrifice in a cause and remembrance of the dead by future generations. Even on 15 February 2002 – the sixtieth anniversary of the Fall of Singapore – the ceremony there was one of the most significant in Singapore and Malaysia. Some 2000 veterans and sympathisers attended, laying wreaths for Australian units in particular. Whether because Australia is rich and close, or because Australians feel less responsible for Singapore's fall – Australians continue to be most prominent among returning veterans. Both veterans and families of the dead came in increasing numbers on 'pilgrimages'. They paid their respects at Kranji, and at Changi in the east of Singapore, where most POWs had been held.

Kranji emerged, then, as a significant focus for commemoration for a number of reasons. First, it was near sites where the Japanese first landed on Singapore's north shore on 8 and 9 February 1942, and so was already the site of graves. Second, when war graves were moved from the former Changi

POW camp they went to Kranji, and it became the central point for all Commonwealth POW and war graves. Gurkhas who died in the Malayan Emergency and even British soldiers' wives who died in Singapore joined those who fell in the Second World War. Kranji thus remained the focus for commemoration both of the soldiers of the Second World War and of those who died after. Ceremonies are still held there, notably on Anzac Day in April and on 11 November. But its primacy did not go unchallenged.

We have already seen that the MCP wanted to commemorate a different date – 15 February – and a different set of heroes – wartime guerrillas of the MPAJA. With the Malayan Emergency declared in June 1948 and the MCP outlawed, there was little chance of state-sponsored monuments being raised to their fighters. But there was an alternative. Britain's Special Operations Executive during the war, known as Force 136, had sent officers to liaise with and support the Communist-led resistance fighters of 1942–5. Many of the officers of Force 136 were non-Communist Chinese. Indeed, many were supporters of the anti-Communist Nationalists in China.

The search for Asian forms and focuses for commemoration

It was one of these Nationalist supporters that Singapore's postwar Chinese businessmen and community leaders chose to honour. Lim Bo Seng was a pre-war anti-Japanese organiser in Singapore who offered his services to Britain at the request of the Chinese Nationalist government. He arrived in Malaya by submarine in November 1943 as a British Force 136 officer charged with liaising with Communist-led guerrillas of the MPAJA. Captured by the Japanese in Malaya in March 1944, he died after several months of torture.

Lim Bo Seng was a safe hero on three counts: he was non-Communist, had left behind a young family in Singapore, and had died after torture. However, Chin Peng – then a local Communist leader and subsequently MCP secretary general – later argued that Lim thrived only when he relied on Communist support. Chin Peng had met Lim off the submarine, smuggled him inland and given him support, but Lim was captured shortly after he attempted to set up his own networks (Chin, 2003, pp. 26, 106–8).

In December 1945 Lim's body was brought back to Singapore and buried the following month by McRitchie Reservoir, in a beautiful but relatively inaccessible site in the interior of the island. When a memorial was proposed by the Lim Bo Seng Memorial Committee, the colonial government suggested it should be at a more accessible location: near Queen Elizabeth Walk, and so close both to the mouth of the Singapore river in the south of the island and to the very heart of the city. The monument (Figure 3.4) was unveiled on 10 June 1954, the tenth anniversary of Lim's death. In the shape of the Nationalist Victory Monument in Nanjing (Nanking), it was guarded by four lions imported from China.

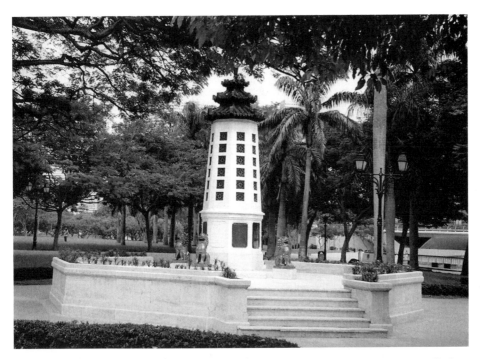

Figure 3.4 The Lim Bo Seng Memorial, Queen Elizabeth Walk, Singapore, unveiled June 1954. Photographed by Karl Hack. Photo: © Karl Hack.

This was a reflection of Lim's identity as a pro-Nationalist, overseas Chinese businessman. He had first enlisted to serve the war effort not in South-East Asia but in war-time China, and was also posthumously promoted from colonel to major general by the Guomindang (Kuomintang or KMT) government, which ultimately lost mainland China to the Communists. But already both Chinese and colonial leaders, as well as newspapers, were presenting Lim as a *Malayan* hero. The memorial plaque pronounced him 'a martyr to the cause of a liberated Malaya'. At a time when Malaya and Singapore were gaining increasing self-government, with many hoping they would eventually unite as one independent Malaya, commemoration was shaped to political needs. Whatever Lim had felt himself to be was less important now than what he could be made to represent.

In this way some fictive kin groups and their supporters (British veterans, pro-Nationalist Chinese businessmen, Force 136 officers) were supported by the state and press, and commemorated by high-profile public memorials, while others (Communist wartime guerrillas, Dalforce) were marginalised. In some cases commemoration of those the state frowned on was violently erased. An INA monument that had been created near the Cenotaph during the war, for example, was blown up by the British on their return.

By 1954, therefore, the INA monument had gone and close by, along the shorefront, were the Cenotaph and the Lim Bo Seng Memorial, while on the other side of the island Kranji hosted the remains of dead soldiers. Communists were restricted to paying their respects in private, or at obscure memorials in Malaya. Missing from this cast of the included and excluded, however, was another category. The victims of the Japanese massacre of Chinese that occurred during February and March 1942 – an operation known as the *sook ching*, or purification – had no substantive memorials. Military casualties in Malaya and Singapore paled in comparison with the numbers of civilian dead: 3500 Japanese; 8000 British empire forces; but as many as 30,000 Chinese killed in Singapore alone, and up to 50,000 in total. (Japanese sources claim that this last figure is in fact only 5000; however, the numbers of the remains themselves attest that it must be several times that number.)

Who were these civilian victims? The Japanese operation of *sook ching* was known among Chinese as the 'screening' because survivors recalled being examined at concentration areas from 18 February 1942. It originated as a Japanese order for the 'severe punishment' (a term that had previously meant 'killing' in China) of all anti-Japanese Chinese. Potential victims included supporters of the pre-war China Relief Fund, China-born men who had arrived in Singapore after 1937 and people who had volunteered to fight Japan alongside the British. Victims were trucked off to be bayoneted or machine-gunned at beaches and other isolated spots.

Post-war Chinese literature reflected intense feelings of loss, anger and concern as well as a desire for resistance and revenge. It was inevitable that Chinese would start to mark the date of 15 February since it was the fall of Singapore that had triggered the *sook ching*. The problem was how to commemorate their dead, when most bodies had not been recovered. Popular Daoist (Taoist) beliefs suggest that those who die violently, or do not receive offerings of food at their graves, might become 'hungry ghosts' – souls released only during each year's 'Feast of the Hungry Ghosts' in the seventh lunar month (around August). The relatives had no state-sponsored commemoration to turn to. Instead, some started to commemorate their dead near known massacre sites. This happened at Siglap on the east coast in 1947. In 1948 High Priestess Miaw Chin was asked to 'screen' ghosts at a ceremony there, to decide which would go to heaven and which to hell, on behalf of Guan Yin (Kuan Yin), the Goddess of Mercy. The three-day soul-raising ceremony at Siglap was attended by thousands, and climaxed on the festival of Dong Zhi (the winter solstice, also Tung-chek or Tang Chek). At this time of family reunion and homage to ancestors, offerings of food, paper clothing and paper money were made, to sustain the victims. And to punish the guilty, paper models of naked, disembowelled Japanese soldiers were burned.

In time, however, the problem changed from one of not having bodies to the accumulation of thousands of unidentified remains from massacre sites all over the island. Discoveries of mass graves at Siglap in February 1962 spurred a campaign by the Chinese Chamber of Commerce, which acted as 'memory activist' for Chinese civilians who lacked fictive kin groups of the sort possessed by the MPAJA and military, and supervised exhumation. Over 100 sites were exhumed, and 600 large funeral urns were filled, each containing the remains of thirty or more people. This represented as many as 20,000 victims.

These urns needed a resting place. The Chinese Chamber of Commerce raised money and campaigned for a memorial site. In 1963 a design competition was held, with a brief that called for 'solemnity, dominance, simplicity and ... moulding the monument into the [proposed] memorial gardens ... [while] maintaining the dominance of the memorial'. The design was also to allow public access to the structures that would contain the urns, and provide an enclosed space for commemoration.

The winning design by architects Swan and Maclaren (Figure 3.5) was thought to fulfil these requirements, albeit with too small a vault to allow adequate public access to the urns (Assessors Report, 1963). The design was to feature a central flame of remembrance and a surrounding 'pool of reflection'. The wings of the arch were felt to reflect 'a local architectural

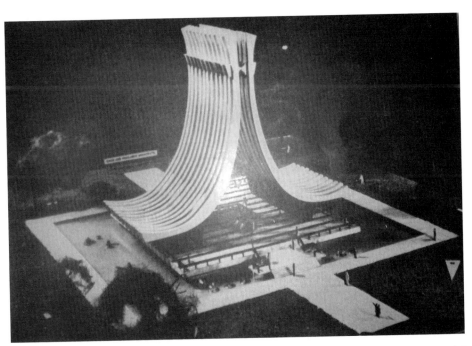

Figure 3.5 Swan and Maclaren, Winning entry for the Singapore Civilian War Memorial design, 1963. Unknown photographer.

mood', but it was thought that access to the sanctum for urns to take cremated remains (presumably under the main platform) should be improved. The designs placed second and third in the competition featured more prominent, accessible urn sanctums but were rejected because the main monument of one was felt to be too severe, and the monument of the other was considered to blend too much with the gardens. Swan and Maclaren would eventually build the monument in a different form (see Figure 3.6).

Singapore nation-building and citizenship agendas

One reason for the change to the final Swan and Maclaren design seems to have been government influence. In March 1963 the government offered an area of four and a half acres of state land on Beach Road, and later agreed to match publicly raised funds dollar for dollar. It is also possible that the technically demanding nature of the proposed sweeping arch provided another opening for change. In addition there were objections to cremation from some of the relatives, meaning that bones rather than ashes would be buried. This necessitated using more urns, which made their display less practical, and it was decided instead to bury the urns beside the monument.

When the monument opened the finished structure took the form of four columns, each of which was said to represent a different community. Unfortunately, this design rendered the funerary aspect of the site – as a place to contain urns – almost invisible to passers-by. A further flaw, in the changing context of the site over time, was unanticipated. When offered by the government, the site had seemed ideal. It was close to the Cenotaph and to the business, government and shopping districts. It had Raffles Hotel to its landward side, and both the *padang* (the public green used for ceremonies and cricket) and cathedral to its west. Beyond the plot was the seafront. Unfortunately, by the time the monument was unveiled land reclamation was proposed on the seaward side. The subsequent building of hotels and shopping complexes there, and the increased intensity of road traffic, eventually gave the site the feel of an isolated island, even though accessible by subways. On the positive side, intensive land use around it means that the monument remains a highly visible part of the urban landscape.

The victims were laid to rest from 1 November 1966, with the urns being interred underground. The memorial, known as the Civilian War Memorial, was unveiled on 15 February 1967, its four pillars soaring 67 metres (Figure 3.6). In the period between the grisly discoveries at Siglap and the unveiling, the initial idea of the Chinese Chamber of Commerce for a memorial to Chinese massacre victims had become subsumed in a wider project. The urns are not visible. They are echoed only in the sculptured urn at the foot of what were soon popularly dubbed the 'chopsticks'. No names are listed. The inscription is to the dead of four communities, not one.

Originally, Chinese poet Pan Shou had penned a more dramatic epitaph. It evoked the need for peace but also stated that the four columns stood for the 'loyalty, bravery, virtue and righteousness which are reflected in the traditional harmony and solidarity of the multi-racial, multi-cultural and multi-religious society of Singapore'. Echoing government-sponsored themes of national unity emerging from common suffering, the epitaph overtly drew attention to the massacre, ending with the words:

> May the souls of the civilian victims of the Japanese Occupation rest in eternal peace and accept this epitaph dedicated to them by the people of Singapore.
>
> Tears stained flower crimson-like
> And blood tainted the blue ocean
> Ye wandering souls who rise with the tide
> Shall guard this young emerging nation.
>
> (quoted in Bose, 2005, pp. 74–5)

Despite the original epitaph emphasising all 'races' of Singapore, it was perhaps too obviously inspired by Chinese experience: the massacre of 1942 and the lost bodies. As a young nation which had experienced racial riots in 1950 and 1964, Singapore was sensitive about inter-communal issues. Hence the eventual simpler epitaph, dedicating the monument to *all* civilian victims, with one pillar for each main ethnic group: Chinese, Malay, Indian and Eurasian. The merging of the four pillars was further presented as a metaphor for the unity of these groups, and the opening ceremony featured priests of all the major religions of Singapore, including Muslim, Christian, Hindu, Buddhist and Daoist. At ceremonies, in the media and in schools the state memorial was presented as symbolising the birth of a nation through common suffering in wartime.

Every year since the unveiling in 1967, on 15 February, the Chinese Chamber of Commerce has organised a ceremony early in the morning, more recently with the Japanese Ambassador also attending. The date so hated by the colonial government had triumphed almost as soon as the postcolonial era had begun. This is not to say that the memorial has been an unmitigated success. The 'island' nature of the site makes its unsuitable for any but small gatherings. Since 1967 the message of commemoration has also become heavily overlaid with one of nation building. As time has gone on, fewer people remember the full purpose of the site – as the burial place for urns containing the remains of massacre victims. The monument has lost in emotional force and personal meaning what it has gained in national utility.

Further shifts in the use of 15 February have occurred. From the 1980s there was the growing feeling that a new 'air-conditioned' generation was less open to messages of vulnerability and sacrifice, and more questioning of the need

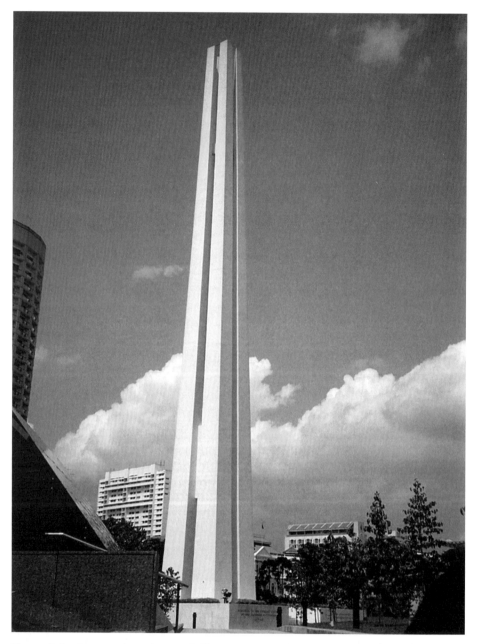

Figure 3.6 Swan and Maclaren, Civilian War Memorial, 1967, Beach Road, Singapore. Photographed by Karl Hack. Photo: © Karl Hack.

for National Service. In the 1990s the focus shifted from nation building through the image of common suffering towards the lesson that Singapore's vulnerability necessitated both National Service and the primacy of community over individual needs.

First, in 1992, the date was declared 'Heritage Day', with the aim of focusing attention on the whole war period. Then, in 1995, fiftieth-anniversary celebrations of the end of the war included exhibitions and the placing of National Heritage Board markers at war sites. In 1998 the date of 15 February was retitled National Defence Day, with a heavier emphasis on the lesson that Singapore is a vulnerable state, requiring not just National Service but 'total defence', and with everyone playing a role in a 'poison shrimp' strategy (deterring a more powerful aggressor by assuring painful consequences post conquest). The five arms of total defence were:

> Psychological Defence – Being loyal and committed to Singapore and having confidence.
> Social Defence – Enhancing social cohesion among race, language and class.
> Economic Defence – Being prepared so that the economy will be able to function in war.
> Civil Defence – Providing for the safety and basic needs of the public in times of war.
> Military Defence – Strong armed forces, national service and reservists.
>
> (Singapore Public Affairs Department, 1985)

Traditionally we think of 'commemoration' as focused on key monuments, and 'heritage' as physical remains. But in Singapore there has been a state-directed attempt to embed war memory into school curriculum, texts and 'values'. War 'heritage' has been reconstructed as multi-faceted 'performances', with 'heritage sites' used to host these. Hence, in the late 1990s schools started to look for ever more creative ways – plays, cutting off the water or fans on 15 February – to impress the 'lessons' of the war on schoolchildren.

At Fort Siloso an event called Siloso Live! combined this 'experience' approach with its historical location. Siloso is an 'artillery park', where cannon and coastal guns are arranged at the site of a Second World War battery, on the island of Sentosa, a stone's throw from Singapore city. Siloso Live! used professional actors to play British and Japanese soldiers, making war commemoration literally 'performance' and 'theatre of memory'.

In November 2001 I experienced this with students aged 9 to 11 years old. We were 'recruited' and led to a flag raising, and to see nineteenth-century gunners' quarters. Then the peace was rent by 'explosions' and we were herded into darkened, smoke-filled tunnels for an air-raid. We were given a 'code' word and told never to reveal it, before being captured by 'Japanese' soldiers who marched us off to be interrogated in front of gun turrets (Figure 3.7). Our 'ordeal' (though seeing their teacher threatened by 'enemy' soldiers is not every student's idea of unpleasantness) was ended by a siren

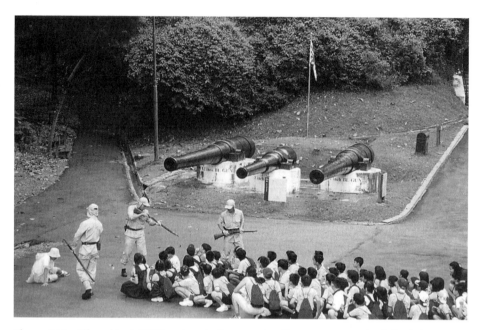

Figure 3.7 Siloso Live!, 2001; actors in Japanese uniforms recreate the fall of Singapore. Photographed by Karl Hack. Photo: © Karl Hack/Kevin Blackburn.

announcing the dropping of the atomic bombs, and our captors became captives. Afterwards we talked to a war veteran. The 'Japanese' had been instructed to tone down earlier, over-enthusiastically frightening performances (Hack and Blackburn, 2004, p. 269).

For these students, commemoration was a structured series of 'performances', including textbooks and lessons extolling total defence, 'experiencing' sites through choreographed events, worksheets that asked them to dwell on what they had learned and the need to be prepared, and the 15 February anniversary (Figure 3.8). It might also include Ministry of Education-listed 'learning journeys' to approved sites such as Kranji.

From 1997 the practice of thinking up practical activities, such as rationing, for Total Defence Day had become widespread. Commemoration was also produced and consumed through the mass media. Television programmes picked out the themes of vulnerability and common suffering. The Chinese-language Channel 8's 32-part Mandarin serial *The Price of Peace* and its follow-up *The Pursuit of Peace* focused on the organisation of anti-Japanese activities before and during the war, mainly from the perspective of non-Communist Chinese Nationalists such as Lim Bo Seng.

The English-language *A War Diary*, shown from 15 August 2001 on Singapore's Channel 5 (a Mediacorp drama serialisation), concentrated on the suffering of an imaginary 'Lim' family. Leitmotifs included ideas that 'the British cannot lose', followed by the shock of defeat, and realisation that

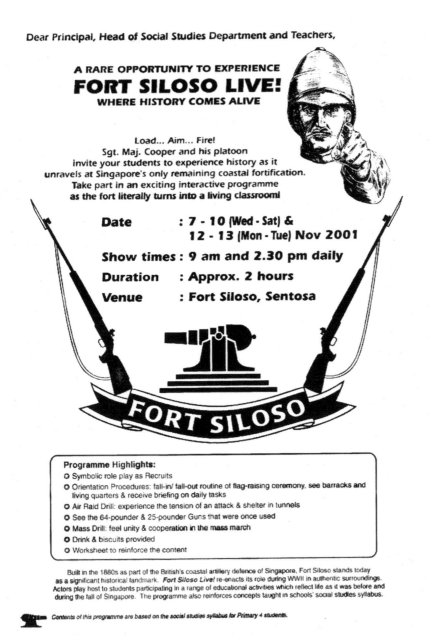

Figure 3.8 Fort Siloso flier for schools. Used with permission of Sentosa, Singapore.

'the price of peace' must be some people resisting aggressors at personal risk. The central dramatic thread was the suffering of the 'Lim' family, which temporarily lost a daughter as a 'comfort woman' (Japanese military prostitute) and a son to the *sook ching*, and seemed destined to become the epicentre for every hardship and stock image of occupation, from hunger to the individually

sympathetic Japanese officer amid more generalised brutality. Typically for Singapore-based commemoration, resistance was a topic that sat more uneasily with the plot. The son who joined the resistance received less central treatment, and the force he joined seemed to be generic rather than Communist.

Reflecting on the case study

We have seen how the Singapore government sought to direct commemoration in ways that suit its postcolonial 'nation-building' agendas, including uniting diverse communities into one nation and enlisting support for National Service. We have seen a shift from Cenotaph to Civilian War Memorial, and a shift in dates from 11 November and 12 September to 15 February. We have also seen how, ironically, the state's desire to support 'remembrance' has intensified as the wartime generation dies off. From a state perspective, if the war was a seminal moment in creating a nation, then preserving its 'memory' is vital. Hence the production of war heritage sites has continued into the twenty-first century, for instance with a museum to the Malay Regiment (called Reflections at Bukit Chandu), opened on 15 February 2002. While the affective impact of commemoration has been weakened by top–down patterning, the state's ability to embed its messages in state-controlled education and media has meant that it has minimised inter-communal friction, and won at least overt acceptance of its messages, especially among younger generations. Though there is a certain degree of awareness that the state is imposing meaning, this has not prevented general acceptance of its line, made easier by the state's adoption of a core identity based on the English language, and meritocracy. A weaker or less successful state, or a country not dominated by one party as European states are not, might have had less success at imposing such a top–down pattern. The lack of space for contestation – in the press and television – and weakness of political opposition are important factors in this Singapore case study.

But among this plenty there still remains a scarcity of public – or at least 'national' – commemoration for the *sook ching* in its specifically Chinese context, for Communists of the MPAJA, and of forms that might meet particular Chinese cultural and memory needs. Here, perhaps, is evidence in support of two of Winter's claims. The first is that the smaller the scale of a monument, the more likely it will faithfully express the cares and sentiments of those who wish to remember. The second is that fictive kin groups and memory activists play a vital part in underpinning meaningful 'remembrance' (acts intended to facilitate collective memory). In Singapore the needs of the state and nation building partially frustrated the desires of Chinese 'memory activists' for a site reflecting the *sook ching* and giving prominence to its urn-encased victims. The 'performances' that arose out of the Civilian War Memorial, both literally at the site and as interpretations in textbooks, schools,

and media and ministerial messages, did not serve the emotive needs of these groups as well as the cenotaphs served those of Europeans. What the state and individuals and groups needed never entirely meshed.

In Singapore, potential conflict was managed by robust state intervention, turning a proposed monument to the massacre of Chinese into a monument to 'common' civilian suffering, and to the latter's role in forming a new nation. State intervention across a range of associated performances and texts – education, media, ministerial pronouncements – successfully created a dominant, state-sponsored AHD, and commemorative performances for each 15 February which served nation-building purposes. But in so doing it undermined the emotive link felt by fictive kin groups, survivors and memory activists. It also detached commemoration from detailed memory, and physical remnants of the past, to the extent that a Civilian War Memorial that is a burial site was scarcely recognised as such by younger generations. Only more recently, since 2002, has the state started to hint that groups such as Dalforce and the wartime Communist resistance may merit increased recognition. Hence, though Lim Bo Seng remains the favoured wartime resistance hero, references to Communist fighters have increased slightly. In this way the tension between the state's integrationist and controlling approach and the needs of different groups continues to lurk below the surface. The state's approach is successful, but within limits.

Case study: Malaysia's contested war heritage

Malaya (Malaysia from 1963) faced similar issues to Singapore, but resolved them in different ways. This is illustrated by the press article below, taken from a privately owned English language newspaper in Malaysia.

Community memories

Friday April 11, 2008

In memory of war dead

By Farik Zolkepli
JOHOR BAHRU: About 100 people recently gathered at the Kebun Teh Memorial Park to pay respects to those killed during World War II.
The yearly event was organised by Johor Bahru Tiong Hua Association. Association member Chan Kwai Hock, 72, said she had been attending the function over the past 10 years. 'I encourage the younger generation to pay their respects as well.'

'The memorial service is to remind us of our country's history,' she said, adding that the event always reduced her to tears. Visitor Wong Kow Yong, 47, said she came often as she felt a need to pray for the

victims. 'The memorial is a chance for us to heal after the horrors of the war ... 'I feel the younger generation is taking an important event like this for granted and this should not be the way,' she said.

Johor Bahru Tiong Hua Association president Lua Ah Seng said the event had been held twice a year since 1946. 'The remains of about 2,000 local Chinese leaders and those who died during the war are in the memorial. It allows people to understand history and family members to pay their respects,' he said.

(Zolkepli, 2008)

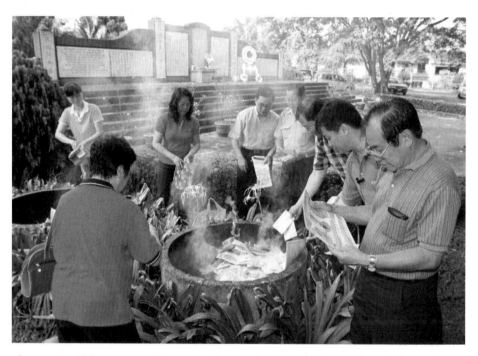

Figure 3.9 Chinese people burning offerings in memory of those killed during the Second World War at Kebun Teh Memorial Park in Johor Bahru, 2008. Unknown photographer. Photo: © *The Star*, Malaysia.

What are the similarities and differences between this site and the Civilian War Memorial in Singapore? The overriding similarity is that both sites are cemeteries for mainly civilian dead, notably those killed during the *sook ching*. Both originated from Winter's 'fictive kinship groups', in this case associations from the Chinese community which took on the role of 'memory activists'. Both provide a physical focus of commemoration for relatives, including those whose bodies could not be found. The monuments act as symbolic graves for individuals, as well as providing an affirmation of shared experiences and identities.

But the differences may appear more striking than the similarities. The Civilian War Memorial is vertical. This one is horizontal. The Singapore memorial does not list the dead. This one does, facilitating intimate, intense personal memory. The Singapore memorial was reconfigured from a mainly Chinese monument to one representing four communities: Chinese, Malay, Indian and Eurasian or 'other'. The Singapore monument did have Daoist ceremonies performed at its opening, but there were Christian and Muslim ceremonies as well. Subsequently, the ceremonies held there have been secular and 'modern', with little cultural specificity. At the Kebun Teh Monument, just across the causeway in Malaysia's city of Johor Bahru, Chinese people can be seen paying their respects in traditional ways, close to the date of *Qingming* (typically early April). Relatives visit at this date to sweep the graves of their ancestors, and offer paper money to their souls by burning it. The folk beliefs loosely tied to Daoism keep a sense of living connection to dead family members.

There is another difference. The Civilian War Memorial is a national monument which attempts to square the personal and the national. It is partly this attempt – in the context of diverse war experiences – that vitiates its full emotional potential. The Kebun Teh Monument, by contrast, is community-based and local, retaining greater affinity to the needs of the sub-national group.

But there is a problem with this formulation that smaller is better. Some individuals and groups felt the need for the dead to be part of something bigger than family or locality: part of a nation. If the dead died in the service of a bigger, national entity, it gives their death added value. It may even seem to confer a degree of immortality, in as much as the nation is seen as an unending union of past, present and future generations. So the question remained, could Chinese fictive kin groups and memory activists achieve national recognition of their experience of war?

In this case, ex-MPAJA, some family and some from younger generations felt and still feel that the wartime resistance was not just pro-Chinese and anti-Japanese but also 'Malayan'. That is, it was a 'nationalist' defence against aggressors. Some argue that the Communists, by organising both anti-Japanese guerrilla activity during 1941–5 and postwar anti-British actions, played a defining part in creating the modern nations of Malaysia and Singapore. In particular, they argue that by 1948 Britain was reluctant to allow faster progress to self-government. That year the MCP reconstituted wartime forces and fought back against a British-declared 'Malayan Emergency'. Thus they request commemoration of Communist-led guerrillas of 1941–5, and many also believe that the 1948–60 fighters deserve the same.

But there remains a problem for 'nationalising' the commemoration of wartime guerrillas and their Communist leadership. Wartime heroes became,

in government parlance, the Emergency 'bandits' or 'Communist Terrorists'. Some Malays, who were predominant in the police and army, died fighting against Communist forces. Worse, sporadic fighting continued after independence. The successor governments who helped vanquish Communists did not acknowledge Communists as 'national' heroes. In Malaysia, the Malay party (UMNO, United Malays National Organisation) predominated, with the elites of other communities playing subordinate parts in the ruling Alliance (since 1969 called the *Barisan Nasional*). In short, the ruling post-independence elite cast the Communists as enemies who had had to be defeated for true freedom to be attained.

But Malaysia's rulers left more space than Singapore's for Chinese-specific commemoration. The reason lies in the ruling Alliance's self-image as a collection of discrete community leaders, each set representing a culturally distinct group. The Alliance comprised UMNO, the Malayan (later Malaysian) Chinese Association, and other communal parties.

The result is that 'Malayan/Malaysian' culture is seen as floating over, but not suppressing, the cultural identities of individual communities. Despite the promotion of Malay as a national language, it is accepted that other languages, and schooling in other languages, persist. Communal-based politics means leaving spaces for each community to educate, live and commemorate in its own way, notwithstanding official national monuments. This allows for a layering of public commemoration, with both a top, 'national' layer, and also distinct public commemoration by different groups. Thus Malaysia's capital, Kuala Lumpur, has experienced a slightly different remembrance story from Singapore.

From colonial to postcolonial commemoration

As with Singapore, Malaya at first had its Cenotaph. This was located close to the central railway station and was dedicated 'To Our Glorious Dead' of the 1914–18 war, and later for 1939–45 and the Malayan Emergency too. It was similar in conception to other cenotaphs in the British empire.

When the Malayan Emergency was about to be officially declared over, in 1960, it was decided that a new monument was needed. The site chosen was the capital Kuala Lumpur's Lake Gardens, close to the new Parliament building. The monument was to be built there adjacent to a new National Mosque, the latter a reflection of the fact that Malays were both the single largest component in the population, and Muslim. Visitors looking upwards from the city would have witnessed expressions of national democracy, commemoration and religion (parliament, monument and mosque). The Cenotaph was also to be repositioned from its central city location to a position close to the new memorial, to make way for an expressway.

The Public Works Department (PWD) was charged with coming up with a suitable monument, and proposed several ideas. Muslim sensibilities dictated against using the human form, and so one idea was for a domed monument surrounded by screens to create a space for Emergency memorabilia to be displayed. The structure was intended to recall Islamic architecture. The selected design, by contrast, had two giant, intertwined vines, formed from reinforced concrete, to represent struggle in the jungle. One concrete vine would be finished in white Langkawi marble and would rise above the other, darker vine, symbolising the victory of democracy over evil. At the base of the vines would be an eleven-pointed star of gold mosaic tiles, representing Malaya's eleven states, with the whole structure encircled by a pool.

In fact, the new National Mosque was built at a more accessible, central location. The monument, meanwhile, was constructed at the original site and bore little resemblance to the design originally selected. The catalyst for change was a visit by Malaya's Prime Minister Tunku Abdul Rahman to the USA in August 1960. He was driven past the United States Marine Memorial at Arlington, designed by Austrian-American architect Felix de Weldon. This features six American troops, five marines and one naval corpsman, raising a flagpole topped by the American flag on Okinawa's Mount Suribachi. It represents the conquest of that Japanese island in March 1945. This memorial is a re-making of a famous photograph by Philip Rosenthal, which in turn was taken of a restaging of the event. As such it is in sharp distinction to most cenotaphs, not classical or traditional in form, but realist.

The result of this encounter between postcolonial prime minister and realist war monument was that by October 1960 plans for the memorial had been altered. When the new monument was unveiled in 1966 it was in a style that might be called 'postcolonial quasi-realism'. This was the bronze *Tugu Negara* (National Monument) (Figure 3.10), its 15 metres outstripping the 10 metre Cenotaph that had been relocated at the Lake Gardens site.

But the monument uses 'realist' forms in unreal ways. Here the forms represent seven men, but not seven nameable men. One holds a flag, two stand guard with guns, and one cradles an injured comrade. Slightly beneath them are two bodies representing 'the defeated forces of evil' (Lai, 2007, p. 128). It is dedicated to the 11,000 civilians and security forces who died in the Emergency. The monument is surrounded by a pool, in a park a short distance from the city centre. The Cenotaph is positioned nearby on lower ground. Facing southwards so as to almost open out to the monument is a crescent-shaped white pavilion, with gold domes to left, right and centre. The pavilion's ceilings are decorated with the emblems of Malayan and Commonwealth units which served in the conflict. The central dome was also intended to contain records of those who had died fighting on the government side.

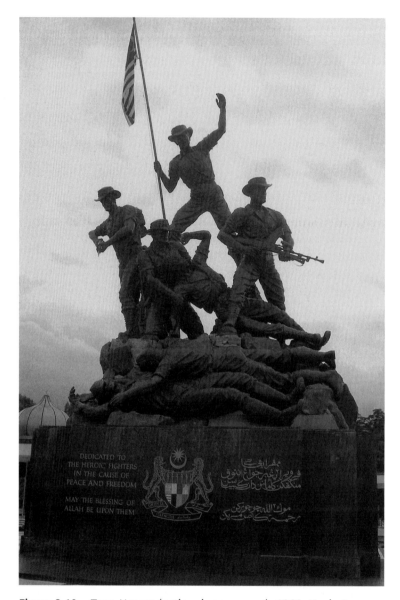

Figure 3.10 *Tugu Negara* (national monument), 1966, Kuala Lumpur, Malaysia. Photographed by Karl Hack. Photo: © Karl Hack. This monument replaced the cenotaph as the focus of annual commemorative ceremonies.

The act of *copying* the form of a realist memorial that was based on a photograph makes the Malaysian monument different in its relationship to the past from the original. The seven figures are located in an imagined scenario. The state later suggested that they represent the virtues of leadership,

suffering, unity, vigilance, strength, courage and sacrifice. The central, flag-bearing figure's facial expression was modelled on Tunku Abdul Rahman as a young man, suggesting *his* leadership.

Why were such meanings attributed to a 'realist' monument? The historical context is instructive. Malay speakers were acutely aware that the British had negotiated an end to empire fairly willingly, in contrast to the anti-colonial fight of their neighbours, the Indonesians, against the Dutch from 1945 to 1949. Indonesia, whose national language was close to Malay, already had a culture of heroes' graveyards, with private ceremonies to mark special occasions. In 1957 the Indonesian government made 10 November (the date of an anti-colonial battle in 1945) a public holiday, as *Hari Pahlwalan* (Heroes' or Warriors' Day). Though initially ceremonies were localised and led by family and ex-comrades, over time more formalised rituals arose, including prayer, ceremonies at graveyards and an official pantheon of national heroes.

Malay Malaysians needed 'heroes', and found them in the police, soldiers and others who had helped defeat Communism – a Communism many Malays also associated with the threat of losing their 'birthright' as indigenous 'bumiputra' (sons of the soil) to Chinese. The Chinese, often second- and third-generation immigrants, wielded more economic power.

Thus, while the *Tugu Negara* suggests victory over terrible conditions, it was also conceived in the context of ethnic divisions. The sculptor was given photographs of Malayan security personnel in uniform, but it was completed overseas. Even at the time some Malaysian politicians complained that the physiognomy seemed rather un-Asian. More than that, the scene presented, though 'realist' in portraying the human body and uniforms, is improbable. The notion of raising the Malaysian flag in a campaign that happened on home territory, and mainly in or near jungle, is also odd, and belies the fact that for most of the Emergency Malaya was a colony. Whose flag would British soldiers, or their Malay Regiment allies, have raised before independence in 1957?

The monument is also problematic as a unifying symbol. Unlike the Marine memorial, the *Tugu Negara* was offensive to a significant fraction of the population. Many Chinese continued to regard the Emergency not as an obstacle but as an aid to independence. Malaysian Chinese, including some in opposition parties, argued that the Emergency caused the British to speed up the march to self-government (Chin and Hack, 2004, pp. 18–22). Hence the message on the monument is seen by some as insulting. The granite base bears inscriptions in English and in Malay (the latter in Jawi script, which many Malays cannot read). The inscriptions in both languages read: 'Dedicated to the heroic fighters in the cause of peace and freedom. May the blessing of Allah be upon them'. The accompanying plaque, this time in romanised

Malay and English, extols those 'who died defending the sovereignty of the country ... [it] also represents the triumph of the forces of democracy over the forces of evil'.

Unlike the Whitehall Cenotaph, a strictly secular approach is belied by the invocation to Allah. The whole structure is premised on the idea that Communism and all those (mainly Chinese) who fought the British in 1948–60 and beyond were anti-national, indeed on the side of 'evil'. These fighters, it should be remembered, included a good number who had also fought the Japanese in 1941–5.

Malaysian Chinese memory activists

There was no national monument that could be said to honour the mainly Chinese wartime MPAJA guerrilla fighters. Where the Singaporean government could imagine the Pacific War as unifying for civilians at least, the Malayan government could not. Huge numbers of rural Chinese had supported the guerrillas. By contrast the Malay wartime resistance had been miniscule, and the police mainly Malay. After the war MPAJA attempts to take over towns from the Japanese, prior to British return, had degenerated into Sino-Malay clashes. In addition, there was a need by those who had lost family members serving in the security forces in 1948–60 to remember their sacrifice as having national meaning, and by many Malays to commemorate what seemed to be a coming of age for 'Malays' during the Emergency. The vast expansion in the number of Malays in the police and army had boosted confidence.

So the commemorative needs of different communities diverged. Meanwhile, the *Tugu Negara* achieved prominence in national commemoration. *Hari Pahlawan* (Warriors' Day) was marked at the National Monument site, including a public holiday on 31 July (the anniversary of the ending of the Emergency), and until recently the laying of wreaths (later garlands, after Muslim leaders' advice against wreaths). In sharp contrast to Singapore's memorial, the Malaysian site offered plenty of space for public ceremonies. The arrangement of the figures on the central monument was also 'imitated in military and national parades, pageants and other enactments', and in advertisements, logos for fund raising, and on some stamps and 1 ringgit notes (Lai, 2007, p. 128).

At the same time, many Malaysian Chinese associated with the MPAJA and postwar anti-British fighters continued to hold private, and sometimes community-based, forms of commemoration. These might be at a stone memorial in a Chinese cemetery (often a simple stone marker inscribed with Chinese characters), or in stories told at their relatives' side (Wong, 2005). There was not just plural society, but also plural remembrance.

But 'plural commemoration' was a compromise, not a solution. Some Chinese continued to want recognition of their dead at national level, or at least at better collective monuments. There were three obstacles to this. First, many Chinese were faced with mourning the absent dead, or those whose bodies lay in inaccessible sites. Second, they needed to commemorate those who had died fighting on the Communist side in the Emergency and so (in their view) for national freedom. Finally, commemoration at its most potent is about more than the local; it suggests that death and suffering serve a wider purpose, and that the dead live on in the nation. Ideally what was needed was a way of mourning not just the wartime MPAJA – with Communist associations – but also those who died fighting against the British in the Emergency, and a way of commemorating them at national level.

These things remained out of reach. Though the initial Malayan Emergency officially ended in 1960, low-level insurgency continued until 1989. In 1975 Communists even tried to blow up the National Monument, though with negligible results. But then agreement in December 1989 ended the conflict and allowed many Communist fighters to return to Malaysia. This and the wider end of the Cold War emboldened 'memory activists' (old comrades, their family, Chinese reared on stories of the heroism of 'mountain rats' and in opposition parties) to argue that their and their relatives' war memories and sacrifices, in the conflicts against the British and the Japanese, should now be marked in a public and national way.

At one level this was expressed by an outpouring of memoirs, including those of Communist Secretary General Chin Peng, who at the time of writing has held this post since he was appointed in 1947 (Chin Peng and Ward, 2003; Chin and Hack, 2004). At another level it was reflected in the restoration of old stone monuments to individual MPAJA fighters, and the setting up of new collective monuments. This culminated in the setting up of two public monuments in the Chinese-run Nilai Memorial Park, close to the capital (Nilai Memorial Park, n.d.).

The park is laid out according to Feng Shui or geomancy, with a hill to the back and water to the front. The first of the new monuments was the '9–1 Monument'. On 1 September 1942 high-ranking Communists of the MPAJA were ambushed by the Japanese north of the capital. Originally the 'martyrs' had been commemorated by a modest stone column with a Chinese inscription. The original was now dug up – no remains were found – and some soil from the site was reinterred at Nilai, with the monument shown in Figure 3.11.

This memorial is similar in form to the original, but larger and fatter, with steps added, and set against an artificial hill. I attended the opening ceremony in September 2003. Imitation firecrackers were set off, incense and fruit were offered by ex-fighters, and struggle poetry was read by an ex-comrade. Veterans of more recent fighting, from as late as the 1970s, attended. It was

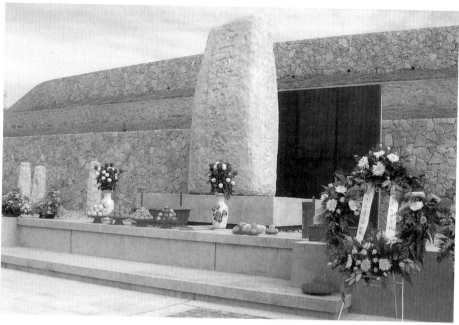

Figure 3.11 1 September Martyrs Memorial, Nilai Memorial Park, near Kuala Lumpur, at its opening in September 2003. Photographed by Karl Hack. Photo: © Karl Hack.

just the sort of public 'performance' that works well for Remembrance Day, except that, in the context of a plural society, it was not as accessible. I could communicate freely only because a Chinese-speaking colleague accompanied me, and the only Malays obviously present (there had been about 10 per cent non-Chinese in Communist-led forces) were watching security personnel. The event was followed by performances and a meal at a nearby Chinese temple.

This very public inauguration of a memorial to Communist fighters could happen because it was taking place in a parallel, Chinese-speaking world which received limited English and Malay language press coverage. But the restriction to a narrow Chinese-speaking world was not enough for the organisers. They wanted their 'war heritage' integrated into public media, school texts, history books and more, with explicit acceptance that their sacrifices had had a national, not just a private and communal, meaning.

This integration was not going to happen in the near future. Frustrated Chinese Malaysian 'memory activists' therefore decided to raise an additional monument that would be dedicated to all who died fighting the Japanese, Communist and non-Communist alike. The result was achieved in September 2007 (see Nilai Memorial Park, n.d.) with the opening of the Monument in Memory of Malayan Heroes in the Resistance Movement against Japanese Invasion 1941–5. Its central form is an obelisk and it is dedicated to those of *all* races who died fighting oppressors – mainly the Japanese but – such is the implication – the British, too. It uses all main

Malaysian languages, and the obelisk footprint takes the form of a peace mandala. Despite these elements, the monument has attracted some bitter press criticism from Malay leaders on the grounds that it is intended to commemorate Communists. In addition, its setting, amid the culturally and linguistically Chinese burial grounds at Nilai, limits accessibility.

Reflecting on the case study

We saw in the earlier case study how the Singapore state constructed a public monument which, though it limited the emotional impact of a burial site for massacre victims, managed not to alienate any major community. Singapore took an integrationist approach, settling on a focus for commemoration that was usable for purposes of nation building while being broadly acceptable, but at the same time leaving little public space for dissonant or subaltern heritage.

The Malaysian approach of building a new monument in memory of the Malayan Emergency failed to establish a discourse that was broadly acceptable across communities. Its *Tugu Negara* did relatively little to support the idea of an all-encompassing nation and to overcome divisions. Rather, it endorsed the viewpoint of Malays at the cost of alienating some Chinese. It branded Chinese Communist, anti-colonial fighting of the 1948–60 period as the evil opposite that had to be defeated to achieve true independence. It all but ignored the anti-Japanese record of predominantly Chinese fighters, many of whom fought in both conflicts. In this respect it is interesting to note that the sentiments and messages (Communism is bad and was overcome by national 'heroes') associated with the monument were more important than the particular form the monument took. The monument chosen before Tunku Abdul Rahman went to the USA had also presented the Emergency as the triumph of good over evil, even though its form – two concrete tendrils with the good, white, marble-clad tentacle soaring higher – was radically different.

Yet at the same time the Malaysian political model of elite accommodation – that is, having a ruling coalition dominated by a Malay party, allied to other communal parties – did leave considerable room for communally specific, subordinate, and separate, forms of commemoration. At the beginning of this chapter it was argued that Malaysia is – in Ashworth, Graham and Tunbridge's (2007, pp. 72–87) classificatory scheme for multicultural societies – a core+ society. That is, it allows space for alternative heritage in addition to a pre-eminent national core. Malaysian war commemoration, it turns out, fits this model well. Furthermore, we have seen that the '+' element in the core+ model has been given more autonomy and space in Malaysia than in Singapore. The assumption of a plural society operating under a vague, higher level national entity has allowed scope for different forms of public commemoration and 'dissonant heritage', in different languages.

Commemoration in multi-ethnic communities

Both case studies have located war memorials in the context of inter-related performances and texts. Both have shown that fictive kin groups, memory activists and whole communities with very different perspectives on past events greatly complicate the construction of any 'collective memory'. To be successful, commemoration needs to engage with, and draw ideas and support from, such groups. But at the same time, to create a national monument successfully, differences in perspective between such groups call for careful engagement, if not dampening. There is a significant contrast between these societies – where cultural differences have in the past led to violence – and those western societies which attempt to manage plurality by requiring (or tempting by funding reward) heritage sites to serve multiple communities. This difference is due not only to the greater chance that heritage can fuel discord, but also to the greater perceived need in many postcolonial societies to harness heritage to a nation-building agenda, and to buttress a relatively recently manufactured 'imagined community'.

The contrast between the case studies, and between how two states dealt with conflicting views of conflicts, is instructive. In Singapore, attempts to set up monuments or ceremonies that served the particularistic memories of specific groups tended to be resisted by the state, or captured by it. Hence, the Chinese Chamber of Commerce's aim of marking the *sook ching* massacre of Chinese was transformed into the Civilian War Memorial, which the state claimed represented the common suffering of all groups, through which a desire for nationalism and independence was supposedly born. Singapore insisted on an integrationist approach to public memories, one that lessened divisions even as it weakened the emotive force of sites and ceremonies. For them the core state heritage and its AHD required the strict limitation of alternatives.

In Malaysia, the state in effect demoted a monument that could serve all communities: its Cenotaph. Since Communist guerrillas had fought the Japanese alongside the British and a few Malays, that monument did not necessarily alienate any one group. Instead, the Malayan (later Malaysian) state sponsored the *Tugu Negara*, which served the needs of Malays while alienating those Chinese sympathetic to the Communist insurgency, or whose relatives had been guerrillas or their supporters. At the same time, they ultimately tolerated individual groups raising their own public memorials. Their notion of a core+ society leaves more room for semi-autonomous, even dissonant, strands of heritage. Specific memory activist groups have thus been able to establish separate monuments and commemorative ceremonies, as at Nilai and Kebun Teh. These are arguably more authentic to each particular group's memories and perspectives, and more successful emotionally and as a focus of 'collective memory', but as a result this 'plural commemoration' is more divisive, or at least of less utility in nation building.

The implication seems to be that there is a trade-off in the management of heritage in such plural societies and in postcolonial states which insist on heritage being an active part of nation building. A Singapore-style integrationist approach and limitation of **dissonance** – by manufacturing commemorative forms which suppress historical detail and difference in order to present a picture of unity – have costs to groups and individuals. To an extent, the Singapore model has been highly successful, especially with younger generations subjected to multiple 'performances' as part of their school education. But at the same time it can drain emotional and affective meaning from heritage, and even engender some cynicism. By contrast, there is the Malaysian-style approach of focusing 'national' monuments more on serving the needs of the state and a predominant group (meaning Malays), while allowing some space for 'dissonant' heritage accessible mainly to individual linguistic or cultural communities. This may provide heritage which is more emotionally satisfying to certain groups, and which better reflects their particular experiences of, and uses for, the past. But at the same time it may further entrench differences, and could even allow heritage to become the cause of further division and conflict. This theme of contentious heritage will be further explored in the chapters that follow.

Conclusion

Beyond the details and dilemmas of the case studies, this chapter has demonstrated just how difficult it is to negotiate the construction of public monuments and ceremonies when different groups – cultural, ethnic, ideological and religious – have experienced the same period or events in different ways. It has shown trade-offs between achieving emotionally satisfactory focuses for each particular group, and the state's desires to dampen ethnic separatism and conflict so as to build up a sense of common citizenship.

This chapter has also followed through Smith's idea (Smith, 2006, p. 69) that heritage is often embedded in performance, seldom more powerfully than when commemoration is involved. The different sorts of 'performance' or text discussed have included formal ceremonies to mark anniversaries, participative events such as Siloso Live!, television programmes, and even school lessons. The monuments, though important in their own right, have therefore also been seen as props or backdrops, with the actors and scripts calling for equal attention. Indeed, part of the reason for Singapore's success in offering an integrationist vision of war heritage is down to the sheer depth and range of performances the state – dominated by one party – has been able to implement.

This chapter has also demonstrated how analysis of the roots of particular heritage decisions, and of the possibilities and limitations when these were taken, often needs to be historical in approach. We need to know about the history commemorated to understand why it is contentious, about the nature of the society doing the commemoration, and about the process by which decisions were taken. This may even include trying to find out about how alternatives were rejected or modified.

This chapter has thus used the case studies of Malaysian and Singaporean postcolonial commemoration to explore a number of approaches to analysing heritage – cultural, historical and as clusters of 'performances' or texts. It is best read alongside later chapters such as Chapter 5, which give examples of heritage issues and management in ex-settler colonies and other, contrasting, multicultural situations. Yet, strangely, for all its championing of analysis, this chapter has also demonstrated that serendipity plays a part. Had Tunku Abdul Rahman not passed the United States Marine Memorial at Arlington in 1960, the Malaysian monument would have consisted of intertwined vines.

Works cited

Ashworth, G.J., Graham, B. and Tunbridge, J.E. (2007) *Pluralising Pasts: Heritage, Identity and Place in Multicultural Societies*, London, Pluto Press.

Assessors Report (1963) 'Competition for a memorial to civilian victims of the Japanese occupation', *Journal of the Singapore Institute of Architects*, no. 6 (December), pp. 7–22.

Chin, C.C. and Hack, K. (2004) *Dialogues with Chin Peng: New Light on the Malayan Communist Party*, Singapore, Singapore University Press.

Chin Peng, Ward, I. and Miraflor, N. (2003) *Alias Chin Peng: My Side of History*, Singapore, Media Masters.

Colony of Singapore Report (1948) Singapore Government Printers.

Hack, K. and Blackburn, K. (2004) *Did Singapore Have to Fall?*, London and New York, Routledge (also published in paperback by Routledge Asia, 2005).

Lai, C.K. (2007) *Building Merdeka: Independence Architecture in Kuala Lumpur, 1957–1966*, Kuala Lumpur, Galeri Petronas.

Nilai Memorial Park (n.d.) Nilai Memorial Park: Of Earthly Beauty and Eternal Peace, www.nilaimemorialpark.com (accessed 16 September 2008).

Singapore Public Affairs Department (1985) *Questions and Answers on Defence Policies and Organisation*, Singapore.

Smith, L. (2006) *Uses of Heritage*, Abingdon and New York, Routledge.

Winter, J.M. (1995) *Sites of Memory, Sites of Mourning: The Great War in European Cultural History*, Cambridge, Cambridge University Press.

Winter, J. (1999) 'Remembrance and redemption: a social interpretation of war memorials', *Harvard Design Magazine*, no. 9 (fall), pp. 71–7; also available online at www.gsd.harvard.edu/research/publications/hdm/back/ 9winter.html (accessed 26 May 2009).

Wong, James W.O. (2005) *From Pacific War to Merdeka: Reminiscences of Abdullah CD, Rashid Maidin, Suriani Abdullah and Abu Samah*, Kuala Lumpur, SIRD.

Zolkepli, F. (2008) 'In memory of war dead', *The Star Online* (11 April) [online], http://thestar.com.my/ (accessed 15 April 2008).

Further reading

Ashworth, G.J., Graham, B. and Tunbridge, J.E. (2007) *Pluralising Pasts: Heritage, Identity and Place in Multicultural Societies*, London, Pluto Press.

Blackburn, K. (2009) 'Nation building, identity and war commemoration spaces in Malaysia and Singapore' in Shaw, B., Ooi, G.L. and Ismail, R. (eds) *Southeast Asian Cultural Heritage in a Globalising World: Diverging Identities in a Dynamic Region*, London, Ashgate, pp. 93–114.

Lim, P. and Wong, D. (2000) *War and Memory in Malaysia and Singapore*, Singapore, ISEAS.

Lunn, K. (2007) 'War memorialisation and public heritage in Southeast Asia: some case studies and comparative reflections', *International Journal of Heritage Studies*, vol. 13, no. 1, pp. 81–95.

Tunbridge, J.E. and Ashworth, G.J. (1996) *Dissonant Heritage: The Management of the Past as a Resource in Conflict*, Chichester, Wiley.

Winter, J. (1999) 'Remembrance and redemption: a social interpretation of war memorials', *Harvard Design Magazine*, no. 9 (fall), pp. 71–7; also available online at www.gsd.harvard.edu/research/publications/hdm/back/ 9winter.html (accessed 26 May 2009).

Chapter 4　Heritage and changes of regime

Tim Benton

Concluding the theme of public and private memory in the first half of the book, this chapter explores the problem of dealing with periods of history that most people would rather forget. Regime change is a particular case, when the dominant ideology and culture stand clearly in opposition to what went on before, but when there is also an inevitable continuity in lives, and therefore memories, between the 'bad' times and the new. What part do memory and forgetting play in these situations, in official and unofficial circles? One case study investigates the agonising issue of remembering the twelve years of National Socialism in Germany, while a second case study considers the twenty-one years of Fascist rule in Italy. A third, short case study considers the most acute question of the memory of the Holocaust in Poland.

Introduction

Revolution, war, liberation and other dramatic political changes raise the difficult problem of how to adapt both tangible and intangible heritage to new conditions. Just as all memory adapts to new circumstances, so too does heritage. In this chapter we look in particular at how to manage 'bad' memories – the personal and collective memories of ideas and events left over from a discredited political regime that the state would rather have forgotten or changed. We will discover that there is no single answer, since different individuals and cultural groups respond differently to private and public memories. We will find that government agencies have particular difficulty dealing with 'bad' associations linked to public buildings and sculpture, partly because they do not like to appear destructive of landmarks in the public domain about which people have very mixed feelings, and partly for more pragmatic reasons.

The most radical solution is destruction (Bevan, 2006). A common feature of ethnic cleansing and conquest is the destruction not just of political or religious targets but also of cultural ones. Rodney Harrison (2010) discusses the political and cultural implications of iconoclasm, the destruction of works of art for political or religious reasons. Of course, how you react to iconoclasm depends in part on your political or religious convictions. Puritans destroying or defacing Roman Catholic sculptures or stained-glass windows in the seventeenth century did so with a clear conscience, because they believed that these things were blasphemous and likely to lead people to sinful thoughts. Similarly, destroying a bust of Hitler might seem justified to avoid a recurrence of National Socialism. But it can also be argued that any repression

of the past can have the opposite effect, encouraging a clandestine sympathy for the suppressed. In discussing these issues, historians have often compared the psychology of trauma – what happens when an individual tries to cope with unbearable memories – with the equivalent situation in the public sphere (Hodgkin and Radstone (eds), 2003, pp. 6–7).

It is sometimes said that the destruction of heritage amounts to destruction of memory and sense of identity. To argue this means accepting that a sense of identity depends on physical artefacts to give it an anchor. This is actually a very contentious issue, which we looked at in Chapter 1 and will also be testing in this chapter. The bombing of German cultural capitals such as Nuremberg or Dresden and the so-called Baedeker raids on historic English cities during the Second World War are sometimes interpreted as a means of undermining the morale of the people and rendering them less willing to resist. Of course, it is often the case that these actions have an opposite effect, although this 'Blitz effect' has been exaggerated. Even in the most extreme cases of destruction there remains a collective identity among survivors. Despite the destruction of almost every physical trace of the lives, worship and everyday practices of Jews in Warsaw, the sense of Polish Jewish identity was not destroyed among the few survivors. There are a number of reasons for this. Intangible heritage, passing on stories and traditions by word of mouth, is if anything accentuated by the loss of physical heritage. Second, disasters of this sort prompt political reactions. A number of histories of the Warsaw uprising, with a wide range of political and emotional convictions behind them, were quickly constructed, in Poland and across the world. But if memories and commemorative practices are manufactured to meet the needs of a grieving people, there are other cases where societies attempt to forget trauma.

Rudy Koshar documents the German and central European towns where the eradication of the Jewish population by the Nazis was not marked by any plaques or memorials and a process of collective amnesia seems to have taken place (Koshar, 2000, p. 139). Just as amnesia may follow trauma in the individual, so may societies try collectively to forget unpleasant aspects of history. Some of the practices of collective amnesia, such as political amnesties or the discontinuing of commemorative practices, may backfire. Furthermore, memories of trauma, whether in the individual or the community, point up in an extreme way what is always the case – that memories are shaped as much by the needs of survivors as by what has actually taken place:

> This is the inherent contradiction of traumatic memory – what I term the 'traumatic paradox'; traumatic events can and do result in the very amnesias and mistakes in memory that are generally considered, outside the theory of traumatic memory, to undermine their claim to veracity.
>
> (Walker, 2003, p. 107)

But there is also a process of natural forgetting, in which the original associations of objects and practices simply fade away, sometimes being replaced by a generalised sense of what the Austrian art historian Alois Riegl called '**age value**', in an essay entitled 'On the modern cult of monuments', written in 1903 (Forty, 1999, p. 4). Each time we seek to protect a public statue, even though we have no idea whom the statue represents or why it was commissioned, we are celebrating either its age value or its artistic value, and probably both, and this appeal to the 'intrinsic' quality of the object is a staple of the authorised heritage discourse (AHD). As Riegl made clear, the meanings attached to artefacts oscillate between memory values (age value, historical value, **commemorative value**) and present-day values (use value, artistic value, newness value and relative artistic value) (Dolff-Bonekämper, [n.d.] 2008, p. 137). Dolff-Bonekämper suggests that another value should be added to this list – conflict value – which is the value to be derived from debates prompted by the survival of artefacts.

The routine toppling or defacing of statues and monuments following regime change is another example of partial destruction. The wrenching of the effigy of Sadam Hussein from its pedestal after the second Iraq war, with the attendant dishonouring of the statue by some members of the crowd, was stage managed by American troops and well covered on television. Acts like this are seen as proof and reward of military victory. Statues of Marx, Lenin and Stalin were removed from their plinths all over Russia and the ex-Warsaw Pact countries after 1989. The fate of these statues is not straightforward. Often, statues are left to lie in the weeds, as if the most powerful message of regime change is the presence of toppled statues rather than their removal, and this is the case especially if, as has often occurred, the empty plinths are left as a reminder of their absence.

Removing Stalinist war memorials may provoke violent reactions, as was seen in street demonstrations in Tallinn in 2007. Statues and memorials do not belong to those who commission them; they become part of the way many people work through their grief over loss of friends and loved ones. Anyone visiting Russia and ex-Warsaw Pact countries since the collapse of state Communism in the 1990s will also be aware of the phenomenon of the 'sculpture park' where statues of Marx, Lenin, Stalin and heroic groups of partisans, soldiers or workers are displayed. These parks have complex and contradictory motives. They present objects in the form of 'trophies', comparable to collections of military booty, in which the authoritative icons of the past can be safely mocked. And this can sit alongside a quite opposite function, of allowing those who still revere the heroes and events of the past to do so. There is also an educational motive, to allow teachers and parents to tell informative stories about the past to a new generation. But we can also discern an aesthetic motive, a reluctance to destroy works of skill and craftsmanship of which many people had become quite fond. An extreme example of the

attempt to instruct through ridicule is the Soviet Sculpture Garden at Grutas Park, Lithuania (also called Stalin World), where a wealthy patron, Viliumas Malinauskas, has created a theme park (opened 1 April 2001) based on a Soviet prison camp, peopled with salvaged statues of Marx, Lenin, Stalin and other Communist dignitaries:

> During a recent gala opening, thousands of invited guests were greeted at the gate by an actor dressed as Stalin; a Lenin look-a-like, complete with a goatee and cap, sat fishing by a nearby pond. Guests were invited to drink shots of vodka and eat cold borscht soup from tin bowls, while loud speakers blared old communist hymns. Nearby, red Soviet propaganda posters read: 'There's No Happier Youth in the World Than Soviet Youth!'
>
> (Baltics Worldwide, n.d.)

One of the arguments for this bizarre production was given by a sculptor who survived under Soviet occupation by creating these statues. Dr Konstantinas Bogdanas was quoted as saying, 'You can't reject those past 50 years because intelligent people made art and it's still art, whatever its flaws are' (Ellick, n.d.), and another Lithuanian sculptor, Bronius Vysniauskas, added, 'It's not the ideology that matters, it's the art' (Ellick, n.d.). The park's founder defended it on historic grounds: 'This is a place reflecting the painful past of our nation, which brought a lot of pain, torture, and loss. One cannot forget or cross out history, whatever it is' (Ellick, n.d.). Whatever the motives, this enterprise was greeted with outrage by representatives of the 60,000 Lithuanian survivors of Soviet deportation. It has nevertheless had considerable economic success, attracting 300,000 visitors in five years of operation.

This is only a rather extreme version of the phenomenon that we have looked at throughout this book, of heritage objects being conserved for a variety of political, cultural and aesthetic reasons, leaving the general public to make what it can of the results. We see here reactions that will recur in this chapter: historical curiosity, aesthetic considerations, a sense of facing up to the past counterbalanced by the fear of encouraging sympathy for discredited ideologies and the outrages they produced, and an ethical distaste for perpetuating images of horror. The problem is that the past cannot simply be erased.

Adaptive re-use of 'bad' memories

Adaptive re-use (changing something to make it useful while conserving as much as possible of its valued properties) poses a different order of problem. The simplest method is the re-labelling or fixing of new symbols to the exterior of buildings or things. Simply flying the red flag or attaching the red star or a political slogan to a royal palace after the Russian revolution was enough in many cases to change its meaning.

The Reichsluftfahrtministerium building (German National Socialist Air Ministry), the biggest office building in Europe when it was built in 1935–6, was given a succession of ministerial functions under the DDR (East Germany) and then transformed into the German Finance Ministry after the re-unification of Germany. Transformation required little more than the removal or replacement of lettering, flags, insignia and some interior redecoration, notably in the main hall, where the frescoes were changed after the war to reflect Stalinist principles. It was said that some of the external wall panels bearing relief carvings of swastikas on the Reichsluftfahrtministerium were simply taken off and turned round, with the swastikas facing inwards, as a measure of economy. Rumours to this effect sparked controversy, since it was thought that the presence, albeit invisible, of Nazi insignia was unacceptable. What is remarkable is that the Reichsluftfahrtministerium, designed by Ernst Sagebiel, is often described as an archetypical Fascist building, designed to overpower the individual by its scale, its lack of humanising detail and its endless repetition of windows and, inside, corridors. But the building itself is too big and useful to be demolished, and so it has been used by National Socialist, Communist and Democratic regimes apparently without difficulty. This may seem an extreme example, but the fact is that many other National Socialist buildings were similarly transformed, in both East and West Germany, mostly without discussion.

Sometimes these changes can be quite subtle. For example, there is a bronze statue of a boxer giving the 'Roman (Fascist) salute' on a pedestal in the new town of EUR (Esposizione Universale di Roma), near Rome. This was a prestigious urban project, begun in 1938, to host a universal exhibition in 1942 which would stage an 'Olympiad of civilisations'. New buildings and statues were designed to demonstrate both modern efficiency and a cultural link to ancient Rome. The figure represents the cruel and vicious sport of Roman boxing, in which athletes or gladiators fought, often to the death, using 'gloves' made of hardened leather, sometimes reinforced with studs of metal. This statue was conceived as a stimulus to remind Italian youth in the 1930s of the manly and fearless nature of their Roman forefathers. Since the end of the Fascist era, the statue has been allowed to remain but it has been given a more humanitarian meaning with the change of label to 'Genius of sport'. The original label can still be deciphered underneath the newly applied bronze letters.

In general, buildings are very weak carriers of meaning compared to sculptures. But they too embody political ideas in their form which pose a problem when transformations take place in the underlying ideology. The first two case studies in this chapter look at how democratic societies in Germany and Italy tried to come to terms with the buildings and sculptures produced in the 1930s by right-wing totalitarian regimes in their country.

Heritage and Fascism

If personal memories are the residue of experience managed in various ways by the mind, buildings and artefacts might be compared with particular kinds of memory of social experience. This view can certainly be contested (see Chapter 1), but some associational link between collective memory and tangible heritage can be assumed. If Freud is right, the subconscious works through the psychic material of recent experience and uses it for its own ends, typically in dreams. The dream dramatises this experience, often in the form of a nightmare, allowing us to realise that we have survived and can move on.

Just as the function of the nightmare, according to Freud, is to demonstrate to the mind that the worst fears can be overcome, so the remains of the works of tyrants and oppressors may reassure later generations of the healthy survival of their own culture. Demonstrating the horrors of Fascism may persuade us that capitalist democracy is perfectly acceptable. And just as the dream, according to Freud, mutilates, fragments and reforms memories into narrative structures intended to purge fears and reassure the ego, so buildings can be transformed, mutilated and reinterpreted, like a dream strung out over time. Without pushing the Freudian analogy too far, we can focus on the twin processes of mutilation and aestheticisation of buildings following regime change.

To explain how mutilation and aestheticisation can support each other, we can take the case of Hitler's favourite sculptor, Arno Breker. Breker was commissioned to create a giant statue – named *Readyness* – of a naked warrior reaching for his sword, which was to have been erected to gigantic scale on a monument to Mussolini in Berlin. After the war Breker removed the forearms and sword of his life-size maquette of *Readyness* and placed the mutilated statue in his garden where it could be admired as a latter-day antique torso throughout the 1950s. By doing so, he not only stripped the figure of its overtly militaristic associations, allowing it to be viewed simply as art, but also suggested a reference to antique statues, whose loss of limbs have also made them more accessible as purely formal artworks. There is a natural process of stripping away of meaning as works of art become accepted as 'Art' in museums, but this process can and must be accelerated in the case of political art, to avoid censure after regime change. In some ways, this process can be compared with the debates about 'authenticity' and 'restoration' (Otero-Pailos, Gaiger and West, 2010). Is it more important to strip a work back to its 'authentic' core, removing all later restorations, with the aim of uncovering the 'truth' of the work? Or does the desire of the spectator to take pleasure in a beautiful form justify trying to recreate the original artist's intentions by restoration and 'improvement'?

Case study: living with the relics of National Socialism

The nightmare of the **Holocaust** has made German National Socialism a focus for both repressed curiosity and a morbid fear of contamination. Furthermore, the Holocaust has become 'a template for collective memory in areas of the world that had nothing to do with those events but that have known other collective traumas' (Suleiman, 2006, p. 4). To this extent, the management of the physical traces of National Socialism and Hitler's racist policies take on a global significance, beyond the confines of German postwar culture.

I want to illustrate my argument with a rather special case of public memory: Albert Speer's Zeppelinfeld in Nuremberg (1934–6). The medieval city of Nuremberg came second only to Munich as the spiritual heart of National Socialism, uniting a sense of history – the Holy Roman Emperors had used Nuremberg for their ceremonies – with freedom from the 'contamination' of modern society. Although Berlin was the capital city, most Nazis had a deep suspicion of the decadent culture in the metropolis. It was therefore in Nuremberg, from 1927, that the annual rallies of the NSDAP (the National Socialist or Nazi Party) were held (Figure 4.1). Party members, members of the SA (*Sturmabteilung* Nazi militia) and SS militias, the Hitler Youth, Labour Service and the army were drawn in from all over Germany to perform in mass ceremonies in a large outdoor arena, the Luitpoldarena. This open parade ground had at one end a speaker's tribune and at the other end a First World War memorial hall and arcade which the NSDAP converted into a monument to the Nazi fallen during the 1923 Beer Hall putsch. The SA and SS paraded in the Luitpoldarena to venerate the Nazi dead and hear speeches. Then Hitler would walk the full length of the arena to salute the *Blutfahne* – a Nazi flag stained by the blood of victims of the putsch. One of the ceremonies at the party rallies was for Hitler to consecrate the regimental standards by touching them with the *Blutfahne*. In the speeches, and in ceremonies like this, the idea of the blood sacrifice, and of relics of these sacrifices, was instilled into the party workers and soldiers. Much of the underlying ideology of the war monuments we were exploring in Chapter 2 was exaggerated, perverted and made more explicit in Nazi mythology and ceremonies.

In 1934 Albert Speer took over from Paul Ludwig Troost the job of stage managing the party rallies and of designing a new group of buildings to make these events more monumental and permanent. His first addition was a new parade ground, the Zeppelinfeld, surrounded by a square amphitheatre of raised seating and a monumental tribune with a central block flanked by long colonnaded wings. The parade ground was surrounded by low towers, which seem to represent all the people of Germany assembled in the rallies (Figure 4.2).

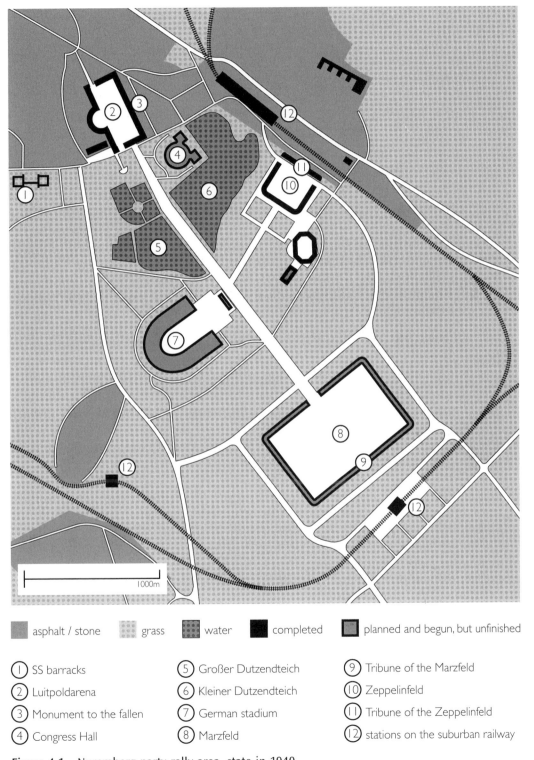

| asphalt / stone | grass | water | completed | planned and begun, but unfinished |

① SS barracks
② Luitpoldarena
③ Monument to the fallen
④ Congress Hall

⑤ Großer Dutzendteich
⑥ Kleiner Dutzendteich
⑦ German stadium
⑧ Marzfeld

⑨ Tribune of the Marzfeld
⑩ Zeppelinfeld
⑪ Tribune of the Zeppelinfeld
⑫ stations on the suburban railway

Figure 4.1 Nuremberg party rally area, state in 1940.

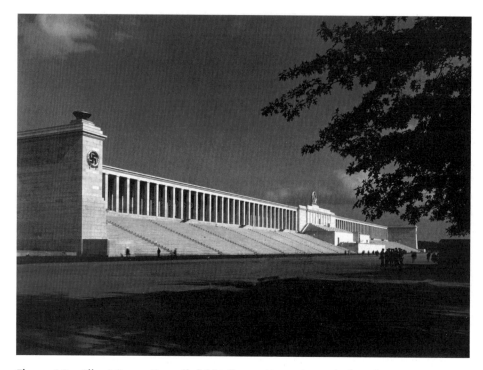

Figure 4.2 Albert Speer, Zeppelinfeld tribune, Nuremberg, designed 1935. Photographed by Karl Kolb, 1938. Photo: © bpk/Karl Kolb.

The party rallies at Nuremberg were the engine house of Nazi brainwashing and indoctrination. It was here that the race laws were promulgated and the speeches and debates transmitted to up to 150,000 soldiers and party members present, as well as to millions more by radio. What were the Allies to make of all this when the Americans took Nuremberg in 1945?

What remains of Speer's monumental backdrop is the central section only, with the steps mutely pointing to the absent wings (Figure 4.3). The wings were apparently demolished for safety reasons, but the central section, with Hitler's podium, has been conserved. A road has been driven through the site next to the podium. The combination of mutilation and preservation is decidedly odd: the exposure of a carefully conserved stump.

The central meanings of the Zeppelinfeld are to do with the domination of the many by one man – the surrender of liberty to a 'higher' ideal of sacrifice and immolation in war. The grassed arena in front of Hitler's podium was not the place where 'performers' were observed by a 'public'. The spectacle was the performance. *Triumph of the Will*, the propaganda film Leni Riefenstahl shot of the Nuremberg party rally in 1934, was designed to project this spectacle into cinemas all across Germany, and in many other countries.

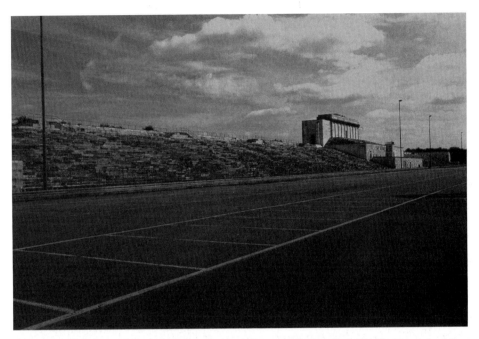

Figure 4.3 Albert Speer, Zeppelinfield, Nuremberg, designed 1935. Photographed by Tim Benton, 1985. Photo: © Tim Benton.

What possible legitimate space is left for the imagination, for those who stand today on Hitler's podium? Assuming we are not neo-Nazis, are we dreaming of being Hitler in order to reassure ourselves that we are not? Or is this a place to ponder objectively on the bringing down of tyrants? Alternatively, is the survival of the Zeppelinfeld in its mutilated condition simply the result of a reluctance to destroy a work of architecture while not wishing to give it too much prominence?

In 1985, when I visited it, Hitler's parade ground was decked out with the 'innocent' accoutrements of an American gridiron football field and, like a stake driven through the heart of a vampire, a 7 metre flagpole with the Stars and Stripes flying. This strange form of de-nazification has long since been removed. Perhaps the empty buildings, mutilated and stained by rust, stripped of screaming voices, searchlights and massed ranks of men in uniform are not capable of supporting this intensity of memory and reflection. Perhaps authority has given up trying to weigh up the pros and cons of conservation and purification. But a brief internet search shows that this site is still venerated by neo-Nazis, who can be seen playing out the Hitler dream on the Zeppelinfeld podium. *Caveat emptor.*

Speer's Nuremberg buildings and spaces are a test case because they have virtually no credible meanings or uses in a democratic society, except for the reflection on political horror. To many Germans, buildings like these can never

lose their associations with evil and national disgrace. You're for them if you think that a nation's 'health' requires some kind of dialogue with its forbidden past; you're against them if you fear the unleashing of uncontrollable forces, present in all of us like original sin.

Since 1985 the area has been tidied up. The unfinished Congress Hall, an enormous horseshoe-shaped building which would have been covered by a gigantic concrete roof, has been turned into a museum (the Dokumentationszentrum), while the Luitpoldarena has been more or less demolished apart from the Ehrenshalle which has now been returned to its original function as a war memorial. The third rallying ground, even larger than the other two – the Marzeld – has been concreted over with blocks of flats, after the towers were dynamited in 1961.

How and in what circumstances can political meanings be separated from the works designed to incorporate them? Moreover, what role does architecture, as an art form, play in resisting or facilitating this process? And how do personal memories fit into these manipulations? These buildings can only be re-used to tell stories about themselves, about their original functions, in the context of a new ideological message. They will always be contested sites, serving as fantasy scenarios for pro-Nazi sympathisers (who will be stimulated by the feeling that society has vandalised Hitler's stage set) or as historical lessons for the curious who will attempt to reconstruct distant events.

Speer built these buildings to last a thousand years, quarrying trainloads of stone with forced labour. He intended the buildings of the Reich to grow into picturesque ruins, like the famous sites of antiquity. Stone links the modern to the antique and legitimises it. As an architectural historian I take pleasure in the internal inconsistency: the supporting reinforced concrete structure betrays its existence by distressingly transitory streaks of rust bleeding through the stone facing.

The Olympic stadium, Berlin

Another difficult case of adaptive re-use is the Olympic stadium in Berlin. On the site of an existing stadium designed by Otto March (1912–14), the Nazis commissioned his son Werner March to build for the Olympic Games in 1936 a massive new stadium with a capacity of 110,000, a parade ground of 112,000 square metres and an open-air theatre. The original stadium had copied the antique form, sinking the field 12 metres into the ground. Werner March expanded this, raising the stands all round but leaving open one end. This was where the Olympic flame was located, but more importantly it gave into the parade ground behind – the Maifeld – and more specifically on to the bell tower which rose over the Langemarkhalle below. This was yet another remembrance shrine, this time for the battle of Langemark in the first days of the First World War, when regiments of very young and enthusiastic

German students and teachers were slaughtered in hopeless attacks against well-defended British positions. It is characteristic of battlefield heritage that this episode features hardly at all in British consciousness. The so-called *Kinderschlacht* (slaughter of the children) was a particularly emotive evocation of the blood sacrifice concept for Germans, and regiments of soldiers renewed vows of loyalty to Hitler in this hall. The clock tower and Langemarkhalle were restored in time for the football World Cup in 2006, with an exhibit intended to demonstrate the dangers of the abuse of sport for political purposes and a documentation centre on the Olympic stadium and surrounding buildings.

How are we to interpret the Olympic stadium? The official Nazi symbols have been removed from the twin towers which frame the entrance to the stadium. The Nazi ceremonies and some of the iconography of the Langemarkhalle have also been removed, along with the parades, speeches and politicised sports displays. The blood sacrifice associations of the Langemarkhalle have been explicitly countered by an exhibition. The stadium is the home ground of the Hertha BSC football club and has been the venue for various sporting events since the 1960s. But can it be separated from its political heritage? Does not the place itself and the building evoke memories of Nazi rallies and the 1936 Olympic Games? Is not the opening in the stands – the Marathontor – with its view to the clock tower over the Langemarkhalle and the military parade ground in between, just too specific a message of sport in the service of a militarised society? In 1998, in the run-up to the football World Cup in 2006, a debate broke out on these questions, with some arguing fiercely that the building should be demolished. In the event, it was decided to keep it and use it, and so it was restored. To some it is just another football stadium, but to others it will always be scarred by the ideology that originally framed it, or it will be a site for attempting to revive Nazi ideas. To discuss this is to observe the slow processes of forgetting, whereby a building loses (for some) its political associations and acquires new ones. These processes will necessarily be contested, until the building acquires the patina and amnesia of 'age value'.

Reflecting on the case study

Representative buildings funded by the state are usually designed with the specific intention of promoting authority and enshrining state ideologies. Whatever the general truth of this proposition, it holds true in most cases in totalitarian states. Because the political and ideological aims of totalitarian states are usually easy to uncover and appear different from those of our own political regimes, they provide a useful indicator to processes which, in cases closer to home, may be more obscure. To be politically effective, such buildings must not only communicate the claims of the patron ('Mussolini ha sempre ragione' – Mussolini is always right) but must also somehow evoke

ideas and associations among those for whom these claims might ring true. A smart, modern and attractive railway station, post office or government building might make a favourable impression on those for whom Fascism represented a positive modernisation of the state. For the victims or opponents of Fascism, however, regime buildings might be expected to attract considerable hostility. Between buildings as 'public memory' and the memories of individuals there is always likely to be a tension.

If art were nothing more than communication, the situation would be critical. If a Fascist building were nothing more than an expression of Fascist values, a post-Fascist world could make no use of it. On this view, to agree to re-use a Fascist building is to accept Fascist values. But we all have choices. We may be able to control our feelings of racial prejudice, violence and sadism, but this doesn't mean that they're not there, to a greater or lesser degree, in all of us. The test of citizenship is to manage anti-social and unethical feelings, and a similar test might be applied to the use of buildings and works of art. It depends more on what we do with them and how we think about them (intangible heritage) than on why they were made or their historic past.

Case study: living with Fascism

Anyone visiting Italy to look at works of art or architecture will necessarily be influenced, perhaps unconsciously, by the ideas and works of Italian Fascism (1922–43). In many Italian cities Fascism (and Fascist thinking) frames the urban fabric, controls the viewpoints from which it is observed, often determines the physical condition and underpins much of the historical literature about it. You observe the Roman Forum from an avenue – the via del Impero (Avenue of Empire, renamed the via dei Fori Imperiali, Street of the Imperial Fora) – which was designed in 1932 for military parades. You approach St Peter's along another piece of Fascist urbanism – the via della Conciliazione – cut through the medieval and Renaissance Borgo (suburb) to the south-east of the Vatican. This avenue (the road of Conciliation) was intended to commemorate Mussolini's historic concordat with the papacy of 1929, which brought to an end the isolation of the Vatican that had lasted since the Unification of Italy as a secular state in the 1860s.

Foro Mussolini

The Foro Mussolini was one of Mussolini's pet projects, originally designed as a sports centre and training ground for sports instructors and the Balilla Youth movement. The guiding figure was Minister for Sport Renato Ricci, from Carrara (which helps to explain the 90 statues of Carrara marble, each 2.5 metres high, that populate the site) (Figure 4.4). Unsurprisingly, the architect of the stadium, Enrico Del Debbio, also came from Carrara.

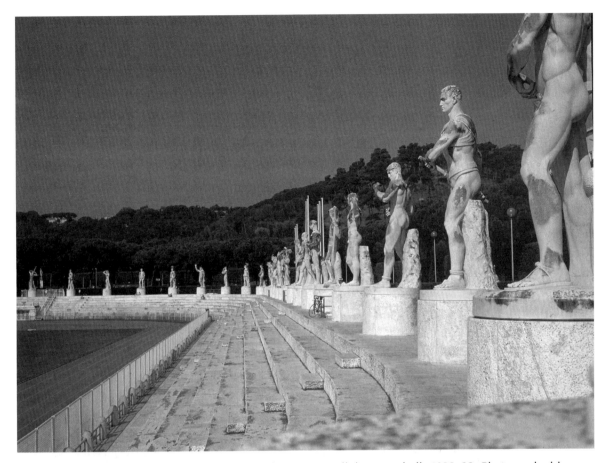

Figure 4.4 Enrico Del Debbio, Stadio dei Marmi, Foro Mussolini, Rome, built 1928–32. Photographed by Tim Benton, 1985. Photo: © Tim Benton.

A passionate follower of Robert Baden-Powell, Ricci founded the Fascist youth movement (the Opera Nazionale Balilla, in imitation of the Boy Scouts movement) and introduced rugby football to Italy in 1928.

The Stadio dei Marmi (stadium of marble statues) was designed primarily for the people participating inside the arena, rather than for the spectators. The marble statues that line the stadium were paid for by Italian cities and represent sports characteristic of the area. Another stadium, set into the hillside with temporary grandstands, provided the venue for football matches. This was used when Italy staged the second football World Cup, in 1934. They won it then and won it again in Paris in 1938. This stadium was turned into a modern facility for the 1990 World Cup, with new stands that dominate the rest of the area.

The Foro Mussolini was intended to demonstrate to the world the Fascist ideals of developing sporting ability throughout Italy. Enrico Del Debbio's

central buildings housed the national academy for training sports instructors and now houses the bureaucrats of the CONI (Italian Olympic Committee) and other sport-related administrations. Although the fasces (bundles of canes and an axe, symbols of Fascist authority over life and death derived from ancient Rome) have been removed from all the buildings, the statues showing soldier and athlete flanking the entrance have been retained. Fasces have been used as classical symbols of authority in non-Fascist contexts. For example, most American government buildings in the 1930s include fasces in their iconography, although usually showing the canes without the axe.

In addition to promoting sport among boys and girls, the Foro Mussolini was also a site where the 14-year-old graduates of the Balilla Youth movement held summer camps and carried out sporting activities before being passed on to the militaristic Avanguardie Giovanile Fasciste (young Fascist avantgardists), where the association between physical fitness and military sacrifice was made explicit. The whole site is full of explicitly political images – sculptures, mosaics and architecture – reinforcing the Fascist message.

Figure 4.5 Luigi Moretti, viale Imperiale, Foro Mussolini, Rome, built 1935–6. Photographed by Tim Benton, 1976. Photo: © Tim Benton. Note the graffiti on the marble blocks commemorating the significant events of the Fascist regime.

The Foro Mussolini, renamed Foro Italico after the war, therefore posed problems of conservation. It is still a sporting centre, and the tennis courts still play host to the annual tennis championships.

For several decades after the war, Fascist iconography was keenly felt as a site of conflict and was fought over by neo-Fascist and leftist students and football supporters. In 1976 graffiti expressing pro and anti Fascist sentiments covered every centimetre of the Carrara marble blocks on the viale Imperiale that commemorate the events of the Fascist era (Figure 4.5).

Now, the blocks have been cleaned up, and stand respectfully in commemoration of the events of 25 years of Fascism. The legends have been tidied up, to accentuate the good features of the regime. The dates, which were originally written in the Fascist style (that is, XI EF, meaning the eleventh year of the Facist regime (Era Fascista) (1936)), have been converted into conventional dates. There is even a new block with the legend 'End of the Fascist Era'.

The Sphere (Figure 4.6), around which many ceremonies of the Balilla Youth movement were celebrated, is framed by mosaics recording the slogans and chants of the pre-adolescent Fascist youth. To read the words 'Duce, duce, duce' might seem innocuous, but if you listen to the Balilla Youth choirs,

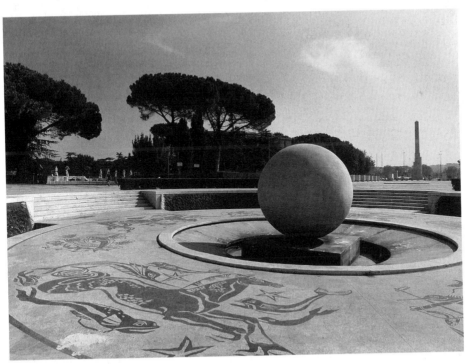

Figure 4.6 Pediconi and Paniconi, Sphere at the end of the viale Imperiale, Foro Mussolini, Rome, with the new obelisk for Mussolini in the background. Photographed by Tim Benton, 1985. Photo: © Tim Benton.

and hear the shrill ardour of the pre-pubescent boys singing the chorus, the meaning of the words becomes clearer. This points up inconsistencies in the way memories work. Anyone over the age of 70 would still remember these chants and with them the forms of Fascist indoctrination, calling for absolute obedience and sacrifice to the Duce. And for all Renato Ricci's deep respect for Baden-Powell and the Scouting movement, the Balilla Youth organisation was different. On graduation at the age of 14, each little boy was presented with his *moschetto* (rifle), a rite of passage rather more specifically militaristic than anything in the Scouts.

> In the Italy of the Fascists,
> Even the little ones are warriors.
> We are Balilla, riflemen,
> the flower of the Regime
>
> Duce! Duce! For you!
>
> We have a fine rifle
> And Italy gave it to us
> Musketeers, we have the duty
> To prepare our destiny.

('Duce a noi', transcribed and translated by Tim Benton from Duck Record, n.d., track 2)

The image of the little boy being presented with his rifle is faithfully reproduced in mosaic in the viale Imperiale (Figure 4.7). A member of the militia hands the boy his rifle. Behind the soldier is the potent symbol, the fasces, to whose authority over life and death the child pledges himself.

To hear these Fascist 'hymns' today you must research the dubious collections of Fascist memorabilia sold as pornography to the 'ultras' and 'skins' of football hooliganism. Labels such as Duck Record, founded by Bruno Barbone, with their inadequate discographic details, do not make the job of the researcher any easier. Cassettes sold by Duck Record are no longer freely available but the firm continues as an online distributor of compact discs. Any Italian over 60 years of age knows these songs by heart, but the cassettes carry strict warnings: 'Listening to this cassette must be purely private. In particular, it is forbidden to transmit it during demonstrations or meetings.' The impression is further strengthened of a very particular kind of disjunction between public and private memory.

The Italian philosopher and novelist Umberto Eco has been reflecting on the residual impact of 'bad' memories from childhood, in a series of interviews and in a novel entitled, in its English translation, *The Mysterious Flame of Queen Luanna* (Eco, 2005). In the novel Eco deploys the device of a man of his own age (Eco was born in 1932) who has lost his memory in an accident

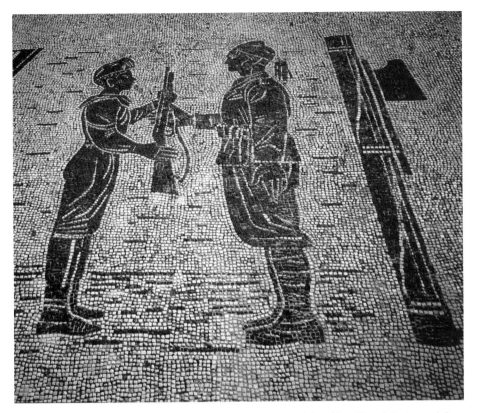

Figure 4.7 Mosaic of Balilla youth on graduation, receiving his rifle, viale Imperiale, Foro Mussolini, Rome. Photographed by Tim Benton. Photo: © Tim Benton.

and finds that memorabilia of his childhood allows him to piece together his identity. Eco was brought up in Fascist Italy, and his childhood memories are of Fascist comics and images, many of which are illustrated in the book. In an interview conducted in 2005, Eco reflected on the power of childhood memories:

> 'You have nostalgia even for the most tragic experiences of your childhood. I can judge Fascism historically for what it was. But it was my childhood. So, often with some friends, all left-oriented people, after a party, we would all sing some of the Fascist songs.' Really? The great left-liberal intellectual singing 'Per l'Italia e per il Duce, eja, eja, eja, alalà?' 'We couldn't do that openly', he says, 'because we would have been considered Fascists, in the same way even today I can't wear a black shirt.'...

> 'With my intimate friends after midnight, sometimes, we sang those songs, because it was our childhood. So I like to retrieve and evoke those experiences, and at the same time, implicitly, I want to judge them.'

> (Whiteside, 2005)

I can personally vouch for a similar experience. After a seminar at the British School in Rome, during which I played some Fascist 'hymns', some of the young Italian archaeologists who work in the excellent library of the British School confessed to me that they not only knew the tunes but also the words of many of these songs. They all held left-wing views and had been born twenty years after the end of Fascism.

Eco's formula for a dual process of 'retrieval and evocation of these experiences' combined with an intellectual process of historical judgement is carried through in his own practice. He has written a number of articles on 'Ur-Fascism', attempting to identify the features of Italian Fascism that can be found in contemporary society while also identifying those features that were specific to the historic conditions of the 1920s and 1930s.

On the other hand, the mosaics of the viale Imperiale, with their images of athletes, artists and Fascist heroes, which had been allowed to rot in the 1970s, have been lovingly restored as official heritage works. Among the excellent artists who worked on these mosaics during 1935–6 was Gino Severini, better known as a Futurist and Cubist painter living in Paris and friend of Picasso.

While the iconography of Fascism can safely be consumed as art, music proves too difficult to manage comfortably. It is forbidden to sing *Giovinezza* (the anthem that was played whenever the Duce attended a public meeting), but it is acceptable to represent the myths of Fascist heroism that *Giovinezza* describes. *Giovinezza* has an interesting history. The tune and some of the words began as an Alpine student song composed by Giuseppe Blanc in 1910. It was then taken up by the Italian storm-troopers, the *arditi*, during the First World War and given increasingly bloodthirsty lyrics, which were then adapted again to serve as the anthem of the Fascist gangs, or *squadri*. The lyrics attributed to Marcello Nanni deliberately merge the heroism of the *arditi* with that of the *fascisti* in the street fighting of 1919–21. The first verse deals with death or glory in the trenches. The second verse is a description of a punishment raid against the 'traitors' (opponents of Fascism):

> With dagger and grenade
> In a life of terror
> When the bombs explode
> Our heart does not tremble
> Our one true flag
> Is of one colour only
> It is a flame of purest black
> Which flares in every breast.

(Savona and Straniero, 1979, pp. 53–69)

These bloodthirsty words were later changed to a more statesmanlike celebration of national duty. This was what lay at the heart of Fascism, the shared experience of street fighting, during the pitched battles of the immediate postwar years. The ever-present slogan 'A noi!' (Join us), originally proclaimed by Gabriele d'Annunzio after his motorboat raid on Fiume, became a street-fighting rallying cry, like those of present-day hooligans.

A mosaic shows a lorry load of Fascist youth, with their black banner flying, inscribed 'Me ne frego', which can perhaps best be translated as 'I don't give a fuck'.[1] The slogan 'A noi', the rifles, machine gun and *manganello* (big stick), as well as the favourite head-gear of the *arditi* and the attachment to pennants, were all very familiar items of Fascist legend. In every *Casa del Fascio* (Fascist Party headquarters) and most municipal buildings, the relics of martyrdom during Fascist street fighting were carefully preserved and

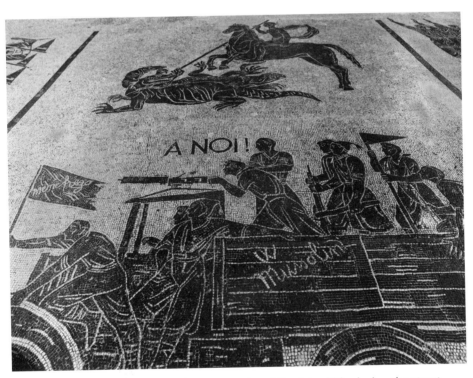

Figure 4.8 Mosaic of Mussolini and a *squadra* of Fascist militia during the street fighting of 1921–2, with the slogan 'A noi' (To us) and the banner 'me ne frego' (I don't give a fuck), viale Imperiale, Foro Mussolini, Rome. Photographed by Tim Benton. Photo: © Tim Benton.

[1] An officially licensed song based on its initials – 'M.N.F. Emme Enne Effe' – by Vittorio Mascheroni with words by Angello Borella, 1929, consists of a loutish attack on intellectuals (*professorfessi*, professor-arses) and the bourgeoisie. Fascism was adept at mobilising youthful energies and prejudices normally repressed by polite society.

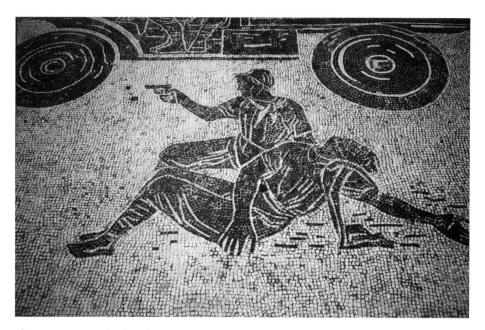

Figure 4.9 Mosaic showing Fascist student with fallen comrade, viale Imperiale, Foro Mussolini, Rome. Photographed by Tim Benton. Photo: © Tim Benton.

reverentially displayed, in a *sacrario*. The *Mostra della Rivoluzione Fascista*, installed in the Palazzo delle Esposizioni in Rome in 1932 to celebrate ten years of Fascist rule, incorporated a massive and painstaking library and hagiography of the deaths of Fascist martyrs (Alfieri, Luigi and Partito Nazionale Fascista (Italy), [1933] 1982). This documentation was continually extended, to provide exhibition material in Rome and elsewhere, and finished up in the last days of the regime in Salo.

In another mosaic representation a Fascist youth shoots at the enemy, who have killed his comrade (Figure 4.9). A telling detail is the scarf soaked in the martyr's blood. This was precisely the kind of memento needed for display in a *sacrario*. As in the case of Nazi symbols such as the *Blutfahne*, blood-stained relics were powerful weapons for committing gullible youths to sacrifice themselves for their country.

Memory and the aural

Mussolini's finest moment came when he could announce in a speech to a mass rally on 9 May 1936 *Il popolo italiano a finalmente il suo impero* (The Italian people finally has its empire), following the invasion of Ethiopia in 1935–6. This was the song – 'Faccetta Nera' (little black face) – the soldiers sang as they went off to fight.

If you, young black girl, look out to sea
You, a slave among slaves
You will see, as in a dream, many ships
And the Italian flag fluttering for you

Chorus:
Little black face – beautiful Abyssinia – wait and hope
Now the hour is approaching when we will come to you.
We will give you a new law and a new King.

Your law is slavery and oppression
Ours is Liberty and duty
We, the black shirts will give thanks
For the heroes who have fallen liberating you

Little black face, little Abyssinian
We will carry you off to Rome, liberated
You will come under our sun
And you too will have a black shirt

Little black face, you will become a Roman
Your flag will be the Italian one
We will march with you, together
And we will parade before the Duce and the King.

(lyrics by Micheli, music by Ruccione, 1935–6, quoted in Savona and
Straniero, 1979, pp. 270–1)

It is difficult to believe that these sentiments could have been so
enthusiastically shared by a very large proportion of Italians in 1935. The
association of conquest with rape is of course as old as warfare itself, but I can
think of few songs which so overtly and joyously celebrate the proposition. So
successful was this song in Roman dialect in capturing the essence of the
soldier's fantasy of conquest that it was eventually banned in case it promoted
unwanted miscegenation with the conquered people. Ruccione, the composer,
was an able and highly popular songwriter, and the tune remains embedded in
Italian culture, whether or not the words are understood or remembered, along
with other songs of the Fascist era such as 'Sole mio' and 'Che bella cosa'.
Songs like this, and the endless songs celebrating sacrifice and victory in war,
raise awkward questions about repressed desires that are not normally allowed
public expression except in the fantasy world of films and cartoons. After a
seminar at the British School in Rome recently I was taken aback to find that
all the Italian men present, of every age and every political persuasion,
admitted to knowing not only the tune but also the words of 'Faccetta Nera'.
By what strange processes of familial and social transmission has this song
(officially unobtainable for sixty years) been handed down?

The role of speeches, as well as songs, in carrying collective memory has been underplayed. One of the buildings in the new city of EUR outside Rome is crowned with an inscription.

The text reads:

> UN POPOLO DI POETI DI ARTISTI DI EROI DI SANTI DI PENSATORI DI SCIENZIATI DI NAVIGATORI DI TRASMIGRATORI (A people of artists, of heroes, of saints, of thinkers, of scientists, of navigators and migrators).

The context was a military and imperialistic one: the speech of 2 October 1935 in which Mussolini defied the League of Nations and declared war on Ethiopia. The speech was delivered to a mass rally and transmitted by radio to listeners all over Italy and to Italian communities abroad. After assuring his '20 million' listeners that he would do everything to avoid a world war, he went on:

> Never more than at this time has the Italian people demonstrated its strength of will and depth of spirit. And it is against this people, to whom civilisation owes the majority of its conquests, against this people of heroes, of saints, of poets, of artists, of navigators, of colonisers and migrators that they dare talk of sanctions. Italy! Italy! Proletarian and Fascist Italy! Italy of Vittorio Veneto and the revolution, on your feet! On your feet!

> (Simonini, 1978, pp. 75–6)

The battle of Vittorio Veneto was the long-awaited Italian victory over the Austrian troops which settled the conflict over the Tyrol in 1918. What reads in stone as a simple list of cultural attributes turns out to have been a near-hysterical call on national pride in the final peroration before a call to arms and death or glory. Children learned large sections of Mussolini's speeches by heart at school, and adults bought the records and books in which they were distributed. To hear the recording of this speech is to realise that the list of Italian attributes (interestingly re-ordered and re-organised for the epigraph) was not scripted but extemporised; one of the genuinely moving passages that would have stirred the patriotism of any Italian then or now. For Italians who had heard the speech live or on record, the inscription would have had quite a different meaning from the apparently innocuous statement of patriotism that appears at first sight on the inscription (Benton, 2000).

The survival of Fascist iconography

In the examples we have looked at so far the gap between an apparently unacceptable content (today) and an acceptable historic artistic expression is legitimated by the artistic value of the work and its 'intrinsic' qualities.

But how do you respond to a whole city centre designed to convey a political message? In 1928 Marcello Piacentini began demolishing and rebuilding part of the historic centre of Brescia (Kelikian, 1986; Ventura, 1992).

The buildings of the Fascist corporate state (insurance offices, post office, banks) surround the square. To many Italians these buildings seem relatively neutral examples of modernisation, not unlike the new office buildings

Figure 4.10 Marcello Piacentini, *sacrario* (shrine) to fallen Fascist youths, Post Office, Brescia, built 1928–32. Photographed by Tim Benton, 1994. Photo: © Tim Benton.

springing up everywhere in Europe and America in the 1930s. As in every Fascist urban design, there is a tower (*Torre del Littorio*), which was here decorated with an equestrian portrait of the Duce (demolished). Italians are used to bell towers or clock towers in their city centres. The relationship between a *Torre del Littorio* (symbol of discipline, obedience and authority) and an *arengario* (pulpit for haranguing the crowd) became an instantly recognisable cliché in Fascist state buildings. In most cases, the *arengario* would be attached as a balcony to the tower, or to the most prominent public building.

Although some of the Fascist iconography has been removed from the piazza della Vittoria (the equestrian relief of Mussolini, the fasces, a monumental statue of a young man by the sculptor Dazzi), the explicit Fascist messages are still there to be seen for those who look attentively at the architecture. But the explicit remnants of Fascist ideology are also there. In the post office we find not a war memorial but a *sacrario*, a monument to Fascist martyrs (Figure 4.10). Although the lamp with the eternal flame has gone out, this porphyry column with the names of a few Fascist youths who died in the street fighting of the early 1920s strikes an odd chord. Fascist *sacrari* like this are buried away in many administrative buildings in Italy and are still used discreetly to remember the 'martyrs' of the Fascist cause. The Fascist ritual involved assembling the members of the original '*squadri*' (the Fascist street gangs) and calling out the names of the roll call, leaving a silence for each 'martyr'.

In the middle of the piazza, among the parked cars, is an *arengario* (Figure 4.11). This *arengario* is not only a memory of Fascist rule, of the practice of haranguing the public in mass meetings, it also embodies the message of the orator – a Fascist message.

Read attentively, this pulpit tells Brescian history from a Fascist perspective. At the disastrous defeat of Caporetto in 1917 the Germans and Austrians came within a whisker of taking Brescia. The fierce fighting that took the Italian army to its final victory of Vittorio Veneto was the seedbed for Fascism. This relief shows the *arditi* (the storm-troopers) forming themselves into the *fasci di combattimento* (veterans' leagues) after the war and greeting the *squadri fascisti*. Mussolini, on the right, is shown saluting a group consisting of veteran soldiers, teenage *avanguardista* and a Balilla Youth member. At the far right of the relief, a lictor's fasces is represented, symbol of civic discipline, but the head of the axe has been knocked off. Lictors had the job in ancient Rome of protecting the magistrates and other important figures, carrying with them a bundle of canes and an axe as symbols of their authority. The canes and axe – known as the *fasces* – gave Fascism its name and came to represent the exercise of totalitarian discipline and power.

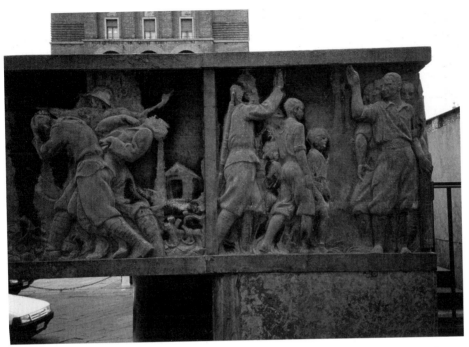

Figure 4.11 Antonio Maraini, *arengario* (pulpit for political speeches), piazza della Vittoria, Brescia, built 1928–32. Photographed by Tim Benton, 1994. Photo: © Tim Benton. The scene shows the fighting in the Alps during the First World War and the return of the veterans, greeted by Mussolini.

At the other end of the pulpit, a classicising relief shows Brixia Colonia Augusta, the Roman city of Brescia, dispensing justice to captured Goths or Germans, thus reinforcing the Fascist myth of the restoration of the Roman empire. Flanking this, is the Lombard King Desiderius, who came from Brescia, shown with the cross of Galla Placidia which he gave to the Benedictines in the eighth century and which had just been put on display in the local museum. This representation of medieval royal piety was carved in the year Mussolini signed the famous concordat with the Pope, finally resolving a conflict between Church and state that had existed since the Unification of Italy.

So, this pulpit has a single purpose, to provide a physical platform for haranguing the populace, while providing a visual 'text' in rhetorical support of Fascist legitimacy. Once again, any feeling of discomfort at the explicitness of this message seems to be assuaged by a conveniently blinkered perception and a reluctance to 'read' the content combined with an understandable pride in the city's historic achievements and a respect for 'art'.

Reflecting on the case study

We have seen a clear separation between the respect for aesthetic qualities of objects (the intrinsic qualities admired by the authorised heritage discourse) and the attempts to change associations and meanings of works that bear witness to a discredited regime. A number of factors make it difficult or impossible for a government to eliminate all traces of a previous regime. Buildings are too useful to be destroyed out of hand. Works of art reflect human values of craftsmanship and skill. And there is also disagreement about whether it is desirable to wipe the slate clean. Is it not better to discuss and debate recent history rather than to repress it? The Italian architect Aldo Rossi believes 'the city itself is the collective memory of its people, and like memory it is associated with objects and places. The city is the *locus* of the collective memory' (Rossi, Eisenman, Graham Foundation for Advanced Studies in the Fine Arts et al., 1982, pp. 130–1). This suggests that a city incorporates a single, unified collective memory. On this view, brutal insertion into the fabric of a city interrupts the collective memory of a community, or rather, replaces one set of memories with another, that of Fascism. But it is quite clear that different meanings and memories overlap and co-exist. We saw in Chapter 1 how a city can provide a venue and set of prompts for individuals to share their memories, which may differ from any 'official' set of memories and meanings inscribed in the city. What is certain is that in the case of 'bad' memories, above all, heritage prompts multiple responses. It is how buildings and places are used and thought about that determines their heritage value.

Case study: the contested heritage of Auschwitz

The collective memory that has perhaps the greatest claim to universal currency is the appalling history of the Holocaust. But even this has been subject to regime change and changing interpretations. A particular case in point is the conservation and contested re-presentation of Auschwitz, a World Heritage site (Huener, 2003). To most people with any knowledge of twentieth-century European history, Auschwitz stands for one thing only, the extreme manifestation of Nazi racial policies. Auschwitz, and the Holocaust in general, has become part of almost everyone's 'memory', due to widespread coverage in television documentaries, feature films and novels. As such, it has had to perform a very generalised and symbolic role as a site for reflecting on evil and the dangers of unlimited political power in an age of mechanisation and bureaucratic control. Auschwitz is a major international tourist site, a place of pilgrimage, on the web as well as on the ground, on television and film. It necessarily escapes, therefore, from any single interpretation, any one 'truth', and has to adapt to the needs of many different groups.

Auschwitz is the German name given to the Polish town of Oświęcim, while the neighbouring Brzezinka was renamed Birkenau. Auschwitz (Auschwitz I) and Birkenau (Auschwitz II) were the two main camps in a delimited zone of some 40 sq km incorporating forty other camps.

Auschwitz began as an internment camp for Polish political prisoners, while Birkenau was opened in the first instance to accommodate 100,000 Russian prisoners of war. But as the Nazi genocidal policies developed, in 1942 both Auschwitz and Birkenau were turned into industrialised extermination camps, with trainloads of Jews and Gypsies from all over Europe being killed on arrival. Auschwitz and Birkenau were not single-function extermination camps, such as Treblinka or Sobibór where there were virtually no survivors. Around 1.1 million Jews (of Polish and other nationalities) were killed at Auschwitz compared to 21,000 Gypsies, 74,000 non-Jewish Poles, 15,000 Russian prisoners of war and 12,000 other non-Jewish prisoners. But to many Poles, Auschwitz is primarily a shrine to Polish suffering under German occupation. It has been estimated that as many non-Jewish Poles as Polish and European Jews were killed across the whole of Poland during the German occupation, and it has been claimed with some justification that Hitler proposed eventually to extend his genocidal policies to Poles. These circumstances have led to a confused and complex understanding of the meaning of Auschwitz in Poland and elsewhere.

Soon after the Red Army liberated Auschwitz in 1945 the Polish state established a museum. The American historian Jonathan Huener has characterised the collective memory enshrined in the state museum as having three components (Huener, 2003, p. 29). In the first instance, the museum was seen by Poles as a site of Polish national martyrdom, focusing on those Poles who were interned for their resistance to the German occupation or who appeared to offer the likelihood of opposition. Second, but at first in a minor register, the victimisation of Polish and European Jews was seen as an additional proof of Nazi barbarism. Third, the Auschwitz Museum during the Communist era was used as a venue for mounting politicised campaigns against West Germany and, in the 1950s, the USA. In the context of Soviet-dominated Poland and the outbreak of ugly anti-Semitic riots and pogroms in 1945–7, the conditions for an objective memorialisation of Auschwitz were difficult.

The origins of the Auschwitz Museum began with a group of former prisoners, led by Józef Cyrankiewicz (later prime minister of Poland) who asked to be given control of the site while it was still serving as a camp for German prisoners of war in April 1946. Their aim was to conserve the buildings and collect relics of the tragic lives of the inmates. The emphasis was on conserving Auschwitz itself, rather than Birkenau, despite the fact that it was at Birkenau that the most ruthless and systematic extermination of deported Jews was carried out.

After its official opening in June 1947, the Auschwitz Museum came under a range of attacks. For some, the very presence of carefully restored buildings, with their appearance of normality, underplayed and betrayed the ultimate horror of what took place there. For others, the vicarious experience prompted by the displayed buildings and artefacts was itself morally unacceptable. There was a concerted move in 1948 to destroy the whole site but this was defeated by a considerable popular reaction. A government report advocated a new interpretative strategy which would play down the emphasis on German war crimes and emphasise 'the unmasking of Hitlerite Fascism as one form of international Fascism inspired and financed by Anglo-Saxon Imperialists' (Huener, 2003, p. 100). On 17 April 1955, however, the museum was re-launched as the most important commemorative site of Polish suffering during the war. Although the fact of the extermination of Jews at Auschwitz and Birkenau was never denied by the Polish government, it was rarely explicitly referred to. And in the late 1960s an 'anti-Zionist' campaign in Poland led to the expulsion of 9000 Jews from the Party and emigration of over 20,000 of the few surviving Jews from Poland. The heritage of Auschwitz was again drawn into this political arena, with the questioning of historical data on the numbers and proportion of Polish Jewish and non-Jewish Poles who died in the camps. In 1968 the International Auschwitz Committee, which had played a major role in lending international credibility to the management of the site, was thrown into crisis and several countries withdrew their support. Paradoxically, in the same year, a new exhibit was opened at Auschwitz, for the first time specifically focusing on the suffering of Jews in the camp.

In 1979 Pope Paul II included a pilgrimage to Auschwitz in his historic return to his native Poland and in the same year Auschwitz was listed as a World Heritage site by UNESCO. The statement of significance gives a measured account of its meaning:

> Auschwitz-Birkenau was the principal and most notorious of the six concentration and extermination camps established by Nazi Germany to implement its Final Solution policy which had as its aim the mass murder of the Jewish people in Europe. Built in Poland under Nazi German occupation initially as a concentration camp for Poles and later for Soviet prisoners of war, it soon became a prison for a number of other nationalities. Between the years 1942–1944 it became the main mass extermination camp where Jews were tortured and killed for their so-called racial origins. In addition to the mass murder of well over a million Jewish men, women and children, and tens of thousands of Polish victims, Auschwitz also served as a camp for the racial murder of thousands of Roma and Sinti and prisoners of several European nationalities.

(UNESCO, [1979] 2009)

From this point onwards Auschwitz became an increasingly international phenomenon, with visitors from all over the world. There was a dramatic rise in German visitors, for whom the site had both an educational and a redemptive quality. As Solidarity union members attacked the anti-semitism of the late 1960s a widespread reassessment of Polish–Jewish relations developed, in part prompted by Claude Lanzmann's nine-hour film *Shoah*, which had some harsh things to say about the indifference and even complicity of some Poles to the Jewish Holocaust. In 2007 Poland successfully petitioned UNESCO to change the title of the site to 'Auschwitz-Birkenau German Nazi Concentration and Extermination Camp (1940–1945)' to dispel any idea that the camps were Polish. By the 1990s, 500,000 people were visiting every year, and the museum was re-interpreted with a much clearer and more informative message, focusing explicitly on the fate of Jewish people. On 27 January 2005 world leaders assembled to celebrate the sixtieth anniversary of the liberation of the concentration and extermination camps. Auschwitz had by now become a universal symbol of evil, allowing every politician to draw their own conclusions from what took place, but focusing now primarily on the Holocaust.

The case of Auschwitz demonstrates how '**battles of memory**' surround any heritage site that touches a deep nerve in national consciousness. It was not only in Poland that explicit commemoration of the tragedy of the Shoah was delayed by several decades. While many of the buildings in Auschwitz remain, the buildings in the much larger Birkenau were allowed to rot or were sold off to local groups. Most of the sheds have now been removed. It is now a mutilated husk, retaining only the railway lines passing through the guard tower and dividing on either side of the reconstructed earth ramp, where Jews were assembled and separated into those earmarked for immediate death and those destined for forced labour. Remains of the underground gas chambers which have been blown up and traces of the other functions of death are left to the imagination. As Huener says:

> The 'silence' at Birkenau may suggest an unwillingness or even inability to approach and understand the past ... But, paradoxically, many visitors have since found the quiet, unvarnished, unheroic voice of Birkenau more effective in articulating the past. Although the lack of explanation and interpretation at Birkenau allowed for continuing ignorance, or even distortion of its history, the site was permitted to speak for itself. Unable to compete with the narrative drone of Auschwitz I, the voice of silence remained, for many, far more articulate.
>
> (Huener, 2003, p. 140)

Reflecting on the case study

The case of Auschwitz, as a site of the tourism of horror and trauma, shows how meanings associated with places are built up over time as a result of a number of different and often conflicting political and social factors. Many Polish people see it quite differently from the international Jewish community, for whom it has become a shrine of the whole Holocaust. As we have seen in each of the chapters of this book, heritage meanings are constructed by people as a kind of dialogue between those responsible for conserving and interpreting the site and those who visit and 'use' it for their own ends. Auschwitz is a particularly poignant example of a site whose significance extends vastly beyond the particular history and local conditions of its first existence. It has been generalised to represent all kinds of evil sustained by racist hatred. That this is so is in part quite independent of the aims of those who have created and managed the heritage site.

Aestheticisation and mutilation

We have seen that mutilation and aestheticisation have been two significant processes for managing 'bad' memories, such as those of National Socialism in Germany and Fascism in Italy. Mutilation, at the very least, means removing some of the direct references to Fascist or Nazi ideology, the symbols and emblems of the regime. It usually means changing the meaning of a work, but we have already seen that this always happens with heritage. Each generation changes the meanings of the objects left to it by previous generations, either intentionally or unintentionally. However, a respect for art as human expression and skill means that much of the political meaning in these works is left in place but conveniently ignored. In fact, the process whereby political art is stripped of its associations to become consumed as pure art is comparable to the processes by which all works of art lose part or all of their context and original meanings as they become High Art in a museum culture. For example, many Renaissance paintings that we look at in museums as 'Art' were originally designed to have a religious function and to be seen in a strongly religious setting.

The tension between allowing artefacts full of direct associations with 'bad' regimes to remain as part of the nation's heritage and the desire to demonstrate a critical condemnation of the regime often leads to a mixture of conservation and mutilation. A paradigmatic example of mutilation can be found in the universal practice of 'military castration'. Sculptures whose Fascist meanings are absolutely clear are rendered aesthetically available by the simple elimination of the index of military aggression. In Italy, as part of postwar 'purification', the ever-present 'fasces', symbols of Fascist control of life and death, were neutralised by the simple act of removing the blade of their axes.

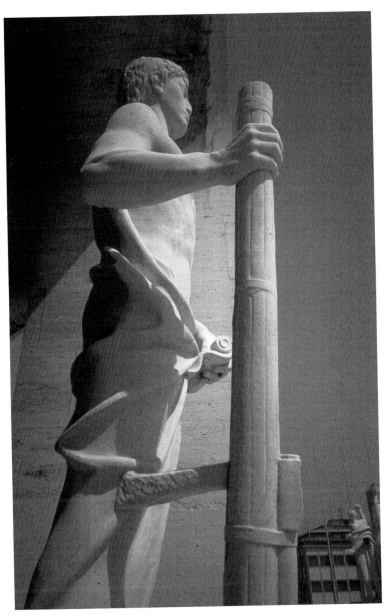

Figure 4.12 Statue of a lictor, 1939–40, on the Palazzo della Civilta Italiana, Esposizione Universale Roma, showing the removal of the axe blade (bottom right) after the war. Photographed by Tim Benton, 1994. Photo: © Tim Benton.

Thus, a statue on the Palazzo della Civilta Italiana, EUR, clearly represents the very Fascist figure of the lictor but the only censorship carried out by law was the removal of the axe blade.

It is difficult to see how this operation could neutralise the connotations of the lictor on a Fascist monument. But it seems to have been considered an acceptable form of mutilation which allowed the (rather mediocre) quality of the sculpture to be appreciated.

Political memorials in the Cold War

In the cases we have looked at so far, regime change has consisted of fairly decisive political shifts, from National Socialism to state Communism, or from Italian Fascism to Christian Democracy. A characteristic of these shifts has been the overt demonisation of what went before. The shift from anti-Fascist alliance to the complex politics of the Cold War was a more subtle and complex change. To create the new alliance that would defend Europe and the West from the threat of Communism meant drawing in the previous enemies – Germany, Italy and Austria – and quickly forgetting part of the trauma of their previous dominance. Some means had to be found to give the new alliance popular expression. But so much of recent history would appear to stand in the way of such cultural harmony.

An example of an attempt to use a monument to achieve political ends was the competition launched by the newly formed Institute of Contemporary Arts in London (ICA) (1951–3) for a monument to commemorate an unknown political prisoner. This was a clever subject, because it could appear to evoke both Fascist and Communist crimes against humanity. It has now been demonstrated that the substantial funds provided to promote this competition came from the American oil millionaire John Hay Whitney (Burstow, 1997). His offer was communicated to the committee by Anthony J.T. Kloman, an American in London who had just been appointed director of public relations at the ICA. Both Burstow and Kloman had links with the CIA, which was spending substantial sums in Europe trying to steer off the perceived threat of Communism.

The initial call for entries received such a big response (stated as 3500 but closer in fact to 2000 real entries) that a system of national screening committees had to be set up to weed out the entries. Kloman persuaded the countries with most entries (including Germany, Italy, France, the UK and the USA) to offer national prizes to the best entries in their countries, and to publicise the preliminary phase of the competition with an exhibition. These national exhibitions became in themselves strong expressions of 'free' artistic expression in which the modern and semi-abstract style of most of the contestants could be seen as a metaphor for the freedom provided to its citizens by democracies, compared to the censorship of the Communist regimes behind the Iron Curtain.

The international jury met in London on 7 March 1953 and announced the winners the next day. On 12 March the shortlisted sculptors were offered a

reception and their work was put on show at the Tate Gallery, where 30,000 people saw them (according to Kloman's report). Kloman used his media contacts with the British Film Institute to ensure that a film was made of the competition.

The winner of the Grand Prize (£4,500), Reg Butler, proposed an open work tower 40 metres high, placed on an outcrop of rock, with three women looking up at it. There was a project to turn Reg Butler's model into a key weapon on the front line of the Cold War. The mayor of West Berlin Dr Ernst Reuter proposed to offer a site on the Humboldt Höhe, directly opposite the pompous Soviet Victory Monument in East Berlin. This came to nothing and the full-size monument was never built. As soon as the exhibition of the winning maquettes had been staged at the Tate Gallery, Kloman returned to the USA, his mission accomplished. Butler's maquette was vandalised by an infuriated political refugee on this exhibition at the Tate and was subsequently restored, minus one of the three figures. These women (mother, wife and sister) conform to the pattern we saw in some war memorials in Chapter 2, but they were represented as such tiny forms in this model that they were usually ignored. Some of the prizewinners' work was completely abstract: the

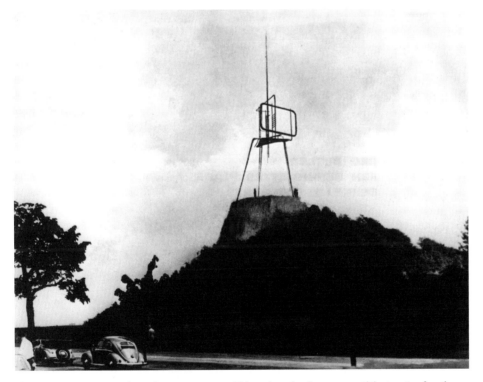

Figure 4.13 Reg Butler, Photomontage of his prizewinning competition entry for the *Monument to an Unknown Political Prisoner*, for an intended site in West Berlin, 1953. Photo: image courtesy of the Tate Archive, © Tate, London 2009. © The estate of Reg Butler.

Russian émigré brothers Antoine Pevsner and Naum Gabo proposed Constructivist works with no biomorphic point of reference. Others, such as Barbara Hepworth and Lynn Chadwick, interpreted human themes in their own way, but their work would have been considered completely abstract by most spectators.

There are two points to make about the form of the selected entries. They are a logical conclusion of the original aims of the competition, to promote modern art. But they also provide one solution to the very difficult brief of commemorating loss of liberty in totalitarian states. The form of the entries themselves, of a kind censured at the time in the Soviet Union, was intended as an expression of freedom. Most critics, especially in the UK, considered the competition to have been a failure in this political objective. For example, a radio programme including interviews with Reg Butler and three of the international jurors, Alfred Barr, Will Grohmann and Carl Sandberg, was transmitted in March 1953. In his introduction Basil Taylor described the competition as having 'fallen away in the end, into disorder and distrust, finally into apathy and boredom' (Henry Moore Institute, 1953, KLO, C2/2/2). Taylor's view was that such a serious topic could only have been successfully interpreted in a 'masterpiece' and that to obtain this would have required 'an exercise of sound patronage'. By this he meant choosing the best sculptor (he was probably thinking of a figure like Henry Moore, Alberto Giacometti or Picasso, none of whom contributed entries). But whatever problems abstraction posed for the general public and the popular newspapers, it allowed for the greatest degree of ambiguity as to the actual subject of the monument. The monuments could be interpreted as physical imprisonment, or exile, or even loss of intellectual freedom through censorship. But this ambiguity also led to criticism. The popular press was almost universally hostile, calling the models incomprehensible. The competition served the interests of the CIA because the process secured a lot of press coverage and all the publicity, good or bad, appeared to demonstrate a united West arguing over aesthetic judgements in a way that was impossible to imagine behind the Iron Curtain. Once again, it seems that activities associated with commemorative monuments are more important than the monuments themselves.

Conclusion

Monuments and sites commemorating world wars, genocide and other momentous historic tragedies form a very large sector of international heritage. In many ways, these sites project in starker form issues and debates that underlie all heritage activities. We have seen, in the first four chapters of this book, that the role of heritage sites and memorials in conserving memories and providing a focus for thinking about traumatic or contested histories is difficult to control and manage. The more traumatic or contested memories are, the

more difficult it is to design a monument that will serve both to assist public and private mourning and to build a confident and consensual future. Monuments such as the Cenotaph, with the very minimum of explicit iconographic references, tend to work better than very explicit representations of public figures, such as the monument to Earl Haig (see Chapter 2). This is partly because strategies for managing grief, mourning, anger and despair vary widely between individuals and groups. It is partly because momentous historical events throw up starkly different responses from different individuals or groups. Chinese memories of the Japanese occupation of Singapore and Malaysia are radically different from the British ones (see Chapter 3). No one monument could easily reconcile these differences. And this is just an extreme case of a general truth about how heritage works in society. Heritage sites are always an intersection between one or more 'official' strategies for commemorating the past and the responses of individuals, whose personal memories and experience can never be obliterated by official policies. For this reason, the formalisation of intangible heritage practices, such as the Moscow walks that we looked at in Chapter 1, are symptomatic of a much wider trend as the wave of conservation campaigns move into a second phase of reflection. Even 'official' heritage organisations – from museums to conservation agencies – now incorporate the idea of plural responses, of several publics rather than one, and of a dialogue between what individuals think and feel and what professionals consider to be important. But memorials also point up a general truth about heritage conservation: that the more sites and artefacts are aestheticised, to strip out the worrying and potentially divisive references to a traumatic past, the less power they tend to have for the general public. Heritage frequently works to keep these debates alive, by interpreting them in a way that reminds people of a contentious past, rather than emphasising aesthetic or age values. The lesson for all of us is that heritage must never be left to the professionals and that, paradoxically, it is in the interest of the professionals concerned to maintain an active public interest in the works in their care, to stimulate public debate and controversy about the meanings and values associated with public heritage.

Works cited

Alfieri, D., Luigi, F. and Partito Nazionale Fascista (Italy) ([1933] 1982) *Mostra della rivoluzione fascista: guida storica: 1. decennale della marcia su Roma*, Milan, Edizioni del Nuovo Candido.

Baltics Worldwide (n.d.) Stalin World [online], http://www. balticsworldwide.com/stalinworld/ (accessed 26 May 2009).

Benton, T. (2000) 'Epigraphy and Fascism', *The Afterlife of Inscriptions*, London, Bulletin of the Institute of Classical Studies, Institute of Classical Studies, School of Advanced Study, University of London.

Bevan, R. (2006) *The Destruction of Memory: Architecture at War*, London, Reaktion Books.

Burstow, R. (1997) 'The limits of Modernist Art as a "weapon of the Cold War": reassessing the unknown patron of the monument to an unknown political prisoner', *Oxford Art Journal*, no. 20, pp. 68–80.

Dolff-Bonekämper, G. ([n.d.] 2008) 'Sites of memory and sites of discord' in Fairclough, G., Harrison, R., Jameson, J.H. Jr and Schofield, J. (eds) *The Heritage Reader*, Abingdon and New York, Routledge, pp. 134–8.

Duck Record (n.d.), *Inni del Fascismo, vol. 3*, DGCD 3367.

Eco, U. (2005) *The Mysterious Flame of Queen Loana: An Illustrated Novel* (trans. G. Brock), London, Secker & Warburg (first published as *La misteriosa fiamma della regina Loana: romanzo illustrato*, Milan, Bompiani, 2004).

Ellick, A.B. (n.d.) From Zappa to Lenin: Lithuanian Sculptors Chronicle the Times through the Soviet Era to Today, Baltics Worldwide [online], http://www.balticsworldwide.com/from-zappa-to-lenin/ (accessed 12 June 2009).

Forty, A. (1999) 'Introduction' in Forty, A. and Küchler, S. (eds) *The Art of Forgetting*, Oxford, Berg Publishers, pp. 1–18.

Harrison, R. (2010) 'The politics of heritage' in Harrison, R. (ed.) *Understanding the Politics of Heritage*, Manchester, Manchester University Press/Milton Keynes, The Open University, pp. 154–96

Henry Moore Institute (1953) Kloman Archive, Leeds, Henry Moore Institute (March).

Hodgkin, K. and Radstone, S. (eds) (2003) *Contested Pasts: The Politics of Memory*, London and New York, Routledge.

Huener, J. (2003) *Auschwitz, Poland and the Politics of Commemoration, 1945–1979*, Athens, OH, Ohio University Press.

Kelikian, A.A. (1986) *Town and Country Under Fascism: The Transformation of Brescia 1915–1926*, Oxford, Clarendon Press.

Koshar, R. (2000) *From Monuments to Traces: Artifacts of German Memory 1870–1990*, Berkeley and Los Angeles, University of California Press.

Otero-Pailos. J., Gaiger, J. and West, S. (2010) 'Heritage values' in West, S. (ed.) *Understanding Heritage in Practice*, Manchester, Manchester University Press/Milton Keynes, The Open University, pp. 47–87.

Riegel, A. ([1902] 1982) 'The modern cult of monuments: its character and its origins', *Oppositions*, no. 25, pp. 25–51.

Rossi, A., Eisenman, P., Graham Foundation for Advanced Studies in the Fine Arts and Institute for Architecture and Urban Studies (1982) *The Architecture of the City*, Cambridge, MA, MIT Press.

Savona, A.V. and Straniero, M.L. (1979) *Canti dell'Italia Fascista*, Milan, Garzanti.

Simonini, A. (1978) *Il linguaggio di Mussolini*, Milano, Bompiani.

Suleiman, S.R. (2006) *Crises of Memory and the Second World War*, Cambridge, MA, Harvard University Press.

UNESCO ([1979] 2009) Auschwitz Birkenau German Nazi Concentration and Extermination Camp (1940–1945), Statement of Significance [online], http://whc.unesco.org/en/list/31 (accessed 27 May 2009).

Ventura, P. (1992) *Itinerari di Brescia moderna* (A Guide to Modern Architecture in Brescia), Florence, Alinea.

Walker, J. (2003) 'The traumatic paradox: autobiographical documentary and the psychology of memory' in Hodgkin, K. and Radstone, S. (eds) *Contested Pasts: The Politics of Memory*, London and New York, Routledge, pp. 104–19.

Whiteside, S. (2005) 'Umberto Eco: miracles in Milan', *Independent* (10 June).

Further reading

Burstow, R. (1989) 'Butler's competition project for a monument "to the unknown political prisoner": abstraction and cold war politics', *Art History*, no. 12, pp. 472–96.

Carman, J. (2003) 'Legacies of war in creating a common European identity', *International Journal of Heritage Studies*, vol. 9, no. 2, pp. 135–50.

Hodgkin, K. and Radstone, S. (eds) (2003) *Contested Pasts: The Politics of Memory*, London and New York, Routledge.

Light, D. (2000) 'An unwanted past: contemporary tourism and the heritage of communism in Romania', *International Journal of Heritage Studies*, vol. 6, no. 2, pp. 145–60.

Macdonald, S. (2006) 'Undesirable heritage: fascist material culture and historical consciousness in Nuremberg publishers', *International Journal of Heritage Studies*, vol. 12, no. 1, pp. 9–28.

Walsh, K. (2000) 'Collective amnesia and the mediation of painful pasts: the representation of France in the Second World War', *International Journal of Heritage Studies*, vol. 7, no. 1, pp. 83–98.

Chapter 5 Multicultural and minority heritage

Rodney Harrison

How can the different traditions, histories and expectations of communities in multi-ethnic and multicultural societies be accommodated by mainstream heritage management? In what ways might the alternative histories and heritages of different ethnic and social minorities within plural societies be seen to act as a challenge to the idea of a 'national' heritage? This chapter considers the ways in which heritage has been challenged by multiculturalism, transnationalism and subaltern studies, and how in multicultural societies heritage may become a key site for the production of collective memory. The challenge of multicultural heritage for the nation-state and the relationship between local and global heritage initiatives is considered with reference to case studies in heritage management from Cape Town, South Africa and New South Wales, Australia. The chapter considers the use of heritage to create particular forms of memory that shape the way in which people see themselves and their environment in the modern world, and the relationship between multicultural/minority heritage and social cohesion in diverse societies.

Introduction

The earlier chapters in this book have focused on the ways in which the memory of events associated with extreme violence, regime change and war might be accommodated by heritage. Chapters have considered how memories have been materialised by various forms of monumental construction, in a period in which it was largely believed that the extreme forms of violence characterised by the world wars were the product of totalitarian regimes. Given the strong connection between heritage and nationalism, one of the greatest challenges to heritage following the Second World War has been the growth of multi-ethnic societies, and the development of new voices which challenge the monolithic view of national heritage produced by the state. This chapter focuses on the ways in which national heritage might be seen to exclude the histories of subaltern and minority groups in society, and the ways in which such groups have developed a voice to challenge mainstream 'national' heritage. It connects some of the issues that have been discussed in relation to the early and middle part of the twentieth century in previous chapters to the late twentieth and early twenty-first centuries, when such forms of violence have now come to be understood to be the result not simply of totalitarian but also of contemporary liberal-democratic nations (Appadurai, 2006, p. 2).

Further, it looks at the ways in which the challenge of minority history, heritage and culture is transforming heritage practices in plural societies. The chapter forms a watershed within the context of this book, in that it shifts the focus from the heritage of the first half of the twentieth century to consider in more detail new developments in heritage and memory relating to the recent past, as well as looking towards the future of heritage.

Multiculturalism and plural societies defined

'Plural societies' are defined as societies containing multiple ethnic (and often racial) social groups of people who are economically interdependent. 'Race' here refers to human genetic variation (most often manifest in the perception of skin colour), but this term has acquired such negative connotations that it is little used, except in very broad terms. In the professional literature, 'ethnicity' refers to human groupings based on the belief in a common geographic ancestry. Unfortunately, 'ethnic' is often popularly used to refer to racial difference, and the term 'ethnic cleansing' refers to violence between groups within a specific geographic territory. Both 'race' and 'ethnicity' must be distinguished from 'cultural' groupings based on shared sets of beliefs, social practices and world views. Examples of plural societies in the contemporary world are abundant, the result of large-scale immigration in the second half of the twentieth century and the acceleration of transnational movements in the later part of the twentieth and the early twenty-first centuries. Many countries now contain large ethnic 'minorities', and some nations are composed of many different ethnic, racial and cultural groups. For example, the 2006 American Community Survey data show that more than 25 per cent of the US population identify racially as other than 'white alone' (see Table 5.1).

The term '**multiculturalism**' came into popular use in the 1970s to describe the development of a series of government policies, beginning in Canada and Australia, to manage the 'problem' of the existence of a wide number of different ethnic groups within a single nation (Ang, 2005). It needs to be set against previous government policies of assimilation of different ethnic and racial groups into a single, mono-cultural nation-state, and it represents an acknowledgement not only of the failure of the assimilation project but also of the positive aspects of cultural diversity. Multiculturalism was first officially adopted as government policy in Canada in 1971, in response to the 1963–9 Royal Commission on Bilingualism and Biculturalism, which had been set up to consider claims of injustice raised by the French-speaking minority located primarily in and around Quebec. The report of the commission recommended the Canadian government should formally acknowledge Canada as a bilingual and bi-cultural society, and should adopt policies to promote that diversity. Australia followed Canada in the adoption of formal policies of multiculturalism in 1973. Other contemporary western

Table 5.1 US racial census data

	Estimate	**% of population**
Total:	299,398,485	100
White alone	221,331,507	73.9253931
Black or African American alone	37,051,483	12.3753074
American Indian and Alaska Native* alone	2,369,431	0.79139712
Asian alone	13,100,095	4.37547137
Native Hawaiian and other Pacific Islander alone	426,194	0.14235009
Some other race alone	19,007,129	6.3484386
Two or more races:	6,112,646	2.04164226
Two races including some other race	1,390,337	0.46437677
Two races excluding some other race, and three or more races	4,722,309	1.5772655

*Alaskan convention for naming indigenous peoples collectively is the term 'native'
(US Census Bureau, 2006)

countries with explicit or implicit bi-cultural or multicultural policies at the national or federal level include the UK, the USA, New Zealand and South Africa.

While multiculturalism emerged as a novel concept in the 1970s among western industrialised nations, it had effectively existed in many countries (for example, India, Malaysia and Singapore) for decades, if not longer. Nonetheless, at the time of writing there are a number of nations, such as Korea, Japan and the Netherlands, who remain opposed to national policies which promote multiculturalism. Indeed, even in those countries where it has been adopted as formal government policy, there remains a significant critique of multiculturalism, often associated with right-wing/Conservative political interests. This has particularly been the case since '9/11' – the terrorist attacks on the US World Trade Center in New York and the Pentagon building in Virginia on 11 September 2001. In the wake of these and other terrorist activities focused on western countries and associated with radical Muslim extremists, many contemporary countries have hosted debates about the value of ethnic and cultural diversity, and many Muslims living in, or wishing to immigrate to, western countries have been the target of calls to limit or halt immigration (Ang, 2005). Multiculturalism is, at best, a contested topic, and one that is seen to have increasing significance in the early twenty-first century as governments struggle to maintain the nation-state in the absence of strict mono-cultural controls.

The definition of multiculturalism employed thus far has focused on explicit recognition of multiculturalism at the level of government policy. However, most of us would recognise multiculturalism by its manifestations within society rather than by the policies that operate at the level of government. While this is not the place for an extended discussion of all of the possible manifestations of multiculturalism, one example of a feature of multicultural societies is the recognition of multiple languages, which we see in Wales, Catalonia, Switzerland and parts of Canada for example, where two or more languages are recognised by the state. Another manifestation is the acceptance of minority dress which might contravene normal work or school-uniform policies, for example, the wearing of the *hijab* by Muslim girls in British schools. Legislation in the UK exempts turban-wearing Sikhs from some health and safety legislation, such as wearing crash helmets on motor cycles or safety helmets on building sites. Tolerance of minority or non-state religion is a further example of a feature of multicultural societies.

Multiculturalism and globalisation

Multiculturalism is integrally linked with globalisation. Anthropologist Arjun Appadurai suggests we might think of the term 'culturalism' as an active term denoting 'identities consciously in the making' (1996, p. 15). He discusses the phenomenon of **culturalism** in the light of the widespread emergence of ethnic nationalism and separatism that characterised the last decade of the twentieth century (for example, in the Balkan states and post-Soviet nations) which was coupled with the phenomenon of globalisation. He suggests that the ethnic violence that accompanied this ethnic nationalism was not a rebirth of 'tribalisms' or old histories but a new phenomenon relating to the employment of cultural differences to serve national or transnational political interests. Appadurai sees culturalism as linked closely to the idea of migration or succession of groups of people. These movements deliberately evoke aspects of history and heritage in the struggle between particular groups and the state.

One of the reasons why groups of people might feel the need to employ heritage more consciously to reproduce their identities in the late twentieth and early twenty-first centuries relates to the rapid acceleration of change (see further discussion in Chapter 8), and the state of mass migration and continual electronic mediation which are a part of globalisation.

> What is new is that this is a world in which both points of departure and points of arrival are in cultural flux, and thus the search for steady points of reference, as critical life choices are made, can be very difficult ... as the search for certainties is regularly frustrated by the fluidities of transnational communication. As group pasts become increasingly parts of museums, exhibits and collections, both in

national and transnational spectacles, culture becomes less what Pierre Bourdieu would have called a *habitus* (a tacit realm of reproducible practices and dispositions) and more an arena for conscious choice, justification, and representation, the latter often to multiple and spatially dislocated audiences.

(Appadurai, 1996, p. 44)

So when we think about multiculturalism it is perhaps better to think of multi-'culturalism', in the sense that multicultural societies are composed of one or more groups actively using various forms of representation to imagine themselves and their relationships not only with other groups of people but also with the nation-state. Similarly, the concept involves the work of the nation-state in imagining itself and its relationship with its citizens in particular ways, and the various economic and political implications of that work of imagination.

'History from below': Raphael Samuel and the new social history

During the 1960s and 1970s the idea of developing a 'total' history which included those who had been left out of previous historical writing – in particular women, children, people of different races and ethnicities, non-elites and the poor – became popular among academic historians and others working in related fields. In the UK, the phrase 'history from below' was popularised by a group of Marxist historians (Kaye, 1984), including Eric Hobsbawm (Hobsbawm and Ranger (eds), [1983] 1992) and Raphael Samuel (Samuel, 1994), both of whom commented on heritage and its relationship to this new form of social history. The group was concerned with explicating a Marxist economic approach that emphasised the social conditions of history rather than a narrative based on the lives of 'great men'. The term 'history from below' came to popularise their approach, which involved attempting to draw out the perceptions and 'voices' of people marginalised in the official texts of history (see further discussion in Chapter 1).

The 'history from below' approach was influential on the development of both feminist history and subaltern and postcolonial studies in the 1970s and 1980s. The term 'subaltern' refers to anyone of inferior rank or status, whether because of race, religion, class, caste, gender, age or sexual orientation. 'Postcolonial studies' describes a body of theory and literary criticism that concerns itself with how individuals and societies deal with the aftermath of colonial rule. Palestinian American literary and cultural critic Edward W. Said's book *Orientalism* (1978) argues that the historical relations of power and domination between coloniser and colonised produced, and were produced by, a perception of the colonial subject as 'other' to the West

(see further discussion in Harrison and Hughes, 2010). Subaltern studies have been influenced both by postcolonial theory and approaches that emphasise 'history from below'. A feature of writing on multiculturalism has been to draw attention to the lack of coherence between race, ethnicity and national identity in the twentieth and twenty-first centuries (Ang, 2005).

Multiculturalism and heritage

Many authors and critics have noted the close connection between heritage and nationalism (see Allen, 2010; Harrison, 2010). Graham, Ashworth and Tunbridge (2000, pp. 55–6) note:

> The origins of what we now term heritage lie in the modernist nexus of European state formation and Romanticism, which is defined in political terms by nationalism. While these nineteenth century European nationalisms evolved many different trajectories, they shared in the mutual assumption of modernity that all people of 'a similar ethical rationality might agree on a system of norms to guide the operation of society'.

The authors suggest that the canon of heritage developed as one of a set of discourses used to frame the idea that all members of a nation would share the same ideas and the same systems of norms. They continue:

> Hence nationalist discourses are sited within a sense of limitless change and advance which, in turn, demanded the creation of modernistic, progressive, linear heritage narratives that sought to subsume the diversity and heterogeneity of the everyday world. These were combined with assumptions of long-term continuities of culture, place and allegiance and constructed to lead directly to the contemporary nexus of power, providing the precepts and traditions which underpin the legitimacy of that authority.
>
> (Graham, Ashworth and Tunbridge, 2000, p. 56)

Nations combine the idea that societies must hold shared cultural beliefs with heritage in order to root those beliefs, and the structures of power and authority that underlie them, in the past. In doing so, they connect these beliefs closely to the idea of racial and ethnic origins.

Another important aspect of heritage and its use in the production of nation lies in the use of heritage to produce origin myths (see West and Ansell, 2010) which establish not only the norms of the current system of political and social power in individual societies, but also the series of behaviours and systems of class, gender and ethnic (or racial) inequalities on which such power rests. In the words of sociologist Stuart Hall, heritage is a

part of the 'educative apparatus' of the state which creates a sense of belonging to the nation:

> We should think of The Heritage as a discursive practice. It is one of the ways in which the nation slowly constructs for itself a sort of collective social memory. Just as individuals and families construct their identities in part by 'storying' the various random incidents and contingent turning points of their lives into a single, coherent, narrative, so nations construct identities by selectively binding their chosen high points and memorable achievements into an unfolding 'national story' ... Like personal memory, social memory is also highly selective, it highlights and foregrounds, imposes beginnings, middles and ends on the random and contingent. Equally, it foreshortens, silences, disavows, forgets and elides many episodes which – from another perspective – could be the start of a different narrative. This process of selective 'canonisation' confers authority and a material and institutional facticity on the selective tradition, making it extremely difficult to shift or revise. The institutions responsible for making the 'selective tradition' work develop a deep investment in their own 'truth'.
>
> (Hall, S. [1999] 2008, p. 221)

Appadurai ([2001] 2008, p. 210) has similarly called archaeology and heritage a 'key site through which the apparatus of nations can reflect the politics of remembering'. This is reflected, for example, in the case study of the Moscow walks in Chapter 1.

Archaeologist Laurajane Smith (2006) has suggested that there is an authorised heritage discourse (AHD) which is a set of ideas, practices and texts about heritage that regulate professional heritage practice and determine what heritage is perceived to be, and conversely, what it is not. The AHD protects this 'deep investment in the truth' of the heritage constructed by the state. It may exclude marginalised groups because it 'sets in stone' a particular set of ideas about what heritage 'is', which is closely linked to a series of normative narratives relating to nationhood and excludes alternative ideas about the past and the function and forms that heritage should take.

> The AHD as a source of political power has the ability to facilitate the marginalisation of groups who cannot make successful appeals to or control the expression of master cultural or social narratives.
>
> (Smith, 2006, p. 192)

We explore some of the ways in which heritage might exclude or marginalise minority groups in plural societies later in this chapter. Meanwhile, we look in the next section at the different forms of plural society and the function of heritage within each of them as background to this discussion.

A typology of plural societies

As we have seen in Chapter 3, Ashworth, Graham and Tunbridge have considered the role of heritage in plural societies in their book *Pluralising Pasts* (2007). In doing so, they develop a typology of forms of plural societies that can help us to understand not only the different forms plural societies take but also the role of heritage in each of them. The five different forms of plural society identified by Ashworth, Graham and Tunbridge (pp. 72–87) were introduced in Chapter 3; they are summarised in more detail below.

Assimilatory, integrationist or single-core societies (2007, pp. 72–6) accept only a single core set of values and cultural norms. Where immigrations occur, people are forcibly and quickly assimilated. Ashworth, Graham and Tunbridge suggest that contemporary examples of such ethnically exclusive societies can be seen in Japan and Korea. In government policy, terms such as 'integration' will be put forward to deal with what is perceived to be the 'problem' of temporary cultural diversity which arises in the case of immigrants entering the society. Heritage in such societies is focused on assimilating outsiders while affirming the cultural norms of insiders.

Melting-pot societies (2007, pp. 76–9) are best thought of as 'creole' societies in which a number of immigrant groups are thrown together and produce a new series of values and cultural norms that are different to any of the constituent ones. Ashworth, Graham and Tunbridge note that melting-pot societies share with assimilatory societies the goal of producing a single core set of values. They suggest that examples of such societies can be seen in the creation of newly independent states such as Indonesia or the Philippines, and in some settler colonies such as Australia, Canada, New Zealand and the USA (although these countries can also be seen to have, at different times, manifest features of both core+ and mosaic societies in their relationships with **indigenous people** – see below). Heritage in such societies promotes the abandonment of previous cultural 'baggage' for a new series of heritage values that are strongly focused in the geography of the new country. Such societies have a need quickly to establish a series of cultural norms, and thus the issue of 'heritage' will be more important than in older and better established nation-states. Melting-pot societies may quickly shift to become assimilatory societies once a series of cultural norms has been established, as is generally the case in settler colonies such as Australia.

Core+ societies (2007, pp. 79–82) are composed of a strong and well-established ethnic core group to which is added one or more well-defined minority cultural groups for whom no attempt is made at assimilation. Ashworth, Graham and Tunbridge suggest that contemporary examples can be seen in the relationship between various western European liberal-democratic countries and what are perceived to be 'relic nations', for example, the English and Welsh, Spanish and Catalan, and French and Basque. Core+ models

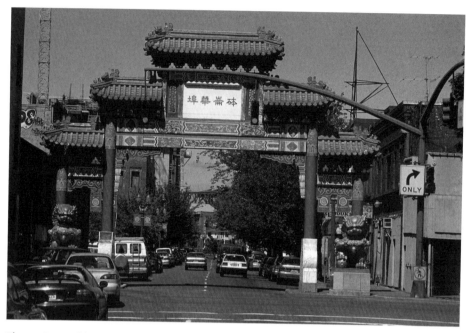

Figure 5.1 Chinatown gate, Portland, Oregon. Photographed by Bruce Forster. Photo: © Bruce Forster/dk/Alamy. Such precincts are a feature of heritage in core+ or mosaic societies.

generally form out of historical circumstance, rather than official policy, and as such heritage will have multiple roles in these societies, depending on whether the 'add-on' culture is perceived to pose the threat of culturally swamping or assimilating the core. As they are largely unstable, heritage policy may shift with changing views of the relationships between the groups. In some instances, heritage will be used, as in single core and core+ societies, to affirm the values and cultural norms of the core group and exclude those of the add-on, while in other instances it may function to promote these values to the add-on group through 'social inclusion' policies. Heritage may also sometimes function to make the culture of the add-on group temporarily available and comprehensible to the core group, through the creation of spatially delineated forms of heritage: for example, 'Chinatown' precincts within cities with Chinese residents (Figure 5.1). Core+ societies may evolve into other models, and are often reasonably temporary forms of society in which heritage policies will shift with time. This is because they are generally unstable as forms of society.

Pillar societies (2007, pp. 82–4) are fragmented societies containing multiple self-contained and disconnected cultural groups. Although maintaining the superstructure of a unified state, this form of society is conceived of as supported by a series of distinct 'pillars', each one maintaining separation from the others and each one managing its own distinct social and cultural norms. Ashworth, Graham and Tunbridge (2007, pp. 82–3) see examples in

post-Reformation Netherlands, and during apartheid-period South Africa. However, they note that in South Africa under apartheid there was no sense of the 'separate-but-equal' egalitarianism that existed between Protestant and Catholic pillars in the Netherlands, and that physical separation based on race was impossible to maintain due to the dependence of white Afrikaners on non-white labour. In pillar societies each group manages its own heritage. The role of the state is not to encourage mutual understanding as in core+ models but simply to manage equal provision of resources to each of the pillar groups. Once again, such societies tend to be reasonably temporary and tend to shift into other forms with time. Heritage policies will also shift to reflect this (as, indeed, has been the case in South Africa, which has developed into a mosaic society following the end of apartheid – see the further discussion later in this chapter).

Finally, *salad-bowl or mosaic* societies (2007, pp. 84–6) represent societies with explicit policies of multiculturalism or pluralism. At a government level, multicultural policies can be descriptive, simply recognising the existence of plurality in society, or prescriptive, in which case social policies will be established to foster, create or strengthen racial, ethnic and/or cultural diversity. Possible approaches to heritage include policies that focus on making heritage available to all members of society, or exclusive policies that seek to recognise and empower each distinct group in the management of its own heritage, with a focus on mutual understanding of each group's heritage. Clearly, there is a tension in such societies that will be manifest in heritage between fostering individual group identity and making heritage available to all members of society. Ashworth, Graham and Tunbridge (2007, p. 85) also identify the difficulties of spatial scale (at a national level cultural diversity may be apparent, but at the local level it may seem irrelevant), scale of group definition (individual, local, regional or national) and the necessity for over-arching policies that bind the various groups together and that may conflict with the encouragement of diversity. Examples of contemporary mosaic societies include Canada, Australia and post-apartheid South Africa, although all display some features of other approaches to heritage which to a large extent undermine their apparent goal of multiculturalism (Ashworth, Graham and Tunbridge, 2007, pp. 180–206). Some of these contradictions in Australia's heritage policies are explored in the first case study in this chapter.

It is clear from Ashworth, Graham and Tunbridge's survey that 'national' heritage may have very different goals in different forms of plural or multicultural society. We also need to be mindful of this as an idealised model, and as such, features of different models might be seen to be present within a single society. For example, returning to the case studies in Chapter 3, both Singapore and Malaysia could be said to belong to the core+ typology,

although heritage is managed very differently in each of them. Nonetheless, this does not diminish the value of these models in helping us think about the role of heritage in different kinds of plural society.

UNESCO, multicultural heritage and diversity

UNESCO, the United Nations Educational, Scientific and Cultural Organization, is responsible for, among other things, managing the **World Heritage List** through its World Heritage Committee. On 2 November 2001, following the recommendations of its World Culture Report titled Cultural Diversity, Conflict and Pluralism (UNESCO, 2000), UNESCO issued its Universal Declaration on Cultural Diversity (UNESCO, 2002). The declaration, which the report itself notes was issued in the wake of the 9/11 attacks, makes a unique claim: that cultural diversity is itself part of the common heritage of humanity:

> **ARTICLE 1 Cultural diversity: the common heritage of humanity**
> Culture takes diverse forms across time and space. This diversity is embodied in the uniqueness and plurality of the identities of the groups and societies making up humankind. As a source of exchange, innovation and creativity, cultural diversity is as necessary for humankind as biodiversity is for nature. In this sense, it is the common heritage of humanity and should be recognized and affirmed for the benefit of present and future generations.
>
> (UNESCO, 2002, p. 13)

Further, it suggests that the promotion of cultural pluralism is a key aspect of social cohesion in plural societies:

> **ARTICLE 2 From cultural diversity to cultural pluralism**
> In our increasingly diverse societies, it is essential to ensure harmonious interaction among people and groups with plural, varied and dynamic cultural identities as well as their willingness to live together. Policies for the inclusion and participation of all citizens are guarantees of social cohesion, the vitality of civil society and peace. Thus defined, cultural pluralism gives policy expression to the reality of cultural diversity. Indissociable from a democratic framework, cultural pluralism is conducive to cultural exchange and to the flourishing of creative capacities that sustain public life.
>
> (UNESCO, 2002, p. 13)

The declaration makes a clear link between cultural diversity and human rights:

ARTICLE 4 Human rights as guarantees of cultural diversity
The defence of cultural diversity is an ethical imperative, inseparable from respect for human dignity. It implies a commitment to human rights and fundamental freedoms, in particular the rights of persons belonging to minorities and those of indigenous peoples. No one may invoke cultural diversity to infringe upon human rights guaranteed by international law, nor to limit their scope.

(UNESCO, 2002, p. 13)

It attempts to tackle the problem of the requirement of different cultural groups to defend a common heritage in times of conflict or threat and the need to promote cultural diversity by expressing them as two sides of the same human impulse. In his introduction to the declaration, Director-General of UNESCO Koïchiro Matsuura notes:

The Universal Declaration makes it clear that each individual must acknowledge not only otherness in all its forms but also the plurality of his or her own identity, within societies that are themselves plural. Only in this way can cultural diversity be preserved as an adaptive process and as a capacity for expression, creation and innovation. The debate between those countries which would like to defend cultural goods and services 'which, as vectors of identity, values and meaning, must not be treated as mere commodities or consumer goods', and those which would hope to promote cultural rights has thus been surpassed, with the two approaches brought together by the Declaration, which has highlighted the causal link uniting two complementary attitudes.

(UNESCO, 2002, p. 11)

The declaration was followed by the Convention on the Protection and Promotion of the Diversity of Cultural Expressions (UNESCO, 2005). The convention puts into practice the principles of the declaration and establishes the rights and obligations of member parties to the convention. Its objectives, among others, are

(d) to foster interculturality in order to develop cultural interaction in the spirit of building bridges among peoples; [and]

(e) to promote respect for the diversity of cultural expressions and raise awareness of its value at the local, national and international levels.

(UNESCO, 2005, p. 3)

The term 'interculturality' 'refers to the existence and equitable interaction of diverse cultures and the possibility of generating shared cultural expressions through dialogue and mutual respect' (UNESCO, 2005, p. 5), while 'cultural diversity'

> refers to the manifold ways in which the cultures of groups and societies find expression. These expressions are passed on within and among groups and societies. Cultural diversity is made manifest not only through the varied ways in which the cultural heritage of humanity is expressed, augmented and transmitted through the variety of cultural expressions, but also through diverse modes of artistic creation, production, dissemination, distribution and enjoyment, whatever the means and technologies used.
>
> (UNESCO, 2005, pp. 5–6)

However, many member states including Australia and the USA have not at the time of writing ratified the convention. One way in which the convention might be considered to be problematic is the fact that it reaffirms on the one hand the sovereign rights of states to maintain, adopt and implement 'policies and measures that they deem appropriate for the protection and promotion of the diversity of cultural expressions on their territory' (UNESCO, 2005, p. 3), and on the other hand the diversity of cultures as a fundamental human right. We have already seen how the perception of the state regarding its interest in promoting diversity, and the diversity of culture itself, might be very different things. Ethnic minorities in single-core or core+ societies would clearly be in a very vulnerable position in relation to the state and what it deems its 'sovereign rights'.

Multicultural heritage and the nation-state

Earlier in the chapter we considered Arjun Appadurai's work on globalisation to help understand the relationship between multiculturalism and globalisation. He suggested that heritage is one of a series of tools that might be used by people who experience the world in a state of flux, and who wish to continue to maintain relationships with groups of people across national borders, in order that they might actively imagine themselves and their relationships with the nation-state in particular ways (see also Chapter 8). Further, he suggested that in circumstances of rapid or constant change heritage becomes an area for conscious deliberation and justification. In this part of the chapter we now focus on heritage and the politics of difference in plural societies, and the ways in which minorities (and by extension, monitory and multicultural heritage) might be considered by the state to be a threat.

Appadurai's *Fear of Small Numbers* (2006) considers the connection between globalisation and extreme culturally motivated ethnic violence in the

genocides that occurred in the 1990s in eastern Europe, Rwanda and India, and in the 2000s in what was termed the 'war on terror'. He begins by noting that globalisation has produced a new level of uncertainty due to the speed and rate at which people, technology, money, images and ideas can cross national borders. 'Globalisation ... challenges our strongest tool for making newness manageable, and that is the recourse to history' (2006, pp. 35–6). Under some circumstances the existence of a new category of minorities within society becomes a focus for anxiety caused by such uncertainty:

> Minorities, in a word, are metaphors and reminders of the betrayal of the classical national project. And it is this betrayal – actually rooted in the failure of the nation-state to preserve its promise to be the guarantor of national sovereignty – that underwrites the worldwide impulse to extrude or eliminate minorities.
>
> (Appadurai, 2006, p. 43)

He suggests that it is not the large size of the minority or a high level of cultural difference that create the most anxiety for nations but the *small* size of the group and the cultural gap between it and the majority that is most likely to cause friction and erupt into ethnically motivated violence, when one group begins to perceive itself as a *threatened majority*. He terms such threatened majorities 'predatory identities'

> whose social construction and mobilisation require the extinction of other, proximate social categories ... [which] emerge out of pairs of identities ... which have long histories of close contact, mixture and some degree of mutual stereotyping ... [in which is involved] some degree of contrasting identification.
>
> (Appadurai, 2006, p. 51)

These predatory identities seek to close the gap between majority and national identities by excluding minority 'others'.

Coupled with this anxiety has been the global discourse on human rights, which has to a large extent focused on the cultural rights of particular minorities in societies. At the global level, after the creation of the United Nations and in particular the 1948 Universal Declaration of Human Rights (United Nations, [1948] n.d.), social and cultural minorities came to be seen as invested with rights that became the focus of anxiety and that were greeted with ambivalence by almost all states:

> conflicts accelerated in the 1980s and 1990s, during which many nation-states had to simultaneously negotiate two pressures: the pressure to open up their markets to foreign investment, commodities and images and the pressure to manage the capacity of their own cultural minorities to use the globalized language of human rights to argue for their own claims for cultural dignity and recognition. This ...

produced a crisis in many countries for the sense of national boundaries, national sovereignty, and the purity of the national ethnos, and it is directly responsible for the growth of majoritarian racisms in societies as diverse as Sweden and Indonesia as well as Romania, Rwanda, and India.

(Appadurai, 2006, p. 65)

Prompted by the Declaration of Human Rights, the discourse of human rights relating to minorities invested heavily in the purity of race and a discourse of culture, language, history and, more generally, 'heritage'. This meant not only that such minorities came to be perceived by the state as a threat to national sovereignty, but also that the state came to adopt the same discourse in relation to threatened majorities, which allowed it to justify and perpetuate racialised forms of violence and ethnic cleansing.

These issues explain why minority and multicultural heritage might be perceived to be a threat by nation-states and by majority cultures within them. Where minorities within societies seek to use heritage as a tool to maintain effective links with groups of people and ideas existing outside national boundaries, the state may perceive this as a threat to its ability to reproduce an image of itself as a nation. Further, the maintenance of multicultural and minority heritage may create tensions within majority groups which cause them to become predatory and to seek to close the gap between majority and minority heritage in the way described by Appadurai above. The majority develops the idea that to maintain itself and its heritage it must destroy or purge itself of other forms of minority heritage. As Appadurai notes elsewhere:

national imaginations require ... signatures of the visible, and ... museums and archaeology are about signatures of the visible ... the general business of retrieving the past, remembering, materialising that memory and further commemorating it, leads directly to the business of the nation, and does so through certain regimes or techniques of truth provided mainly by archaeology [as heritage].

(Appadurai, [2001] 2008, p. 215)

We can see similarities here with what Ashworth, Graham and Tunbridge (2007) describe as the function of heritage within plural societies, and in particular within core and core+ societies. In some cases, however, a different strategy emerges: a dominant group may find it opportune to celebrate the heritage of subaltern groups precisely as a means of disguising its authority behind a screen of liberal even-handedness. Furthermore, the professional castes that manage heritage do not always follow the state agenda, being motivated by specific aesthetic or specialised interests.

Both of the case studies in this chapter examine the relationship between nationalism and minority heritage in plural societies. The first study, below, looks at the ways in which heritage can be used in plural societies to exclude particular minorities from national historical narratives, and hence from a sense of belonging to the nation and its history, using the case of the Indigenous Australians and the heritage of cattle and sheep ranching in Australia. While Australia has an explicit multiculturalism policy, and could therefore be considered a mosaic society in the typology discussed above, it has long had a strong colonial tendency towards assimilation, and its relationship to heritage is generally seen as reflecting its historical values as an assimilatory society. The case study itself, which was sponsored by a state government heritage agency (see Harrison, 2004), shows the way in which the transformation from an assimilatory to a mosaic society is accompanied by changes in ways of thinking about heritage and minorities within such societies.

Case study: Indigenous Australians and pastoral heritage

In the early 2000s I undertook a study of the heritage of the cattle- and sheep-ranching ('pastoral') industry in the state of New South Wales (NSW), Australia (Harrison, 2004). As I will go on to explain, this extensive form of livestock grazing has formed one of the most important domestic and export industries throughout much of the country's history. Its physical heritage consists of the many remains of pastoral homesteads, dwellings and outbuildings, shearing sheds, paddocks and yards, long stretches of fencing and a network of travelling stock routes that criss-crossed the country from cattle and sheep station to market and port. Much of this physical heritage is now caught up within a system of reserves and national parks, as changes in world markets, the widespread industrialisation of the work and land degradation have conspired to make it impossible for some properties to continue as commercial ventures. Management of the physical remains of these pastoral ventures often sits uncomfortably with the aims of such organisations, whose interests lie primarily in the rehabilitation of natural landscapes. Nonetheless, these physical remains are often interpreted and re-used as visitor and tourist facilities, and form the focus for the interpretation of local land use histories in these national parks (Figure 5.2).

One of the observations that came out of this study was the way in which – in the interpretation surrounding the heritage of such places – the integral role of Indigenous Australians as a labour force in the pastoral industry in Australia had been erased by the selected emphasis on the histories of the white owners/ managers and their families. This had been effected in three ways. In the first

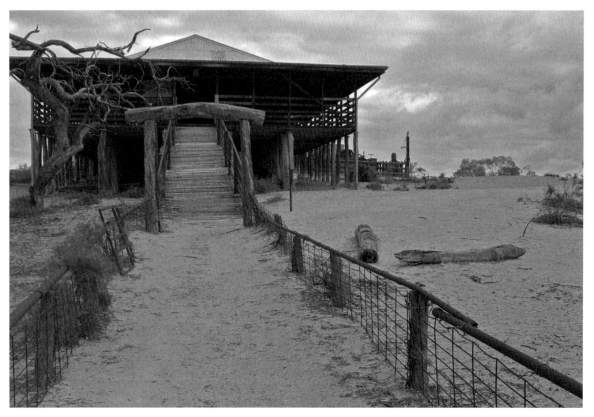

Figure 5.2 Kinchega woolshed; a historic 'shearing shed' in western New South Wales dating to the late nineteenth century, now managed as part of Kinchega National Park. Photographed by Geoff Main. Photo: © Geoff Main.

instance, Indigenous Australian heritage was managed in a way that separated it from historic/settler heritage and emphasised its existence in the deep, pre-European past (see also Harrison and Hughes, 2010). In the second instance, the interpretation of pastoral heritage was undertaken in a manner that tended to discuss only the lives of the (almost exclusively) white managers and owners of historic cattle- and sheep-ranching properties. Third, a focus on the built heritage of the industry – the woolsheds and homesteads – had taken the emphasis away from the oral accounts of those who had laboured within the industry – accounts that might reveal the intimate attachment of Indigenous and working-class settler Australians with the industry.

The image of Australia's national fortune riding 'on the sheep's back' is a persistent stereotype that relates to deep historical structures involved with Australian nationalism and identity. The history of the pastoral industry is linked to pervasive pioneer mythologies that are common to settler societies in the New World. The pastoral industry has played a major role in the history of both the Australian nation and the state of NSW, particularly as a land use that

opened up the vast arid and semi-arid rangelands to non-indigenous settlement and occupation. The development of rangeland grazing in the semi-arid inland of the Western Division in the 1850s and 1860s, for example, turned what had previously been considered, in the colonial vision, 'wastelands' into profitable agricultural lands. The heritage of the cattle- and sheep-ranching industry is an integral part of the way in which Australia promotes and understands its pioneering past; and yet, in general terms, the heritage of the pastoral industry has been promoted as one belonging to European settlers, and one from which Indigenous Australians have largely been excluded. This picture is historically inaccurate.

To understand how extreme has been the erasure of Indigenous Australians' histories from this industry, it is necessary to consider briefly the history of the industry itself and **Aboriginal people**'s role in it. I limit my comments in this case study to the state of NSW, which was the focus of my original study, and look particularly at the period 1850–1950, during which the bulk of the places now managed as pastoral heritage in the state were established. These issues have been considered in more detail in Harrison (2004, 2008).

Dual occupation

In the last years of the nineteenth century Australia was producing the biggest wool clip in the world, and was the major provider of raw wool to the mills of northern England and Europe. From 1860 to 1890 the success of the wool industry in the colonies (until Federation in 1901 Australia was composed of six separate British self-governing colonies) stimulated a rapid expansion of pastoral runs and led to their consolidation in the late 1800s, both of which placed serious pressures on Aboriginal landowners. A continuing issue for British land reformers in the early to mid-1800s was the recognition of Indigenous Australians' property rights in land. The British Colonial Office, in response to lobbying from these humanitarian and reformist groups, was forced to recognise 'native title' and usage rights over pastoral lands in NSW in the 1840s (Goodall, 1996).

In 1849 Earl Grey, the secretary of state for colonies – who was sympathetic to reformists' demands – instructed Governor Fitzroy to enforce an interpretation of the legislation governing land tenure to guarantee Aboriginal people access to their traditional lands. This was to be in the form of 'dual occupancy' with pastoralists: a situation where Aborigines and squatters had 'mutual rights'. Grey argued that Crown leases to pastoralists allowed only limited rights, and that much of the rights of possession remained 'reserved' to the Crown. Further, Grey called for the establishment of small, agricultural reserves for Aboriginal people. In 1850 around forty of these areas were approved as reserves across the new pastoral districts outside the nineteen counties (Goodall, 1996).

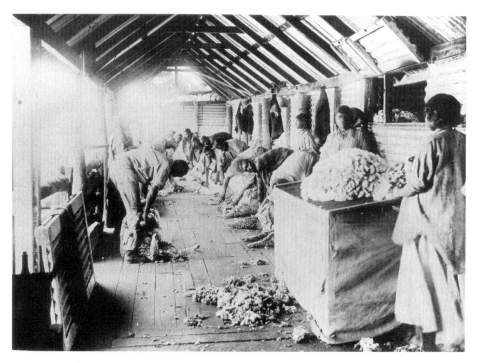

Figure 5.3 Aboriginal shearing team on Corunna Downs Pastoral Station, 1906.
Unknown photographer. Courtesy State Library of Western Australia, The Battye Library,
call number 001304D.

The transportation of convict labour to NSW ended in the 1840s, and the
discovery of gold in the 1850s produced an employment gap in the
burgeoning pastoral industry which was met by Aboriginal men and women.
Many Aboriginal men and women were employed as stock workers, shearers
and shepherds at this time. While in most instances this work was undertaken
simply in return for rations, in some cases Aboriginal labourers received cash
wages that were equal to those earned by white labourers. This was most
notable in the shearing sheds (Figure 5.3). Aboriginal women were employed
on sheep stations as domestic workers as well as outdoor labourers, and
occasionally also as shearers. Aboriginal children often assisted their parents
with domestic tasks and labouring work, such as feeding and tending goats
and pigs, and watering homestead gardens and orchards. This was particularly
the case where Aboriginal people formed large resident encampments on, or
close to, pastoral stations.

During the early 1850s Aboriginal labour was important not only in
shepherding and shearing but also on cattle ranches. In this industry, where
cattle were mustered at regular intervals rather than tended all the time, there
was less need for continuous labour, particularly after the introduction of
perimeter fencing in the 1860s which allowed cattle to be maintained without
the need for regular herding. The presence of an Aboriginal camp on or near

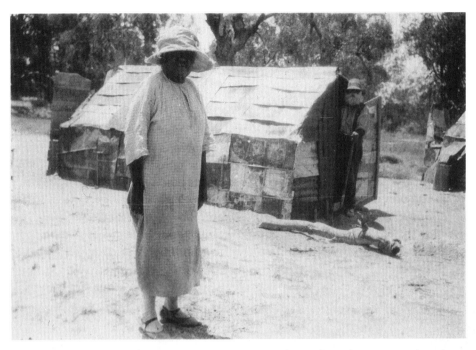

Figure 5.4 Aboriginal dwelling on 'Albermarle' station, Wilcannia, New South Wales. Photographed by Lola Murray. Mitchell Library, State Library of New South Wales, Sydney, call number BCP 06800. Aboriginal pastoral labourers would often live on or adjacent to large pastoral properties and homesteads on which they worked. Such places have generally not been actively conserved or interpreted as an aspect of pastoral heritage in Australia until very recently.

a pastoral cattle property was important to this irregular seasonal pattern of the industry (Figure 5.4). During the off-season the Aboriginal community would often return to their kin in the 'bush', and until the twentieth century would largely support themselves on wild bush food; during the busy periods they could be recruited rapidly. Camps established during the 1850s on the big runs continued for as long as the properties remained large enough to require significant numbers of seasonal workers, and to have a low enough stock density to allow the modified continuation of a subsistence economy for Aboriginal workers and their families.

Pastoralists came to value the importance of Aboriginal knowledge of the land to locate feed, water and stock across vast distances. The work of shepherding and droving often gave Aboriginal people a relative sense of autonomy, the potential to continue ceremonial activities and hunting and gathering, and the opportunity to travel relatively widely through their country. This was in marked contrast with settlers, for whom it was often lonely, monotonous work in alien land.

Aboriginal people were recruited from the extended family groups already resident on their land or seeking to return to it. They were embedded in a social network that was itself directly attached to the land. This offered a strong continuity in labour for the pastoralists in contrast to the rapid turnover of white workers. Aboriginal people also trained their young men and women in stock work, as well as in the knowledge of the country that made their work so valuable.

In later years, as more white workers became available, pastoralists reduced the cash component of Aboriginal workers' wages to virtually nothing, or entrapped it in the accounts book of the property store. By the beginning of the twentieth century, Aboriginal workers from resident camps were still making up around 30 per cent of pastoral labour in north-west NSW, but they were increasingly relegated to casual or seasonal jobs while the better-paid permanent jobs were for white employees (Goodall, 1996, p. 62). In the twentieth century, as the gold rush slowed and other economic and environmental factors impacted on the industry, the levels of Aboriginal workers in the pastoral work fluctuated. However, in most areas Aboriginal women and men had created a distinctive place for themselves in the rural workforce.

The subdivision of properties that began before the First World War accelerated with the introduction of a Soldier Settlement Scheme. Following both world wars, large parcels of Australian farming lands were purchased, divided up into small blocks and given to returned soldiers by the federal government. Land was made available through subdivided Crown lands, unsettled or leasehold holdings, farming allotments carved from state government purchased estates, and individual farms bought by the State Land Settlement Authority.

The Soldier Settlement Scheme, along with broader economic conditions, changed the social landscape of pastoralism for both Aboriginal people and settlers during the 1930s. Intensive grazing, interference with water supplies, the shooting of native game and the postwar subdivision of properties, coupled with the 1930s economic depression, the intrusion of the Aborigines Protection (and later Welfare) Board and the dispersal of Aboriginal communities by these government agencies altered the social landscape. Family-sized Soldier Settlement blocks needed few if any permanent workers and had neither the means nor the need to support an Aboriginal camp, as the larger pastoral properties had done in earlier periods.

This was a time of increasing government control over Aboriginal people in rural areas. By the 1930s in most parts of NSW nearly all Aboriginal pastoral workers were either 'fringe dwellers' occupying the margins of towns or pastoral encampments, or 'clients' of the Aborigines Protection Board. The labour roles of Aboriginal women had largely been superseded, and pastoral work for men tended to be limited to contract shearing and stock work.

Long (1970) notes that by 1930 there was a major increase in the populations of supervised reserves, when large numbers of Aboriginal people found themselves out of work after it was made obligatory to pay Aboriginal workers the same wages as white workers. The Aborigines Protection Board (1909–39) and later Aborigines Welfare Board (1940–69) forcibly removed Aboriginal people from 'fringe camps' to reserves and managed stations throughout this time.

Heather Goodall (1995, pp. 84–7) describes the policies of the Aborigines Protection Board after 1934 in terms of systematic segregation, as it sought to concentrate Aboriginal people throughout NSW into a limited number of supervised reserves. By 1935 many Aboriginal people had been forced off smaller unsupervised reserves, many of them self-established farms, and the population of the small number of supervised reserves doubled. The 1936 amendments to the Aboriginal Protection Act dictated that Aboriginal people would be confined on reserves until they had been educated so that they could be assimilated into white society. This was one of the major contributing factors during the middle part of the twentieth century to challenge and severely undermine the relative stability of relationships between Aboriginal people and pastoralists that had been established during the period 1855–1930.

The introduction of mechanisation in the pastoral economy, notably the increasing availability and use of utilities and trucks, was another important factor which diminished the role of both Aboriginal and settler drovers and musterers in outback NSW. The period from the 1910s to the 1960s brought a new series of economic factors, the end of large-scale properties, and a lessening need for Aboriginal labour. The subdivision of large pastoral properties and the decline in the proportion of wage labourers to self-employed smallholders accelerated this process. In the post-Second World War period, advances in technology – in the form of improved machinery, selective plant and animal breeding, fertilisers and pesticides – promised to revolutionise the pastoral industry. Consequently, by the late 1950s and 1960s whole categories of jobs were lost as technology and industry structure shifted. Mechanised harvesters, for example, eliminated the need for many workers in the inland wheat and coastal corn industries, while wheat silos eliminated employment for bag sewers. In the pastoral industry, trucks and motorbikes reduced the need for horsemen and women in both the sheep and the cattle industries, while road trains virtually eliminated the droving jobs. As the industry began to be dominated by large corporate landholders who managed their properties from a great distance, small parcels of land and smaller landholders were increasingly forced to abandon their properties, many of which have subsequently been acquired by the state and managed as heritage, either as natural areas and national parks or for the historic heritage values of the former woolsheds and pastoral homesteads themselves.

Missing from history?

This brief historical account has demonstrated the importance of Aboriginal labour to an understanding of the history of pastoralism in Australia, and the importance of Aboriginal history in relation to pastoral heritage in NSW. However, an analysis of listings of places under the theme 'pastoralism' in the State Heritage Register (the official register of places of state heritage significance in NSW) in 2004 showed that of thirty-seven places listed under the theme of 'pastoralism', none contained information on associations with individual Aboriginal people or communities who worked there (Harrison, 2004, p. 7). With the exception of one very early archaeological site (a large sandstone cut drain), all of the entries focused on the buildings that were the dwellings of white pastoral managers and their families (as opposed to the rather more humble dwellings of Aboriginal pastoral workers shown, for example, in Figure 5.4). Of the three entries that do mention Aboriginal people at all, two discuss frontier violence perpetrated against Aboriginal people from the perspective of the settlers, without consideration of the disputed pastoral property's possible significance to Aboriginal people. The third listing mentions the existence of pre-European Aboriginal sites on the property, but is silent on the continued presence or associations with Aboriginal people after the property was established. This demonstrates the emphasis, in pastoral heritage management in Australia, on the pioneering myths of white settlers doing battle against nature and the foreign Australian frontier. Aboriginal people are naturalised in this myth, so they appear in roles as a part of the natural world, waiting to be subdued by settlers. Almost all of the register's listings mention the owners and managers by name in their historical analysis, but none discusses the lives or social history of workers – settler or Aboriginal – on the properties.

In NSW, as in most other states of Australia, the division in the management of Aboriginal and 'historic' heritage comes about partly through the separate allocation of responsibilities for each of these to different state agencies. At the time this research was undertaken, the Department of Environment and Conservation (NSW) (formerly the NSW National Parks and Wildlife Service) had primary responsibilities for managing Aboriginal heritage, while the NSW Heritage Office had primary responsibilities for managing 'historic' heritage. The logic of this division is apparent in the origins of each 'stream' of heritage conservation practice. The provisions relating to Aboriginal 'relics' in the National Parks and Wildlife Act 1974 were largely a response to pressure from professional archaeologists, whose main concerns were with the material remains of the pre-contact Aboriginal past. Historic heritage legislation meanwhile arose through popular postwar preservationist and environmental movements that were concerned with prominent European-built heritage places such as 'The Rocks' precinct in Sydney (see Davison, [2000] 2008). Managing Aboriginal heritage in separation from 'historic' heritage allows the

aspects of historic heritage that relate specifically to European settlers to be selectively emphasised, while Aboriginal heritage becomes relegated to prehistory. Archaeologists such as Denis Byrne (1996) and Laurajane Smith (2004) have shown how archaeological heritage management in settler societies such as the USA and Australia has marginalised indigenous people: it has done this by distancing them practically from the everyday management of their own heritage and conceptually by conspiring in the concept of 'prehistory' which posits a break in the lives of indigenous people before and after the arrival of European settlers (see also Harrison and Hughes, 2010). By promoting the idea that the period prior to European contact was a sort of untouched 'golden age', in opposition to the period following European contact when indigenous cultures were seen to have been impacted or destroyed by the influence of the dominant culture, a wedge is placed between contemporary indigenous people and their own past. This has allowed certain scientific 'experts' to assume the right to determine the management of this past.

The entanglement of Aboriginal and European lives on the pastoral frontier of Australia demonstrates the deep historical attachments and long involvement of Indigenous Australians with historic pastoral properties. An example comes from East Kunderang in north-eastern NSW, which was managed as a historic site and national park by the NSW National Parks and Wildlife Service and was one of two case studies I explored in detail for the book that arose from my study of this subject (Harrison, 2004). Here, Aboriginal people had a long and intimate history of working on the property, and yet their contribution to the property's history was not acknowledged in on-site interpretative signage or other media prior to this study and the subsequent implementation of a new Conservation Management Plan and Interpretation Strategy. The property had been acquired by the National Parks and Wildlife Service in 1989, and much effort had gone into the conservation and interpretation of its vernacular cedar homestead and some of its outbuildings, but all of this reconstruction and the accompanying on-site interpretation focused on the white families who had owned and managed the station. Most written historical accounts of the property omitted to mention that the property had employed a large Aboriginal workforce. Working with members of the local indigenous and settler communities, we were able to document a number of places of importance to the Aboriginal history of the property, including mustering camps, Aboriginal missions and reserves that formed pastoral labourers' camps, and an Aboriginal stockmen's hut (which lay uninterpreted and in ruin not far from the homestead) in which Aboriginal labourers lived while working on the property (Figure 5.5).

We also documented graffiti associated with the shoeing forge adjacent to the homestead that was executed almost exclusively by Aboriginal stockmen (Figure 5.6). The graffiti consists of a series of names and initials of stockmen

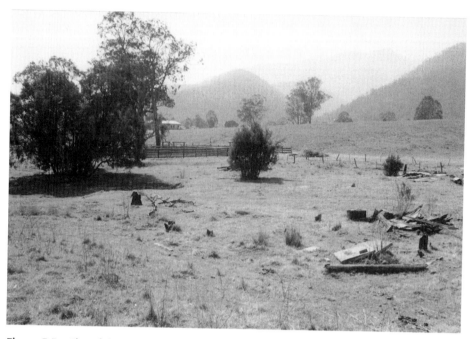

Figure 5.5 Site of the Aboriginal stockman's hut at East Kunderang, looking towards the homestead, *c.*2000. Photographed by Rodney Harrison. Photo: © Rodney Harrison. At the time this photograph was taken, the stockmen's hut lay in ruin and was not part of the official interpretation of the property, which focused on the homestead where the white station manager's family had lived.

worked in shoeing nails and scratched into the ceiling joists and timber posts in the central portion of the forge building. Initials can be matched against the continuous series of wages records from the period 1919–47: 'W Cohen' (Bill Cohen), 'GC' (George Cohen), 'Cohen', 'LWK', 'LW Kelly' and 'LK' (Lewis Kelly), 'BWC' (Bill Cohen or William Crawford), 'J Little', 'TD' (Tommy Davison or Tommy Dureaux), 'FD' (Fred Dunn), 'ED' (Edward Dureaux?), 'HD' and 'HD 1959' (Harvey Dunn), 'JD' (Johnny Dureaux), 'W Little' and 'NRH' (N. Hilton), are all names and initials of Aboriginal people who were known to have worked on East Kunderang over this time. It was possible to identify twenty-two out of thirty-nine initials (some of the graffiti is composed of numbers and motifs, or generic terms such as 'BREAKER' or 'HORSE BRE[AKER]'), and twenty-one sets of initials were found to belong to Aboriginal people. This simple act of marking one's name as part of the routine of undertaking pastoral labour can be seen as an almost defiant act that worked against the exclusion of Aboriginal people from the documentary histories and interpretation of the heritage of the property. For this reason the heritage fabric associated with this building is considered of great importance to the local Aboriginal community. As a result of this study and the implementation of the new Conservation Management Plan and Interpretation Strategy these sites and their association with Aboriginal

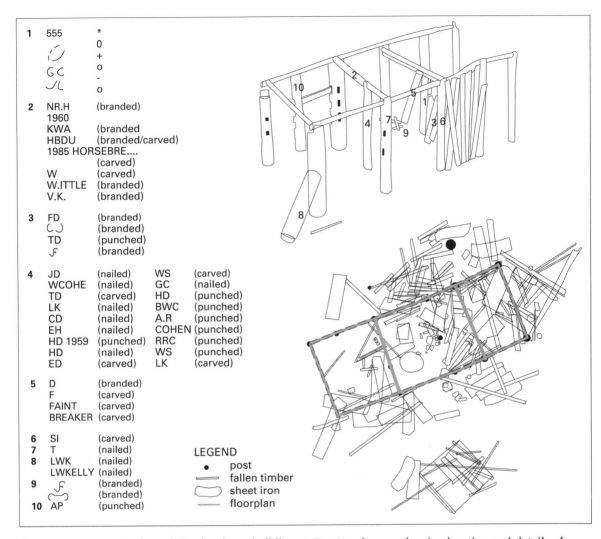

Figure 5.6 Isometric view of shoeing forge building at East Kunderang, showing location and details of stockmen's graffiti (after Burke, 1993). The building has now been reconstructed by the park managers.

pastoral labour have now been interpreted by the park managers. Nonetheless, there remains a reluctance in many heritage sectors of Australia to include Aboriginal people in the interpretation of historic heritage sites in general, and of pastoral heritage in particular.

Reflecting on the case study

The case study provides an example of the use of heritage to exclude a minority group from an aspect of heritage that forms an important area of the national imagination – a foundation myth associated with the pioneering

pastoralists who formed the backbone of the Australian economy through the nineteenth and twentieth centuries. Despite the importance of Indigenous Australian labour in maintaining this industry, they have routinely been erased from the interpretation of pastoral heritage places. However, where projects have investigated the history and archaeology of the contribution of Indigenous Australian people to individual pastoral properties, their thorough embeddedness in this history becomes clear. This case study has illuminated Appadurai's suggestion, discussed earlier in the chapter, that archaeology is a 'key site' for reflecting on the national politics of remembering and forgetting. It reinforces the potential for archaeology and heritage both to reveal and to obscure aspects of national history. In this sense, it also highlights the political responsibilities of archaeologists and other heritage professionals in terms of their roles in developing national historical narratives within plural societies, most particularly when dealing with minority and multicultural groups. This study was commissioned by a state government heritage management agency which subsequently adopted new ideas for heritage interpretation that were inclusive of minority groups whom they had previously denied. The study itself is a demonstration both of the sorts of change that occur when plural societies shift from the assimilatory to the mosaic model, and of the important role of heritage in postcolonial nations (see also Harrison and Hughes, 2010).

The next case study investigates an example of heritage that explicitly seeks to identify and celebrate the history of minorities in a plural society. We look here to South Africa, a nation that has had a complex relationship with heritage throughout its history, and that has been attempting to use heritage as a tool to re-write its history in the years following the dissolution of the apartheid system (see, for example, Coombes, 2003; Ashworth, Graham and Tunbridge, 2007; Murray, Shepherd and Hall (eds), 2007; Laurence, 2010). As in Australia, South Africa has seen a shift from one model of society to another; in this case from a pillar society to a mosaic society. The case study briefly considers a particular museum that was established simultaneously with this shift, and the ways in which the museum seeks to celebrate the history of previously marginalised minorities as part of a new political regime.

Case study: District Six Museum, Cape Town, South Africa

Many readers will be familiar with the recent apartheid and post-apartheid history of South Africa. Apartheid – a system of racial segregation in which the state classified and kept separate white, coloured and black citizens – was enforced by the National Party government of South Africa between 1948 and 1990. The system was dismantled over the period 1990–3 and finally

removed in 1994 during the country's first general elections with universal suffrage, at which time the African National Congress (ANC) was elected as the governing body. Under the presidency of Nelson Mandela, post-apartheid South Africa quickly sought to establish itself as a new nation in which

> Each of us is as intimately attached to the soil of this beautiful country as are the famous jacaranda trees of Pretoria and the mimosa trees of the bushveld – a rainbow nation at peace with itself and the world.
>
> (quoted in Manzo, 1996, p. 71)

In their discussion of heritage and plural societies, Ashworth, Graham and Tunbridge (2007, p. 194) suggest that South Africa's 'rainbow nation' demonstrates an attempt to develop a mosaic society in which a new past must be created to reflect the new circumstances of the present. They point to the use of the heritage of apartheid in the post-apartheid era to contrast with the modern situation, to develop a vision of history in terms of a linear narrative from 'bad past' regime to 'good contemporary' one, as well as to develop the theme of the struggle for freedom (see also Coombes, 2003, p. 120). As we will see, both 'bad past' and 'good contemporary' narratives are embodied within the District Six Museum in Cape Town.

The museum explains its origins and meaning in terms of reparation and memorialisation of the clearances of large numbers of 'non-whites' from the mixed community of coloured and immigrant people that occurred in Cape Town in 1965 (more detailed analyses of the museum are presented in Hall, M., 2001; Rassool and Prosalendis (eds), 2001; Coombes, 2003; and Rassool, 2007):

> Up until the 1970s, District Six was home to almost a tenth of the city of Cape Town's population. In 1965, the apartheid government, as it had done in Sophiatown in 1957, declared District Six 'white'. More than 60,000 people were forcibly uprooted and relocated onto the barren plains of the Cape Flats. In the process, over a century of history, of community life, of solidarity amongst the poor and of achievement against great odds, was imperilled.
>
> The District Six Museum Foundation was established in 1989 and launched as a museum in 1994 to keep alive the memories of District Six and displaced people everywhere. It came into being as a vehicle for advocating social justice, as a space for reflection and contemplation and as an institution for challenging the distortions and half-truths which propped up the history of Cape Town and South Africa. As an independent space where the forgotten understandings of the past are resuscitated, where different interpretations of that past are facilitated through its collections, exhibitions and education

programmes, the Museum is committed to telling the stories of forced removals and assisting in the reconstitution of the community of District Six and Cape Town by drawing on a heritage of non-racialism, non-sexism, anti-class discrimination and the encouragement of debate.

(District Six Museum, 2009)

The museum is located in the middle of the former district in what was a Methodist Mission church. The exhibition on show at its centre is called *Streets* and has formed the core of the museum since it opened in 1994 (Rassool, 2007, p. 119). *Streets* consists of a large floor overlain by family names handwritten by District Six former residents and showing the spaces where the people lived prior to being relocated (Figure 5.7). Bordering the map is a series of artists' prints and paintings, and hanging above are four banners with symbols representing the religions of Christianity, Islam, Judaism and Hinduism, 'an acknowledgement of the religious harmony and tolerance that existed in the neighbourhood' (District Six Museum, 2009). A series of seventy-five original District Six street signs hangs in three tiers as a backdrop to the map – 'a tangible reminder of "home", signposting nothing but our memories and treasured experiences of a past District Six' (District Six Museum, 2009, see Figure 5.8). Below the signs are boxes containing artefacts collected from archaeological excavations at District Six by the University of Cape Town. Further displays adjacent to the floor map focus on individual and family memories of individual places

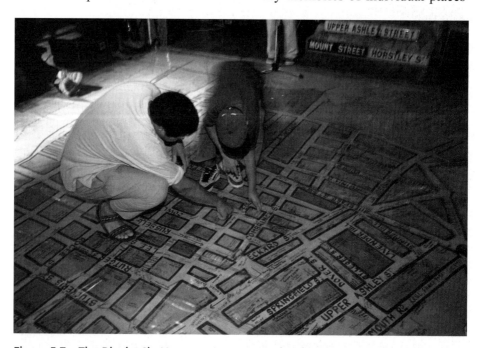

Figure 5.7 The District Six Museum, Cape Town, showing the *Streets* exhibition, 2002. Photographed by Per-Anders Pettersson. Photo: © Per-Anders Pettersson/Getty Images.

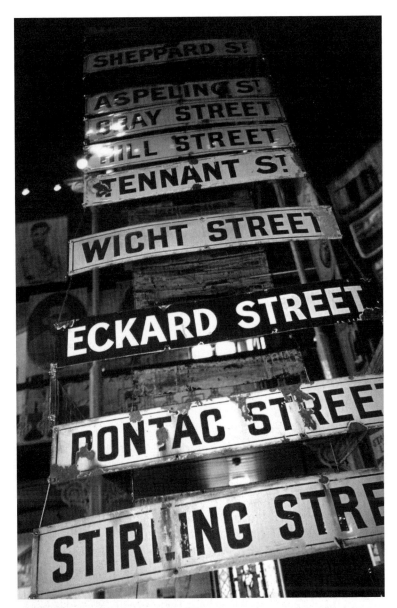

Figure 5.8 Original street signs at the District Six Museum, Cape Town, 2002. Photographed by Per-Anders Pettersson. Photo: © Per-Anders Pettersson/Getty Images.

and streets in District Six through the use of photographs and oral recollections of the area. Temporary exhibits deal with other aspects of the history of District Six and other forced removals in South Africa's history.

The District Six Museum Foundation developed out of the 'Hands off District Six' campaign, one of a series of groups concerned with preserving the

memory of District Six that grew up in the years following the forced removals and in tandem with the struggle for freedom from apartheid (Rassool, 2007, p. 119). This local remit was itself already a significant one, but with the change of political regime South Africa has sought to re-imagine its past (using heritage) in different ways. Central to the process has been the emergence of the victim of forced removal as a prominent figure in the perception of Cape Town's past and the national imagination.

> If the emblematic figure of African modernity in Johannesburg is the migrant worker, a figure that moves from the margins to the underground world of the mine, then in the case of Cape Town, with its history of (limited) racial cohabitation and subsequent segregation through apartheid, the emblematic urban figure is the victim of forced removal. The experience of forced removal has emerged as a key event in shaping communities of memory in the post-apartheid period, just as it has been central to public negotiations around heritage, identity and the transformation of urban spaces.

> (Shepherd and Murray, 2007, p. 14)

District Six has thus emerged as a key part of South Africa's re-imagining of its past, and as a forum for discussion of the impact of forced removals on South African history and society more generally. This is reflected in the global attention that has been focused on the museum, and its place in academic commentary on the role of heritage in post-apartheid South Africa (for example, Hall, M., 2001; Coombes, 2003; Shepherd and Murray, 2007).

An over-arching theme of the museum is compensation for past injustices – those in relation to apartheid more generally as well as injustices specific to Cape Town. This is in part a reflection of the growth of the museum in tandem with a movement that called for land restitution for the victims of forced removals. The museum has explicitly articulated its mission as the recovery of lost memory (Hall, M., 2001; Rassool and Prosalendis (eds), 2001; Rassool, 2007). Through its emphasis on the histories of the poor and dispossessed, it seeks explicitly to place the history of subaltern people in the forefront of heritage and tourism in the city. By encouraging former residents to write themselves back on to the map of District Six the museum attempts to recover for them the places from which they were forcibly removed (Coombes, 2003, p. 128). It is a development consistent with the museum's involvement in the political struggle to secure land restitution for former District Six residents. Its focus on the recovery of memory and history can be seen as an attempt to counter the negative aspects of a past political regime and to create a new past to assist in the production of a new future.

Another reason for the museum's emergence as a place of national heritage importance is the way in which on the one hand it conserves the memory of apartheid (Figure 5.9), while on the other it celebrates a counter-memory of

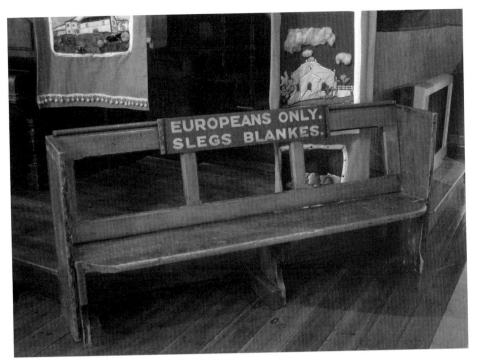

Figure 5.9 'Whites Only' apartheid-era bench, District Six Museum, Capetown. Photographed by Nick Fraser. Photo: © Nick Fraser/Alamy.

apartheid through its stories of harmonious relations among mixed communities which existed for a time simultaneously with the regime. This sees the museum transform District Six into a popular symbol of the subversion of apartheid and part of the new national history of resistance to the regime. In doing so, it can be seen to outline a series of values – plurality, tolerance, community – which promote a positive model of society to which South Africans in general, and residents of Cape Town in particular, might aspire (Rassool, 2007, p. 124). While we might question the use of nostalgia to promote these values, the District Six Museum is a clear example of heritage being used to promote a new vision of nationhood that is inclusive of, and even celebrates, ethnic minorities and multiculturalism.

Reflecting on the case study

The District Six Museum in Cape Town demonstrates the use of heritage to redress past prejudices towards ethnic minorities in South Africa. Given that it deals primarily with the history of absence – the forced removal of non-white ethnic groups from the area – it is explicitly concerned with the 'recovery' of heritage and memory. It does this through an emphasis on narrative, photographs and archives, and by involving the community in its work. In this

sense, it could be seen to represent a form of intangible heritage (see further discussion in Chapter 7). It demonstrates the potential for heritage not only to educate about the past but also to be involved in compensation and reconciliation of the past in the present.

The case study also shows the way in which the role of heritage changes in particular societies with a change in regime. In this sense, it recalls the case studies in Chapter 4. What is distinctly different about the District Six Museum, and indeed the engagement with multicultural and minority heritage in the later part of the twentieth century, is the way in which it has more explicitly acknowledged the role of heritage in incorporating minority groups (and their heritage) into a vision of nationhood. While this might be seen to be a generally positive outcome of developments in heritage in the later part of the twentieth century, it remains for us to question the extent to which minority and subaltern heritages may also develop their own AHDs which control access to the past for members of minority and multicultural groups. This idea is explored in more detail in Chapter 8 in relation to the AHD of the virtual heritage of Second Life.

The future of heritage in multicultural societies

At an official level a major influence on heritage throughout the 1980s and 1990s was increased recognition of minority voices, which involved a shift of emphasis so that 'histories from below' were perceived to be just as important as 'official' or 'mainstream' histories. 'Whose heritage?' was a frequent query in relation to places that were being conserved as part of the **World Heritage Convention**. Countries with significant indigenous and migrant populations began to question the emphasis on material heritage within the World Heritage Convention and the **Venice Charter** (see further discussion in Chapter 7), as well as the emphasis on individual 'sites' and buildings (see further discussion in Chapter 6). These challenges saw a major shift in approach from the production of a single heritage 'canon' to the development of more 'representative' approaches to heritage. This was reflected in the launch of the UNESCO Global Strategy for a Balanced, Representative and Credible World Heritage List in 1994, which was an acknowledgement that the World Heritage List lacked balance not only in the geographic areas it covered but also in the nature and types of heritage it conserved. A study of the list found that

> Europe, historic towns and religious monuments, Christianity, historical periods and 'elitist' architecture (in relation to vernacular) were all over-represented on the World Heritage List; whereas, all living cultures, and especially 'traditional cultures', were underrepresented.
>
> (UNESCO, [1994] 2009; see Donnachie, 2010)

The implementation of the strategy ratified a change in direction for heritage that had been developing in many western countries for some years, and saw UNESCO host a series of thematic workshops and studies intended to 'plug the gaps' in the World Heritage List. The implications of several of these thematic workshops are discussed in more detail in Chapters 6–8.

Nonetheless, multicultural and minority heritage continues to present a challenge to the nation-state, as explored in the earlier part of this chapter. This is because the state often sees the need to produce cohesive heritage narratives to create the nation in a single, unified image. Acknowledgement of plural forms of heritage may appear as a challenge to these unified national discourses. We have seen that under certain circumstances heritage develops predatory forms that seek the erasure of competing or alternate (particularly minority) heritages. The role of heritage in plural societies will continue to be an area of debate and contention in relation to broader debates regarding pluralism, multiculturalism, class and ethnicity in society.

Conclusion

This chapter has considered the place of minority and multicultural heritage in plural societies. All heritage needs to be seen as plural, as there are minorities in every society. Nonetheless, heritage assumes different functions in different forms of plural society, and for this reason minority or multicultural heritage will be seen as more or less problematic depending largely on the extent to which the society conforms to an 'assimilatory' or 'mosaic' model. We have also considered the issue of how different groups within societies use heritage in the production of varied place-identities, and how different groups may need to rely on different forms of heritage to do this. This will produce a diverse range of types of heritage in plural societies, and again these will be seen as more or less in competition with one another depending on the degree to which the society is inclusive of plurality. Finally, we have considered the ways in which various critiques of heritage have emerged from minorities and people of different ethnic and cultural groups within plural societies, and the influence of this critique on the work of UNESCO and the World Heritage List. The ways in which various minority groups have challenged the ideas of heritage embodied by the World Heritage List will be an ongoing theme in the remaining chapters of this book.

Works cited

Allen, R. (2010) 'Heritage and nationalism' in Harrison, R. (ed.) *Understanding the Politics of Heritage*, Manchester, Manchester University Press/Milton Keynes, The Open University, pp. 197–233.

Ang, I. (2005) 'Multiculturalism' in Bennett, T., Grossberg, L. and Morris, M. (eds) *New Keywords: A Revised Vocabulary of Culture and Society*, Malden, MA and Oxford, Blackwell Publishing, pp. 226–9.

Appadurai, A. (1996) *Modernity at Large*, Minneapolis and New York, University of Minneapolis Press.

Appadurai, A. (2006) *Fear of Small Numbers: An Essay on the Geography of Anger*, Durham, NC, Duke University Press.

Appadurai, A. ([2001] 2008) 'The globalisation of archaeology and heritage: a discussion with Arjun Appadurai' in Fairclough, G., Harrison, R., Jameson, J.H. Jr and Schofield, J. (eds) *The Heritage Reader*, Abingdon and New York, Routledge, pp. 209–18.

Ashworth, G.J., Graham, B. and Tunbridge, J.E. (2007) *Pluralising Pasts: Heritage, Identity and Place in Multicultural Societies*, London, Pluto Press.

Burke, H. (1993) 'The outbuildings of Kunderang East: an archaeological report'. Unpublished report prepared for the NSW National Parks and Wildlife Service, Sydney.

Byrne, D. (1996) 'Deep nation: Australia's acquisition of an indigenous past', *Aboriginal History*, no. 20, pp. 82–107.

Coombes, A. (2003) *History after Apartheid: Visual Culture and Public Memory in a Democratic South Africa*, Durham, NC, Duke University Press.

Davison, G. ([2000] 2008) 'Heritage: from pastiche to patrimony' in Fairclough, G., Harrison, R., Jameson, J.H. Jr and Schofield, J. (eds) *The Heritage Reader*, Abingdon and New York, Routledge, pp. 31–41.

District Six Museum (2009) About the Museum [online], www.districtsix.co.za/frames.htm (accessed 9 June 2009).

Donnachie, I. (2010) 'World Heritage' in Harrison, R. (ed.) *Understanding the Politics of Heritage*, Manchester, Manchester University Press/Milton Keynes, The Open University, pp. 115–153.

Goodall, H. (1995) 'New South Wales' in McGrath, A. (ed.) *Contested Ground: Australian Aborigines Under the British Crown*, Sydney, Allen and Unwin, pp. 55–120.

Goodall, H. (1996) *Invasion to Embassy Land in Aboriginal Politics in New South Wales, 1770–1972*, Sydney, Allen and Unwin/Black Books.

Graham, B., Ashworth, G.J. and Tunbridge, J.E. (2000) *A Geography of Heritage: Power, Culture and Economy*, London, Arnold.

Hall, M. (2001) 'Cape Town's District Six and the archaeology of memory' in Layton, R., Stone, P. and Thomas, J. (eds) *The Destruction and Conservation of Cultural Property*, London and New York, Routledge, pp. 298–311.

Hall, S. ([1999] 2008) 'Whose heritage? Un-settling "the heritage", re-imagining the post-nation' in Fairclough, G., Harrison, R., Jameson, J.H. Jr and Schofield, J. (eds) *The Heritage Reader*, Abingdon and New York, Routledge, pp. 219–28.

Harrison, R. (2004) *Shared Landscapes: Archaeologies of Attachment and the Pastoral Industry in New South Wales*, Sydney, University of New South Wales Press.

Harrison, R. (2008) 'Aboriginal people and pastoralism 1850–1950' in Atkinson, A., Ryan, J.S., Davidson, I. and Piper, A. (eds) *High Lean Country: Environment, Peoples and Tradition in New England*, Sydney, University of New South Wales Press, pp. 111–21.

Harrison, R. (2010) 'The politics of heritage' in Harrison, R. (ed.) *Understanding the Politics of Heritage*, Manchester, Manchester University Press/Milton Keynes, The Open University, pp. 154–96.

Harrison, R. and Hughes, L. (2010) 'Heritage, colonialism and postcolonialism' in Harrison, R. (ed.) *Understanding the Politics of Heritage*, Manchester, Manchester University Press/Milton Keynes, The Open University, pp. 234–69.

Hobsbawm, E. and Ranger, T. (eds) ([1983] 1992) *The Invention of Tradition*, Cambridge, Cambridge University Press.

Kaye, H.J. (1984) *The British Marxist Historians*, Cambridge, Polity Press.

Laurence, E.A. (2010) 'Heritage as a tool of government' in Harrison, R. (ed.) *Understanding the Politics of Heritage*, Manchester, Manchester University Press/Milton Keynes, The Open University, pp. 81–114.

Long, J.P.M. (1970) *Aboriginal Settlements: A Survey of Institutional Communities in Eastern Australia*, Canberra, ANU Press.

Manzo, K.A. (1996) *Creating Boundaries: The Politics of Race and Nation*, London and Boulder, CO, Lyne Reinner.

Murray, N., Shepherd, N. and Hall, M. (eds) (2007) *Desire Lines: Space, Memory and Identity in a Post-Apartheid City*, Abingdon and New York, Routledge.

Rassool, C. (2007) 'Memory and the politics of history in the District Six Museum' in Murray, N., Shepherd, N. and Hall, M. (eds) *Desire Lines: Space, Memory and Identity in a Post-Apartheid City*, Abingdon and New York, Routledge, pp. 113–27.

Rassool, C. and Prosalendis, S. (eds) (2001) *Recalling Community in Cape Town: Creating and Curating the District Six Museum*, Cape Town, District Six Museum.

Said, E.W. (1978) *Orientalism*, Harmondsworth, Penguin.

Samuel, R. (1994) *Theatres of Memory: Volume 1, Past and Present in Contemporary Culture*, London and New York, Verso.

Shepherd, N. and Murray, N. (2007) 'Introduction: space, memory and identity in the post-apartheid city' in Murray, N., Shepherd, N. and Hall, M. (eds) *Desire Lines: Space, Memory and Identity in a Post-Apartheid City*, Abingdon and New York, Routledge, pp. 1–18.

Smith, L. (2004) *Archaeological Theory and the Politics of Cultural Heritage*, London and New York, Routledge.

Smith, L. (2006) *Uses of Heritage*, Abingdon and New York, Routledge.

UNESCO (2000) *World Culture Report 2000: Cultural Diversity, Conflict and Pluralism*, Paris, UNESCO.

UNESCO (2002) Universal Declaration on Cultural Diversity [online], http://unesdoc.unesco.org/images/0012/001271/127160m.pdf (accessed 31 May 2009).

UNESCO (2005) Convention on the Protection and Promotion of the Diversity of Cultural Expressions [online], http://unesdoc.unesco.org/images/0014/001429/142919e.pdf (accessed 31 May 2009).

UNESCO ([1994] 2009) Global Strategy for a Balanced, Representative and Credible World Heritage List [online], http://whc.unesco.org/en/globalstrategy/ (accessed 31 May 2009).

United Nations ([1948] n.d.) Universal Declaration of Human Rights [online], www.un.org/en/documents/udhr/ (accessed 28 May 2009).

US Census Bureau (2006) American Community Survey [online], http://factfinder.census.gov/servlet/DTTable?_bm=y&-geo_id=01000US&-ds_name=ACS_2007_3YR_G00_&-redoLog=false&-mt_name=ACS_2007_3YR_G2000_B02001 (accessed 29 May 2009).

West, S. and Ansell, J. (2010) 'A history of heritage' in West, S. (ed.) *Understanding Heritage in Practice*, Manchester, Manchester University Press/Milton Keynes, The Open University, pp. 7–46.

Further reading

Anderson, B. (2006) *Imagined Communities: Reflections on the Origin and Spread of Nationalism* (revised edn), London and New York, Verso.

Ashworth, G.J., Graham, B. and Tunbridge, J.E. (2007) *Pluralising Pasts: Heritage, Identity and Place in Multicultural Societies*, London, Pluto Press.

Bennett, T. (2006) 'Culture and differences: the challenges of multiculturalism' in Boda, S. and Cifarelli, M.R. (eds) *When Culture Makes the Difference: Heritage, Arts and Media in Multicultural Society*, Rome, Meltemi Editore, pp. 21–37.

Gardner, J.M. (2004) 'Heritage protection and social inclusion: a case study from the Bangladeshi community of east London', *International Journal of Heritage Studies*, vol. 10, no. 1, pp. 75–92.

Littler, J. and Naidoo, R. (eds) (2005) *The Politics of Heritage: The Legacies of 'Race'*, London and New York, Routledge.

Tunbridge, J.E. and Ashworth, G.J. (1996) *Dissonant Heritage: The Management of the Past as a Resource in Conflict*, Chichester, Wiley.

Chapter 6 Heritage, landscape and memory

Susie West and Sabelo Ndlovu

The relationship between nature and culture is a defining problem for recent debates over the meanings of heritage landscapes. There is a centuries-old aesthetic discourse in the West that treats natural landscapes as objects of beauty, and this has influenced designations of natural heritage beyond the scientific significance of their natural history. Most landscapes are exploited by human occupants, with results that are often desirable to conserve as traditional management practices. The World Heritage Committee now recognises 'mixed' cultural landscapes whose significance includes natural and cultural criteria. The recognition and protection of intangible values in landscapes are ongoing challenges for heritage. The case study in this chapter, by Sabelo Ndlovu, a historian of international politics, explores the complex meanings of the Matobo Hills, Zimbabwe, a World Heritage site. Postcolonial political significances intermingle with religion and ritual performed in the landscape.

Introduction

Landscapes are all around us, defined broadly as the land surfaces that form our surrounding environments: urban or rural, beautiful or bleak. Art historians use the term landscape to describe a genre of art that depicts rural views, and this seems to be the oldest use of the word in English. It is a guide to ways of thinking about the cultural values that landscapes attract. For example, we might bring to mind a beautiful landscape, somewhere with long views across an expanse of country that creates a harmonious effect for the viewer. For those born and educated in western Europe, it may be difficult to avoid visualising a landscape as a 'picture of a landscape', bounded by the borders of a picture frame or a cinema screen. The ideal imagined landscape probably does not feature human inhabitants. It is something to look at, not something that keeps people alive or provides daily work. Tourists include gazing at landscapes among their leisure practices. There are often optimal viewing points that become tourist destinations as famous beauty spots, and there is the irresistible urge to capture the view in a form to take home. Landscape architects often indicate the best viewpoints with some sort of architectural feature, and architects have long tried to frame the landscape in the windows of their buildings. We are so used to this aesthetic understanding of the landscape that we hardly notice how pervasive it is. Much of this

activity, of finding beauty in the view, celebrating it and transforming memories of it into souvenirs, is entirely the work of humans who imagine the physical environment as something that can support 'added value', usually of beauty. In this sense, popular uses of the idea of landscapes are clustered around what landscapes represent: beauty, national characteristics or significant moments of history. To return to the dictionary origins of the word, the English use of 'landscape' was first coined to describe a way of capturing a view. In the history of western art, landscape painting traditionally included buildings, people at work or stories taken from the Bible or literature. In this tradition, landscape was usually seen as ordered and composed. In the nineteenth century, however, following the example of earlier work in the Netherlands, some artists focused on nature itself, in all its wildness and chaotic effusion. In these paintings nature was seen as the opposite of ordered, challenging the confidence of 'civilised' and urban men and women to be able to organise the world. We will see that this difference has some parallels in different approaches to landscape conservation.

This chapter focuses on how landscapes can be understood as heritage by exploring the relationship between official and unofficial heritage through the range of values that different communities give to landscapes. Is landscape to be valued for its natural qualities, or is it more useful to assess the relationship between human culture and the land as it has been exploited by different communities? In Britain, with over 4000 years of tree clearance and farming, distinctive landscapes have emerged from the inter-relationship of human communities and natural resources. Massive changes in farming practices in the later twentieth century have reshaped some of these landscapes quite rapidly. The economic benefits of cheaper food and the cessation of some arduous labouring jobs are benefits, but there are costs to our perception of the heritage values of these changing landscapes. These are not World Heritage-quality landscapes (in contrast to the case study of the Matopo Hills, Zimbabwe), but neither should they be blank spaces between points of official heritage interest. One solution is to identify, nurture and reproduce the variety of ways in which people act out their attachments to the local landscape. This chapter will look at a range of unofficial heritage practices that start from small-scale landscapes in England and extend to the majestic mountain range of the Matobo hills in Zimbabwe. The next chapter will explore the relationship of communities to landscapes in greater detail.

The tensions that exist in relation to 'natural' and 'cultural' landscapes, and in relation to identifying and managing change, are central to our understanding of heritage landscapes. We will look first at the concept of natural landscapes and then see how the tension between 'natural' and 'cultural' has prompted change in official heritage practices, particularly through the World Heritage List.

Natural landscapes

The idea of a landscape, once we move away from a pictorial representation with clearly defined edges, is difficult to define closely. Should it be characterised scientifically by geologists, botanists and zoologists for the natural characteristics and living organisms that inhabit one zone and not another? This is one way of drawing boundaries on maps (Harrison and O'Donnell, 2010).

The first category of landscape conservation that was enshrined at the global level as World Heritage was defined simply as 'natural' sites (Donnachie, 2010). These are sites whose significance is derived primarily from their scientific, non-anthropological interest: geology, natural habitats, species rarity or biodiversity, for example. The human presence, associated with exploitation and impact on the natural environment, tended to be discounted. This understanding of **natural heritage** informed environmental conservation as practised by official bodies and governments from the nineteenth century in the West, particularly in settler societies. The USA was a settler society that was still expanding to its western-most border during the nineteenth century. The huge redwood forests that were encountered by migrant Americans heading west, and captured in some evocative contemporary photographs, are just one example of the outstanding natural beauties of a country that was still being explored by its citizens (Figure 6.1). In contrast, the disenfranchised indigenous peoples from these same lands were not positively associated with their local landscapes (Harrison and O'Donnell, 2010): to the migrant eye the majesty of America's natural wonders was distinct from any human use or management. The relationship between a landscape and its inhabitants is one of the key themes to be explored in this chapter.

Western explorers in the New World may have been insensitive to the lived culture of the indigenous people they encountered there, particularly when these people had not constructed monumental buildings, but they brought with them a sensibility to the beauty of nature. In Europe ancient buildings and curiosities of a mysterious prehistoric past were celebrated for their evocative qualities of times long past and for their impressive, monumental qualities that could be linked to a modern nation's sense of its roots. As colonisers, Europeans inevitably carried with them these understandings of 'what to value'. Their encounters with cultures that did not create similar monuments led them to rank such peoples, who still used stone rather than metal technology, on a par with their own prehistoric ancestors. The natural landscape in territories without ancient cities was re-imagined as unoccupied wilderness and admired for its sense of being untouched by humans, even as indigenous peoples were being actively evicted from it. The imposition of a particular European understanding of the significance of a landscape is, in its limited and exclusionary form, another aspect of Laurajane Smith's authorised

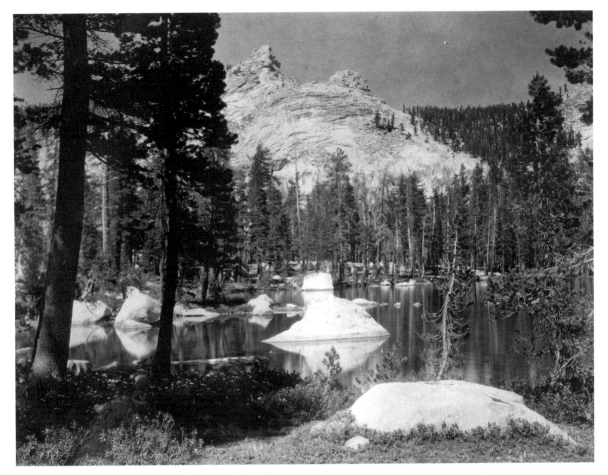

Figure 6.1 Redwood trees, Sequoia National Park, California, 1925. Photographed by L. Eddy. Photo: © L. Eddy/US Geological Survey.

heritage discourse (AHD) (Smith, 2006; see further discussion in Chapter 7). The meanings of landscape, which we will be exploring further in this chapter, have in the early history of environmental conservation been derived from western concepts.

This understanding of a natural landscape as something untouched by humans, perhaps even an escape for industrialised westerners to contemplate, has been a powerful driver for official action to protect its perceived natural qualities, by marking off areas as being beyond development and identifying features that deserve extra protection. In other words, environmental conservation management has a long history similar to that of the built environment or to a public museum culture. We noted that the USA has an early history of such environmental protection, linked to promoting access to and understanding of its national parks for white migrants in the early decades. In the UK it is often pointed out that the largest conservation charity

associated with buildings (often country houses), the National Trust for England and Wales, was actually founded to protect landscapes. It has also built up a substantial portfolio of stretches of coastline.

Natural sites as World Heritage

UNESCO devised a clear distinction between natural and cultural criteria for **World Heritage site**s when it set up the World Heritage programme. The criteria for natural sites are:

vii to contain superlative natural phenomena or areas of exceptional natural beauty and aesthetic importance;

viii to be outstanding examples representing major stages of earth's history, including the record of life, significant on-going geological processes in the development of landforms, or significant geomorphic or physiographic features;

ix to be outstanding examples representing significant on-going ecological and biological processes in the evolution and development of terrestrial, fresh water, coastal and marine ecosystems and communities of plants and animals;

x to contain the most important and significant natural habitats for in-site conservation of biological diversity, including those containing threatened species of outstanding universal value from the point of view of science or conservation.

(UNESCO, [2008] 2009a)

Since 1992 the relationships between people and their natural environment have been recognised as **cultural landscape**s, which we will explore later in this chapter. Natural sites inscribed on the World Heritage List do not exclude human occupants, but they do not prioritise the cultural contribution that indigenous communities make. Some natural sites have been re-inscribed as cultural landscapes, others may well be re-considered as the relationship between humans and their environment is better understood. One such example is the natural World Heritage site of Darien National Park, in Panama, South America.

Darien National Park, Panama

Darien National Park was inscribed on the World Heritage List in 1981 as a natural site, for its 'exceptional variety of habitats – sandy beaches, rocky outcrops, mangroves, swamps and lowland and upland tropical forests containing remarkable wildlife' (UNESCO, [1981] 2009b) (Figure 6.2). Note also that 'Two Indian tribes live in the park' (UNESCO, [1981] 2009b). It is inscribed under criteria (vii), (ix) and (x), covering natural beauty, processes and diversity. The evaluation document supporting the inscription noted as the

Figure 6.2 Darien National Park, Panama. Photographed by Kudo Fubomichi. Photo: ©
UNESCO/Kudo Fubomichi.

additional value of the national park that its conservation status could resist
development pressures. These threats were judged to be of more than local
significance, as a result of the park's position on the narrow land bridge
between South and North America. Development from the possible routing of
the Pan American Highway and from southern cattle ranches were the most
serious threats, along with the spread of cattle disease and the usual
environmental degradation and loss of rainforest. The park was therefore seen
as highly strategic for its size and location, which added to its political value.
More positively, its value as a home to indigenous peoples, including the
Chocos and Kunos groups, was cited as an additional reason for protecting the
area. The presence of cultural groups and the 'conservation of major cultural
resources' that they represent was noted as an important objective in the new
management plan that was drawn up for the park (for further discussion of the
role of planning in conservation see West and McKellar, 2010). However,
despite the recognition of the presence of humans across the area, there was no
way for the clear division of criteria into natural and cultural World Heritage
sites to bridge this artificial division at the time.

We shall go on to see how the World Heritage List was criticised for this strict
division and the resulting shift to 'cultural landscape' as a new category. At
the time of writing, Darien National Park remains inscribed for its natural
significance.

Protection by theme, the World Heritage Forest Programme

Darien National Park is also included on the long list of World Heritage Forest sites (totalling ninety-seven at the time of writing), joining other national parks across the world with significant forest components. This programme is an example of thematic conservation, the theme selected being a category of natural heritage. It forms part of the World Heritage Committee's response to the threats to this category, in which the resources available to World Heritage sites may be enhanced by the additional scientific and political awareness of their significance. The programme originated in a report prepared for the committee that examined the threats and opportunities for World Heritage tropical forest sites, thirty-three in all at the time. The authors were careful to state right at the beginning that 'much of the world's forest biodiversity is the product of millennia of forest manipulation by people', whether in the low-density population of South American rainforests or in the high-density areas of southern China (UNESCO, CIFOR and Government of Indonesia, 1999, p. 2). Indeed, two of the three issues highlighted as key problems for the World Heritage Committee to address (in their role as overseers of the continuing survival of the sites) concerned human populations. These were

> the issue of how much human modification of forests is consistent with World Heritage status, especially to dispel the myth that conservation objectives are best met by excluding people ... [and] ... how to reconcile the needs and interests of local people with the maintenance of the global values of the sites.
>
> (UNESCO, CIFOR and Government of Indonesia, 1999, p. 3)

These are clear statements of the tensions in the range of conservation positions: natural versus cultural, local versus global, change versus stasis. By raising these problems as challenges to be solved creatively, the authors are opening up the earlier AHD around the natural/cultural site split. There is potential here to imagine that cultural activities in forests will include not just the stuff of daily survival but the full range of cultural practices that create meaning in social life.

Each of these sites retains its World Heritage natural status by adhering to agreed management practices that attempt to maintain if not enhance the qualities that make them particularly significant. Natural heritage landscapes pose particular problems of conservation. Because of their 'natural' components they are more obviously problematic to conserve 'as found'. Even geological formations can erode over time, and some of these sites may suffer from too many visitors just as much as cultural sites. Living species will always be subject to growth, decay and renewal; natural sites are, after all, populated by flora and fauna that may not subscribe to human management agreements. Nonetheless, the point to remember is that from UNESCO down to local government levels, natural sites exist in official terms because they have been identified, assessed, defined and

protected. Their conservation problems parallel those of cultural sites (decay, access, research, funding) and raise similar philosophical issues about who determines the range of meanings ascribed to them. The challenge we have been following up in this discussion of natural sites remains how the human presence can be acknowledged by official conservation bodies as a positive component of significant natural heritage areas.

Cultural landscapes

As we have already seen, the purity of the World Heritage view of the distinction between natural and cultural sites has been under challenge almost since the World Heritage Convention was adopted in 1972. One of the major changes over time for our planet has been the spread of human populations, whose exploitation and manipulation of the land they can live on has only intensified in the recent past. Geographers, archaeologists and historians all work with the results of millennia of relationships between humans and landscapes. We need to think about the possible distinctions between, on the one hand, long-established heritage practices that use landscapes and, on the other hand, the impacts on landscapes of industrialisation and of an increasingly globalised economy. As the example of Darien National Park shows, cultures and their associated landscapes need to be understood as a whole. But this example is also unusual, in that the rainforest communities have retained their traditional ways of life and their territories are able to be defined within the enormous area of the park. Major development threats are supposed to stop short at the park boundary. This is rarely possible in landscapes that are less remote and that have a longer history of development or a more intrusive history of colonisation.

One possible solution to the natural/cultural site divide in conservation terms is the rise of 'cultural landscape' as a concept. We can think about cultural landscapes as inhabited landscapes, although ones that are recognisably rural or 'wild' (perhaps desert) in character: they support communities and with that comes culture and cultural meanings. From this standpoint, Darien National Park could be understood as a cultural landscape, since the indigenous communities are reported to be highly significant cultures in their own right. Their current lifestyles are also conserved within their environment, although any innovations that have adverse impacts on the natural heritage conservation goals would probably be vetoed by the park managers.

The World Heritage Committee recognition of cultural landscapes

So how did the World Heritage Committee respond to this recent thinking? We can follow British landscape archaeologist Peter Fowler's experience of working with the World Heritage Committee on the recognition of cultural

landscapes and suggest that, as with other heritage categories, we should be looking for values, significance and meaning (after Fowler, 2004). This follows the gradual widening of the formal qualities of aesthetic or national historic values found in earlier conservation judgements, pushed on by the successful adoption of the cultural values set out in the Australian Charter for the Conservation of Places of Cultural Significance (Australia ICOMOS, 1999), known as the Burra Charter (see West and Ansell, 2010). This breadth of approach to looking for natural significance is now the standard official process for identifying landscapes deserving of special care and protection, whether at World Heritage or local government level. But as Fowler insists, the notion of cultural landscape has to include recognition that it bears *cultural* meanings.

Acceptance of the need to recognise this relationship was a major innovation for the World Heritage programme. It did so in 1992 by allowing 'mixed criteria' to define the significance of proposed sites, so the current list now shows 'mixed sites' that use criteria from both halves of the cultural/natural definitions. Some early inscriptions as natural sites have already been re-inscribed as cultural landscapes.

Re-inscribing natural World Heritage as cultural landscapes

The first two landscapes to be recognised as World Heritage cultural landscapes were originally inscribed as natural sites, in the dominant westernised view of these two places as significant without the contribution of indigenous cultural associations. Tongariro National Park, New Zealand, includes three volcanoes. These peaks are tangible reminders to the Māori people of their arrival by canoe at the North Island of New Zealand, as well as the fire and the fire-gods that warmed their ancestors. The mountains themselves are the first children born to the Earth Mother and Sky Father, the last children being the Māori themselves. The physical presence of the volcanoes acts as a crucial cognitive prompt to the collective memory of the Māori; the landscape speaks to them about their origins and their relationship to the cosmos. Fowler champions the World Heritage decision to list Tongariro on the grounds of its 'non-tangible, non-monumental, spiritual and oral values' (Fowler, 2004, p. 34).

The second World Heritage natural site to be re-inscribed as a cultural landscape has been known since 1993 as Uluru-Kata Tjuta National Park, Australia, and is equally central to a people's consciousness. Uluru, to use the short form, is the great mound-shaped mountain that famously changes colour through the day. It sits within a complex cultural landscape managed for millennia by the Anangu people. The Anangu recognise the physical traces of their ancestors across this landscape at the time of their origins (the Law) which created the landscape and which continues to unify all the components of their world. Hundreds of rock art sites, from 9000 BCE to the recent past, document the narrative and spiritual significance of the landscape to its people

around the sacred mountain. It seems difficult now to understand how this landscape could be officially recognised only for its natural qualities, however outstanding. Fowler emphasises that at least the 'natural' status initially bestowed on both Tongariro and Uluru National Parks raised the questions with heritage experts that led to the development of the World Heritage cultural landscape category.

Difficult heritage as cultural landscapes

We have been concentrating so far on high-impact landscapes such as rainforests and deserts, which have retained their natural characteristics and cultural integrity to a high degree, hence their qualification for World Heritage status. But should we also be thinking about landscapes that are harder to assess for their natural and cultural qualities? Fowler reminds us that each generation finds new values and meanings, and that our ideas of interesting landscapes inevitably change. He gives the example of the pebbly beachscape that includes massive concrete structures of national defence built during the Cold War era, on the otherwise largely undeveloped coast of the east of England, at Orford Ness, Suffolk.

Ugly or evocative? Orford Ness Nature Reserve, England

Orford Ness is now a nature reserve with public access, in the care of a major conservation body, the National Trust, who purchased the site from the Ministry of Defence in 1993. It is a very good fit for the cultural landscape definition. A major part of the site's significance comes from the nationally rare species of flora and fauna found in the variety of salt and freshwater marshes there, as well as its importance as a bird breeding ground. Culturally, its history includes river defences created to protect grazing land from salt marsh in the twelfth century. In 1913 the land was purchased by the War Department and was used for military experimentation, putting an end to traditional exploitation of the land. Use by the military included a top-secret Anglo-American radar project from 1968. But the most chilling use of the site was in the 1950s for testing a component of nuclear bombs, in distinctive concrete structures known as the Pagodas which still stand on the shingle beach (Greeves, 2004, p. 282) (Figure 6.3).

> The National Trust's futuristic perception of significance in a twentieth-century landscape of ugliness and deadly high-tech, lurid beauty and iconographic redundancy, brought a stretch of barren, shingly coast from government dereliction into heritage care. It is not yet a World Heritage cultural landscape but its scientific and historical significances, and expressive dramatic qualities of natural/human interaction, should bring it into consideration during the twenty-first century.
>
> (Fowler, 2004, p. 26)

Figure 6.3 Orford Ness pagoda, Suffolk, 2007. Photographed by David W. Fincham. Photo: © David W. Fincham, 2007.

Here, Fowler is suggesting that the harsh qualities of the surviving military structures, in their use of materials and forms, set into a liminal type of landscape as the sea interacts with the land, create their own aesthetic qualities, as well as objective scientific and historic interest. The cultural component has, in his view, not detracted from the natural significance of the site, but its extraordinary recent uses have made possible the niche species and left enduring reminders of more desperate human histories. Developed, certainly, but ruined, no – not as understood in these conservation criteria.

Redundancy and revival: rice terraces of Cordilleras, Philippines

Cultural landscapes are perceived to be particularly vulnerable to the impact of the loss of traditional human practices that reshaped them into the forms we value now. It is harder for us to accept the inevitable decay of recently abandoned horticultural terraces than the eroded forms of field boundaries that have not been rebuilt since the Bronze Age. This leaves us with Fowler's problem of what to do about 'redundant' landscapes as the human population moves out to find work in the towns or mechanises traditional agricultural techniques and retreats from difficult terrain. If recognition as a World

Heritage site brings additional funding and greater tourist numbers, the failure of the cultural landscape to survive in the condition that merited world status risks the loss of all benefits.

For example, the outstanding rice terraces of the Cordilleras in the Philippines were inscribed as World Heritage in 1995 but were placed on the World Heritage in Danger List in 2002 (Fowler, 2004, p. 151) (Figure 6.4). One tactic for reasserting the continuing value to the inhabitants of their 'intangible heritage resting in the semi-magical, legendary status of the terraces' has included the revival of a ritual called Patipat, which had gone out of use since the period of American military occupation in the Second World War. The ritual sent rats and evil spirits down the terraces, known as the 'stairway to the river', for both bad forces to be drowned. Fowler notes that 'the event quite properly stressed the basis of the coexistence between the traditional society of the Ifuago and their working landscape: you can't have one without the other'. But he is sceptical of the revival of this practice, seeing it as 'conscious heritagization' as a cure for the erosion of the Ifuago people's relationship to their territory (Fowler, 2004, pp. 38–40).

Perhaps Fowler is writing too much from the perspective of a western heritage professional, making a judgement that 'revival' is not as good as 'continuity'. But this raises the problem of authenticity, as to whether the revival of a practice has the integrity of its earlier use. Authenticity is a difficult concept for heritage professionals, who have worried about it in terms of physical integrity of built structures since at least the late nineteenth century in the West. The problem for buildings is to understand how best to intervene when major repairs are necessary, and how to decide which parts of a much altered building should be retained and which removed (Otero-Pailos, Gaiger and West, 2010). There are parallels for intangible heritage here.

The problem set by a western demand for authenticity is based on the assumption of a linear chronology from a first (and by implication 'best') manifestation towards changes in form, practice or adoption by new communities. But the essence of intangible practices is their ability to withstand considerable change, as the owners rearrange their social requirements or even take their practices with them when relocating. Intangible practices can easily be incorporated into new cultural groupings, which carry powerful meanings for their practitioners. Caribbean carnival is one such practice that has been successfully exported with Caribbean communities in diaspora (West and Bowman, 2010).

Just as heritage can move from place to place, we can also reflect on how heritage changes over time. If the revival of a place-specific practice in its previous site is successful, this is because it meets the new needs of the community that is reviving it. There are many cultural forms that are capable of meeting new needs, away from their original period of creation. How else

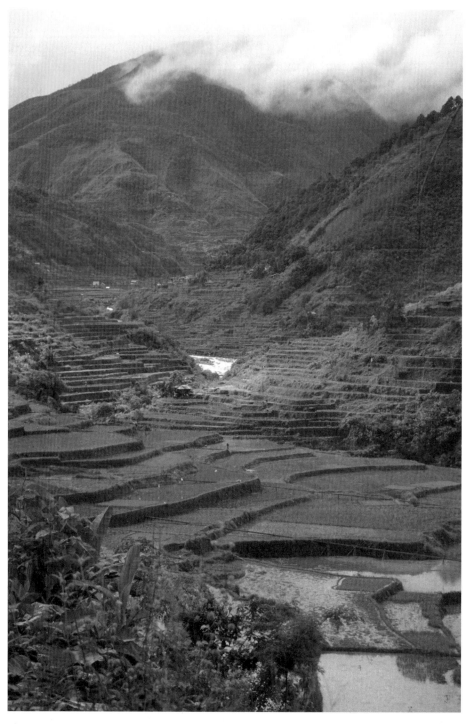

Figure 6.4 Rice terraces of the Cordilleras, Phillipines. Photographed by Hilary Scudder. Photo: © Hilary Scudder/Sylvia Cordaiy Photo Library Ltd/Alamy.

could nineteenth-century novels retain their value as explorations of the human condition for readers of the early twenty-first century? The revival of the Patipat ritual is one way for the local population to reinforce their historic connection to their locality. If the landscape retains its range of meanings for the inhabitants, it has a better chance of being worked (and therefore conserved) in ways that are in harmony with those meanings.

We can explore the relationship between exactly these intangible practices and landscapes through the concept of collective memory. Collective, or social, memory does not need to be continuous in strict chronological time to have powerful effects within and between communities (the rise of the spiritual economy of the small English town of Glastonbury is one example: West and Bowman, 2010). Indeed, memory practices are to be found in landscapes all over Britain, in the heart of the countryside.

Cognitive landscapes

Heritage professionals tend, as we have seen, to think about landscape in functional terms in order to set up ways of protecting and maintaining the physical characteristics of the environment in their care. However, there are other long-standing intellectual traditions that think about landscapes – **cognitive landscapes** – as the result of 'layers on the land', in which human perceptions of the land generate multiple understandings of what landscape can be. Historical geographers and archaeologists in particular draw on a number of ways in which people understand their landscapes, sometimes to help them think about past understandings of the material culture they are analysing. Although we do not want to analyse a landscape as a text or suggest that we can read it in the same manner, it can be helpful to consider briefly how different users of a landscape make different 'readings'. For instance, a farmer in the beautiful upland landscape of the English Lake District might read the fields and open grazing and recall the changing condition of the land, memorable depths of snowfall, tragic sites of mountain accidents and more recently the horrors of mass slaughter of sheep to prevent the spread of a terrible disease. A tourist who enjoys English literature might read the Lake District as a series of invocations of the work of William and Dorothy Wordsworth and Beatrix Potter, perhaps, which they could experience through a 'writers' trail' and forget that the 'essential and eternal' sight of grazing sheep has been threatened by mass culling. A tourist who comes prepared with walking boots and a different sort of publication might want to follow the recommendations of a famous writer on hill walking, Alfred Wainwright, and relish access to open landscapes and pleasant pubs, guided by Wainwright's explanations of how to follow the best routes, and the names of rocks, slopes and water. Each will describe the same region with very different understandings: their points of reference differ emotionally, experientially,

cognitively and intellectually. Each forms personal memories of the Lake District but not in isolation from encounters with other minds, whether the working community around the farmer or the voices from the past that survive in print and in the associations of 'their' landscapes.

No single individual can generate an understanding of the landscape they are in without wider sources of references, whether from their own community, or even transposing their knowledge of a different landscape to a new land to make it comprehensible. There are many examples in settler societies of colonial attempts to organise open landscapes into regimented farming areas and to create domestic gardens reminiscent of those in the imperial homeland. We can explore how landscape is produced as a series of cognitive layers on the physical landform in a more structured approach, following the historical geographer Denis Cosgrove's analysis of historic European categories of understanding landscapes (Cosgrove, 1998).

Cosgrove proposed that there are five 'layers of meaning' associated with cognitive landscapes:

1 custom, law and land
2 aesthetic appreciation of scenery, implying visual control
3 visual representations creating a 'discourse of landscape'
4 landscape as imagined community, supporting identity
5 landscape container of collective memory.

Custom, law and land refers to the European tradition of associating the control of land with social and economic power, from pre-capitalist feudal societies that used land as their primary asset (Olwig, 1996). This layer of meaning extends a grid of ownership over the landscape, parcelling it up into legally defined areas with a range of civil and legal rights: access, extraction, exploitation. Custom, of course, is an essential practice in oral societies without written traditions for asserting historic divisions of land or historic land use practices. Our discussion so far began with the English dictionary definition of 'landscape' as originating from visual representations – capturing the view. We moved on to consider the use of aesthetic appreciation as a criterion in the World Heritage natural site inscriptions, which valued scenery without human intrusions. The recognition of mixed sites as World Heritage cultural landscapes expanded this aesthetic discourse to Cosgrove's fourth layer, which allows for the interaction between local human communities and their land as an essential component of their cultural identity. We follow up 'imagined communities' in the case study, but it is closely linked to collective memory.

Landscape and collective memory: unofficial heritage

Cosgrove's two categories of landscape as imagined community and as a container of collective memory seem to be intertwined, and highly relevant to our consideration of how landscapes become part of **cultural heritage** (further to Chapter 1's discussion of collective value). These 'layers of meaning' that people give to landscapes are currently largely outside the formal criteria for World Heritage cultural landscapes, but they can be captured within the broader significances outlined in the Burra Charter, which looks for social significance. Our understanding of how heritage is made, running throughout this book, suggests that the most powerful factor is what present communities think about their past. Material reminders of the past have no inherent qualities that make them universally appreciated; people ascribe values to places, such as aesthetic appeal or outstanding scientific interest (to use the official language of heritage assessments). We should expect cultural values to be highly specific to communities and their landscapes, even though general fields of human behaviour show similar patterns across very diverse cultures. One example would be in the field of religion, where physical landscapes can carry many landmarks to be interpreted as places for special religious events, activities or behaviours. The case study in this chapter, on the Matobo Hills of Zimbabwe, draws out the relationship between religion, politics and landscape by looking at specific communities and different memories in the area.

The concept of collective memory suggests that meaningfulness is transmitted over time and around society. Archaeologists seek to interpret the meanings of past landscapes, often where there is no continuity of community understanding, typically in the West. For example, archaeological layers of activities around a landmark suggest recognition of the landmark between successive cultural occupations. In England, archaeologists have pointed out that prehistoric burial mounds (earth mounds from cultures older than 2000 BCE) survive with the addition of Anglo-Saxon burial mounds (pre-Christian age of migrations in Europe, fifth to seventh centuries BCE). Early Christian churches in England dating from the seventh century are beginning to be recognised for their association with much earlier enclosures, suggesting a deliberate succession of 'special place' uses.

Celebrating the local through landscapes

Various intangible heritage practices still take place that are particular to localities and landscapes, even in post-industrial, urbanised western societies. In the UK there are some well-known and rather flamboyant traditions that are unique to individual places, such as rolling large round cheeses down the very steep Cooper's Hill outside the Gloucestershire village of Brockworth each May. Threats to the continued performance of these highly localised traditions

from increasing fragmentation of communities and pressures of modern post-industrial life are recognised as threats to local distinctiveness. The charity Common Ground documents and promotes local support for a wide range of customs and practices, ancient and modern. Its position is that our collective sense of identity comes from a series of small-scale practices, many of which are about interacting with locality and place. Celebration and encouragement of the local and particular is one means of encouraging the repetition and thus survival of these practices between generations. In fact, this is a similar issue to the revival of Patipat as a practice in the Philippines rice terraces discussed earlier (Clifford and King, 2006).

Some of us may have grown up in an English parish (a historic unit of landscape associated with a Christian church) that performed the ritual of beating the bounds each year. This is a ritual tied to the western Christian calendar (the Sunday after Easter, itself a moveable date), in which the parish priest and congregation walk around the boundary of the parish, using points in the landscape such as trees, streams and stones, to delimit the territory, and saying prayers for the protection and success of the agricultural crops and animals. As a pan-European ritual found in the medieval western Catholic religious year, it is adaptable to local conditions: in Venice, a city built out of the sea, the agricultural was replaced by the maritime, in which a flotilla of boats marked out the boundaries of the lagoon. This ritual was certainly established before the 1400s, and in Britain survived the transition from Roman Catholic to Protestant practices (Muir, 1997). Not all Anglican churches use this ritual but some are reviving it, and thus we must conclude that it continues to serve purposes for these communities. What might these purposes be? Marking the route of the parish boundary relates to Cosgrove's meanings 1, 4 and 5. This performance of ritual establishes the present group of parishioners in a collective sense of receiving past practices, performing them within previously specified patterns and maintaining them for future performances (for heritage as performance see West and Bowman, 2010).

So we can take the concept of collective memory as 'acts of remembering' and as the reiteration of group narratives about the past. New members of the group gain their own memories of the community narratives by participating in the event. By situating this memory work in a landscape, the material elements in that landscape can be picked out as aids to memory, the cognitive map. This is how humans create mental worlds out of landscapes: the 'cheese-rolling hill' is set into memory through the annual event.

One very new work that has quickly come to be seen as heritage draws together a strong sense of regional identity and a monumental artwork in the landscape. This is a giant iron figure of a winged man by the artist Antony Gormley, placed in 1998 on high open ground near the post-industrial (and economically challenged) town of Gateshead on the river Tyne (Figure 6.5).

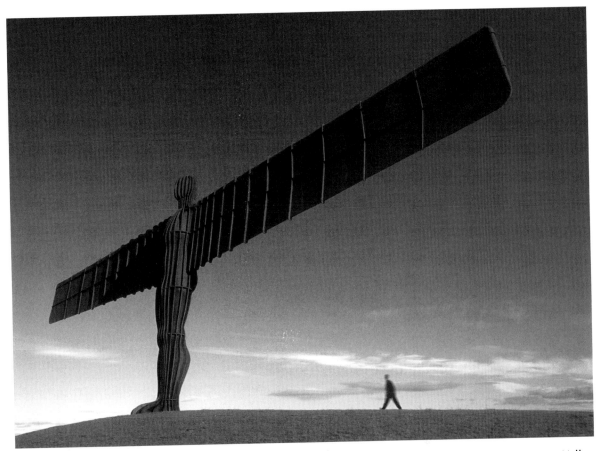

Figure 6.5 Antony Gormley, *Angel of the North*, 1998, corten steel, height 20 m, wingspan 58 m. Team Valley, Gateshead. Photographed by Chris Rout. Photo: © Chris Rout/Alamy.

The success of the *Angel of the North* on its prominent rise comes not from its acclaim by art critics but from its adoption by locals as part of the identity of Gateshead (probably partly in visual opposition to Gateshead's dominating partner on the other side of the river Tyne, Newcastle). Although officially installed as a piece of public art, the *Angel of the North* functions as an emblem of a locality that has gained national recognition.

The English examples briefly introduced here, the cheese rolling, beating the bounds and the *Angel of the North*, span the range of the intensely local, the pan-European and the local made nationally recognisable. None is officially designated as heritage – that is, none is scheduled on a heritage list – but they are all examples of heritage practices that centre on landscape and memory. The first two are also examples of intangible heritage – heritage that exists in action. The following case study takes these points and shows how layers of meaning, from the past re-made in the present, give an area of natural beauty a complex role in modern Zimbabwe.

Case study: the Matobo Hills, a mixed heritage site in Zimbabwe

On 5 July 2003 the Matobo Hills became Zimbabwe's latest entry to the World Heritage List. The decision of the World Heritage Committee was based on the following criteria:

iii The Matobo Hills has one of the highest concentrations of rock art in Southern Africa. The rich evidence from archaeology and from the rock paintings at Matobo provide a very full picture of the lives of foraging societies in the Stone Age and the way agricultural societies came to replace them.

v The interaction between communities and the landscape, manifest in the rock art and also in the long standing religious traditions still associated with the rocks, are community responses to a landscape.

vi The Mwari religion, centred on Matobo, which may date back to the Iron Age, is the most powerful oracular tradition in Southern Africa.

(UNESCO, [2003] 2009c)

While the Matobo World Heritage site is classified as a cultural site, this tends to overshadow its unique mix of complex landscape, cultural artefacts and multi-layered histories that have included appropriations by various pre-colonial societies, missionaries, the colonial state and African nationalists. Commenting on the uniqueness of this heritage site, Hyland and Umenne (2005, p. 7) have noted that 'the intangible heritages of the Matobo Hills reside, as it were, in the tangible aspects'. On the distinction between tangible and intangible heritage, the International Council on Monuments and Sites (ICOMOS) had this to say:

> The distinction between physical heritage and intangible heritage is now seen as artificial. Physical heritage can only attain its true significance when it sheds light on its underlying values. Conversely, intangible heritage must be made incarnate in tangible manifestations.

(quoted in Munjeri, 2004, p. 18)

The name 'Matobo' derives from the Kalanga word *Matombo*, meaning rocks, and the founding leader of the Ndebele state called the hills 'the bald heads'. Early missionaries anglicised Matobo to form 'Matopos Hills'. However, since the achievement of independence in 1980 Matobo Hills has been accepted as the official name. In its justification of the inscription of Matobo Hills as a World Heritage site the nomination dossier (UNESCO, [2003] 2009c) noted that the landscape contained both cultural and natural attributes of exceptional aesthetic, scientific and educational significance. Numerous

photographers and writers have found beauty and solace here; biologists and scientists have been over-awed by the flora and fauna; and many spirit mediums (traditional religious practitioners) have visited the ancient shrines of the *Mlimo* (the Ndebele name for God) and the *Mwari/Ngwali* (the Shona/Kalanga name for God) cults, deep in the hills. Writing on the interface between intangible and tangible heritage, Arjun Appadurai noted that

> Intangible heritage because of its very nature as a map through which humanity interprets, selects, reproduces and disseminates cultural heritage as an important partner of tangible heritage. More important it is a tool through which the tangible heritage could be defined and expressed [thus] transforming inert landscapes of objects and monuments turning them into living archives of cultural values.
>
> (quoted in Munjeri, 2004, p. 18)

Natural, cultural, historical and spiritual treasures make this heritage site a unique tapestry within which the intangible and the tangible are inextricably intertwined.

The Matobo Hills and its unique natural landscape

The Matobo Hills occupy an area of about 3000 sq km in the south-west of Zimbabwe, lying about 30 km south of Zimbabwe's second largest city Bulawayo. The natural landscape comprises geological formations that provide a wide diversity of environments supporting a variety of flora and fauna (Figures 6.6 and 6.7). What distinguishes these hills is their great scenic beauty and the very rich cultural life embedded in them. The geomorphology is of outstanding universal value. It supports a unique landscape made up of extensive open grasslands with groups of *kopjes* (rock outcrops) interspersed with wetlands (marshes and streams). The area of the Matobo Hills is home to birds of prey, including the largest population of black eagle (*Aquila verreauxii*) to be found anywhere in the world. It also hosts a large population of leopards (*Panthera pardus*) and is an important sanctuary and research centre for two endangered rhinoceros species, *Ceratotherium simum* and *Diceros bicornis* (UNESCO, [2003] 2009c). What immediately attracts the eye of any visitor is the unique combination of huge granite relief, distinctive and diverse outcrops (whalebacks, inselbergs, dwala and castellated kopjes) – all interspersed by awe-inspiring rock formations. Hyland and Umenne (2005, p. 3) conclude that 'if there is anything like "architecture without architects", then the Matobo Hills is clearly a living example'.

The nomination dossier (UNESCO, [2003] 2009c) argued that 'Nowhere else on the granitic shield of Zimbabwe, if not the world, can one find so profuse an expression of granitic landforms in so limited an area.'

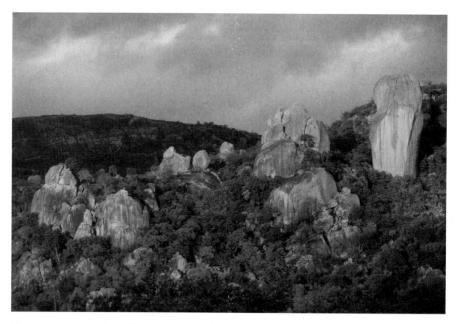

Figure 6.6 Matobo Hills, Matobo National Park, Zimbabwe. Photographed by Nick Greaves. Photo: © Nick Greaves/Alamy.

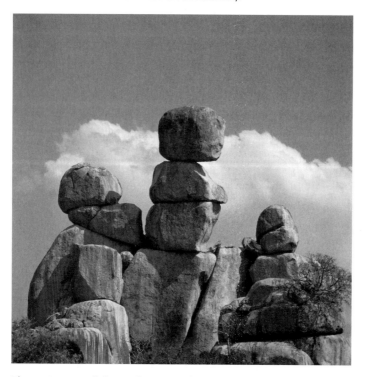

Figure 6.7 Rock formations, Matobo Hills, Matobo National Park, Zimbabwe. Photographed by R. Frank. Photo: © R. Frank/Arco Images GmbH/Alamy.

Matobo's unique history

The history of the Matobo Hills, just like its landscape, is complex and multi-layered. Marked by layers of appropriation stretching from prehistoric times to the present, it has meant different things to the different communities who have inhabited it. This is how Terence Ranger (1989, p. 219) put it:

> To the Banyubi, the hills were an ancestral home; to the Ndebele they held the grave of Mzilikazi. To African cultivators, they offered not a wild but a domesticated environment in which their stock had opened up grazing, and where they could achieve good crops on the vleis and sponges.

The earliest inhabitants of Southern Africa were San who are associated with Stone Age culture and rock art in the Matobo Hills. These Stone Age people were replaced by Iron Age people generically known as the Bantu, who practised agriculture. The present-day Banyubi people residing around the hills are descendants of the Iron Age people who introduced agriculture to the area. But it is the San who left behind over 3000 rock-painting sites that have been identified throughout the Matobo heritage site. Archaeologists have described the Matobo Hills as the most densely endowed area of prehistoric rock art in the world, with two major periods of intensive painting activity having taken place: the first, from the eighth to the sixth millennium BCE, and the second between 200 BCE and 500 CE (Garlake, 1987). San rock paintings constitute one type of rich tangible heritage here (Figure 6.8). In 1839 a group known as the Ndebele under King Mzilikazi Khumalo entered and conquered the south-western part of Zimbabwe, and established the Ndebele state (Cobbing, 1976). The Ndebele were followed in the 1890s by the colonising white settlers who established the Rhodesian colonial state (Walker, 1995). In short, the Matobo Hills has been a site of human habitation from the later part of the Middle Pleistocene (700,000 to 125,000 BCE) through to the Late Pleistocene (125,000 to 12,000 BCE) to the end of the Holocene (12,000 BCE to the present) (Walker, 1995).

The evidence of human habitation includes rock shelters, stone tools, ash and rock art, bones, iron implements and other historical remains. Spectacular hemispherical caves such as Bambata, Nswatugi, Pomongwe and Inanke have provided invaluable archaeological data testifying to past lifestyles (Garlake, 1987). For example, Pomongwe Cave is the only site in Zimbabwe where Early, Middle and Late Stone Age deposits have been found with a wide range of stone tools and implements, bone tools and other related domestic paraphernalia (UNESCO, [2003] 2009c). There are also important historical sites that depict significant contemporary events. These include the burial site of King Mzilikazi Khumalo, founder of the Ndebele nation (for the

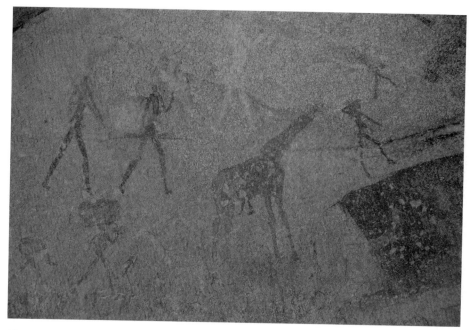

Figure 6.8 Rock art inside Nswatugi cave, Matobo National Park, Zimbabwe. Photo: Jeremy van Riemsdyke. Photo: © Jeremy van Riemsdyke/Images of Africa Photobank/ Alamy.

Ndebele a form of claiming and appropriation of the area for ritual and religious purposes) and the burial site of Cecil John Rhodes, founder of the colony of Rhodesia, who died in 1902.

Both whites and Africans have competed to appropriate the Matobo Hills. In his will, Rhodes gave clear instructions that reflected his admiration of the hills:

> I admire the grandeur and loneliness of the Matoppos in Rhodesia and therefore I desire to be buried in the Matoppos on the hill I used to visit ... I desire the said hill to be preserved as a burial place.
>
> (National Archives of Zimbabwe, 1898)

White settlers worked hard to appropriate the Matobo Hills during the founding decades of colonialism, and it became a theatre of war in 1896 between white colonial forces and the Ndebele people. The Jesuit M. Barthelemy, commented that the British soldiers had 'written with their blood on these imperishable rocks a glorious and authentic page of English history' (*Zambesi Mission Record*, 1 May 1898, p. 21). What continued to attract whites to the Matobo Hills after the defeat of the Ndebele was the grave of Cecil Rhodes (Figure 6.9).

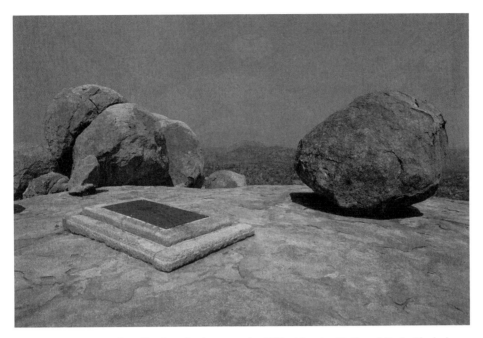

Figure 6.9 Grave of Cecil John Rhodes, Matobo Hills, Matobo National Park, Zimbabwe. Photographed by Jose B. Ruiz. Photo: © Jose B. Ruiz/Nature Picture Library/Alamy.

The laying to rest of Rhodes at the Matobo Hills, where the founder of the Ndebele nation was buried and at a place that the African people considered to be sacred, was to signal and seal white conquest over the local people. This was captured in the *Zambesi Mission Record*:

> A man stronger than Mzilikazi coming after him broke the power of his heir and of his race, divided their spoils, and even in death holds the land. From his vantage point his spirit will keep watch over his conquest.

> (*Zambesi Mission Record*, 24 April 1904, pp. 496–500)

Rhodes's body was buried at the summit of Malindidzimu (also known as the Hill of Spirits). Before his death Rhodes had negotiated with the Ndebele at the Matobo Hills in 1896 the famous *Indaba* (Peace Settlement) that brought to an end the war between the Ndebele and the early white settlers.

The Matobo Hills also played a central role in the manufacturing of African nationalism. When in 1952 Dr Joshua Nkomo, a founder nationalist politician, visited Britain for the first time, he observed how the British valued their past through the graves of kings at Westminster Abbey. This experience inspired him to make a pilgrimage in 1958 to the Matobo Hills to consult Mwari/Ngwali (the Shona Kalanga name for God) for blessings in the prosecution of the nationalist struggle for independence. In his autobiography he wrote that he was given an assurance here that the African nationalists would emerge

victorious after a protracted liberation struggle (Nkomo, 1984). Nkomo was born in Matobo District where the Matobo Hills are located. From the start of his political career in the 1950s he modelled himself as a cultural nationalist who worshipped at the Matobo religious shrines. Because of his association with the shrines, he was believed to have been appointed by Mwari/Ngwali to lead his people to freedom and independence. Nkomo's visit to the Matobo Hills provoked other nationalists such as Simon Muzenda and others from Mashonaland to make similar pilgrimages to Great Zimbabwe (another traditional heritage site in Masvingo in south-eastern Zimbabwe), during which they offered beer to ancestral spirits (Fontein, 2006, p. 106). Competition was beginning among nationalists for ritual blessings. During the formative years of nationalism the grave of Mzilikazi Khumalo was transformed into a national monument and used to inspire the struggle for national independence. A speech made at the graveside by C.C. Hlabangana, for example, who was president of the Matabele Home Society, included the observations:

> Here in the Matopos fate has provided a resting place for two champions of freedom – Cecil John Rhodes, who believed that the greatest amount of freedom was possible only under British rule, and King Mzilikazi, who sought that freedom which was denied him under the rule of Chaka.

> (quoted in Ranger, 1989, p. 238)

Here is a case of an African cultural nationalist trying to syncretise the legacies of Rhodes and Mzilikazi as symbolic of the quest for freedom. White memorials such as Rhodes's grave have sat uncomfortably alongside indigenous shrines in the Matobo Hills. This has added to the paradoxes of the Matobo Hills World Heritage site. Rhodes and Mzilikazi are sometimes remembered together as important empire builders, and their graves were accorded national monument status in 1937 and 1942 respectively. While a traditional custodian cares for King Mzilikazi's grave, Rhodes's grave is taken care of by the National Parks and National Museums and Monuments officials.

The Matobo Hills as a religious site

Terence Ranger's book *Voices from the Rocks: Nature, Culture and History in the Matopos Hills of Zimbabwe* (1999) was written with the aim of reinstating 'culture into nature'. The phrase 'voices from the rocks' is derived from the Kalanga term *Gulati* (voices from the rock). Among Zimbabweans, the area of the Matobo Hills is known as the home of the shrines of the Mwari/Ngwali. This High God is said to have communicated through a voice that sounded as though it emanated from the rocks themselves. Ranger summed up the religious and political significance:

Religion and politics have thus been central to the history of these apparently 'wild' and 'remote' hills – and white religion and politics as much as black. The hills have been the site of an intense symbolic struggle, with mission schools thrust up against every Mwari shrine, and with the grave of Cecil Rhodes standing to this day as a sign of the white endeavour to capture and embody the spirit of the land. White settlers came on pilgrimage to Rhodes's grave – and to the other memorials of white achievement and sacrifice which were erected in the hills – just as blacks journeyed as pilgrims to Mzilikazi's grave and to the shrines. Such white and black travellers have come from all over Southern Africa. These introverted hills, with their locked valleys, have been at the centre of two great international symbolic systems, each proclaiming its own myth of the sacred history of the Matopos.

(Ranger, 1999, p. 3)

The Jesuit missionaries who encountered the Ndebele kingdom by way of the Matobo Hills felt challenged by the African people's religious attachment to the Matobo Hills and their strong belief in a mountain God who spoke from the rocks. The hills were a site of a very strong African religion that pre-dated and even countered Christianity. The Jesuits had this to say about the oracular cult of the African High God:

This God lives in a subterranean cave in a labyrinth of rocks ... In this cave is a deep, black well, the well of the abyss. From time to time dull sounds like thunder come forth from this well. The faithful trembling with fear, place offerings on the edge of the abyss – wheat, corn, poultry, cakes and other gifts – to appease the hunger of the terrible God and to make him propitious ... They seek information about hidden things, future happenings, the names of people who have bewitched them ... After a few moments of deep silence, they hear, in the midst of the subterranean noises, inarticulate sounds, strange words, broken and incomprehensible, which the accomplices of the makers of thunder explain to the credulous devotees ... This is the bliss of the children of nature ... the people whose beliefs, ideas, traditions, habits and customs, we must attempt to change completely ... It is obvious that we shall meet with terrible opposition, with an uprising of primeval passions.

(quoted in Ranger, 1999, p. 15)

The most important examples of intangible heritage sites in the Matobo Hills include such shrines as Njelele, Dula, Zhilo, Manyangwana and Wirirani/Wililani – all of them centres of the Mwari/Ngwali religion. The mountain God and his religious manifestations, particularly his 'voice from the rocks', have attracted the attention of politicians, lay persons, missionaries and others

in the past and the present. The fact that this God resides in the tangible heritage of the Matobo Hills means that any despoliation would deprive the God of a home to live in, and so the tangible aspect of the site receives great respect (Zimbabwe [2003] 2009, p. 8).

Christian missionaries made frantic efforts to disconnect Africans from their sacred Matobo Hills and their oracular cults. Their 'steps to claim the Matopos for Christ' (Ranger, 1999, p. 15) included celebrating their first Mass in a cave in the hills of Matobo. Catholic missionaries went further to establish mission schools and churches around the Matobo Hills in an endeavour to turn Africans away from their heritage. This strategy failed to reduce the sacredness of Matobo Hills in the minds of Africans, who continued to perform religious ceremonies in praise of the mountain God.

The most prominent religious shrine in Matobo Hills is Njelele (often referred to by locals as *Dombo Letshipoteleka*, that is, 'shifting or turning rock'. Njelele is highly respected as a rain-making shrine. It lies to the south-western edge of the hills. To the African people the rocks of Matobo are above all a sacred symbol of God's endurance. Water from the rocks is read as a key indication of the benevolence and mercy of God. Believers hear the voice of Mwari/Ngwali issuing commands and prohibitions from the rocks. Until recently, for example, these determined the pattern of life and land use by Africans (Ranger, 1999, pp. 21–4). The voice of God also narrated and articulated reasons for the fall of earlier political formations such as the Rozvi state, which had dominated the south-western part of the Zimbabwean plateau and was finished off by the Ndebele kingdom in the late 1830s. The Ndebele kingdom was in turn destroyed by white settler colonialism. Ngwali could not protect these kingdoms because they did not respect the voice of God. One strong believer in the power of Ngwali cults was quoted by Ranger stating that 'No one can rule this country unless he comes to the rock' (1999, p. 100). Even today, people from as far away as South Africa, Namibia, Botswana and Lesotho occasionally join their Zimbabwean counterparts at Njelele to pray for rains, good harvests, good health and guidance in many national and regional issues. A traditionally appointed and tested shrine-custodian resides at Njelele and has the responsibility to lead pilgrims in all ceremonies performed at the site. In the past it was here that rules concerning when to plant, when to eat certain plants and when to reap were laid down.

Today, Zimbabweans attach more significance to the traditional rain-making shrines than to the voice of God, which has fallen silent due to anger at the people who have disobeyed prohibitions and other commands. The sacredness of Matobo Hills is captured in an inscription beside the path to the summit of Malindidzimu Hill, also known as Dwelling Place of the Benign Spirits and as World's View, that reads 'This ground is consecrated and set apart for

ever to be the resting place of those who have deserved well of their country.' It is important to mention that many Zimbabweans have consistently linked all major political, economic and natural disasters that have befallen the country to disregard for their traditional religion. 'Indigenous God' is said to be angry due to being neglected. A member of Parliament of Zimbabwe, in support of a motion on propitiation of ancestral spirits, had this to say:

> I do not think we will be able to defeat these spirits of our ancestors ... I beseech you Mr Speaker, let us look behind us and find out what we can do for those who fell on the battle ground because there is real possibility of the spirits visiting their wrath on us. I appeal to you, Mr Speaker, that means be made to bring back the spirits of our relatives back home. All the necessary rituals must be performed in the time honoured Zimbabwe fashion. There is a spirit that talks through me saying, I died in Chiredzi [a small town in south-eastern Zimbabwe] ... If we don't take care of the spirits of the departed we will find that they are going to be vengeful spirits (as opposed to the benevolent) ... I think if we put our minds together we might even have rain in Zimbabwe. Probably, it is one of the reasons why we do not have rains because we do not take time to think where we are coming from and where we are going.
>
> (Ministry of Justice and Parliamentary Affairs, Government of Zimbabwe, 1995, pp. 23–4)

By 2000 some Zimbabweans were advocating the removal of Rhodes's grave from the Matobo Hills in the name of indigenisation and a final push on colonialism. But President Robert Mugabe, addressing the 14th General Assembly and Scientific Symposium of ICOMOS, which met for the first time in Africa at the Victoria Falls in 2003, offered this version of heritage:

> Now that land has returned to the people, they were able once more, to enjoy the physical and spiritual communion that was once theirs. For it must be borne in mind that the non-physical or intangible heritage is an equally strong expression of a people, manifesting itself through oral traditions, language, social practices and traditional craftsmanship. The objectives of ICOMOS were synonymous with Zimbabwe's philosophy. ... Zimbabwe values heritage so much that even the graves of the country's colonialists such as Cecil John Rhodes were being preserved. We accept history as a reality.
>
> (quoted in Ranger, 2004, p. 228)

The context in which this statement was made is the controversial fast-track land reform programme under which land was violently taken from the white commercial farmers at the beginning of 2000 and given freely to Africans. Mugabe had been trying by every means to present the programme as an aspect of empowerment of the formerly colonised – through righting the

wrongs of colonialism. At the same time he wanted the programme to be seen not in terms of resistance but of modernising – in the context of poverty reduction in Africa and fulfilment of the ideals of the national liberation struggle.

Wider meanings

Having looked at the various aspects that intersect to make the Matobo Hills a unique heritage site one wonders why the UNESCO nomination dossier pushed for it to be inscribed as a 'cultural landscape' rather than as a mixed heritage site. The decision to inscribe it simply as a cultural site overshadows its unique landscape and its complex political and social histories. Intangible and tangible heritages are inseparable here, forming a unique cultural landscape where the cultural and the natural co-exist and feed into one another. The unique features of the intangible and tangible aspects lured both the empire builder and diamond magnate Cecil Rhodes and the mighty Ndebele King Mzilikazi Khumalo, who is accredited with naming the hills 'Matobo', meaning 'the bald heads'. There is also exciting political history hidden behind the hills and mountains of Matobo. The history cuts across missionary endeavours, colonial conquest and African resistance as well as the manufacturing of African nationalism.

In 1960, when the African nationalists began to imagine the postcolonial state as Zimbabwe, members of the Matabele Home Society protested that they wanted the postcolonial state to be named after the Matobo Hills. The name Zimbabwe was derived from a prehistoric site, Great Zimbabwe in Masvingo, which is identified with the Shona group. The Matabele Home Society argued that the Matobo Hills is a far more renowned heritage site with a pan-ethnic resonance, whereas Great Zimbabwe is associated with a particular tribe: 'The Matopos are both historically and traditionally of great significance and attempts to belittle [the Matopos] would be resisted in Matabeleland' (*Bantu Mirror*, 20 August 1960). The reality, however, is that the name Zimbabwe was acceptable to the majority of the Shona-speaking people who can imagine the current Zimbabwe with the mirror of Shona history.

The other question that arises in relation to the Matobo Hills heritage site was one posed by Ranger in his article 'Whose heritage? The case of the Matobo National Park' (Ranger, 1989). This is pertinent in heritage studies where too many stakeholders become involved in the management of heritage sites. The human-made structures in Matobo Hills consist of the Rhodes Matobo National Park, Lake Matobo and Recreational Park, parts of Rhodes Matobo Estate, several communal areas and some commercial farms of the Matobo Rural District Council. Diverse interest groups are represented by the communal people of Matobo and Mzingwane District, commercial farmers, the Department of National Parks and Wildlife Management (DNPWM), the

Matobo Conservation Society (MCS) and the Department of National Museums and Monuments of Zimbabwe (NMMZ). The addition of the Matobo Hills to the list of UNESCO-designated World Heritage sites in July 2003 added the international community as another interested stakeholder and further complicated matters. Since the listing local ownership of the heritage has completely eroded as the site must be managed in accordance with UNESCO World Heritage standards rather than local taboos and religious beliefs.

As is generally the case, the processes of heritage management tend towards focusing attention on aesthetically and historically significant works of tangible heritage (artworks, archaeological sites and monuments) (Figure 6.10).

However, local people who are still deeply involved in traditional religion continue to attach great significance to the Matobo Hills, and local adherents are still given access to the religious shrines. The religious significance of the shrines increases during times of crisis such as famine and drought. This was manifested clearly during the years 1991–2 – a period that has entered the

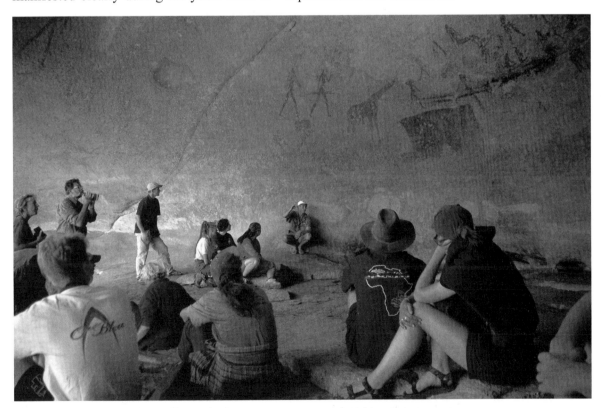

Figure 6.10 Guide Ian Harmer gives a lecture on the rock art inside Nswatugi cave, Matobo Hills, Matobo National Park, Zimbabwe. Photo: Jeremy van Riemsdyke. Photo: © Jeremy van Riemsdyke/Images of Africa Photobank/Alamy.

annals of Zimbabwean history as a drought unprecedented in human memory. Many Zimbabweans blamed the drought on the anger of God, and initiatives were taken to return to cultural and traditional value systems. The shrine of Njelele became very important as people tried to appease God through dance, offerings and other rituals aimed at securing rain (Mafu, 1995, pp. 288–308).

Reflecting on the case study

The 'layers of meaning' proposed by Cosgrove (initially for European landscapes) can be drawn out of the case study. The definition of the boundaries of the World Heritage site creates an inevitable but artificial line on the map, throwing a grid of ownership and formal designation over the landscape (as do the other stakeholders, listed at the conclusion of the case study). The Matobo Hills have an existence as a legal entity. In contrast, Cosgrove's aesthetic appreciation category is not found in the World Heritage criteria selection, but it is a quality emphasised in the case study. Rhodes specified that the 'grandeur and loneliness' of the area drew him to select it as his burial place. Writers and photographers visit for the scenic beauty, a point made in the nomination dossier, and their creations contribute to Cosgrove's third category, of visual representations creating a discourse of landscape. Of course, the case study's main focus is on Cosgrove's final categories: landscapes as imagined community and landscape as a container of collective memory. All three World Heritage criteria touch on these, citing 'community responses to a landscape' over millennia, through rock art and religious traditions. But as we have seen, the Matobo Hills have been an absorbent medium for the complex political history of successive dominant groups, documented in the colonial and postcolonial eras. All of these groups have linked their objectives to the cultural life of the Matobo landscape, even those in opposition such as the Christian missionaries.

Memory and forgetting

Scholars who investigate collective memory identify the selection process implied by 'acts of remembering'. Communities choose how to represent their memories to themselves and choose what is suitable to be forgotten. 'Collective amnesia' can be a serious accusation against a community, particularly if it is the dominant power group in a society. In settler societies, the failure to acknowledge the pre-existing presence of indigenous peoples in 'empty' landscapes has become written into the colonisers' own accounts of the land they found and claimed. This process is usually discussed as a political act, but the important ways that these 'empty' colonial landscapes are represented are through the cultural layers of meaning identified by Cosgrove. Legal identification of land, mythologising the qualities of the new and

strange landscape or the projection of the colonisers' homeland identity on to the unfamiliar landscape, and the creation of collective memories around discovery and the settling process are increasingly recognisable as how the new land is 'made over' into part of the homeland, as the Matobo case study has shown with Cecil Rhodes.

While acts of remembering can be highly selective and therefore destructive by omission, it is also possible for collective memories to shift and respond to new currents. This might take place because a less powerful group gains recognition and its collective memories become more acceptable to the dominant group. In fact, the two World Heritage sites discussed earlier in the chapter, Tongariro National Park and Uluru-Kata Tjuta National Park, both changed their designation from natural to cultural landscape because of this recognition. Both of these landscapes, whose meaningful limits go well beyond the official limits of the national park boundaries, are spectacular examples of spatial frameworks for collective memories that operate in unique understandings of the meaning of time passing. There are no calendars that record the dates of the heroic ancestors for either peoples. Equally, the collective memories that recall origins, connections and meanings are taken to be part of a long chain of memory that connects the present re-tellers with the original actors.

In contrast, western ideas about calendar time and the rapid processes of change that are accessible to living memory, let alone over the past 200 years or so, contribute to our concerns over loss of traditions and the need for authenticity in those traditions we have. We do not use the language of 'collective memory' in thinking about the past, in general, unless for some exceptional cases usually linked to political struggles. In the British Isles, with a long history of border disputes, (internal) colonisation and resistance, long-term memory associations cluster around key figures and outrages. For example, the historic Robert the Bruce, Mary Queen of Scots or the Highland Clearances all still operate as part of Scottish cultural identity. But away from politically charged memories, many British citizens might feel disconnected from collective memories and particularly those that make the British landscape more than an attractive backdrop. This is not to discount the deeply felt inherited memories of conflict from battlefield sites of the English Civil Wars of the seventeenth century or the Scottish Jacobite sites of the eighteenth century. However, there are no battlefield landscapes that carry the visible acknowledgement of the dead to the degree seen in continental Europe, for example. The experience of those who fought in the war zones of the First World War and the concerns of their generation to commemorate their war dead have led to the creation of a series of designated cemeteries and associated monuments. The commemoration of personnel who died on foreign soil was often accomplished through designs that symbolised their origins,

reconnecting them, perhaps, to land with which they could not be reunited. These more recent and painful landscapes of memory can be experienced only by leaving Britain.

Conclusion

This chapter has discussed landscape in three broad dimensions: as a natural environment, as a particular type of cultural environment and as a canvas for memories. All three have important claims to be heritage dimensions, carrying elements that we recognise and celebrate now and wish to pass on to successive generations. While the idea of purely natural environments, with no cultural effects from human occupation, is increasingly difficult to sustain, we should not overlook the immense scientific significance of landscapes. Their geology, flora and fauna carry the story of our planet as we understand it through scientific investigations.

The concept of cultural landscape has the virtue of simplicity in stating something that is observable but 'taken for granted' in many ways: that humans interact with their landscapes. We have identified cultural landscapes as both an advance in official heritage understandings and as a continuing problem to reconcile diverse interests and threats.

While we have explored the benefits of recognising the interaction of people and land, the challenge for heritage managers continues to be how to understand, recognise and support the intangible meanings that communities make of their land. We also noted some problems arising from identifying cultural landscapes: ugliness, redundancy, the imposition of heritage management frameworks on indigenous cultures. The following chapter will take the last issue much further and reiterate this chapter's emphasis on the role of intangible heritage in making our understandings of landscapes.

Works cited

Australia ICOMOS (1999) The Australia ICOMOS Charter for the Conservation of Places of Cultural Significance [online], www.icomos.org/australia/ (accessed 4 September 2008).

Clifford, S. and King, A. (2006) *England in Particular: A Celebration of the Commonplace, the Local, the Vernacular and the Distinctive*, London, Hodder and Stoughton.

Cobbing, J. (1976) 'The Ndebele under the Khumalos, 1820–1896', unpublished PhD thesis, University of Lancaster.

Cosgrove, D. (1998) 'Cultural landscapes' in Unwin, T. (ed.) *A European Geography*, Harlow, Longman, pp. 65–81.

Donnachie, I. (2010) 'World Heritage' in Harrison, R. (ed.) *Understanding the Politics of Heritage*, Manchester, Manchester University Press/ Milton Keynes, The Open University, pp. 115–96.

Fontein, F. (2006) *The Silence of Great Zimbabwe: Contested Landscapes and the Power of Heritage*, New York, University College of London Press.

Fowler, P. (2004) *Landscapes for the World: Conserving Global Heritage*, Bollington, Cheshire, Windgather Press.

Garlake, P. (1987) *The Painted Caves*, Harare, Modus.

Greeves, L. (2004) *History and Landscape: The Guide to National Trust Properties in England, Wales and Northern Ireland*, London, The National Trust.

Harrison, R. and O'Donnell, D. (2010) 'Natural heritage' in West, S. (ed.) *Understanding Heritage in Practice*, Manchester, Manchester University Press/Milton Keynes, The Open University, pp. 88–126.

Hyland, A.D.C. and Umenne, S.I.K. (2005) 'Place, tradition and memory: tangible aspects of the intangible heritage in the cultural landscapes of Zimbabwe: a case study of the Matobo Hills', paper presented at Forum UNESCO University and Heritage 10th International Seminar, *Cultural Landscapes in the 21st Century*, Newcastle-Upon-Tyne (11–16 April).

Mafu, H. (1995) 'The 1991–92 Zimbabwean drought and some religious reactions', *Journal of Religion in Africa*, vol. 25, pp. 288–308.

Ministry of Justice and Parliamentary Affairs, Government of Zimbabwe (1995) Parliamentary Debates, vol. 22, no. 33, pp. 23–4 (5 September).

Muir, E. (1997) *Ritual in Early Modern Europe*, Cambridge, Cambridge University Press.

Munjeri, D. (2004) 'Tangible and intangible heritage: from difference to convergence', *Museum International*, vol. 56, nos 1–2, pp. 12–20.

National Archives of Zimbabwe (1898) Ministry of National Affairs, File S.246/245.

Nkomo, J. (1984) *Nkomo: The Story of My Life*, London, Methuen.

Olwig, K. (1996) 'Recovering the substantive nature of landscape', *Annals of the Association of American Geographers*, no. 86, pp. 630–1.

Otero-Pailos, J., Gaiger, J. and West, S. (2010) 'Heritage values' in West, S. (ed.) *Understanding Heritage in Practice*, Manchester, Manchester University Press/Milton Keynes, The Open University, pp. 47–87.

Ranger, T. (1989) 'Whose heritage? The case of the Matobo National Park', *Journal of Southern African Studies*, vol. 15, no. 2 (January), pp. 217–49.

Ranger, T. (1999) *Voices from the Rocks: Nature, Culture and History in the Matopos Hills of Zimbabwe*, London, James Currey.

Ranger, T. (2004) 'Nationalist historiography, patriotic history and the history of the nation: the struggle over the past in Zimbabwe', *Journal of Southern African Studies*, vol. 30, no. 2 (June), pp. 215–34.

Smith, L. (2006) *Uses of Heritage*, Abingdon and New York, Routledge.

UNESCO ([2008] 2009a) The Operational Guidelines for the Implementation of the World Heritage Convention [online], http://whc.unesco.org/en/guidelines/ (accessed 28 July 2009).

UNESCO ([1981] 2009b) Darien National Park [online], http://whc.unesco.org/en/list/159 (accessed 12 January 2009).

UNESCO ([2003] 2009c) World Heritage Committee, Matabo Hills [online] http://whc.unesco.org/en/list/306 (accessed 28 July 2009).

UNESCO, CIFOR and Government of Indonesia (1999) The World Heritage Convention as a Mechanism for Conserving Tropical Forest Biodiversity [online], http://whc.unesco.org./uploads/activities/documents/activity-43–7.pdf (accessed 12 January 2009).

Walker, N. (1995) *Late Pleistocene and Holocene: Hunter-Gatherers of the Matopos: An Archaeological Study of Change and Continuity in Zimbabwe's Societies*, Uppsala, Archaeological Upsailiensis.

West, S. and Ansell, J. (2010) 'A history of heritage' in West, S. (ed.) *Understanding Heritage in Practice*, Manchester, Manchester University Press/Milton Keynes, The Open University, pp. 7–46.

West, S. and Bowman, M. (2010) 'Heritage as performance' in West, S. (ed.) *Understanding Heritage in Practice*, Manchester, Manchester University Press/Milton Keynes, The Open University, pp. 277–312.

West, S. and McKellar, E. (2010) 'Interpretation of heritage' in West, S. (ed.) *Understanding Heritage in Practice*, Manchester, Manchester University Press/Milton Keynes, The Open University, pp. 166–204.

Zambesi Mission Record (1898) 1 May, p. 21.

Zambesi Mission Record (1904) 24 April, pp. 496–500.

Zimbabwe, State Party of ([2003] 2009) Nomination Dossier for the Proposed World Heritage Area [online], http://whc.unesco.org/en/list/306/documents (accessed 15 october 2009).

Further reading

Aplin, G. (2007) 'World Heritage cultural landscapes', *International Journal of Heritage Studies*, vol. 13, no. 6, pp. 427–46.

Bell, C. and Lyall, J. (2002) *The Accelerated Sublime: Landscape, Tourism and Identity*, Westport, CT, Praeger.

Gezon, L. (2006) *Global Visions, Local Landscapes: A Political Ecology of Conservation, Conflict and Control in Northern Madagascar*, Lanham, MD, AltaMira Press.

Longstreth, R.W. (2008) *Cultural Landscapes: Balancing Nature and Heritage in Preservation Practice*, Minneapolis, University of Minnesota Press.

Lowenthal, D. (1997) *The Heritage Crusade and the Spoils of History*, Cambridge, Cambridge University Press.

Moore, N. and Whelan, Y. (2007) *Heritage, Memory and the Politics of Identity: New Perspectives on the Cultural Landscape*, Aldershot, Ashgate.

Murray, N., Shepherd, N. and Hall, M. (eds) (2007) *Desire Lines: Space, Memory and Identity in a Post-Apartheid City*, Abingdon and New York, Routledge.

Olwig, K. (2002) *Landscape, Nature and the Body Politic: From Britain's Renaissance to America's New World*, Madison, University of Wisconsin Press.

Palang, H. and Fry, G. (eds) (2003) *Cultural Heritage in Changing Landscapes*, Dordecht, Boston, London, Kluwer Academic Publishers.

Pearkes, E.D. (2002) *The Geography of Memory: Recovering Stories of a Landscape's First People*, Nelson, BC, Kutenai House Press.

Penning-Rowsell, E.C. and Lowenthal, D. (1986) *Landscape Meanings and Values*, London, Allen and Unwin.

Chapter 7 Intangible heritage

Rodney Harrison and Deborah Rose

This chapter considers the concept of intangible heritage and the uses to which it has been put, in the context of the World Heritage List and other state-led heritage management initiatives, and as part of a non-western and indigenous critique of western ideas of heritage conservation. The first part of the chapter explores the history of the concept as it has been employed by UNESCO. The case study, written by anthropologist Deborah Rose, then explores an alternative way of thinking about the relationship between tangible and intangible heritage which emerges from the study of Indigenous Australian world views. It does this through an exploration of people's values surrounding the Australian landscape and natural heritage conservation areas such as national parks. The discussion following the case study explores some of the broader implications of the indigenous and non-western critique both for heritage management and for the concept of intangible heritage in general.

Introduction

In a low shelter made of *ubim* leaves and black straw, a *Wajãpi* woman is painting geometric designs on the body of a man using thick, red, scented vegetable dyes (this section draws on Gallois, 1997 and UNESCO, 2008a). The woman focuses intently on the designs, an anaconda and a jaguar painted across the man's face and torso. They are standing in a small village of five huts on the banks of the Oiapoc river in the Amazon rainforest. The man knows he is lucky to have the older woman paint him, as she is an expert in mixing and applying the dye, and not only knows the traditional designs but has also begun to design her own symbols. A group of children play nearby in the reeds. Beyond the banks of the river the children call to a group of men who are returning from working in the maize fields. As they prepare for the maize feast, the men and women will paint their bodies with *kusiwa* designs which recall the stories of their ancestors and their creation and make the world come alive anew.

The *kusiwa* designs belong to an oral and pictographic tradition associated with the *Wajãpi*, a group of some 580 Tupi-guarani language speakers who are indigenous to the northern Amazonian region (Figure 7.1). Today, the *Wajãpi* live in a series of approximately 40 small villages on a specially designated reserve in the state of Amapá, one of the northern states of Brazil and bordering French Guiana. In 2003 the *kusiwa* designs were proclaimed by UNESCO as one of a series of Masterpieces of the Oral and Intangible Heritage of Humanity. This immediately raises a number of questions. How is

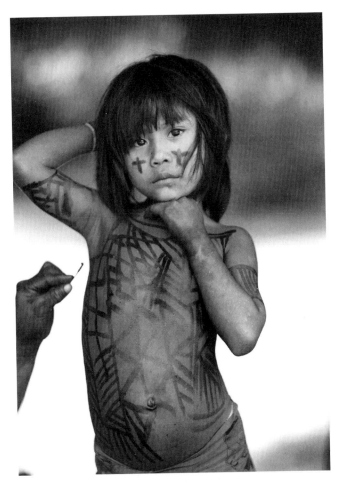

Figure 7.1 *Wajãpi* child being decorated with red *kusiwa*
designs. Photographed by Bo Mathisen. Photo: ©
Bo Mathisen.

it that an oral and pictographic tradition can be considered to be World
Heritage, in the same way that the Great Barrier Reef or the Pyramids at Giza,
for example, can? How can the process of making these designs, which only
a small number of skilled individuals can render and which are legible to
fewer than 1000 people, be considered part of the shared heritage of all of
humanity? And what does such a listing mean in practical terms? How can the
oral and pictographic tradition be adequately protected when it resides only in
the minds, stories and traditions of such a small group of people?

The aim of this chapter is to explore the ways in which the concept of
intangible heritage has transformed and continues to challenge official
practices of heritage conservation in the modern world, particularly those
associated with the World Heritage Convention. The term 'intangible heritage'
was originally coined in order to problematise the focus of official heritage

management on material things. It has had particular potency in traditional societies and in settler societies where indigenous cultural heritage might be more (physically) ephemeral in comparison with the heritage of the usurping group or of other more developed societies in general. It has also been used to highlight those non-material aspects of culture – such as language, literature (both oral and written), music and religious and cultural practices – that are important to people in helping establish their identity and sense of community in the world. However, as the case study in this chapter demonstrates, the concept of intangible heritage as it has been applied by UNESCO in its Convention for the Safeguarding of the Intangible Cultural Heritage of 2003 and in other official 'western' heritage practices can be seen to be flawed in many ways.

Intangible heritage is intimately connected with memory. Paul Connerton's work (1989), discussed in Chapter 1, established two forms of social memory, both of which relate to intangible heritage. Most of the chapters in the book have so far concerned themselves almost exclusively with collective memory, and in particular with the kind of social memory that Connerton calls *inscribed* **memory** – those monuments, texts or representations that materialise social memory. Connerton contrasted this with *embodied* **memory** – the performative, bodily, behavioural contexts in which memory is produced and reproduced. Intangible heritage is concerned primarily with those non-material aspects of social life that relate to aspects of tradition and the past. These might include such things as spoken language, song, dance, cuisine, types of craft and forms of artistic expression. It might also be seen to include people's sense of 'attachment' to a place, building or object. Intangible heritage occupies the fluid, slippery space between people and things. It is a form of social memory that is grounded both in 'everyday' practices such as speaking, walking, gesturing and communicating, and in more specialised ceremonial or ritual contexts. Whatever the case, intangible heritage can be thought of as the non-material aspects of culture that help societies to remember their past and their traditions, to build a sense of identity, community and locality in the present.

A history of the concept of intangible heritage and the World Heritage Convention

As has been noted by a number of authors (for example, Smith, 2006, pp. 21, 89–95; Byrne, 2008), the wording of UNESCO's International Charter for the Conservation and Restoration of Monuments and Sites (1964, known as the Venice Charter,) and of the Convention Concerning the Protection of the World Cultural and Natural Heritage (1972, known as the World Heritage Convention) is focused on the material aspects of culture – great works of art, architecture and archaeology. Article 1 of the World Heritage Convention

defines cultural heritage as monuments, groups of buildings and sites, in opposition to natural heritage which it defines as natural features, geological and physiographical formations and natural sites:

> monuments: architectural works, works of monumental sculpture and painting, elements or structures of an archaeological nature, inscriptions, cave dwellings and combinations of features, which are of outstanding universal value from the point of view of history, art or science;
>
> groups of buildings: groups of separate or connected buildings which, because of their architecture, their homogeneity or their place in the landscape, are of outstanding universal value from the point of view of history, art or science;
>
> sites: works of man or the combined works of nature and man, and areas including archaeological sites which are of outstanding universal value from the historical, aesthetic, ethnological or anthropological point of view.
>
> (UNESCO, [1972] 2009)

It is worth pointing out that not only the aspects of cultural heritage are identified as material 'things', but also that their significance is defined with reference to 'history, art or science', and not with reference to the contribution of heritage to a sense of collective identity or a 'sense of place' within the world. Similarly, the significance of natural heritage in the charter is articulated in terms of scientific or aesthetic significance, not in terms of human relationships with landscape. Despite the concerns of a number of member states with the need to safeguard non-material aspects of cultural heritage – concerns that were raised with the ratification of the World Heritage Convention – it was many years before UNESCO explicitly addressed the issue of non-tangible heritage. As early as 1973, Bolivia suggested to UNESCO that a protocol might be added to the Universal Copyright Convention in order to protect aspects of folklore (Aikawa, 2004). However, it was not until 1982 that the Mondiacult World Conference on Cultural Policies, held in Mexico City, officially acknowledged these concerns regarding the importance of intangible cultural heritage and included it in its new definition of cultural heritage (UNESCO, [2003] 2008b). UNESCO subsequently established a Committee of Experts on the Safeguarding of Folklore, and in 1989 the Recommendation on the Safeguarding of Traditional Culture and Folklore was adopted by the General Conference of UNESCO in Paris (Kurin, 2004).

The Recommendation on the Safeguarding of Traditional Culture and Folklore defined folklore (or traditional and popular culture) as

> the totality of tradition-based creations of a cultural community, expressed by a group or individuals and recognized as reflecting the expectations of a community in so far as they reflect its cultural and

social identity; its standards and values are transmitted orally, by imitation or by other means. Its forms are, among others, language, literature, music, dance, games, mythology, rituals, customs, handicrafts, architecture and other arts.

(UNESCO, 1989)

It called on member states to develop a national inventory of institutions concerned with folklore with a view to their inclusion in regional and global registers of folklore, and to establish national archives where collected folklore could be stored and made available. In this regard, UNESCO followed a long-standing western tendency to 'materialise' aspects of culture; in this case, the focus became the collecting of folklore as archives.

However, the Committee had made clear that the preservation of folklore

is concerned with protection of folk traditions *and those who are the transmitters*, having regard to the fact that each people has a right to its own culture and that its adherence to that culture is often eroded by the impact of the industrialized culture purveyed by the mass media.

(UNESCO, 1989; emphasis added)

It recommended that 'measures must be taken to guarantee the status of and economic support for folk traditions both in the communities which produce them and beyond'. How to put such preservation into action seemed harder to define, and recommendations were made, among others, to 'guarantee the right of access of various cultural communities to their own folklore by supporting their work in the fields of documentation [and] archiving', and to 'provide moral and economic support for individuals and institutions studying, making known, cultivating or holding items of folklore'.

It is worth pausing to reflect for a moment on the term 'folklore' and the way in which it was employed by UNESCO in its recommendations. The term is most often associated with non-industrial societies, and its use seems to imply that 'traditional culture' cannot exist except in such contexts. However, some authors (for example, Smith, 2006) would suggest that all aspects of tangible heritage – buildings, landscapes and monuments – are animated and are made significant only by the traditions, stories, representations, history, criticism, activities and, for want of a better word, 'renown' (or gossip/ rumour – see also Byrne, 1995) that surround them. Nonetheless, it is clear that UNESCO's initiative was aimed at preservation of the non-material aspects of indigenous/first nations and developing peoples, and intended to address what many perceived to be an imbalanced focus on the 'tangible' and monumental aspects of heritage that were being promoted as World Heritage

through inclusion on the World Heritage List. In 1996 the Report of the World Commission on Culture and Development, *Our Creative Diversity*, noted that the 1972 World Heritage Convention was not appropriate for celebrating and protecting intangible expressions of cultural heritage such as dance or oral traditions, and called for the development of other forms of recognition (besides World Heritage listing), for the whole range of heritage found in societies across the world (UNESCO, [2003] 2008b). An underlying principle of the report was that the diversity of world cultures must be protected and nurtured. The 1989 Recommendation on the Safeguarding of Traditional Culture and Folklore had remained largely unacknowledged due to a lack of incentives or possible sanctions, as well as an absence of operational guidelines to explain how the recommendations should be carried out (Schmitt, 2008, p. 97).

In June 1997 the UNESCO Cultural Heritage Division and Moroccan National Commission organised an international consultation on the preservation of popular cultural spaces in Marrakesh. The consultation grew out of concerns raised a year earlier by the Spanish writer Juan Goytisolo, among others, regarding the impact of commercial and urban development on the character and traditions associated with Jemaa el Fna Square in Marrakesh, a centre for the transmission of **oral history** and culture by *halaiqui* (oral storytellers), musicians, acrobats and seers (Schmitt, 2008). Despite the Recommendation on the Safeguarding of Traditional Culture and Folklore, as Schmitt (2008) has noted, it was not until significant external pressure developed around the issue of Jemaa el Fna Square that there was sufficient impetus to get the development of a convention on UNESCO's agenda, and the final shape of the convention was strongly influenced by the particular debate over the future of the site. As a result of this consultation and the external discussion regarding Jemaa el Fna Square, the creation of an international convention to protect and draw attention to outstanding examples of folklore and popular culture, including intangible heritage, was recommended. In 1999 UNESCO and the Smithsonian Institution jointly organised a conference in Washington DC titled A Global Assessment of the 1989 Recommendation on the Safeguarding of Traditional Culture and Folklore: Local Empowerment and International Cooperation. This was followed in May 2001 by the First Proclamation of nineteen Masterpieces of the Oral and Intangible Heritage of Humanity. In October 2003 the 32nd session of the General Conference adopted the Convention for the Safeguarding of the Intangible Cultural Heritage, at which time the Second Proclamation inscribed twenty-eight new Masterpieces of the Oral and Intangible Heritage of Humanity. A further forty-three were inscribed in 2005 (UNESCO, [2003] 2008b).

What is intangible cultural heritage?

The Convention for the Safeguarding of the Intangible Cultural Heritage defines intangible cultural heritage as

> the practices, representations, expressions, knowledge, skills – as well as the instruments, objects, artefacts and cultural spaces associated therewith – that communities, groups and, in some cases, individuals recognize as part of their cultural heritage. This intangible cultural heritage, transmitted from generation to generation, is constantly recreated by communities and groups in response to their environment, their interaction with nature and their history, and provides them with a sense of identity and continuity, thus promoting respect for cultural diversity and human creativity. For the purposes of this Convention, consideration will be given solely to such intangible cultural heritage as is compatible with existing international human rights instruments, as well as with the requirements of mutual respect among communities, groups and individuals, and of sustainable development.

<div align="right">(UNESCO, 2003)</div>

It goes further in defining the areas in which intangible cultural heritage is manifest, namely: 'oral traditions and expressions, including language; performing arts; social practices, rituals and festive events; knowledge and practices concerning nature and the universe; and traditional craftsmanship'. The convention urges member states to establish inventories of intangible cultural heritage in their territories, to ensure recognition and respect for intangible cultural heritage, and it directs UNESCO to develop a 'Representative List of the Intangible Cultural Heritage of Humanity ... [to] ensure better visibility of the intangible cultural heritage and awareness of its significance, and to encourage dialogue which respects cultural diversity'. It also makes provision for the development of a 'List of Intangible Cultural Heritage in Need of Urgent Safeguarding' and establishes a fund for the safeguarding of the intangible cultural heritage. There are ninety items on the list of 'Masterpieces', ranging from the language, dance and music of the Garifuna in Belize, Guatemala, Honduras and Nicaragua, to the Slovácko Verbuňk Recruit Dances of the Czech Republic, and the Wayang Puppet Theatre of Indonesia.

An example is *el Día de los Muertos* (Day of the Dead) celebrations in Mexico City, which were placed on the UNESCO list of Masterpieces of the oral and intangible heritage of humanity in 2003 (Figure 7.2). Alongside the development of the Convention for the Safeguarding of the Intangible Cultural Heritage was a widening definition of heritage associated with World Heritage Convention. In 1992 the concept of cultural landscapes was adopted by UNESCO (see further discussion in Chapter 6). Until the end of 2004,

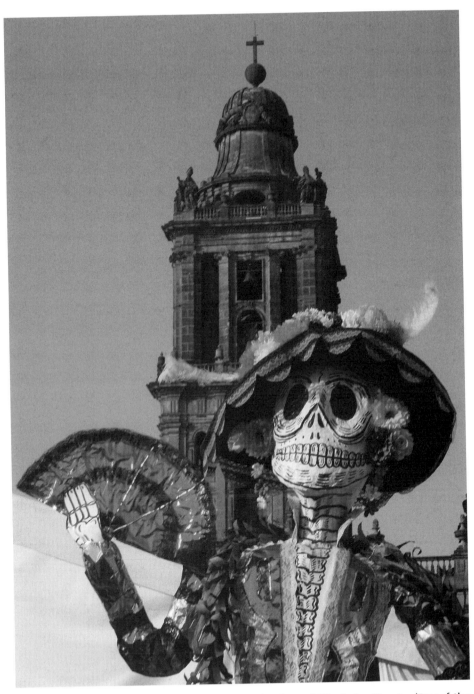

Figure 7.2 La Catrina, a symbol representing death at *el Día de los Muertos* (Day of the Dead) celebrations, Mexico City, 2008. Photo: Luis Acosta. Photo: © Luis Acosta/AFP/Getty Images. In Mexican folk culture, the Catrina is the skeleton of a high-society woman and one of the most popular figures of *el Día de los Muertos*.

World Heritage sites were selected on the basis of six cultural and four natural criteria. With the adoption of the revised Operational Guidelines for the Implementation of the World Heritage Convention, a single set of ten criteria was adopted. This was to allow for the increased recognition of places with mixed natural *and* cultural heritage significance (see further discussion in Chapter 6).

We can make two broad observations here. The first is that UNESCO adopted the concept of intangible cultural heritage as part of a programme of expanding its overall conception of heritage and developing what it perceived to be more inclusive definitions of heritage in the same way that it did for multicultural heritage (Chapter 5), landscape (Chapter 6) and twentieth-century heritage (see Chapter 8). The second is that the adoption of intangible cultural heritage as a 'class' of cultural heritage within the remit of the World Heritage List and the World Heritage Committee occurred as part of a general push to develop more *representative* approaches to cultural heritage. This move towards representative approaches to heritage constitutes one of the most important historical shifts in heritage to occur in the twentieth century. It signalled a move away from a 'canon' of World Heritage places and towards a 'representative list' of places as part of a general relativism which became widespread during the late twentieth century; this was associated with the adoption of ideas derived from post-structural theory and the influence of anthropology and cultural studies on the arts and humanities. Instead of basing selection on a set of absolute judgements of quality and historical claims made by professionals within their field, decisions would now take into account a broad recognition of the importance of preserving cultural diversity all over the world. The requirement to shift towards more representative lists of heritage was made clear by criticism of the narrow conception of heritage that seemed to be inherent in the Venice Charter and the World Heritage Convention, and the bias within the World Heritage List towards the built heritage of western Europe. This shift is reflected in the geographic spread of the ninety 'Masterpieces', 14 of which are located in Africa, 8 in Arab States, 30 in the Asia-Pacific region, 21 in Europe and 17 in Latin America and the Caribbean.

In 2005 the list of 'Masterpieces' was closed, to be replaced in 2008 by a Representative List of the Oral and Intangible Heritage. The call for a more inclusive and representative World Heritage List came largely from those countries who were able to see the economic and political benefits, particularly in terms of tourism, of having World Heritage nominations put forward by states parties, but who had been excluded from the World Heritage List due to the nature of their more ephemeral architectural traditions and lifeways. Nonetheless, it is worth pointing out that as we have seen in the quotation above, this cultural relativism is not given a completely free rein. It is permitted only 'as is compatible with existing international human rights

instruments, as well as with the requirements of mutual respect among communities, groups and individuals, and of sustainable development' (UNESCO, [2003] 2008b).

The Convention for the Safeguarding of the Intangible Cultural Heritage perhaps raises as many problems as it attempts to solve. Problems seem to arise when its definition of heritage merges completely into 'culture', especially seeing as the convention allows for re-invention of forms and practices of heritage. This forces us to query whether any identity-forming practices are capable of being classed as heritage. Or does there have to be an element of tradition anchored in the practices of ancestors? To return to the example with which this chapter began, is everything the *Wajãpi* people do to be preserved? If not, how would we choose between them? One wonders, beyond the gesture of acknowledging various aspects of non-western cultures as a part of the world's cultural heritage, quite how the convention is to be applied in the real world.

One of the problems with this broadening of the concept of heritage is that it has opened a wider discussion that questions the notion of heritage itself, and the legitimacy of a list of World Heritage more generally. These 'Masterpieces' of oral and intangible heritage are largely drawn from traditions that emphasise an integrated approach to heritage, where heritage is seen as an aspect of everyday life (that is, as culture). For the *Wajãpi*, their oral and pictographic tradition is celebrated as an integrated part of their everyday social lives. But the tradition that gave rise to the World Heritage List was one which saw heritage in rather more separatist terms, which could be described as a perception of heritage as the canon of 'high culture' and those things in the world which have become rare or exotic, as a tool of education about the great artistic and architectural endeavours of the past for those living in the present. So although the concept of intangible heritage was developed to challenge the cultural materialism that lies inherent in the 1972 World Heritage Convention, the distinction between intangible and tangible heritage continues a 'western' world view, or ontology, which emphasises a duality between nature and culture, between the material and the non-material world, and most importantly between the physical and the cultural world.

In the case study, written by anthropologist Deborah Rose, we look at the ways in which Indigenous Australian world views provide a fundamental challenge to the notions of intangible and tangible heritage contained within both the World Heritage Convention and the Convention for the Safeguarding of the Intangible Cultural Heritage. Following the case study, we will explore the ways in which this challenge might be seen to deconstruct various notions of heritage inherent in the World Heritage Convention.

Case study: Indigenous Australian world views and intangible heritage

> Life is always 'preserving the past, making a difference between past and present; life binds time, expanding complexity and creating new problems for itself'.
>
> (Margulis and Sagan, 2000, p. 86)

Challenges

Indigenous cultures offer interesting and often profound challenges to heritage, and implicitly to modernity more generally. The Indian cultural theorist and critic Ashis Nandy urges us, in his essay 'History's forgotten doubles', to consider alternative modes of engaging with the past. One of his great statements is 'It is my suspicion that, broadly speaking, cultures tend to be historical in only one way, whereas each ahistorical culture is so in its own unique style' (Nandy, 2003, p. 86). What Nandy is referring to here is the fact that some cultures perceive past, present and future as integrally related, and that they do so in ways that are integrated with other aspects of their cultures. One could say the same about heritage: just as Nandy suggests that the field should be left open for ahistorical peoples to articulate their own realities, so too could heritage. It should be noted that those who work within western history are attuned to the myriad differences and nuances within the field; in contrast, from an outside perspective, particularly from a subaltern viewpoint, what stands out are some key issues that seem oppressive, perhaps even intractable. Nandy identifies a few such problematic features of the western mode of history and they are pertinent in thinking about heritage. These are problems of encounter; they arise when people come up against **modernity**'s certitude (in its own ways of knowing), its attachment to reliable and valid knowledge (as it defines such knowledge), its rejection of religion and magic and its secularisation of nature (Nandy, 2003, p. 88).

I have been learning from Aboriginal people in Australia for about twenty-eight years, and much of my learning has involved matters that can be defined as heritage (Figure 7.3). What I have to say about Aboriginal Australia is true for many parts of the world where indigenous people come into contact with the heritage constructs of modernity. Without wishing to claim that all indigenous people everywhere are the same, or experience encounters with western heritage in the same way, I am confident that my experience of heritage issues in Australia resonates across numerous continents and contexts.

I will discuss some of the major challenges that indigenous cultures offer to heritage, and I will draw on a few case studies both to clarify and enliven the discussion, and to link the more abstract points with real world events.

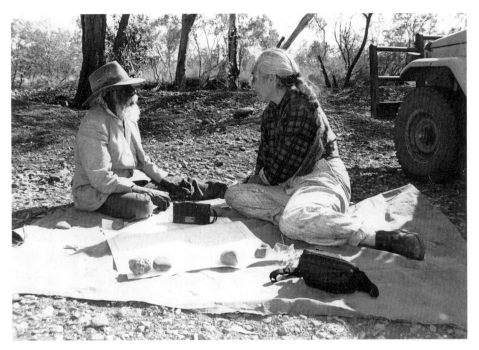

Figure 7.3 Jimmy Mangayarri and Deborah Rose undertaking research in the bed of Wattie Creek, 1991. Photographed by Darrell Lewis. Photo: © Darrell Lewis. In Aboriginal culture, knowledge is emplaced. Learning, for Aboriginal people and for outsiders, is connected with country.

My analysis extends to questions of ontology, or to questions of 'how the world really is'. It thus complements the work of other heritage scholars, particularly that of Laurajane Smith (2006). The vast majority of studies exploring the interface of indigenous people and heritage focus on identity politics, and these are also questions of control. Who owns the past? Who holds the human remains and other sacralia? Who decides what (if any) conservation measures are to be taken? Who are the experts? These are important questions, but they remain within a sociopolitical domain that is only part of the encounter. Within that domain, where the context is settlers and indigenous people, it makes sense to assert that it's all about control. Moving to a wider domain, however, different questions arise.

At the most abstract, an indigenous ontological challenge destabilises western anthropocentrism (the treatment of humans as pre-eminent) and the thinking that sustains it. One of the great western dualisms is between nature (the non-human) and culture (the human). Within an ontology in which 'culture' is everywhere, not only is there no boundary between nature and culture, there is no mind–matter binary. This contrasts with a western dualism derived from a philosophical tradition that has its roots in the work of Descartes which sees the mind and body as separate, and the mind itself as non-physical. Rather

than mind being a strictly human property, leaving matter and nature mindless, indigenous ontologies hold mind to be widespread. The world is full of sentient beings, only some of whom are human and, in fact, only some of whom would be classed in western ontology as living. Australian Aboriginal philosopher Mary Graham writes of these matters in a fascinating article entitled 'Some thoughts about the philosophical underpinnings of Aboriginal worldviews' (Graham, 2008). She identifies two basic precepts. Each one is deceptively simple and extraordinarily complex.

The First: The Land is the Law.

The Second: You are not alone in the world.

(Graham, 2008, p. 181)

The case study will illuminate these precepts in specific detail. For the moment, I want to note that these precepts challenge anthropocentrism and the idea that heritage meaning is made only by humans. They thus challenge the western tangible–intangible dualism. Within this binary structure, tangible matter is made meaningful by being brought into a world of intangible meanings which are the property of human culture and experience. In contrast, I will suggest that indigenous ontologies propose a philosophy of 'becoming', in which life and place combine to bind time and living beings into generations of continuities in particular places. The generations are not only human; they also involve other plants and animals, and, indeed, whole ecosystems.

'Heritage' in this context is a cross-species collaborative project. As my opening quote from Lynn Margulis and Dorian Sagan announces, the relationships between past, present and future concern all life. From this life perspective, the mainstream western heritage concept can come to seem to be a narrow domain carved out of a much wider set of relationships and processes, and hedged about by exclusions so that only humans and the meanings they make in the world count. Sociopolitical analysis probes the processes of determining which humans and which meanings get to count. The wider indigenous issues are life processes, relationships, partnerships, communication and collaboration in weaving past, present and future together into place. They ask which species get to count, which places, ecosystems, ways of life.

Nature and culture

The challenge that indigenous cultures offer to the western split between natural heritage and cultural heritage has been well analysed over several decades. I raise it again for two points: first, it is still established in legislation and thus continues to be a problem; second, if it were to be accepted that the split is a false dichotomy, there are major implications for heritage discourse

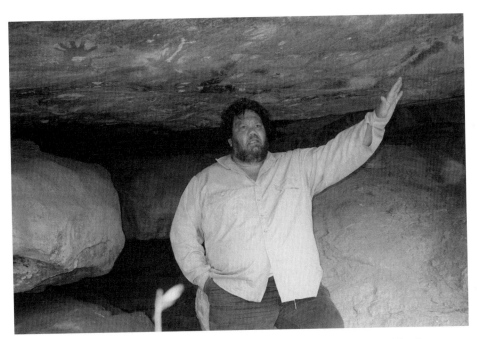

Figure 7.4 Phil Sullivan teaching visitors about his life, philosophy and heritage at a rock art site in Gundabooka National Park. Photographed by Deborah Rose. Photo: © Deborah Rose.

and management. Indigenous Australians argue against this split. They hold it to be arbitrary, false, and enmeshed in relations of power and control that lead to exclusion and domination, and ultimately to poor practice. Through my years of learning, I have come to agree with this contention.

Phil Sullivan (Figure 7.4), a Ngiyampaa man whose home country is in the region around Bourke and Cobar in western New South Wales (NSW), explained the problem vigorously in a critique of the NSW National Parks and Wildlife Service:

> The 'natural' and 'cultural' heritage of National Parks is not separate. This is an artificial white-fella separation. They are still boxing the whole into sections, we need to integrate management into a holistic view of the landscape.
>
> (quoted in Rose, Smith and Watson, 2003, p. 105)

From an Indigenous Australian point of view, a holistic view of landscape would include humans along with the others, but would not generate hierarchy. Rather, this living web, or living system, is characterised by relationships of reciprocity and mutuality. With mutuality, the absolute separation between the knower and the known breaks down. Steve Meredith,

another Ngiyampaa man, described the mutual knowing that can be apprehended when we put aside hierarchy and dualisms:

> What happens is because the fellow went to school, for birds, they're a bird expert, and then you get somebody went to school, they're a plant expert. And the birds eat the plants, which is related to the soil which is related to the water which is related – that all interacts with the people, but they never seem to look at it that way. So that's why we say they pigeonhole things.
>
> Whereas, the funny thing about it is, they pigeonhole all these things, and because they went to school they're higher than all that, they're above nature, and they tend to look down and study nature, like it's ants on the ground. But when you fall asleep, eh, them ants they'll crawl all over you. They'll bite you, or sometimes they don't, but them ants might be carrying out their research then, on you. But either way you look at it, you can't be separate from it.
>
> (quoted in Rose, 2003, pp. 98–9)

Here we see a logic of connection. Human beings are enmeshed in webs of life as much as are koalas, eucalypt trees, coral, ants and bacteria. The web of life really is *Earth*, because this is what Earth is – a place where life came into being and keeps on coming. At the same time, Aboriginal Australian cultures do not posit undifferentiated webs of connection. Rather, creation forms life into patterns of connection. Kinship is one of the big organising patterns. Out of creation came groups of kin, and within each group some of the members are human and some are other animals or plants. The kangaroo creator (Dreaming – see further discussion below), for example, is the ancestor of groups that include kangaroo people and kangaroos; other creators are ancestral to other groups. No humans are without non-human kin, and most species with whom humans interact have human kin.

Another of the eloquent Ngiyampaa men, Paul Gordon, explained his problem with national park managers, the natural/cultural divide, and the protection of endangered species. He used the term 'meat' (*tinggah* in Ngiyampaa, totem in the technical literature, meaning the 'flesh' that you are as a result of being a member of a multi-species kin group). In his words, 'Some animals can't just be classified as fauna. Pademelon [a small, kangaroo-like marsupial] is my meat. They are my people, my relations.' The implication for the management of national parks, and for heritage more generally, is that nature and culture are not separate; Aboriginal people do not want to be sidelined out of decision making on the basis of a false separation. To quote Paul again, 'If National Parks has something going with Pademelons, they should talk with us – it's our family' (in Rose, 2003, p. 54).

Sentience

The term 'sentience' connotes the capacity to sense, and thus to engage in relationship. In this minimalist definition, there is no life without sentience, as scientific research increasingly makes clear. It is not necessary to embark on a full discussion of recent biological science, but given that the reason versus religion dualism sets up the possibility of other people's ontologies being dismissed as mere 'beliefs' (as opposed to facts, see Smith, 2006, pp. 280–1), it is worth noting the continuities of sentience across organisms as dissimilar as humans and bacteria. Biochemist Daniel Koshland discusses the life of desire experienced by bacteria.

> 'Choice', 'discrimination', 'memory', 'learning', 'instinct', 'judgement', and 'adaptation' are words we normally identify with higher neural processes. Yet, in a sense, a bacterium can be said to have each of these properties.
>
> (quoted in Margulis and Sagan, 2000, p. 219)

In the context of Indigenous Australia, sentience takes us into a world of animism. Graham Harvey has recently brought fresh insight to this term, rehabilitating it from the old anthropological evolutionary view that animism was a primitive and erroneous form of understanding the world. Harvey's definition is succinct: animism involves the recognition 'that the world is full of persons, only some of whom are human, and that life is always lived in relationship to others' (Harvey, 2006, p. xi). Indigenous Australian thought seeks out pattern, difference, relationship and connection among persons. A person in this context is both autonomous and connected, enmeshed in relations of interdependence, always bearing responsibilities for others, and always the beneficiary of the actions of others.

Persons, whether human or not, act, and they act according to their own culture. Indigenous thought does not, as far as I am aware, concern itself with organisms such as bacteria that are not visible to the naked eye. The concern is with the perceptible engaging world, and at that scale other beings have culture. They have their own ways of doing things, their own languages and their own ceremonies: 'birds got ceremony of their own – brolga [a crane], turkey, crow, hawk, white and black cockatoo – all got ceremony, women's side, men's side, kids too, everything' (Doug Campbell, in conversation with Deborah Rose). Plants as well as animals are sentient, and, according to many Aboriginal people, the Earth itself has culture and power within it.

'No more nothing'

My teacher Big Mick Kangkinang was about 80 years old when I first met him back in 1980 (Figure 7.5). His memory was sharp and keen, and his enjoyment of life was altogether inspiring. He had been born around the time

Figure 7.5 Big Mick Kangkinang, 1982. Photographed by Darrell Lewis.
Photo: © Darrell Lewis.

that whitefellas (the colloquial term for colonisers) were first setting up cattle
properties in the Victoria river district of the Northern Territory of Australia.
His country was in the rough ranges, and he and his family were able to
live there during his childhood in spite of the violence that surrounded them.
His father had encountered whitefellas, and he wanted to keep his family safe
in the hills. By the time Big Mick was due to be put through 'young men's
business' and transformed from a boy to a young man (around the age
of puberty), most of the people in the region lived and worked on cattle

properties. Most of the country in the region is open savannah, and most of the Aboriginal people had little choice but to seek refuge from violence by aligning themselves with whitefellas. They became the unpaid and unfree workforce that sustained the cattle industry from about 1900 until about 1970 (see further discussion in Chapter 5). When important ceremonies were held, people went bush, but in order to sustain relationships within the regional ceremonial network, people who lived in the bush had to have contact with settled people living in the 'blacks camps' of local properties.

Over the decades the pattern that developed meant that most people lived for most of the year on cattle properties. During the wet season, when their labour was not needed, they went bush and carried on their specifically Aboriginal knowledges and practices. That was how Big Mick lived for most of his life; after being made a young man he went to work on a property, gaining recognition for his horse and cattle skills, and continuing his education within the Indigenous country-based system of knowledge and authority. When Aboriginal people in this region walked off the properties in protest against the horrific and unchanging working conditions (1966–72), Big Mick walked off too. He was one of the founders of the community of Yarralin where I went to live and learn, and he became one of my great teachers. Indigenous people in this region have struggled to ensure that the western school system includes Aboriginal culture and languages (Figure 7.6). The struggle continues. (The history I summarise here is written more fully in Rose, 1991; an ethnographic account of Yarralin and nearby communities is in Rose, 2000.)

Big Mick and others frequently contrasted their relationships with country with the attitudes and practices of whitefellas, and their contrasts were rarely favourable towards whitefellas. One of their many points of contrast was that whitefellas went around without knowledge, acting as if they knew what they were doing, and destroying things all the time. Anzac, a senior man in the neighbouring community of Pigeon Hole, connected ignorance and arrogance with colonisation in one neat summary: 'White people just came up blind, bumping into everything. And put the flag; put the flag' (quoted in Rose, 1996, p. 18).

Similarly, people spoke about damage, and its rippling effects through country and through people. According to another teacher, Daly Pulkara, 'A lot of things are damaged in this country. We're trying to take care' (in conversation with Deborah Rose). That which is being cared for is that which was created. Dreamings are foundational to relationships between past, present and future. These great creative beings emerged from the earth and started travelling, singing up and making everything. Singing was understood as part of creation. The Australian continent is criss-crossed with their tracks as they went walking, slithering, crawling, flying, chasing, hunting, weeping, dying, giving birth. They were performing rituals, distributing the plants, making the

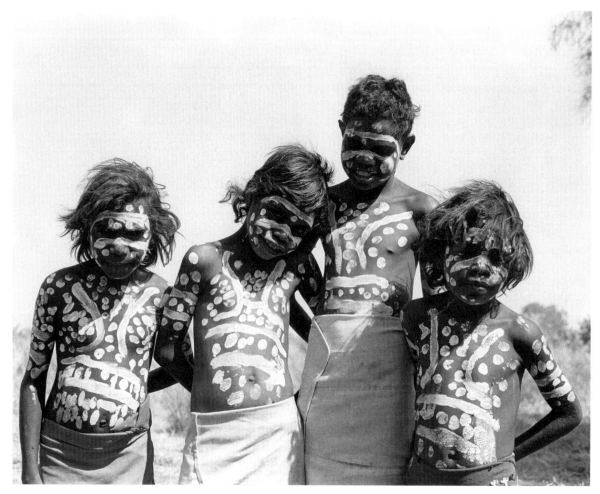

Figure 7.6 Young girls at Yarralin participating in their weekly 'Aboriginal way' lesson. Left to right: Kathy, Julie, Maryanne and Rina. Photographed by Deborah Rose. Photo: © Deborah Rose.

landforms and water, and making the relationships between one place and another, one species and another. They were leaving parts or essences of themselves; they would look back in sorrow; and then continue travelling, changing languages, changing songs, changing identity; and they were becoming ancestral to particular animals and particular humans (these forming what anthropologists refer to as totemic groups). They travelled, and they stopped; they changed over into permanent sites or into other living things, and they stayed. Equally, however, they kept going. Dreamings are masters of the art of being here and not here at the same time. They also are both then and now: both origins and contemporary presence. People interact with Dreamings in daily life as they do their hunting, fishing, gathering, visiting and resting.

Within an ontology of creation, that which exists is 'no more nothing', as Big Mick put it. 'No more' is the Aboriginal English term which expresses the concept 'absolutely not'.

> Before Dreaming, salt water was everywhere. Tide went back, dry time then. No more salt water. All the Dreamings come up. Old people never born yet. Dreamings were first ... All the Dreamings were travelling in country.
>
> The salt water went back, Dreamings put up all those big hills, rivers ... Dreaming. Tree, everything, sugarbag, tucker, goanna, fish, that no more nothing. All from Dreaming. Everything all from Dreaming.
>
> (in conversation with Deborah Rose)

Heritage and country

In Aboriginal English the word 'country' is not only a common noun but also a proper noun. People talk about country in the same way that they would talk about a person: they speak to country, sing to country, visit country, worry about country, grieve for country, and long for country. People say that country knows, hears, smells, takes notice, takes care, is sorry or happy. Country is a living entity with a yesterday, today and tomorrow, with consciousness, action and a will towards life.

A country is small enough to accommodate face-to-face groups of people, and large enough to sustain their lives; it is politically autonomous in respect of other structurally equivalent countries, and at the same time is interdependent with other countries. Each country is itself the focus and source of Indigenous law and life practice. As I have discussed in detail elsewhere, one's country is a 'nourishing terrain', a place that gives and receives life (Rose, 1996).

Country is rich in sentience. The Dreamings are there, of course, and so too are the dead people who belonged to the country in life. As I will discuss shortly, Dreamings left future generations of people in the country, and their yet-to-be-born sentience is also there. Animals are deemed to be sentient beings, as are some trees, rocks and other sites; and then there are all the extra-ordinary beings. People call out to country, and if they did not do so it would be a sign that they were sneaking around. Country, this nexus of sentience and communication, would know and respond, just as it is held to know and respond when the proper people address it in the proper way.

Much of the contemporary theorising about place builds on a presupposition that place is a human artefact: human endeavours to make the world meaningful do so culturally, investing space with meaning (for example, Schama, 1995, p. 10; Smith, 2006, pp. 74–80). Smith (2006) takes this view of place in the context of heritage. While offering a sensitive account

of north-west Queensland Waanyi women's engagement with place, the focus is all on humans and their world of meaning (Smith, 2006, p. 1). My experience has been different; I have not encountered a human-centred view of place. In my experience, people hold place to be the product of the lives of many living things, including extra-ordinary beings and non-human beings. I use the term 'eco-place' to speak to a locatedness that is not human-centred and that is attentive to the many living things who participate in the life of a given place.

Country is homeland, and the generations follow each other in holding and caring. Dora Jilpngarri, the oldest of my women teachers, explained this to me extremely eloquently. She was talking about one of the leading younger men in the nearby outstation known as Lingara, a man named Riley Young Winpilin:

> Winpilin holds up that country. His father is washed away, and they're living together there now. Old people, washed away people, another mob holds up the country. They wash away, another mob, their kids, hold up the country, hold up the country.

To be there and to be 'holding up the country' is to be sustaining relationships between past (creation) and present life. It is to be taking care.

One could also say that country holds up living beings, nurturing them and bringing them forth. The past is visible in country as the traces of care. The future is there too, in the form of unborn people who will come forth for country. Big Mick spoke of 'tribal land', describing it as country 'where old people and Dreamings walked – back and forth, right round'. Tribal land, or country, is a place of past action, the action of Dreamings and of old people. It is equally the place of present action. People walk there today, all my teachers did and still do. I went walking with people, too, and that walking became a 'footwalk' way of learning. It was a mode of storytelling in which stories were stimulated by being in the places where they happened. And it was a mode of communication, as people called out to country, ancestors, Dreamings. It was open to the spontaneous interactive, communicative presence of others – birds called or flew past, and smells came drifting across the air. There were footprints and other signs of other (non-human) creatures' activities, useful knowledge for hunting and for knowing more generally what others are doing. My teachers always knew where we were going, but we never knew exactly what was going to happen, and it was that combination of received knowledge and openness to the new that made this process of footwalk learning so richly enjoyable for everyone.

For me, an appropriate way to think about footwalk learning is that it is a form of embodied, kinetic, emplaced, multi-species dialogue. Dialogue works with given knowledge and situated persons; it is open to interaction and

Figure 7.7 Margaret Daiyi 'cleaning up the country' with fire in her home country, the former Wagait Reserve, in the floodplains of north Australia. Photographed by Deborah Rose. Photo: © Deborah Rose. This is one of a number of areas where Aboriginal burning has been fairly continuous.

spontaneity; it thus sustains continuities and is committed to response and change. Let us think a bit more about that walking action in its living context. It is action towards life, and involves hunting and gathering. It is action towards care, and involves visiting sacred sites, checking, observing, knowing what is going on. For many people it would involve the use of fire; people would be burning the country strategically to 'clean it up', and keep it healthy (Figure 7.7). In the Victoria river savannah country Indigenous fire regimes were suppressed by whitefella pastoralists. In other parts of Australia they have been sustained, and the study of fire is an important focus for landscape ecologists as well as for anthropologists. It should be possible to designate some of the areas where Aboriginal burning has been continuous as heritage landscapes (see further discussion of landscape in Chapter 6).

Action in country sustains creation into the present moment, keeping the people and country good, 'holding up country', in Dora's terms. Within a context of action in place, heritage is visible as the traces of all the living beings who have walked around holding up the country, taking care, going back and forth, and holding up, holding up. If heritage work is the work that holds past, present and future alive to each other, it involves walking, holding, taking care; it is directed toward the future, seeking to ensure that there will be generations who continue to hold and to care.

Broken connectivities

Walking in country does not always give happy news. Life comes, and it goes. According to my teachers, people and country thrive together, and they suffer together. When significant beings are damaged or destroyed, everyone suffers. Trees and people have had a tough time in Australia since the arrival of new settlers, many of whom lived by the motto 'if it moves shoot it; if it doesn't move chop it down'. In recent years trees and other sites have been bulldozed, and in some cases all that remained was the song, the knowledge, and the design for the Dreaming (sometimes called a photograph). In the land claim of Kidman Springs and Jasper Gorge, one of the senior claimants, Allan Griffith, discussed these matters in relation to his ancestor – Jirrikik, the Owlet-nightjar Dreaming. He spoke of stones and trees that were the transformations of Jirrikik, and he spoke of how damage to the transformations had hurt the old people of the country. His evidence was elicited by the claimants' lawyer Ross Howie.

ALLAN GRIFFITH: At Kangkiji [place name] they knocked one rock, Jirrikik.

ROSS HOWIE: And what knocked it down?

ALLAN GRIFFITH: The bulldozer.

ROSS HOWIE: And how did you feel when that happened?

ALLAN GRIFFITH: No good.

ROSS HOWIE: Why not?

ALLAN GRIFFITH: Well, that's when. As soon as we tell the old fella, Old Dan, that's when he died from the Dreaming.

ROSS HOWIE: When you told him that that had been knocked down, you say he died?

ALLAN GRIFFITH: Yes ...

ROSS HOWIE: And why did he die?

ALLAN GRIFFITH: Well, he was thinking about for the Dreaming, you know.

ROSS HOWIE: All right, and is that Jirrikik still there?

ALLAN GRIFFITH: Yes, he's still there, but he's been moved. ... We lift him up and put him in the tree now.

ROSS HOWIE: He's a stone, is he?

ALLAN GRIFFITH: Yes, a stone.

ROSS HOWIE: And was there a tree knocked down there at VRD [Victoria River Downs station]?

ALLAN GRIFFITH: Yes, one been get knocked off right in the middle, right at
the airstrip. One bloodwood.

ROSS HOWIE: And how did you feel when that happened?

ALLAN GRIFFITH: No good. We still using a photograph [design] every year
on the ceremony time, on the ring place time, tell them that the
bloodwood be still gone but we can dream. ... They shouldn't touch
the tree, but they done it. We still got the photograph.

(Transcript of Proceedings, 1988, pp. 162–4)

Allan Griffith's evidence poses wonderful questions about tangible and
intangible heritage. On the one hand, as long as song and memory exist, there
is a heritage value that is intact. Every time the design is painted on a boy who
is going through young men's business the Dreaming is given new, albeit
short-lived, physicality. But as Allan says, the tree is gone. Something has
been lost, and the loss is the physicality of the tree. Tangible and intangible
were intertwined. Without the tree, part of the heritage is gone. What is
memory in the absence of that which is remembered? Can it continue
indefinitely without a material referent?

Allan's account of the tree offers still more possibilities for heritage thinking.
There are many manifestations of the Owlet-nightjar ancestor, as I learned
when we documented sites for registration under the Northern Territory
Aboriginal Sacred Sites Act 1989. There were a number of stones, the long
track of his travels, and many places where various events occurred. There
were the Owlet-nightjar birds themselves, and there were the Owlet-nightjar
people who were using the new legislation to help take care of their country.
Allan's focus on the one site that was no longer there raises questions.
Couldn't another tree have taken over from the one that was killed (as I will
discuss in the next section)? Or, is the current significance of the tree
located in the fact that it is not there, that is has been replaced by an airstrip?
Is one of the roles of memory to hold on to the history of colonisation?
If that history is inscribed in absences, then it seems that memory of absence
anchors itself in replacement. The airstrip has become a place of memory
on account of what has been destroyed.

Another of my teachers, Daly Pulkara, also experienced the loss of trees.
He told me numerous stories about how death to trees entailed death to the
old people whose lives were enmeshed with those trees. He described how
some of the old men had been forced by whitefellas to cut down some
Dreaming trees and to dig into a billabong to try to expand it. They didn't
want to do either thing, as both trees and billabong were Dreaming sites. They
did as they were told, and later a big huge wind came blowing through in a
straight line knocking down trees. The wind was announcing death, and
one by one the old men of the country began to die. Many years later Daly saw

Figure 7.8 Daly Pulkara, Riley Young and Darrell Lewis take a break from documenting a historic boab tree, the inscription on which points to a spot where one of the last 'wild' bush people was killed in 1894. Photographed by Deborah Rose. Photo: © Deborah Rose.

that some trees that were associated with his life had been chainsawed down, he was deeply affected. 'You hurt me', he said. 'You hurt me.' (This is discussed further in Rose, 2008.)

Daly and others experienced these deaths as colonising attacks. When the past is held in relationship with the present collaboratively by people and trees, how better to eradicate that relationship than to chop them down? Indeed, to the extent that Aboriginal persons are held to be deficient (primitive, underdeveloped), how better to improve them than to disenchant them from their own relational heritage? Resistance to this approach can take many forms, including the documenting of places and natural forms where memories are embedded (Figure 7.8).

The future in the past

Not all trees die as a result of human beings with axes and chainsaws. Trees, like people and other animals, die of old age. One year we visited a billabong called Wuyang, known to whitefellas as Buffalo Hole. Some terrible things had happened in the vicinity, including the deaths of trees and old men that Daly described. Wuyang itself, however, had so far been free from wanton destruction. There were concerns about the amount of water in the billabong, but nothing had happened that amounted to destruction.

Wuyang is a lovely little billabong well off the beaten track. It is on a cattle property, and cattle have had a negative impact on it, but it is still thriving. The water is still there (unlike a number of other billabongs) and it is surrounded by old coolabah trees (*Eucalyptus microtheca*). Wuyang is a site on the track of the Dreamings known as 'karu'. The precise translation is children or kids, but in context the kids are boys and the purpose of calling them boys is to indicate that they have not yet been through young men's initiation. Their track is extensive. They come from the north, crossing many countries and languages. Much of the track through Ngarinman country is marked by snappy gum trees (*E. brevifolia*) that form an extended line marching through other plant communities. At Wuyang the boys stopped to rest and play.

The boys were accompanied by an old man and an old woman. These two personages were present at the billabong in the form of two old coolabahs, one at each end of the billabong. On my first trip to Wuyang we encountered something that surprised Daly, Riley and the others. The old man had died. The men looked at the old man for a long time, walking around him, inspecting him, discussing him. They found that there were no suspicious circumstances concerning the death, and they concluded that probably the old tree had died when Riley Young's father Old Riley had died. Old Riley's death had not been entirely natural; he had died as a result of killing other trees and digging into a billabong; the damage rippled out through relationships and across species, affecting others whose lives were mutually intertwined. So Old Riley's death had been experienced in country as the death of this old man/tree at Wuyang.

What to do about a dead tree? It happens; it can't be helped for trees any more than it can be helped for people. The appropriate action, therefore, is to have a funeral and then to pay attention to other trees and to find and identify the new tree that will take over from the old one. This was Riley's country, and it was his father's death that was connected with the death of this old tree, but Daly was older than Riley and he identified the new tree that would take over the role of the old man who accompanied the boys. It was not far from the old tree, and was a healthy, younger coolabah.

There was another aspect of Wuyang that mattered: here men got a substance known as *jirri*. The term is often translated into English as love magic. Wuyang had men's *jirri* – the men would use it to attract women as lovers as well as wives, and they would use it as fertility magic so that their wives would have lots of children. *Jirri* such as this is also part of a regional trade network, and they would always gather more of the white clay and the bark from the trees than they needed in order to have some to trade on to other men in other countries (Rose, 2000, pp. 211–3).

The stories that account for the presence of the *jirri* are sacred and as such are not suitable for public dissemination. The point I wish to draw out is that the future of the group is located here at Wuyang. We have seen that the

generations of people and trees are washed out, and that new generations take over. The new generations of people for this country are here in this billabong, just as the new trees grow not far from the old ones. The place was created in Dreaming, and it contains its own future.

When we got there that day, Daly Pulkara said that the Dreaming would be happy to hear all the children running around playing. These children, his and others', were born from the billabong. In sensing the children, the billabong, or the Dreaming, was sensing powerful time-binding connectivities. The past (creation) was alive in the present in the bodies of the children. The children would grow up, the men would come and gather more *jirri*. Old generations of trees and people would be washed away and new generations would keep coming. At any rate, that was what creative action appears to have intended. Thus heritage work would not only seek to save Wuyang for the future, as western heritage constructs would propose (Smith, 2006, p. 29) but caring for the place would also save the future generations for Wuyang.

Dialogical heritage

A dialogical concept of heritage suggests that heritage making is interactive – meaningfulness arises out of encounter and dialogue among multiple subjects, some of whom are human. Place (construed interactively) may also be a subject in its own right. Dialogical heritage calls to be differentiated from recent postmodern approaches to heritage, including Smith's study. Smith takes a moderate approach when she writes of her critical realism perspective. According to this account, the world exists, but knowledge arises only through discourse (2006, p. 54). Logically, within this approach it is perhaps not possible to know that reality exists at all (Mathews, 2003, p. 162). Smith and other proponents of the 'critical realism' perspective may reject the implications of this extreme dualism, but this form of realism still seems to hold to the view that reality is of little value or meaning until humans start to invest meanings into it. The correlate of this anthropocentric perspective is that heritage is inherently intangible: it concerns human-made values and meanings that are symbolised and represented by material objects. This perspective on symbolism and representation replicates the mind–matter dualism in suggesting that the material world has no values or meanings in and of itself. The old story that the world is on top of an elephant that is on top of a turtle invites the question of what the turtle is on top of, and receives the answer that it's turtles all the way down. Similarly, the idea that the world is only present to us through language suggests that it's language all the way down.

The story of Wuyang gives a different account. Wuyang may symbolise or represent a great many things to a great many humans, and offers various values to numerous species. It is a sacred site for the Aboriginal people, a

waterhole for whitefellas and for cattle, a home for the coolabah trees that like to have their toes in water, and a great nesting place for cockatoos who need the hollows that coolabahs provide so generously, a home for fish, and so on. From an Indigenous perspective, though, it is first and foremost itself. It has its subjectivity, its own meanings and values. Meaning is not polarised. Stated as a wider generalisation, this is the point that philosopher Mary Graham writes about in relation to her first precept 'The Land is the Law'. I should note that Graham uses the term 'land' in a very inclusive way to address water, plants, animals, indeed the whole of what we tend to call the natural world. She expands on this first with the following explanation of becoming human:

> The two most important kinds of relationships in life are, firstly, those between land and people and, secondly, those amongst people themselves, the second being contingent upon the first ... all meaning comes from the land.

(Graham, 1999, p. 106)

This precept offers a major challenge to the discursive turn in heritage studies. Working with the precept that all meaning comes from the land, we would have to say that it's not language all the way down, and the world is not only present to us through language. Rather, in Jim Cheney's memorable words, it's world all the way up (1989, p. 120). Many of my teachers were perfectly clear: 'Everything comes up out of ground – language, people, emu, kangaroo, grass. That's Law' (Hobbles Danaiyarri, quoted in Rose, 2000, p. 57). A number of dynamic western philosophers are currently offering a critique of this 'discursive turn' in postmodernism (for example Curry, 2008).

Communication runs through living systems, including land and people. The processes and practices of keeping the past alive in the present, like the practice and processes of keeping the future alive in the present, is collaborative. We are not alone (as humans) and while we certainly are meaning-making beings, we are not the only ones. Aboriginal philosophers and storytellers are saying that meaning does not start and finish with us. We are not discourse isolates, and we are not time lords. We are beings of time and we work with others to bind past, present and future. Within this wider view of meaning and communication, stories and analysis remain open to the world, they are always becoming, and always open to new tellings and new encounters. That has been my intention in this case study – to offer stories and ideas that can be taken up by other people in other contexts and worked with as steps toward new questions and new analysis.

One does not have to be an academic philosopher or a wise Indigenous Elder to get this point. Contemporary western animists are saying similar things in relation to their own heritage (contesting who owns the past, the human remains and sacred sites, for example), and I have drawn on scientific work that is also making related points. Smith has made the important move of

shifting the referent of the term 'heritage' away from things or objects, and towards experience and practice. She thus argues that all heritage is inherently intangible (2006, p. 56). As far as it goes, this is excellent, but it does not go as far as it could. Indigenous ontologies push us to rethink, and to move outside of, the tangible–intangible boundary. Rather than imagining a process by which human meaning makers engage in heritage practices by making meanings in or through physical realities, we are rather pushed to imagine that humans and other sentient beings bind time collaboratively. Heritage is thus both tangible and intangible, embodied, material, and equally mindful and emergent. Some of the others are human, some of them are living organisms, and some of them, like Wuyang, are sentient places. Defining heritage modestly as the processes and practices of keeping the past alive in the present, an Indigenous perspective shifts the focus to local multi-species relationships that bind time, place and generations.

Implications

The implications of Indigenous Australian ontologies for heritage are profoundly challenging and urgent. In 1988 my colleague Darrell Lewis and I were commissioned by the Australian Heritage Commission to research Aboriginal people's cultural relationships with rock art in the Victoria river district, and to provide recommendations on protection of the art (Lewis and Rose, 1988). Our report made two main findings, both of which emerged directly from our consultations with traditional owners, including Daly Pulkara, Anzac Munnganyi, Riley Young Winpilin and others. The first finding was that many of the images on the rock faces were not regarded as 'art' at all. A painting might represent a bullock, but its function might be the communication of important information (Figure 7.9).

In contrast to the majority of images which were regarded as Dreaming beings, this painting was spurred by colonisation. According to Big Mick, when people from this country first encountered bullocks out in the open country, they came back into the ranges and told people there what they had seen. The image is an illustration: it expresses people's desire to communicate visually about something new in the country.

Other images were regarded as the living presence of Dreaming beings. People's view was that as Dreaming beings were there on the rock, they would take care of themselves: if they chose to wash away they would do so, and if they chose to remain they would do so. Accordingly, the standard preservation techniques available at that time were deemed to be disrespectful, intrusive and unnecessary. The second point was that the 'art' was believed to be in danger from tourists and other casual visitors who might be getting around the country without permission or guidance (many people were still 'coming up

Figure 7.9 Aboriginal rock art painting. Photographed by Darrell Lewis Photo: ©
Darrell Lewis. This bullock painting was made to show an image of the animal to people
who had never seen these animals in the bush.

blind', in Anzac's terms). Their response to this threat was that they should be
provided with vehicles so that they could get around the country regularly to
monitor the sites and warn off tourists. Their assertion that what the 'art'
needed was empowerment of the traditional owners was never responded to,
although the underlying issue of empowerment is increasingly being taken
seriously. On behalf of Daly and the others, and their descendants who are still
struggling to protect the sites, I should state that nothing in the past twenty
years has caused me to find fault with their recommendation. I believe it to be
a profoundly important approach, and one for which I would now offer other
reasons as well.

In the case of the old man/tree at Wuyang, we have seen that heritage involves
the future as well as the past, country as well as people, trees, stories, songs,
billabongs, the dead and the unborn. Protection of heritage would have to
include support for the people who are already trying to protect it, and support
for new generations of people and trees to take over the job. In this holistic
understanding of heritage, care of people, facilitation of learning, land care
and ecological restoration would all be part of heritage action. Bilingual
education and control of noxious weeds such as the invasive neem trees
(*Azadirachta indica*) would be part of heritage work. Providing people with
the means to get around the country and protect their own sites would
certainly be an important part of heritage work.

At the heart of collaborative multi-subject heritage work is a passion for protecting endangered connectivities and for sustaining relationships. These are matters on which many Indigenous Australian people are particularly well qualified to speak. I will give the last word to Phil Sullivan, the Ngiyampaa man whose words opened my discussion. Out in western New South Wales where Phil lives, the damage has been enormous (Sullivan, Rose and Muir, 2008). When Phil speaks, he is always speaking from this place of harm, a place where people have been killed, languages eradicated, children taken from their families, sites desecrated, and country degraded almost beyond belief. Phil speaks from these ruins, and he talks about the last line of defence:

> The outward things may pass, but the respect, the thing inside, will last. We respect our animals and our land. That's what I call our last line of defence. The last line of defence is respect.
>
> (quoted in Rose, Smith and Watson, 2003, p. 71)

In a heritage practice founded in encounter and dialogue, the last line of defence is also the first mode of action. Respect is at the heart of it all.

Reflecting on the case study

The case study of Indigenous Australian world views offers profound challenges to the notion of intangible heritage, and to the definition of heritage that stands at the heart of the World Heritage Convention. Where UNESCO seeks to divide heritage into different forms – tangible and intangible, cultural and natural – many people throughout the world perceive heritage in an integrated fashion. Indigenous Australians hold world views that emphasise heritage not as the tangible or even the intangible but as the relationships and connections which exist between a series of human and non-human entities and the world. It is important to reiterate that this idea of an integrated heritage is not necessarily peculiar to non-western or indigenous cultures, but is also manifest in the ways in which people in the western world speak about their 'sense of place', which is composed not only of the physical things that surround them but also the cultural practices and beliefs that animate them, and the relationships between them. The dialogic understanding of heritage that is outlined resonates with the ideas of Byrne (2008), which are themselves based on the work of Appadurai (1996), and see heritage as part of the cultural 'work' that societies do to create a sense of locality, community and identity in the present. The idea that heritage involves the future *as well as* the past, which is a feature of Indigenous Australian world views, can similarly be abstracted to other societies if we hold that all heritage is about the production of the past in the present. Those things that society chooses to promote as a part of their past will open up certain possibilities to the future, while removing others.

The case study also forces us to reconsider our definition of heritage. If we think of heritage as relationships sustained between past and present, and oriented towards the future, then the term is so broad as to encompass a host of cultural, biological and chemical events. The heritage focus is one 'lens' for examining life's continuities and loss of continuities. In the case, for example, of a waterhole sacred to Indigenous Australians where a massacre occurred, there's a heritage lens, but there's also a postcolonial lens, a religious lens, and a ceremonial or performative lens. Surrounding the waterhole there are personal memories as well as collective memories, and given that it's a waterhole, there are also ecological and hydrolic lenses. If much of what has been discussed in the case study can be defined as heritage, it can also be defined as other things too. This idea of the thorough entanglement of heritage and everyday life does not sit comfortably with a model of heritage that seeks to draw a line around a particular object, place or practice, and to single it out as special and hence separate from everyday life. The model of heritage offered by Indigenous Australian world views challenges official representations of heritage as museum pieces, removed from the context of other objects, places and practices in the world.

This chapter has largely drawn on case studies in indigenous heritage, but we can see examples of similar forms of intangible heritage in all societies. We might think, for example, of French President Nicolas Sarkozy's suggestion in 2008 that the correct methods for preparing classic items of French cuisine might be considered for protection as part of the UNESCO World Heritage List (Figure 7.10). We might also, with historian Peter Read (1996), ruminate on the deep sense of loss that people in contemporary western societies feel when places dear to them are 'lost', either through natural disasters (earthquakes, fires, extreme weather), the circumstances of life and history, or the tide of development. What we might often perceive to be 'ordinary' places, such as people's homes, towns and open spaces, are not insignificant but are animated by the attachments of the people who love them and by the everyday life rituals undertaken in them. While Smith (2006, p. 13) has suggested that 'there is no such thing as heritage' (without intangible heritage), our case study (like others in this book) has suggested the corollary, that there is no such thing as intangible heritage without tangible objects and, more importantly, without *places* to attach itself to.

But we should be careful of thinking that all aspects of Indigenous Australian world views discussed here might be representative of the views of all societies, or indeed, of all indigenous/first nations groups. One of the problems with established global and national heritage lists is the way in which they fossilise and canonise particular ways of understanding heritage and the past. The case study urges us to consider the range of perceptions of heritage that might exist throughout the world; this involves the ways in which

Figure 7.10 A dish of beef bourguignon. Photographed by Eric Fenot. Photo: ©
Eric Fenot/Stockfood.

heritage is caught up in so many other aspects of contemporary life – welfare,
housing, health and society – and its active role in producing a sense of
community and locality in the present, for the future.

Understanding intangible heritage

In this chapter we have seen how the concept of heritage has been broadened
and made more inclusive by the recognition of intangible cultural heritage
in the work of UNESCO. But we have also seen how the concept of intangible
heritage itself assumes a divide between tangible and intangible heritage.

This divide is not supported by non-western world views, or, indeed, by the ways in which people attribute significance to various aspects of heritage as part of everyday life in the western world. Earlier in the chapter the terms 'renown', 'gossip' and 'rumour' were used to describe a process whereby certain heritage objects, places and practices acquire significance. We can see this process operating in both western and non-western societies. One good example from a western, post-industrial context is the way in which various popular ideas about the Musée du Louvre in Paris, France have grown up through its representation in books such as *The Da Vinci Code* and the film of the same name. Intense popular interest was generated in various artworks that the book and film suggested held secret messages relating to the location of the Holy Grail. These ideas, although many historians would disagree with them, form one of the many layers that give the place significance, or an 'aura'. This aura ties into a series of ideas about heritage, as it is understood to be very firmly rooted in the material space of the Louvre and its collection. In fact, the term 'aura' may well be a very good one for thinking about the complex relationship between heritage places and objects and the ideas we hold about them, and for thinking about the relationship between tangible and intangible heritage and memory in general (see also Harrison, Fairclough, Jameson and Schofield, 2008, pp. 3–4).

A clear message that emerges from the case study is that heritage needs to be thought about in a more integrated fashion. We might characterise the western tradition of heritage as separatist in terms of the way it promotes a 'canon' of heritage that is 'special' and outside the realms of the everyday. Indigenous and non-western views of heritage might be characterised as more integrated, emphasising the inter-relationships between heritage objects, places and practices and everyday life while not privileging the human-centred aspects of those relationships. This characterisation is rather crude but helps us to think about the ways in which heritage as a notion is being challenged and transformed by broadening its purview to consider the world views of indigenous and non-western people. This can be exaggerated, though. Criteria of selection are not the same as practices of presentation and access. A country house can both be an elitist monument and a place where you play in the park with your kids. And if the second did not exist, the first would not survive, in many cases. The fact that intangible heritage grows around tangible objects requires a more nuanced view of separatist philosophies of heritage – one that is conscious of the ways in which certain societies hold certain classes of places to be different, somehow more 'special' than others, and vest them with value and power by listing them as heritage. The fact that these philosophies are different does not mean that they cannot co-exist in the world, but it does once again raise the question of the applicability of western models of heritage to non-western cultures, and asks us to consider the global reach of 'World' Heritage.

A series of questions at the beginning of the chapter were stimulated by the listing of the *kusiwa* designs of the *Wajãpi* as Masterpieces of the Oral and intangible heritage. It is helpful to return to those questions now that we have looked in more detail at the notion of Intangible Heritage and some of the problems inherent within it. One of the problems raised was the possibility of 'preserving' oral and intangible culture in the same way that we might legislate for the protection of material heritage. In the case of the *Wajãpi* it is impossible to preserve the *kusiwa* designs and the tradition to which they belong without preserving the people who have the contextual knowledge to make and 'read' them. While conserving the *kusiwa* designs is certainly an admirable goal, we need to see that such an approach comes from a notion of culture and tradition that sees it as somehow remote and fossilised in a pre-modern past. Culture and intangible heritage are not remote from everyday life, but are the things that people *do*, the ways they live, and the sources they draw on to create a connection between themselves and their environment in the present. While heritage draws on 'tradition', it need not be old or continuous with the past. Many people talk about the loss of heritage, but it is impossible to lose 'living heritage' because culture is dynamic and changing. The development of an integrated approach to heritage suggests that the conservation of heritage needs to be considered alongside issues of environmental health, social well-being, housing, welfare and all other indices of societal and environmental fitness.

Another question raised was how a series of designs that can be rendered by only a small number of skilled individuals and that are legible to less than 1000 people could be considered part of the shared heritage of all of humanity. Clearly, non-*Wajãpi* can never stake a claim of ownership over this heritage. The only answer to this question lies in a shared responsibility to promote and nurture human diversity. A notion of global heritage as diversity challenges the ways in which heritage has been employed by the state – as something to be owned and promoted by certain national interests and agendas. It broadens the agenda of World Heritage to include issues of global human rights and local diversity.

Conclusion

This chapter has considered the concept and the history of intangible heritage as it has come to be employed by UNESCO (and other western national heritage managers) as a form of critique of the World Heritage concept in general. The case study of Indigenous Australian world views throws up a series of challenges to this concept, suggesting that many societies perceive heritage in an integrated fashion, which makes the delineation of intangible and tangible heritage impossible and illogical. Although the chapter was developed as part of the critique of the western focus on tangible buildings

and sites in the World Heritage List and other similar heritage lists, it questions the idea of representative approaches to heritage, arguing instead for local approaches to heritage which take into account the diversity of different social and cultural groups, and the role and definition of heritage within them. Finally, it argues for an integrated conception of heritage which is focused on the social 'work' that heritage does in different societies, the joint involvement of humans and material things in the production of heritage objects, places and practices, and the role of heritage in the production of the present, for the future. This new model for a global heritage linked to local, grassroots social action provides a challenge and new agenda for heritage and heritage studies in the twenty-first century.

Works cited

Aikawa, N. (2004) 'An historical overview of the preparation of the UNESCO International Convention for the Safeguarding of the Intangible Cultural Heritage', *Museum International*, vol. 56, nos 1–2, pp. 137–49.

Appadurai, A. (1996) *Modernity at Large*, Minneapolis and New York, University of Minneapolis Press.

Byrne, D. (1995) 'Buddhist stupa and Thai social practice', *World Archaeology*, vol. 27, no. 2, pp. 266–81.

Byrne, D. (2008) 'Heritage as social action' in Fairclough, G., Harrison, R., Jameson, J.H. Jr and Schofield, J. (eds) *The Heritage Reader*, Abingdon and New York, Routledge, pp. 149–73.

Cheney, J. (1989) 'Postmodern environmental ethics: ethics as bioregional narrative', *Environmental Ethics*, no. 11, pp. 117–34.

Connerton, P. (1989) *How Societies Remember*, Cambridge, Cambridge University Press.

Curry, P. (2008) 'Nature post-nature', *New Formations*, no. 26 (spring), pp. 51–64.

Gallois, D.T. (1997) Wajãpi: Encyclopaedia of Indigenous People of Brazil [online], www.povosindigenas.org.br/pib/epienglish/waiapi/populat.shtm (accessed 16 July 2008).

Graham, M. (1999) 'Some thoughts about the philosophical underpinnings of Aboriginal worldviews', *Worldviews: Environment, Culture, Religion*, vol. 3, no. 2, pp. 105–18.

Graham, M. (2008) 'Some thoughts about the philosophical underpinnings of Aboriginal worldviews', *Australian Humanities Review*, no. 45 (November), pp. 181–94; also available online at www. australianhumanitiesreview.org/archive/Issue-November-2008/graham.html (accessed 8 June 2009).

Harrison, R., Fairclough, G., Jameson, J.H. Jr and Schofield, J. (2008) 'Heritage, memory and modernity: an introduction' in Fairclough, G., Harrison, R., Jameson, J.H. Jr and Schofield, J. (eds) *The Heritage Reader*, Abingdon and New York, Routledge, pp. 1–12.

Harvey, G. (2006) *Animism: Respecting the Living World*, New York, Columbia University Press.

Kurin, R. (2004) 'Safeguarding Intangible Cultural Heritage in the 2003 UNESCO Convention: a critical appraisal', *Museum International*, vol. 56, nos 1–2, pp. 66–77.

Lewis, D. and Rose, D. (1988) *The Shape of the Dreaming: The Cultural Significance of Victoria River Rock Art*, Canberra, Australian Institute of Aboriginal Studies.

Margulis, L. and Sagan, D. ([1995] 2000) *What Is Life?*, Berkeley, University of California Press.

Mathews, F. (2003) *For Love of Matter: A Contemporary Panpsychism*, Albany, State University of New York Press.

Nandy, A. (2003) *The Romance of the State and the Fate of Dissent in the Tropics*, Oxford, Oxford University Press.

Read, P. (1996) *Returning to Nothing: The Meaning of Lost Places*, Cambridge, London and Melbourne, Cambridge University Press.

Rose, D. (1991) *Hidden Histories: Black Stories from Victoria River Downs, Humbert River and Wave Hill Stations, North Australia*, Canberra, Aboriginal Studies Press.

Rose, D. (1996) *Nourishing Terrains: Australian Aboriginal Views of Landscape and Wilderness*, Canberra, Australian Heritage Commission; also available online at www.ahc.gov.au/publications/generalpubs/nourishing.pdf (accessed 8 June 2009).

Rose, D. (2000) *Dingo Makes Us Human*, Cambridge, Cambridge University Press.

Rose, D. (2003) *Sharing Kinship with Nature: How Reconciliation is Transforming the NSW National Parks and Wildlife Service*, Sydney, NSW National Parks and Wildlife Service; also available online at www.nationalparks.nsw.gov.au/PDFs/Sharing_Kinship.pdf (accessed 8 June 2009).

Rose, D. (2008) 'On history, trees and ethical proximity', *Postcolonial Studies,* vol. 11, no. 2, pp. 157–67.

Rose, D., Smith, D. and Watson, C. (2003) *Indigenous Kinship with the Natural World*, Sydney, NSW National Parks and Wildlife Service; also available online at www.nationalparks.nsw.gov.au/PDFs/Indigenous_Kinship.pdf (accessed 8 June 2009).

Schama, S. (1995) *Landscape and Memory*, London, Fontana Press.

Schmitt, M. (2008) 'The UNESCO concept of safeguarding intangible cultural heritage: its background and *Marrakchi* roots', *International Journal of Heritage Studies*, vol. 14, no. 2, pp. 95–111.

Smith, L. (2006) *Uses of Heritage*, Abingdon and New York, Routledge.

Sullivan, P., Rose, D. and Muir, C. (2008) Wounded Rivers [online], www.ecologicalhumanities.org/woundedrivers.html (accessed 1 December 2008).

Transcript of Proceedings (1988) Re the Kidman Springs-Jasper Gorge Land Claim, Adelaide, Commonwealth Reporting Service.

UNESCO (1989) Recommendation on the Safeguarding of Traditional Culture and Folklore [online], http://portal.unesco.org/en/ev.php-URL_ID=13141&URL_DO=DO_PRINTPAGE&URL_SECTION=201.html (accessed 16 December 2008).

UNESCO (2003) Convention for the Safeguarding of the Intangible Cultural Heritage [online], http://unesdoc.unesco.org/images/0013/001325/132540e.pdf (accessed 4 June 2009).

UNESCO (2008a) Proclamation 2003: Oral and Graphic Expressions of the Wajapi [online], www.unesco.org/culture/ich/index.php?topic=mp&cp=BR#TOC1 (accessed 16 July 2008).

UNESCO ([2003] 2008b) Brief history of the Convention for the Safeguarding of the Intangible Cultural Heritage [online], http://www.unesco.org/culture/ich/index.php?pg=00007 (accessed 18 April 2008).

UNESCO ([1972] 2009) World Heritage Convention [online], www.unesco.org./en/conventiontext/ (accessed 4 June 2009).

Further reading

Boswell, D. and Evans, J. (eds) (1999) *Representing the Nation: A Reader. Histories, Heritage and Museums*, London and New York, Routledge/ Milton Keynes, The Open University.

Brown, M.F. (2005) 'Heritage trouble: recent work on the protection of intangible cultural property', *International Journal of Cultural Property*, vol. 12, no. 1, pp. 40–61.

King, T.F. (2003) *Places that Count: Traditional Cultural Properties in Cultural Resource Management*, Walnut Creek, CA, AltaMira Press.

Read, P. (1996) *Returning to Nothing: The Meaning of Lost Places*, Cambridge, London and Melbourne, Cambridge University Press.

Rose, D. (1996) *NourishingTerrains: Australian Aboriginal Views of Landscapes and Wilderness*, Canberra, Australian Heritage Commission; also available online at www.ahc.gov.au/publications/generalpubs/ nourishing.pdf (accessed 8 June 2009).

Silverman, H. and Ruggles, D.F. (eds) (2008) *Cultural Heritage and Human Rights*, New York, Springer Publications.

Chapter 8 Heritage and the recent and contemporary past

Rebecca Ferguson, Rodney Harrison and Daniel Weinbren

This chapter considers the heritage of the recent and contemporary past, both as a specific time period taking in the twentieth and early twenty-first centuries, and in terms of a series of themes that characterise the period – globalisation, transnationalism and the influence of new communicative technologies. In doing so, it considers the usefulness of what some authors have described as 'the postmodern condition' as a way of characterising some of the social and economic changes that have given rise to the accelerated interest in heritage in the late twentieth century. The chapter looks not only at the ways in which new technologies are transforming heritage practice and our relationships with heritage, but also at the ways in which these technologies might be considered to be a part of heritage itself. The case study, on heritage in the virtual world Second Life, written by historian Daniel Weinbren and virtual worlds researcher Rebecca Ferguson, considers the ways residents have not only begun to develop their own distinctive heritage, but have also recreated and reworked real-world heritage sites within this virtual environment. The contrast of old and new highlights aspects of heritage that are important in both real life and virtual life, and raises a series of questions about the role of authenticity in heritage. The concluding section considers the implications of the case study for heritage management in the twenty-first century.

Introduction

In post-industrialised western societies in the early twenty-first century we have become so accustomed to the almost constant rate of technological change and the mediating role of technology in everyday life that it is difficult to imagine a world without plastics, the internet, mobile communication technologies or computers. Indeed, it is possible to argue that there is a distinct material culture of the late twentieth and early twenty-first centuries that we can view as part of the period's material heritage, and to a large extent as a defining factor in the production of its 'intangible' heritage. This chapter is concerned with the heritage of the various changes that occurred throughout the course of the twentieth century, and with the ways in which these changes might have influenced how we conceive of heritage itself and how we make decisions about managing it. We will consider the emergence of a field of 'virtual' heritage and the issue of authenticity that is closely associated with it. Before doing this, we need to look in more detail about how the technological

changes of the late twentieth century have influenced the ways in which we experience the world around us, and how these might relate to the way we perceive of heritage in the early twenty-first century.

Many authors have pointed to the changes that have come about in post-industrialised western societies since the middle of the twentieth century as heralding a new and distinct period of history. In the same way that we are used to thinking of the modern age, or 'modernity', as relating to the outcomes of the Enlightenment and the Industrial Revolution, some authors have suggested we use the term '**postmodernity**' to define a separate historical period. These authors point to the growth of communicative technologies, increased globalisation, and the widespread experience of migration and transnationalism that characterise the later part of the twentieth century. In *The Postmodern Condition*, French philosopher and literary theorist Jean-François Lyotard suggested that *modernity* should be seen as a cultural condition characterised by the pursuit of progress, while *postmodernity* is the logical end product of this process, where constant change has become the status quo (Lyotard, [1979] 1984). Under such circumstances the notion of progress fails to have any meaning, as everything is constantly in flux. In this context we can begin to understand the recent 'heritage boom' as motivated at least partially by a desperate search for stability in a world that is constantly changing. We might think here of the expectation when we purchase a laptop or personal computer that it will become instantly outdated, or the idea that as soon as we drive our brand-new car out of the showroom it immediately loses value. Such notions would have been ridiculous as recently as the 1960s or 1970s. It is not important to engage with the nuances of Lyotard's argument here except to note that there seems to have been a series of technological and economic conditions in the late twentieth century that can be said to have heralded a new series of relationships with the material world, characterised by an expectation of constant change. The role of this chapter is to look at how these new relationships are transforming our relationship with heritage and its role in the production of social memory.

Postmodernity, heritage and nostalgia

The geographer David Harvey has suggested that the changes in technology and society that occurred during the later part of the twentieth century have given rise to a distinct way of experiencing time and place, which he terms the 'condition of postmodernity':

> There has been a sea-change in cultural as well as in political-economic practices since around 1972. This sea-change is bound up with the emergence of new dominant ways in which we experience space and time ... there is some kind of ... relation between the rise of

postmodernist cultural forms, the emergence of more flexible modes of capital accumulation, and a new round of 'time-space compression' in the organisation of capitalism.

(Harvey, 1990, p. vii)

This new experience of time and space relates to a new series of economic and material circumstances that arose in the later part of the twentieth century, which relate not only to changes in technology and the economy, but also to the ways in which humans in the post-industrialised West experience the world. Harvey associates postmodernity with a phase of 'late capitalism' when more flexible forms of capital accumulation and distribution develop, characterised by more flexible labour processes and markets, increased spatial mobility, rapid shifts in patterns of consumption, and a revival of entrepreneurialism and neo-conservatism (1990, p. 124). These shifts in material and economic conditions are understood to have produced changes in the ways people relate to the past and the material world around them.

Some authors would suggest that what Harvey describes as the postmodern condition should be seen as the setting for the rise of official forms of heritage as a social phenomenon in the West. As Harvey notes, Robert Hewison sees a link between the heritage industry and postmodernity in his book *The Heritage Industry*:

> Both conspire to create a shallow screen that intervenes between our present lives, our history. We have no understanding of history in depth, but instead are offered a contemporary creation, more costume drama and re-enactment than critical discourse.
>
> (Hewison, 1987, p. 135)

Hewison (1987) suggested that the 'heritage boom' was intended to capture a middle-class nostalgia for the past and to impose this on society. Nostalgia is defined as a longing for the past, and in this sense we can see nostalgia as one important aspect of public memory. Hewison believed that the 'heritage industry' constituted a form of popular entertainment which substituted nostalgia for an interest in contemporary art and critical culture. Keeping heritage safely in the past, he believed, was preventing Britain from developing a lively and creative culture, and was contributing to a sense of decline:

> In the face of apparent decline and disintegration, it is not surprising that the past seems a better place. Yet it is irrecoverable, for we are condemned to live perpetually in the present. What matters is not the past, but our relationship with it. As individuals, our security and identity depend largely on the knowledge we have of our personal and family history; the language and customs which govern our social lives rely for their meaning on a continuity between past and present.

> Yet at times the pace of change, and its consequences, are so radical that not only is change perceived as decline, but there is the threat of rupture with our past lives.
>
> (Hewison, 1987, pp. 43–5)

Reflecting on these major changes in technology (particularly information technology) since the 1960s and 1970s, as well as on the increased pace of change of material, cultural and social life, helps us to understand the motivation to conserve, celebrate and remember the past. It also helps us to understand that this motivation, in turn, gave rise to the acceleration of heritage as a formal concern in the modern world and to the growing interest in the past in western societies. In Chapter 5 we saw how societies with small ethnic minorities might develop the greatest vested interest in preserving homogenous nationalisms using heritage as a tool of the state. We might add to this that when the pace of material and economic change shifts in society, it becomes more concerned with anchoring its values in the past (but this is always a version of the past that is created in the present). Similarly, as we saw in Chapter 5, heritage in the late twentieth century became in many places stronger and more appealing as a nationalising tool in response to the development of transnational communities who do not form strong connections with particular places or whose sense of cohesion crosses national borders. Heritage in the late twentieth century, at least in its official uses by the state, seems to be about establishing control and stability in societies that are experiencing periods of rapid change.

If we are to acknowledge that it is this postmodern condition which provides the contemporary setting for the increased interest in heritage and the past in post-industrialised western countries, what about the *heritage* of this recent past? It might be argued that if increased interest in heritage is a product of postmodernity precisely because it offers escape from the conditions of postmodernity, then it would seem perverse to use heritage to seek to establish a memory of that postmodernity itself. However, in addition to the growth in popular forms of nostalgia and heritage throughout the twentieth century, we have also seen the development of a process whereby the present is made almost immediately past through the creation and conservation of what we might term *postmodern* heritage, in which certain aspects of everyday life which relate to the present are almost immediately conceived of in heritage terms, sometimes even before they move outside the realm of everyday contemporary life. 'Heritage' developed as a way of giving value to 'dead' objects and places which had been divested of their function, within the context of de-industrialisation. However, with such a rapid pace of change in many societies, technologies and aspects of material culture become almost instantly redundant. Emails, text messages and other forms of electronic communications have replaced the letters that might, in the past, have formed the basis for archival collections. CCTV surveillance images are constantly

collected. How do we decide which of these to keep, and which to delete or throw away? Which of these should we keep for posterity? And should we feel an obligation to keep some of these for the future?

Decisions that we make every day, for example, whether or not to delete a certain email from our email inbox, employ the same sorts of assessment of value that are made in establishing the significance of heritage (and hence the ways in which heritage should be managed or conserved). The decision about what is worth conserving (or protesting to conserve) and, indeed, how to conserve it, is always based initially on an assessment of *value*. Sometimes this is an explicit assessment, as in the case of official heritage assessments carried out using explicit criteria, such as those against which World Heritage sites are assessed by UNESCO. In other cases the assessment will not be made formally but is implicit in any decision to invest time and energy in conserving one object or place instead of another. It is important to realise that concepts of value always underpin heritage in the sense that the attribution of something to the category of 'heritage' sets the object, place or practice apart from other categories of things as worthy of conservation or management. These decisions about value are everyday decisions that constantly influence those things we choose to keep from the past and those things we choose to discard. Given that the things we choose to keep will form the building blocks of social memory, this everyday process of choosing which things to discard and which to preserve has wide-ranging effects on the ways we will be able to use what remains to construct our heritage in the future.

Twentieth-century heritage: new chronologies of nostalgia

The later part of the twentieth century saw an incredible proliferation and diversification of official and unofficial practices of heritage around collecting the modern. We need only think of the rise of vintage clothes as fashion rather than thrift, the proliferation of amateur collectors of twentieth-century technology and design, and the increased popularity of oral and family history to get a feeling for the range of unofficial practices around heritage which relate to the growth of nostalgia for the contemporary and recent past in the late twentieth century. These unofficial practices have been mirrored by a series of official heritage practices around recognising, collecting and conserving the heritage of the twentieth century. This section of the chapter briefly outlines some of these initiatives, in particular those relating to ICOMOS and the World Heritage List.

At the national and international level, 'recent' or 'twentieth-century' heritage began to receive increasing 'official' heritage attention among architectural historians in the 1960s and 1970s. An important international non-profit,

Figure 8.1 Cover of *Docomomo Journal*, no. 33 (September 2005).
Unknown photographer. Photo: Y. Aloni private collection, © 2009
Docomomo International.

non-government organisation, the International Working Party for
Documentation and Conservation of Buildings, Sites and Neighbourhoods of
the Modern Movement (DoCoMoMo) was established in 1988 at the
Technical University in Eindhoven, the Netherlands, its international
secretariat moving to the Cité de l'architecture et du patrimoine in the Palais
de Chaillot in Paris in 2002 (DoCoMoMo, 2008). DoCoMoMo rapidly
became an important force in the conservation of modern architecture, setting
out its goals to conserve and educate the public about the architectural
significance of the Modern Movement in its Eindhoven Statement in 1990.

At the time of writing, DoCoMoMo has working parties in over thirty countries, each of whom undertakes to work on developing a national register of Modern Movement buildings and running campaigns to preserve what it perceives to be key works of architectural Modernism (Figure 8.1).

During the late 1990s, twentieth-century heritage became a major agenda item for ICOMOS. After a series of meetings of experts held in 1995 in Helsinki and in 1996 in Mexico, and national ICOMOS conferences in Helsinki and Adelaide in 2001, ICOMOS announced the Montreal Action Plan on 'recent' (last 100–150 years) heritage in late 2001 (ICOMOS, 2001). The plan acknowledged the findings of the *Heritage at Risk 2000* report, which expressed

> concern over the fate of various heritage types associated with the 19th and 20th centuries, such as residential or urban architecture, industrial complexes, landscape creations or new building types such as stadiums, airports, waterworks or large city parks.
>
> (ICOMOS, 2001)

It aimed to

- Understand the full diversity of 20th century heritage and of the issues related to its recognition and conservation. To that effect, ICOMOS, with the support of US/ICOMOS, is carrying out a survey of illustrative cases, through all its National and International Committees. This survey should be ready in April 2002 and published later as a Scientific Journal. Its result will help ICOMOS identify needs for new international committees or further partnerships with other organisations.
- Promote 20th century heritage by dedicating the International Monuments and Sites Day, on 18th April 2002 to 20th century heritage in all its diversity. Our Finnish ICOMOS colleagues are working on a poster that could be distributed to all committees for that purpose.
- Put a special emphasis on 20th century heritage in the 2002 edition of the Heritage@Risk Report, and invite our partner organisations TICCIH [International Committee for the Conservation of Industrial Heritage] and DOCOMOMO to contribute substantially to its content.
- Co-operate fully with UNESCO and other partners to develop workshops and meetings on that theme.

<div align="right">(ICOMOS, 2001)</div>

The Montreal Action Plan was followed by a UNESCO Heritage at Risk conference titled Preservation of 20th Century Architecture and World Heritage in April 2006 in Moscow and an ICOMOS International Scientific Committee meeting on 20th Century Heritage held in Berlin in 2007. The Berlin meeting found that twentieth-century heritage was under-represented on World Heritage List. According to the ICOMOS report and action plan *Filling the Gaps* (ICOMOS, 2005), in the year 2004 twentieth-century heritage made up less than 3 per cent of the (then) 800 World Heritage sites, and nominations for twentieth-century sites were seldom on the tentative lists of the signatory countries of the World Heritage Convention.

ICOMOS responded to this flurry of recommendations regarding the listing of twentieth-century sites on the World Heritage List with the widely publicised listing of several new twentieth-century World Heritage sites during the early 2000s, as a result of its Modern Heritage Programme, undertaken jointly with DoCoMoMo. This was the same approach that we saw UNESCO adopt in Chapter 7 – quickly to insert representative intangible heritage places on to the World Heritage List – and in Chapter 6 in relation to cultural landscapes. For example, the city of Tel Aviv was listed on World Heritage List in 2003 (Figures 8.2 and 8.3).

Figure 8.2 Arieh Sharon, Carl Rubin, Josef Neufeld and Israel Dicker, Meonot Qvdim workers' flats, blocks VII, 1935–6, Spinoza, Tel Aviv. Photographed by Tim Benton. Photo: © Tim Benton.

Figure 8.3 Genia Averbouch, The Zina Dizengoff Circle, 1934, Tel Aviv. Photographed by Tim Benton. Photo: © Tim Benton.

The listing description notes,

> Tel Aviv was founded in 1909 and developed as a metropolitan city under the British Mandate in Palestine. The White City was constructed from the early 1930s until the 1950s, based on the urban plan by Sir Patrick Geddes, reflecting modern organic planning principles. The buildings were designed by architects who were trained in Europe where they practised their profession before immigrating. They created an outstanding architectural ensemble of the Modern Movement in a new cultural context.

(UNESCO, 2008)

What is interesting about this phenomenon of twentieth-century heritage is that it is, perhaps even more than other forms of contemporary western heritage management, very narrowly focused on what are perceived to be key or seminal works of architecture, and in particular architectural Modernism. Indeed, it appears to be focused on developing a new 'canon' of Modernism. One might distinguish between the DoCoMoMo and ICOMOS campaigns in this regard; the listing of places like Tel Aviv depends on the quantity and consistency of the housing and planning, as Tel Aviv has few really 'important' buildings from the perspective of the canon of Modernism. Nonetheless, what we have seen in the 1980s and 1990s has been a shift in policy to conserve increasingly 'modern' buildings as heritage. This has shifted the landscape of heritage, to make it into something that embraces both the very old and the comparatively new.

Postmodern heritage: collecting 'us'

Another movement which reflects this impetus to historicise the immediate past as heritage relates to a field of research that we might term the 'archaeology of the **contemporary past**'. Throughout the 1980s and 1990s archaeologists developed in increased interest in oral testimony and the forensic or archaeological study of the contemporary or very recent past, in order to study contemporary societies (Gould and Schiffer (eds), 1981; Buchli and Lucas (eds), 2001; Harrison and Schofield, 2009). Projects including William Rathje's study of the archaeology of contemporary rubbish disposal in Arizona (Rathje and Murphy, 2001) and various projects relating to the archaeology of the Cold War (for example Schofield and Cocroft (eds), 2007), coupled with the increased reliance during the 1990s on forensic archaeological techniques in understanding the circumstances of war crimes have brought to the fore the archaeological study of the very recent past. This process of turning an archaeological lens on the present has influenced the development

of an interest in the heritage of the recent past which moves beyond a nostalgia for architectural Modernism to encompass the tangible and intangible heritage of the late twentieth and early twenty-first centuries in all its forms.

The idea of a postmodern heritage is reflected in the case example of an English Heritage book *Images of Change: An Archaeology of England's Contemporary Landscape* (Penrose (ed.), 2007). This developed out of an earlier discussion document titled *Change and Creation: Historic Landscape Character 1950–2000* (Bradley, Buchli, Fairclough et al., [2004] 2008) which set out to raise a series of questions about the importance of the twentieth-century landscape to people's sense of place in England.

A question posed by English Heritage in its discussion document in 2004 was: what does the landscape of the twentieth century mean to you? It is hard to answer this question without thinking about what the landscape of the twentieth century actually looks like. *Images of Change* develops a typological approach to the contemporary English landscape. Typology means the study of 'types' – in archaeology, typology is used to group things that are like each other based on particular criteria. The approach of *Images of Change* derives from that of historic landscape characterisation (HLC), a relatively new approach to heritage characterisation developed by English Heritage in the 1990s (see further discussion in Chapter 6). HLC focuses on understanding time-depth in *contemporary* landscapes (rather than the reconstruction of past landscapes, for example). It breaks down the landscape features of contemporary England into a number of broad themes – people, politics, profit and pleasure – before further isolating sub-themes. The themes and sub-themes employed by *Images of Change* are listed in Table 8.1.

There is something strangely familiar – shockingly so, perhaps – about this list. We may not think of shopping malls as part of our heritage, but they occupy a large part in the everyday culture of most of us (Figure 8.4). The sub-themes represent not only what is 'new' about the late modern landscape but also those things that typify it. It is worth pausing to reflect on this table and to document examples of these features from your own immediate environment. Are there examples on your list that you would consider to be heritage sites? You might not immediately consider any of them to be heritage, but think for a moment about how the loss of any item would change your familiar landscape. Would you be able to recognise it as the same landscape in which you had previously worked and lived? Would you be happy with those changes?

Table 8.1 Themes towards a typology of features for an archaeology of the post-1950 English landscape

People	Politics	Profit	Pleasure
Temporary Housing	Hospitals	Forestry	Back Gardens
Social Housing	Mental Health	Farming	Front Gardens
Privatopia (private housing and estates)	Detention	Metals and Industrial Minerals	National Parks
New Towns	Schools	Industry	Country Parks
Edge Towns (commuter satellite towns)	Higher and Further Education	Freight	Heritage
Migration	Defence Research and Development	Brownfield	Zoos
Faith	Defence Infrastructure and Support	Materials of Power	Television Landscapes
Homelessness	Memorialisation	The National Grid	Theme Parks
Airspace	Cemeteries	Energy	Swimming Pools
Airports	Crematoria	Nuclear Power	Leisure Centres
Motorways	Protest (eg places associated with protest, even where little material remains of this)	Renewable Energy	Sports Stadia
Roads		Water	Artificial Services
Car Parks		The Office	Golf Courses
Motorway Service Areas (roadside truck stops and diners)		Information (Internet, etc)	Cultural Centres
The Rail Network		Mobile Phones	Art and Place
Railway Stations		Out of Town Commercial Estates	Holiday Camps
		Town Centre Shopping	The Seaside
		Shopping Malls	

(Penrose (ed.), 2007, p. 5)

Figure 8.4 Bluewater shopping centre, Kent. Unknown photographer. Photo: © Terry Harris just Greece photo library/Alamy. Located in Kent, UK, the Bluewater shopping centre is one of the largest retail shopping malls in Europe.

It is clear that while the heritage of Modernism, relating as it does to what is now an increasingly distant past, may produce an element of nostalgia in the early twenty-first century, such heritage has very little to do with the ways many of us, particularly those of us in the post-industrialised West, live our everyday lives in the present. We are far more likely to relate to the physical manifestations of the last thirty years as anchors for ourselves in the places in which we live and work. On the other hand, we saw, in the case study in Chapter 1, that people can be interested in juxtaposing recent personal memories with a certain nostalgia for 1920s architecture in Moscow.

In the context of the increasingly transnational world in which we live, we should also think about the potential importance of postmodern or 'recent' heritage to migrant communities, who need to build effective links with places that they have occupied over relatively short periods of time (see further discussion in Chapter 5). To what extent would a recent migrant from Ghana consider an eighteenth-century English country house to be a part of their heritage? How could they relate to such a place and use it to build a sense of themselves and the space in which they live? Many people are beginning to challenge the conventional forms of heritage promoted during

the past thirty or so years as they become increasingly remote from the needs of contemporary communities. It has been argued that heritage is in part motivated by the desire to root one's self in a particular place and a community. But once that community loses its association with place, for example through the development of online communities over the internet, the conventional role of heritage is challenged. Some of these issues are explored in more detail in the case study in this chapter.

Digital heritage and the 'memory of the world'

So far this chapter has argued that the 'heritage boom' that started in the 1970s and 1980s was motivated by a desire to seek stability in the past, and that this desire was caused by societal changes reflecting the postmodern cultural forms that emerged at the time in many post-industrialised western countries. This led to the efflorescence of 'conventional' sites of heritage – the very old, the very grand and those places associated with famous historical events and figures – as well as to increasing interest in both the heritage of the recent and even the contemporary past, and in the heritage of the everyday. The postmodern condition has prompted people to seek a sense of stability in sites of memory of the distant past, and to 'historicise' and make even the most quotidian objects into heritage. One area of heritage that exemplifies this move to consider increasingly the everyday aspects of contemporary life is digital heritage and the conservation of computer technology.

We now focus on some of the opportunities and problems that have been generated for museums, archives and other collecting institutions of heritage by the proliferation of new technologies, particularly information technologies. One of the major shifts in heritage in the second part of the twentieth century came about partially in response to an increased recognition that heritage values are ascribed rather than intrinsic. Throughout the second part of the twentieth century the increased recognition of cultural diversity, the postcolonial critique and the contribution of multiculturalism to western societies created a conundrum – how could the old ideas about a canon of heritage represent the increasing numbers of diasporic communities who now made such a contribution to the character and make-up of society (see further discussion in Chapter 5)? This challenge, together with a recognition that heritage values could not be seen as intrinsic, and the influence of the nature conservation movement, led to the development of the concept of representativeness. This recognises that those in positions of power cannot always anticipate the places that diverse members of society will find important. By conserving a 'representative sample' of the diverse range of places, objects and practices, it is thought that we might

safeguard the protection of a sample of places and things that may be recognised as heritage in the future. A representative heritage place or object derives its values from the extent to which it can act as an exemplar of a class of place or type of object. The concept of representativeness was largely borrowed from the idea of biodiversity conservation in natural heritage management, where representative samples of species and habitats are quantified statistically. We might also see a metaphor of democratic representation here in the political impulse towards inclusiveness that pushes heritage organisations to reach out to all segments of society.

In the late twentieth and early twenty-first centuries, as the rate of change in technology has become almost constant, museums and archives have been faced with a problem of storage. How can they possibly conserve a sample of all the diverse forms of technology, and continue to archive important documents in the history of the nation, when such items have become so numerous and ubiquitous? Many enthusiasts for legacy technology have developed collections of old computer hardware and software along with other rapidly changing forms of technology, but such collections are necessarily

Figure 8.5 The Amstrad CPC 464, on display as part of an exhibition of working computers and software associated with the history of personal computing technology at the National Museum of Computing at Bletchley Park, UK. Photographed by Rodney Harrison. Photo: © Rodney Harrison.

large and pose problems of storage as well as problems relating to the ongoing maintenance of the artefacts. Countries have established national museums of computing and technology in attempts to tell the story of their own role in the history of computing. The National Museum of Computing at Bletchley Park in the UK, for example, tells the story of the development of computing technology and its association with British code-breaking during the Second World War. In addition to various code-breaking devices, the museum holds a very large collection of now defunct computing equipment which is maintained in running condition by a group of volunteers and paid staff (Figure 8.5).

At an official level, UNESCO made a gesture of recognising forms of digital heritage as part of its Charter on the Preservation of the Digital Heritage (UNESCO, [2003] 2009). The charter defines digital heritage as follows:

> The digital heritage consists of unique resources of human knowledge and expression. It embraces cultural, educational, scientific and administrative resources, as well as technical, legal, medical and other kinds of information created digitally, or converted into digital form from existing analogue resources. Where resources are 'born digital', there is no other format but the digital object.
>
> Digital materials include texts, databases, still and moving images, audio, graphics, software and web pages, among a wide and growing range of formats. They are frequently ephemeral, and require purposeful production, maintenance and management to be retained.
>
> Many of these resources have lasting value and significance, and therefore constitute a heritage that should be protected and preserved for current and future generations. This ever-growing heritage may exist in any language, in any part of the world, and in any area of human knowledge or expression.
>
> (UNESCO, [2003] 2009)

Its definition of digital heritage is incredibly broad, and its take on the significance of digital heritage perhaps even broader.

> The digital heritage is inherently unlimited by time, geography, culture or format. It is culture specific, but potentially accessible to every person in the world. Minorities may speak to majorities, the individual to a global audience.
>
> The digital heritage of all regions, countries and communities should be preserved and made accessible, so as to assure over time representation of all peoples, nations, cultures and languages.
>
> (UNESCO, [2003] 2009)

It goes on to describe the threat of loss of digital heritage as a potential loss of the 'memory of the world' (its programme for conserving documentary heritage).

> The world's digital heritage is at risk of being lost to posterity. Contributing factors include the rapid obsolescence of the hardware and software which brings it to life, uncertainties about resources, responsibility and methods for maintenance and preservation, and the lack of supportive legislation.
>
> Attitudinal change has fallen behind technological change. Digital evolution has been too rapid and costly for governments and institutions to develop timely and informed preservation strategies. The threat to the economic, social, intellectual and cultural potential of the heritage – the building blocks of the future – has not been fully grasped.

<div align="right">(UNESCO, [2003] 2009)</div>

The charter requires member states to develop and enforce legal and institutional frameworks to secure the protection of digital heritage. Its implications are far reaching. At a time when museums and archives are increasingly having to recognise that it is impossible to conserve an example of 'everything' and are shifting towards a thresholds-based heritage system, in which things must be assessed against a series of criteria to qualify for heritage status (and hence preservation), digital heritage presents particular problems. At the time of writing, new government initiatives are being developed in countries such as the USA, Canada, the UK and Australia to attempt to deal with the problem of how to archive digital publications such as websites, as well as government documents and electronic communications that form part of governments' remits as archiving institutions. Given the sheer volume of material being produced, this is pushing governments towards developing selection criteria to limit the material that is archived – to root out the 'treasure' from the 'junk'. Such selection criteria raise the same sorts of problems as the criteria that motivated the 'heritage as canon' model – principally, how can one dominant group in society decide what is significant and worthy of preservation for the future (see also Laurence, 2010)? It seems we have returned to the arguments in heritage that were common in the 1970s and 1980s and that led to the development of representative approaches in the first place.

Whatever the outcomes of these decisions, it is important to acknowledge the responses of museums and other archives to a 'post-representativeness' model of heritage. One of these responses is the increasing repatriation of materials from museums back to the communities in which they originated. While the push to repatriate indigenous cultural heritage began with debates

in the 1970s over who owns human skeletal materials held in overseas museums (see also Harrison, 2010), the redistribution of materials to communities who have a stake in them is being seen more and more as a solution to the problem of storage. In some ways this has had the effect of shifting the power balance from official institutions to communities to whom items have been repatriated. It is also leading to the development of new meanings and forms of significance for items of material culture that are in circulation once more – items both remembered and forgotten – as they are put to new uses in terms of the production of identity and locality in the communities who now hold them. Within this context, museums and other heritage institutions are increasingly shifting focus from their object/place collections to media that do not present the same problems of storage and maintenance – so called 'virtual heritage'.

Virtual heritage

'Virtual heritage' is a term with three distinct meanings. The first involves the use of virtual reality to supplement access to and interpretation of heritage sites. English Heritage, for example, used virtual reality in 1996 to produce a high-quality and accurate 'walk-through' record of Stonehenge that allowed visitors to explore Stonehenge in ten different eras, from 8500 BCE to 2000 CE (Burton, 1997). Across the Channel, the prehistoric cave paintings situated in the cave of Lascaux, France, were closed to the public in 1963 to avoid further deterioration but the virtual version is always open to visitors from around the world (Wilson Fuller, 2008). The increasing use of virtual reality (VR) in museums and heritage sites in the early twenty-first century can be understood to be an element of postmodern heritage practice. A VR representation of a place offers the viewer a realistic impression of moving in a three-dimensional world, either represented photographically or reconstructed graphically. In some VR representations the viewer is in control and can move or turn and look as they wish. In others, the program 'flies' the viewer through the space. VR heritage sites are increasingly replacing 'real' heritage sites. On the one hand, VR can be considered to be a tool to help understand and interrogate heritage in non-intrusive ways to promote conservation of certain types of heritage. For example, the use of non-invasive digital imaging techniques has increasingly taken the place of excavation of archaeological sites that might otherwise be destroyed by excavation. VR is also being used as a medium that allows off-site and widening access, for example over the internet for people who cannot visit heritage sites. Museums are using VR to help communicate heritage to a broader audience, as well as to create new ways of interrogating and understanding heritage from a conservation perspective.

A second interpretation of virtual heritage involves the preservation and interpretation of computer programs, games and other material that is available only in electronic form. Due to rapid changes in hardware and software, this is a fast-growing area that poses complex problems and in which heritage workers continually face new challenges. In 2008 the US Library of Congress launched a major project to preserve virtual worlds – worlds that have moved from a category of 'new phenomenon' to 'endangered heritage' within twenty years (Library of Congress, 2007). This interpretation of the term virtual heritage relates to the issues surrounding digital archives and legacy computer software and hardware discussed above.

The third interpretation concerns items and locations that can be read as reflections on the past and are considered worthy of preservation in the medium of cyberspace. The case study of virtual heritage in the online environment of Second Life demonstrates that heritage is not necessarily rooted in a physical location or a long-term connection to a setting. Within six years of this virtual world opening to the public it already had its own heritage sites including memorials, monuments and a historic house. These play a part in establishing Second Life as a thriving and developing community with its own perspectives and traditions. Residents of Second Life have not only begun to develop their own distinctive heritage but have also recreated and reworked real-world heritage sites within this virtual environment. The incongruity of this juxtaposition of new and old highlights aspects of heritage that are important in both real-life and virtual settings, and challenges the authenticity of real-world heritage sites.

Case study: the virtual heritage of Second Life

At the time of writing, Second Life is a thriving virtual world, with up to 76,000 people logging in concurrently by November 2008 (Nino, 2008). Virtual worlds are collaborative online environments that people normally access using a computer interface and where they can interact with others. These environments 'share three distinctive features: the illusion of three-dimensional space, avatars which serve as the visual representation of users and interactive chat which allows users to communicate with each other synchronously' (Sheehy, Ferguson and Clough, 2007). Such environments can be accessed from many different locations and they persist when users are not online because they are not confined to the computers of individual users.

Second Life operates like the better-known environment of a massively multiplayer online game (MMOG) such as World of Warcraft, but with some important differences. Unlike an online game, there is neither plotline to follow nor roles to which players adhere. Players, known as 'residents', may extensively customise their avatars – the animated characters that represent

them 'in world' (see the Appendix for a list of common Second Life terms). These avatars can perform a wide range of actions including walking, running, flying and teleporting. They communicate in a variety of ways, including text-based chat. They can also own and develop virtual land, either on the world's mainland or on individually owned islands known as 'sims'. Island name and three associated coordinates can precisely identify in-world locations, a reference method that is used throughout this case study. For each setting we describe, we have included the island on which we found it, and the coordinates that we used to locate it (for example Hyojong 182, 178, 49). However, virtual location is not permanent, and even well-known landmarks may be moved or removed without notice.

Residents use Second Life for many purposes, including teaching and learning, trading, social networking, engaging in sexual activity, working, building and creating art. Using building blocks known as 'prims' and the Linden scripting language (LSL), they can create and program objects. Once this is done, they own the copyright to their creations. These can then be reproduced, bought and sold using the in-world currency of Lindens. A distinctive feature of this virtual world is that its currency has a real value – Lindens can be exchanged for US dollars.

Second Life developed from the first persistent games, which were developed in the 1970s. Such games have localities that persist when individual players log off. They were originally text based but, as computer memory and processing power increased, graphical environments quickly became popular. In 1986 Habitat, a graphical environment in which people could interact and see representations of themselves in virtual space, was launched. Habitat involved avatars, money and marketplaces. Soon developers found that, even with role-play games, many players preferred to have greater freedom. At the same time, interest grew in online chat rooms where people could communicate without intending to reach a specified goal.

The Alpha version of Second Life was launched by Linden Lab as Linden World in 2002. It was presented not in terms of gaming but as a result of 'research in streaming 3D content' and as 'an online society within a 3D world, where users can explore build, socialize, and participate in their own economy' (Detheridge, 2007; Rosedale and Ondrejka, 2003). The Alpha version was followed by a Beta test, and then a public launch to adults in 2003. The majority of the world, the SL Grid, is currently an adults-only zone, officially accessible only to those aged 18 or over. In January 2006 Linden Lab supplemented the SL Grid with Teen Second Life, a virtual world for those aged 13–17 (Second Life Wikia, 2008).

The Second Life community is not confined to activity on the SL Grid and in Teen Second Life. Residents share ideas and comments through websites, wikis and blogs. Some of these sites are ephemeral, while others persist.

Second Life photographs are shared through image-sharing sites such as Flickr, where the Second Life group has posted over 251,000 pictures. Talented film makers such as Robbie Dingo share videos created in world (known as machinima) through social networking sites such as YouTube. Torley Linden's photographs and video tutorials, distinctive due to Torley's repeated use of the watermelon colours pink and green, are both popular and ubiquitous. The New World Notes blog by Wagner James Au (Au, 2008a) has provided consistent and detailed coverage of Second Life, and Au has built on the material in the blog to produce a book on Second Life (Au, 2008b).

Researching Second Life heritage

Our investigation of Second Life heritage has involved extensive visits to the current major heritage sites on the SL Grid. We have studied material available on these sites, as well as discussions and background information available online, particularly blog accounts by Second Life residents and images of Second Life posted on social networking sites. In addition, we have made an in-depth study, involving participant observation and interviews, of the uses of heritage on The Open University's original education sim in Teen Second Life, Schome Park (also known as SPii) (Schome, 2008).

We have found that Second Life heritage is characterised by a blending of reality and fiction. The in-world reproduction of real-world images, texts and sounds challenges the concept of a straightforward binary divide between the authentic and the counterfeit, between the real and the virtual. At the same time, the contrasts between Second Life and everyday reality serve to make the familiar strange, throwing into relief some of the ways in which the past is utilised by individuals, groups and societies and providing an insight into the ways in which heritage is constituted. In this case study we concentrate on two aspects of Second Life heritage. The first is the development of an in-world heritage involving items that have never had physical reality but have links to real-world heritage conventions. The second is the reproduction of buildings, communities and settings which draw upon and make reference to counterparts in the real world.

Developing Second Life heritage

In both physical and virtual reality, individuals and communities commonly – and often consciously – select and use elements of the past to position themselves within a certain context. For example, the classical architectural style of Ancient Greece can be used as a marker of culture and refinement. It is therefore frequently used in heritage settings such as London's British Museum or the Harris Museum in Preston. Here it leads the visitor to connect these buildings with civilisation, culture and the glories of the past, overlooking the slightly inappropriate relocation to England of a style of

architecture designed for a hot, dry climate. Such a selection and re-contextualisation of elements of the past is commonplace in real life, but in Second Life the incongruities of such an approach become clearer. In the real world, old-fashioned architectural features such as towers, crenellations and arrow-slit windows suggest power even when they are added to modern buildings for which they have no defensive value. In Second Life, where flight and teleportation are possible, it is more obvious that castles and their features are used as signifiers of a particular atmosphere and way of life, rather than as strong defensive structures. Indeed, Castle Row, where castles are arranged for buyers to browse, as in a supermarket, extends the metaphorical implications of these structures by including castles in the air (Hyojong 182, 178, 49).

Buildings on Schome Park also make use of references to the past. The use of classical design was a conscious decision on the part of architect and builder Woop Kamachi. Only six months after the central meeting area, Scholympia, was constructed, one resident commented that it gave the island coherence and a unified feel: 'Scholympia is all about the history of SPii ... it was the first build I saw it was the first glimpse of that mysterious island, and it has been here, as the landmark, as the centre of the community'. He added, 'it does give a certain Greco roman [*sic*] feel to that particular area, and because of that people are sometimes hard to bend to the modern way' (Schome Park Resident, in-world interview, 2007). In an environment that has little need for roofs, walls or floors, classical architecture can be used as a marker for culture and history in a world which is less than two years old.

These stylistic and architectural references to the past act to set Second Life in a historical context linked to that of the USA and western Europe, where 80 per cent of Second Life residents are based (comScore, 2007). At the same time, these references are employed by residents as they develop their own, distinctive in-world heritage which situates them within a thriving and developing community with its own traditions.

Establishing continuity with the past is a frequent response to novel situations (Hobsbawm, 1983). Invented traditions, practices that promote values and norms connected to a suitable historical past, were part of the fast-changing culture of Europe in the years prior to the First World War. The choice of a Gothic style for Britain's nineteenth-century Houses of Parliament and the development of rituals for imperial governance exemplify this trend.

Linden Lab, the company that developed and owns Second Life, is represented in world by a team of staff whose avatars share the surname Linden. One avatar, Governor Linden, has more powers than others to control what is happening in the world. Unlike the majority of other avatars, Governor Linden is not controlled by one real-world individual but by members of staff who need to use this avatar's powers. The Governor, unlike many other

Lindens, is rarely seen in world, s/he is a figurehead rather than a character and, as a rarely present avatar, is unlikely to have need of a house. Nonetheless, Governor Linden's mansion has its place on the SL Grid (Clementina 139, 132, 64). It is one of the oldest buildings in this world, having been one of the few to be transferred from the Beta test version of Second Life. The importance of this building is implied by its transfer from one world to the next. Its heritage role is emphasised by the existence of an in-world group named 'Gov's Mansion Restoration Team', founded by Governor Linden, which has pledged to restore it to its former glory. Its age and status establish it as a site that is important to the community, a site which attracts virtual tourists as well as demonstrations by disaffected residents.

The oldest structure in Second Life, *The Man* statue built by oldjohn Linden, is even older than the Governor's mansion (Figure 8.6). It dates from the world's Alpha Test and, being six years old, is fast becoming a venerable

Figure 8.6 *The Man* statue in Second Life. Captured by Rebecca Ferguson/Marie Arnold. The simple outline contrasts with the intricate architecture of the Ivory Tower of Primitives seen behind it.

antique. This build, which has no real-life counterpart, and which has had elements added and removed throughout its existence, thus merits a privileged position in world beside the old Delerium (*sic*) Castle and the popular and frequently visited Ivory Tower of Primitives (Natoma 189, 191, 40). The juxtaposition of the intricate design of the Ivory Tower and *The Man*'s basic shape and texture suggests a time when the world was a simpler place, indicating how much it has developed since then.

Second Life has its historic house and its ancient monument – it also has its memorials. There are two Beta monuments. One of these, which is located beside Governor Linden's mansion (Clementina 162, 115, 60), was presented to Linden Lab by the Beta testers. It bears the inscription (reproduced as it appears):

> This monument has been presented to Linden Labs to mark the culmination of its Beta Test. This will be an everlasting reminder of all they have done for and given to their beta testers. May it forever be a token of our appreciation and Gratitude for giving us the tools to create this amazing world.

On the back are listed the in-world names of twenty-five Linden Lab employees, six 'liaisons', seven 'secondary contributors' and three 'true believers'. The monument thus gives continuity to an environment in which the active life of many avatars can be measured in weeks – or even shorter periods.

A second, larger, monument (Plum 129, 56, 35) was created by the Lindens. Its inscription, which appears to be carved in stone, begins 'The 1500+ names listed here recognize the most active residents who made the Second Life Beta a tremendous success'. Further along the wall, these avatar names are inscribed. With these builds, residents have created a simulacrum of heritage, selecting and gathering in Second Life the elements that conventionally signify heritage in the USA and western Europe without the conventional context of a past. This in-world heritage is elsewhere represented in the SL Historical Museum (Phobos 228, 132, 45) and, on Schome Park, by the Schome Park Museum, which houses a variety of artefacts that residents wish to see preserved.

Residents are thus creating a Second Life heritage which reinforces the view that their world contains a thriving, developing community. They are also engaged in reworking real-world heritage sites in a variety of ways: for art, for role play, for political purposes and for personal reasons.

Reworking real-world heritage

We found that examining the heritage artefacts that are assembled in Second Life, away from their real-world contexts, added to our understanding of how heritage functions and is used in the real world. Second Life heritage sites

hold up a mirror to reality, helping visitors to understand what they regard as normal by observing what reality could be, what it has been and what it is not. Heritage sites that have been reproduced or recreated in Second Life demonstrate in different ways that, even in the physical world, such sites are not fixed and authentic but represent versions of reality that are produced for a purpose and that change over time. Whether in the physical or the virtual world, the location of any heritage site in time and space is open to interpretation.

Situating heritage in time

Heritage sites in Britain and elsewhere often make an effort to remove their visitors from real time, giving them the chance to forget the current hour and date as they meet a medieval jester, re-enact past battles or celebrate a Victorian Christmas. Actors, artefacts, costumes and settings are employed to enable visitors to experience the past. This 'authentic' experience is gained through a reproduction of the past, and a move away from contemporary norms and realities. In Second Life, the situation is more complicated because Second Life is already situated outside real time.

In world, residents can select the time of day whenever they wish. If they appear in Second Life when the default regional time is night, they can switch to dawn, noon or dusk. The world's isolation from normal temporal continuity is emphasised by the progress of its sun through the sky, producing three hours of daylight followed by one hour of night. At the same time, the real-world time in California is displayed to residents at the top of their screens. An individual logging on after breakfast may find that Pacific Standard Time is midnight, but that dusk is fast approaching in Second Life. Meanwhile, the avatar next to them may be eating supper in their home country, having set the in-world time to dawn. There is no guarantee that avatars standing next to each other are experiencing the same temporal context in either the physical or the virtual world.

In addition, due to a delay in computer response known as 'lag', Second Life residents do not necessarily experience events in the same sequence as one another. A countdown entered by one resident as the five statements '5', '4', '3', '2', '1' may come across to another as '5', '4', '2', '1', '3'. An avatar may simultaneously be crashed but still able to communicate from the perspective of its owner, recorded as offline in some residents' chat lines, and still online or back online for someone else. The more residents and complex objects that are crowded on to a sim, the greater the likelihood that residents will experience linear time as distorted with even their own typed comments appearing to them out of order in world.

A further complication is the rate of change in world. Schome Park residents have noted that the fast pace of Second Life, in which complex structures are created within hours and entire landscapes in weeks, gives a feeling that history has been speeded up, that the pace of change is far faster than real life. The terms 'history' or 'heritage' may therefore be used without irony to refer to events that took place only a few months previously. Here we see a radical example of the ways in which accelerated perception of change motivates individuals in society to historicise the immediate past and even those aspects of everyday life which are still current but which they understand will soon be superseded.

The sense of being outside real time is exploited effectively in the ancient-Roman-themed role-playing sim of Roma (Roma 206, 25, 22). Designed, built and owned by Torin Golding, this is managed jointly by Emperor Julian Augustus and Torin. A note card offered to visitors on arrival explains that

> The sim of ROMA was designed to be an immersive experience, and many visitors (though certainly not all) are interested in role playing like they were a Citizen of ancient Rome. The owners of ROMA encourage this, as this is the only place in SL that this is possible.

This being Second Life, the card goes on to clarify that

> sexual roleplay, including sexual slave relationships, should be kept to the confines of Caligula's Pleasure Palace up on the Palatine Hill. Visitors are encouraged to create a character based on an ancient Roman model and to join various role-playing groups based in the sim, including Roma citizens (SPQR) and Legion XIII.

Free togas and sandals are available for visitors to Roma to wear and posters advertise resources and animations, so that their role-playing experience can begin quickly (Figure 8.7). Ancient Romans could not fly, so the owners of the sim have switched off flight capabilities. Neither did they make typing motions or keyboard noises when they spoke (as the majority of Second Life avatars do), so it is possible to visit the Roman Market and buy a 'moving scroll typing override' which replaces avatars' default typing animation with a writing animation. When a Roman role player begins to type a comment on their computer keyboard, the override places an unfurling scroll in one hand and a stylus in the other.

Unlike most real-world role-playing experiences, the opportunity to engage in role play as an ancient Roman is available 24 hours a day, seven days a week. As one nation's role players are logging off for the night, another's are switching on their computers on the other side of the world. This extended role-play gives citizens a chance to build relationships, share information and develop both their knowledge of ancient Rome and their understanding of Latin.

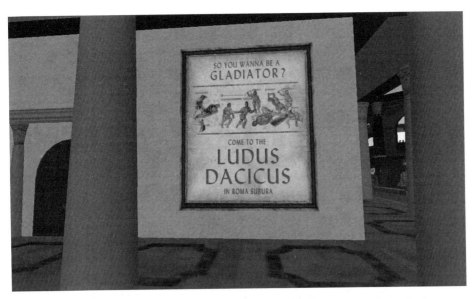

Figure 8.7 Poster advertising gladiator job in Second Life. Captured by Rebecca Ferguson/Marie Arnold. Second Life residents can travel between present-day reality and life in ancient Rome.

Situating heritage in space

Historic settings within Second Life, such as Roma, are clearly modern interpretations of the past. In the real world, heritage sites appear more authentic but may be even more painstakingly constructed in order to present their owners' interpretation of the past. The heritage site of Blists Hill Victorian Town in Ironbridge is one such location. 'Visitors are transported back to a world of pounds, shillings and pence, where steam engines and horses powered industry and gas, and candles lit shops, factories and homes' (Ironbridge Gorge Museum Trust, 2008). In fact, the seemingly Victorian town is a modern amalgamation of buildings carefully moved from their original locations, including a canal warehouse from Wappenshall, a tollhouse from Shelton and Jackfield's Wesleyan chapel. They are combined in a location designed to help visitors understand the twenty-first century in the light of the nineteenth century. Elements of the past are blended seamlessly with the new, so that it is impossible to distinguish relocated originals from modern reproductions.

In Second Life such juxtapositions are far more easily achieved. In real-world Jerusalem, the Western (Wailing) Wall of the Second Temple is next to the Muslim shrine Masjid Qubbat As-Sakhrah, the Dome of the Rock. The proximity of the two sites supports understanding of conflict in the Middle East and the struggle for control of Jerusalem. However, in Second Life the Wall's setting and context are Jewish, and its nearest neighbour is a synagogue

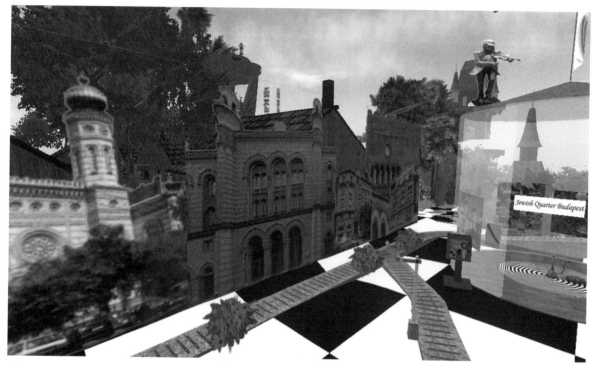

Figure 8.8 Virtual Budapest in Second Life. Captured by Rebecca Ferguson/Marie Arnold. The artificiality of this Jewish Budapest emphasises what will be lost when only reproductions of the buildings survive.

(Nessus 117, 128, 106). What is reproduced in Second Life is not a physical map but rather a mental map of the associations that the Wall has for many orthodox Jews: it is relocated from a physical to a spiritual setting.

Nearby, on the same sim, the Second Life Jewish Budapest (Nessus 143, 36, 103) was set up as a heritage site to draw attention to the destruction of the buildings of real-life Jewish Budapest (Figure 8.8). A train takes visitors on a tour of the old buildings and they can stop to examine a slideshow of photographs, or the note card they were automatically given on arrival, giving information about the site. Times and places are selected and re-contextualised to produce one grand image of Budapest's Jewish heritage. The location is far from realistic – the 'buildings' are facades and a fiddler stands on one roof, a reference to a surreal painting by Chagall and the Yiddish story of eastern European Jewish life popularised by the musical *Fiddler on the Roof*. By accentuating its artificiality, the site makes a persuasive point about the need to preserve the real buildings.

Representations of real-world heritage

Second Life heritage locations take the opportunity afforded by the medium to tidy up reality, positioning and highlighting key locations and key elements. As in real life, they remove items from their original setting and recontextualise them to support a particular interpretation or set of interpretations. When the residents of Schome Park filmed a version of the Hindenburg airship disaster (Schome Park, 2008), they used a vast boat with a balloon as a sail. This interpretation of the Hindenburg preserved it as a flying form of transport at the same time as it drew attention to the metaphor within the term 'airship'. The Second Life reproduction of Stonehenge (Mystica 179, 213, 38) tidies up the stones that lie about the real-life modern-day ruins and instead takes the form of a complete stone circle. The virtual builder thus privileges the ring of stones above the sacred landscape within which English Heritage locates the real-world site.

This tidying of heritage in Second Life allows builders to make powerful points. Chebi contains a detailed replica of the Mezquita in Cordoba, Spain – a beautiful building, designed as a mosque which replaced earlier temples and churches on the site (Chebi 150, 212, 85). The Mezquita in Cordoba is now the Cathedral of the Assumption of the Virgin for, despite the original purpose of the current building, it was consecrated as a church in 1236. During the sixteenth century a Renaissance cathedral nave and dome were

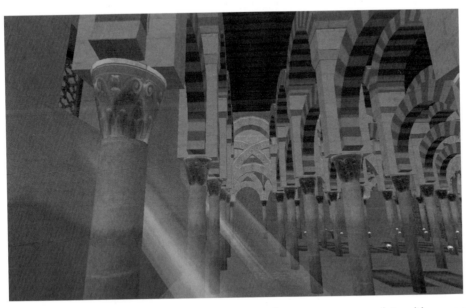

Figure 8.9 The Mezquita in Second Life, recreated as a mosque, complete with prayer mats. Captured by Rebecca Ferguson/Marie Arnold.

constructed in the middle of it – startlingly incongruous additions – and the building is currently a cathedral. In Second Life there is no place of Christian worship to be found within the Mezquita, which functions as a virtual mosque, though avatars of all religions are welcome to visit and to pray there (Figure 8.9). Some visitors experience this building as subversive. Spanish Muslims are not permitted to pray in the real-world building, although they are currently campaigning for this right, so the Second Life build challenges the real-world order. The presence of a Second Life mosque has angered racist avatars who have attacked it in the past, forcing it to close temporarily.

On the educational sim of Schome Park, a reproduction of Hadrian's Wall was constructed to help students understand the original wall as it existed in Roman times. Archaeology lecturer Alan Greaves reported, 'the reconstruction included all the major features that made up the Wall system: the forward ditch, berm, wall, military way and the vallum (a wide flat-bottomed ditch flanked by raised banks)' (Greaves, 2007). Although archaeologists know enough about Hadrian's Wall to be able to construct its ground plan, the model was intended to provoke investigation of other aspects, including its original full height and external appearance.

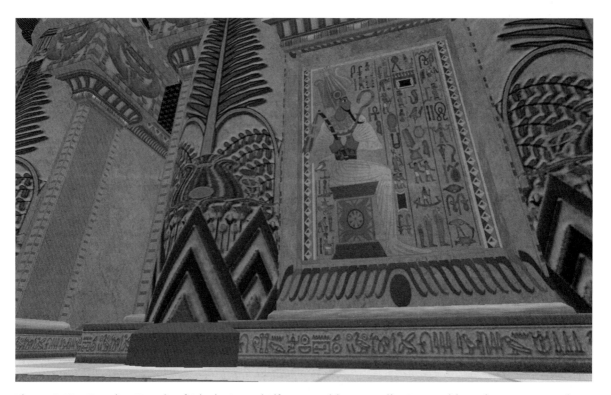

Figure 8.10 Egyptian Temple of Isis, in Second Life, created by Aura Lily. Captured by Rebecca Ferguson/ Marie Arnold.

The Schome Park wall was not constructed as a full reproduction of the 73-mile-long original, but rather as a version of it that would help students to understand the Roman wall in ways which would not be possible on a visit to the real-life site.

Similarly, on the Main Grid of Second Life, avatar Aura Lily has used information collated by one of Napoleon's artist engineers to construct the ancient Egyptian Temple of Isis and buildings on the island of Philae (Themiskyra 54, 241, 36). The aim is to give visitors 'the feeling of being on Philae back in the time when the paint was still wet on the Temple walls' (Lily, 2006). The builds do, indeed, look brand new, allowing an understanding of them as spaces where real people lived their lives, rather than as the crumbling remains of an ancient civilisation (Figure 8.10).

Regulating experience of heritage

In the real world, heritage sites offer different experiences on different occasions. They may have opening times and closing times, winter seasons and summer seasons, times when tours and guides are available, when festivals are being celebrated or re-enactments are taking place. These sites are more accessible and comprehensible to the public at some times than at others. A cathedral or church, for example, maintains a tension between its role as a place of worship, and its role as a heritage site. At certain times, particularly Sunday mornings and festivals, casual visitors will be discouraged or excluded. The difficulty that some cathedrals experience in persuading visitors to donate to their upkeep may be seen in terms of their role as the interface between the sacred, mysterious interior and the profane, commercial and chaotic exterior of everyday life.

Behaviour in real-world heritage sites is also regulated – visitors may have to dress appropriately, leave their pets or children behind, travel at a particular pace or confine themselves to certain areas. Likewise, different parts of Second Life have their own conventions and codes of content. These are sometimes recorded on note cards, which are issued automatically to any visitor to the area. A note card in Roma informs visitors that 'ALL role play and citizen activity must respect the covenant of the sim. If you haven't yet, read this brief document. Open the land info window and click on the Covenant tab.' Appropriate costume enhances the heritage experience: togas in Roma, head coverings in the Mezquita mosque, and variants of Victorian costume in steampunk locations such as Caledon are a few of the many examples of visitors being encouraged to make their experience of the location more immersive. The no-flying rule enforced on heritage sims such as Roma and Paris 1900 (Paris 1900 9, 174, 16) not only draws attention to how much slower transport often was in the past, but also forces avatars to visit more of the sim than can be seen by just flying quickly between the most striking builds.

Unlike real-world heritage sites, those in Second Life are always open (except for times when the world is closed for software updates) but many of Second Life's heritage sites are best visited when their creator or an interpreter is available to explain the thinking behind them, how they are used and which developments are planned. If in-world interaction at a site is not possible, the opportunities for exploring and understanding the sites are enhanced by discussion of them in blogs, by machinima and the associated comments posted on online video sites, and by images shared in social networking sites which, again, are often associated with comment and discussion.

Understanding heritage in Second Life

To understand heritage in Second Life it is necessary to look beyond the virtual world itself to interpretations and representations that appear elsewhere. In the same way, understanding of heritage in the physical world is enhanced by study of interpretations and representations that appear in other settings. The artefacts and locations of Second Life, even those that can exist only in virtual space, mirror their real-life counterparts and many are produced within the same cultural discourses (Harrison, 2009). A heritage artefact in Second Life is not simply a copy from one medium to another, it provides a vantage point from which to reflect on heritage in the real world. By offering a re-organised, re-articulated space, the virtual opens up the possibility of a multiplicity of juxtapositions. Second Life residents are enabled to reassess their society as if from the outside, to come to fresh understandings of time and space and to realise that heritage, be it in real life or Second Life, is concerned with relationships, communities and contested accounts of the past, the present and the future.

Reflecting on the case study

The case study raises a number of issues about virtual heritage, the heritage of the recent and contemporary past, and heritage more generally (see also Harrison, 2009). Virtual heritage is not simply a 'copy' of heritage in real life but provides an opportunity to engage with and interrogate certain aspects of heritage in new ways. The ability to move between the online and real world provides Second Life users with particular ways of interacting with heritage sites from the real world. In doing so, they contribute to the significance of these places in the real world.

However, we should not assume that the ways in which Second Life residents interact with heritage is somehow unique. Indeed, many tourists 'visit' heritage sites virtually, over the internet, before they ever encounter them physically, and their interactions with a heritage site may shift backwards and forwards between virtual and real space. A whole series of virtual encounters

occurs as they move from the internet to a museum, to reading about the place in a guidebook or magazine, to seeing the image of the site used on a tourist poster at the airport or bus station, to eating a themed meal in a hotel named for the site. They may then see the place in the 'real' world, but their encounter with the place is changed and mediated by all of these other 'virtual' encounters. The tourist may take photographs of the site, which they will later show to their friends – another series of virtual encounters. In the contemporary world interactions with heritage are entangled in a web of virtual representations that inevitably influence the ways people interact with, respond to, memorialise and remember those places when they encounter them in 'real' life (see also Basu, 2007).

Another issue that emerges from the case study is the way the creation of imaginary worlds breeds its own self-replicating nostalgia. This acutely modern form of time–place creation cannot easily be linked to postcolonial issues or, in one sense, to Modernism because it seems to be curiously uninterested in modernity in the traditional form of exchanging one world for another. What we do see is the way in which the accelerated sense of time–place change creates an equally accelerated and fragmented series of heritages which may be intensively memorialised by particular minority groups while being totally ignored by others. The case study underlines the increasingly fragmented and localised (in this case thematically, rather than spatially) nature of communities in the early twenty-first century, and the ways in which they deny the idea of national heritage while actively creating their own new forms of commemoration and social memory in the present (see also Chapter 5).

Virtual heritage and the transformation of social memory in the twenty-first century

The three forms of virtual heritage raise a series of issues relating to heritage and authenticity. As Parry (2007) notes, the increasingly virtual presentation of heritage has produced a challenge for a heritage industry that has traditionally emphasised the 'tangible' and material aspects of heritage. As discussed in detail in Chapter 7, the various official charters of world and national heritage have traditionally articulated the value and significance of heritage as manifest within its physical fabric. We might call this special quality of the 'real' heritage object its 'aura'. Harrison, Fairclough, Jameson et al. (2008) have discussed the way in which the work of German-Jewish literary and cultural critic Walter Benjamin (1892–1940) on the idea of the 'aura' of art objects might help us to understand more recent processes in the field of heritage during the twentieth and twenty-first centuries. Writing just before the Second World War, Benjamin used the term

'aura' to refer to the 'special' qualities of authenticity that are attributed to works of art, and the ways in which the new reproductive technologies such as the camera and the phonograph were having an influence on the notion of authenticity by removing that aura. He noted,

> Above all, it [reproductive technology] enables the original to meet the beholder halfway, be it in the form of a photograph or phonograph record. The cathedral leaves its locale to be received in the studio of a lover of art; the choral production, performed in the auditorium or the open air, resounds in the drawing room.
>
> (Benjamin, 1999, p. 215)

The aura is intimately connected to the originality, or authenticity, of the artefact or artwork. Benjamin suggested that this aura, the basis for conceiving of an object's authenticity, became threatened during the twentieth century with the emergence of reproductive technologies such as the camera and photocopier. For Benjamin, it is the shared history of art object and its viewer that makes the artwork worthy of display and the attribution of sentimental value. As Price and Wells note,

> Formerly unique objects, located in a particular space, lost their singularity as they became accessible to many people in diverse places. Lost too was the 'aura' that was attached to a work of Art which was now open to many different readings and interpretations.
>
> (Price and Wells, 1997, p. 25)

Benjamin saw in the death of the aura the demystification of the process of creating art, making art itself much more widely available and generating radical new roles for art in mass culture. With the death of the aura, the 'distance' between the work of art and the masses grew smaller. He noted that concepts of the aura and the authentic have their roots in the associations of objects now venerated as 'art', and their creation within ritual contexts, or the 'cult' of beauty and aesthetics. Benjamin saw this as a revolutionary and largely positive uncoupling, as 'the instant the criterion of authenticity ceases to be applicable to artistic production, the total function of art is reversed. Instead of being based on ritual, it begins to be based on another practice-politics' (Benjamin, 1999, p. 219).

But the death of aura has of course been greatly exaggerated. It might be said that aura has never been more highly regarded, and that it has been 'reborn' in the accelerated interest in the 'real' and the 'tangible' which is a major feature of the interest in heritage in the early twenty-first century. Even in virtual worlds such as Second Life we see an interest in the tangibility of heritage, and various discourses which reinforce the power (and hence the 'aura') of the authentic object.

In the same way that Benjamin saw art being transformed by the ability to reproduce images, we could argue that heritage has been transformed by the virtual. While traditional views of heritage have emphasised the connection between its physical fabric and its significance, the growing forms of virtual interactions with heritage have challenged this. If we can have a copy of a heritage site and interact with it in virtual reality, do we even need the original any more? On the other hand, we have seen that the circulation of images also contributes to the renown and significance of heritage objects, places and practices, and increases anticipation for the aura of the authentic original. We might compare this process to film or television trailers. Why bother to see the film when you have seen the best bits condensed into a few seconds? But we are attracted to see the whole thing, with those 'best bits' shown in their correct context in the film. What this all suggests is that the growth of new communicative technologies is making heritage more widely available as a 'tool' for the production of local forms of commemoration and social memory, and is democratising heritage by uncoupling it from its isolated existence in space. However, we should not necessarily see this as something radically new but as a continuation of the development of forms of virtual interactions with heritage which originally came about with the widespread adoption of personal photography during the late nineteenth and early twentieth centuries, as discussed by Benjamin.

Conclusion

This chapter has focused on the heritage of the recent past and the contemporary world. It has argued that new technologies are transforming heritage practice and our relationships with heritage, as well as the ways in which these new technologies might be considered to be a part of heritage itself. The case study on virtual heritage raises many of the same issues that apply to conventional heritage – questions of value, control, power and representation. It also causes us to question issues of authenticity and reality. In the museum sector in particular, virtual heritage and the challenges of the new communicative technologies are forcing us to rethink our attitude towards conservation and the representative approaches to heritage that developed as a result of the multicultural and subaltern challenges of the 1990s. As we look towards the future of heritage we can see that while many challenges to the AHDs that emerged throughout the second part of the twentieth century have been levelled, such discourses continue to hold sway in many areas. Perhaps more than ever, heritage (both as a contemporary phenomenon and in terms of its critical academic study) is in a state of flux. The increasingly localised and fragmented manifestations of heritage, together with new global communicative technologies, points towards the ongoing negotiation and conflict between global, national and local forms of social memory and heritage in the twenty-first century.

Works cited

Au, W.J. (2008a) New World Notes [online], http://nwn.blogs.com/nwn/ (accessed 29 June 2008).

Au, W.J. (2008b) *The Making of Second Life*, New York, Collins.

Basu, p. (2007) *Highland Homecomings: Genealogy and Heritage Tourism in the Scottish Diaspora*, Abingdon and New York, Routledge.

Benjamin, W. (1999) *Illuminations* (trans. and ed. H. Arendt), London, Pimlico.

Bradley, A., Buchli, V., Fairclough, G., Hicks, D., Miller, J. and Schofield, J. ([2004] (2008)) 'Change and creation: historic landscape character 1950–2000' in Fairclough, G., Harrison, R., Jameson, J.H. Jnr and Schofield, J. (eds) *The Heritage Reader*, Abingdon and New York, pp. 559–66.

Buchli, V. and Lucas, G. (eds) (2001) A*rchaeologies of the Contemporary Past*, London and New York, Routledge.

Burton, N. (1997) World Heritage Sites and GIS [online], www.eng-h.gov.uk/cas/whs/shenge.htm (accessed 30 June 2008).

comScore (2007) comScore Finds that 'Second Life' Has a Rapidly Growing and Global Base of Active Residents (press release, 4 May) [online], www.comscore.com/press/release.asp?press=1425 (accessed 29 June 2008).

Detheridge, L. (2007) RMIT Campus in Second Life: A 3D Virtual World [online], http://emedia.rmit.edu.au/ed/Issue/2007b/Elearning/article1_pg1.html (accessed 29 June 2008).

DoCoMoMo (2008) General Information [online], www.archi.fr/DOCOMOMO/index.htm (accessed 23 September 2008).

Gould, R.A. and Schiffer, M.B. (eds) (1981) *Modern Material Culture Studies: The Archaeology of Us*, New York, Academic Press.

Greaves, A. (2007) Reconstructing Hadrian's Wall in Second Life [online], www.liv.ac.uk/sace/organisation/people/greaves.htm (accessed 29 June 2008).

Harrison, R. (2009) 'Excavating Second Life: cyber-archaeologies, heritage and virtual settlements', *Journal of Material Culture*, vol. 14, no. 1, pp. 75–106.

Harrison, R. (2010) 'The politics of heritage' in Harrison, R. (ed.) *Understanding the Politics of Heritage*, Manchester, Manchester University Press/Milton Keynes, The Open University, pp. 154–96.

Harrison, R. and Schofield, J. (2009) 'Archaeo-ethnography. auto-archaeology: introducing archaeologies of the contemporary past, *Archaeologies*, vol. 5, no. 2, pp. 185–209.

Harrison, R., Fairclough, G., Jameson, J.H. Jr. and Schofield, J. (2008) 'Heritage, memory and modernity: an introduction' in Fairclough, G., Harrison, R., Jameson, J.H. Jr and Schofield, J. (eds) *The Heritage Reader*, Abingdon and New York, Routledge, pp. 1–12.

Harvey, D. (1990) *The Condition of Postmodernity: An Enquiry into the Origins of Cultural Change*, Malden, MA and Oxford, Blackwell Publishing.

Hewison, R. (1987) *The Heritage Industry: Britain in a Climate of Decline*, London, Methuen.

Hobsbawm, E. ([1983] 1992) 'Introduction: inventing traditions' in Hobsbawm, E. and Ranger, T. (eds) *The Invention of Tradition*, Cambridge, Cambridge University Press, pp. 1–14.

ICOMOS (2001) The Montreal Action Plan [online], www.international.icomos.org/20th_heritage/montreal_plan.htm (accessed 23 September 2008).

ICOMOS (2005) *The World Heritage List: Filling the Gaps – an Action Plan for the Future*, Paris, International Secretariat of ICOMOS.

Ironbridge Gorge Museum Trust (2008) Learning [online], www.ironbridge.org.uk/learning/ (accessed 30 June 2008).

Library of Congress (2007). Digital Preservation Program Makes Awards to Preserve American Creative Works (press release, 3 August) [online], www.loc.gov/today/pr/2007/07-156.html (accessed 29 June 2008)

Lily, A. (2006) Temples in Second Life (forum posting, 14 June) www.tiltedmill.com/forums/showthread.php?t=7337&page=2 (accessed 30 June 2008).

Lyotard, J.F. ([1979] 1984) *The Postmodern Condition: A Report on Knowledge*, Manchester, Manchester University Press.

Nino, T. (2008) Second Life Charts [online], http://taterunino.net/statistical%20graphs.html (accessed 11 December 2008).

Parry, R. (2007) *Recoding the Museum: Digital Heritage and the Technologies of Change*, Abingdon and New York, Routledge.

Penrose, S. (ed.) (2007) *Images of Change: An Archaeology of England's Contemporary Landscape*, London, English Heritage.

Price, D. and Wells, L. (1997) 'Thinking about photography: debates, historically and now' in Wells, L. (ed.) *Photography: A Critical Introduction*, London and New York, Routledge, pp. 9–64.

Rathje, W. and Murphy, C. (2001) *Rubbish!: The Archaeology of Garbage*, Tucson, University of Arizona Press.

Rosedale, P. and Ondrejka, C. (2003) Enabling Player-Created Online Worlds with Grid Computing and Streaming [online], www.gamasutra.com/resource_guide/20030916/rosedale_01.shtml (accessed 29 June 2008).

Schofield, J. and Cocroft, W. (eds) (2007) *A Fearsome Heritage: Diverse Legacies of the Cold War*, Walnut Creek, CA, Left Coast Press.

Schome (2008) Second Life Heritage [online], www.schome.ac.uk/wiki/Second_Life_Heritage (accessed 29 June 2008).

Schome Park (2008) Hindenburg – Trailer [online], blip.tv/file/1488173 (accessed 14 July 2009).

Second Life Wikia (2008) Timeline [online], http://secondlife.wikia.com/wiki/Timeline (accessed 29 June 2008).

Sheehy, K., Ferguson, R. and Clough, G. (2007) 'Learning and teaching in the panopticon: ethical and social issues in creating a virtual educational environment', *International Journal of Social Sciences*, vol. 2, no. 2, pp. 89–96.

UNESCO ([2003] 2009) UNESCO Charter on the Preservation of the Digital Heritage [online], http://portal.unesco.org/ci/en/ev.php-URL_ID=13366&URL_DO=DO_TOPIC&URL_SECTION=201.html (accessed 10 June 2008).

UNESCO (2008) White City of Tel Aviv: The Modern Movement [online], http://whc.unesco.org/en/list/1096 (accessed 10 December 2008).

Wilson Fuller, M. (2008) The Cave of Lascaux: English translation [online], www.culture.gouv.fr/culture/arcnat/lascaux/en/ (accessed 29 June 2008).

Further reading

Bradley, A., Buchli, V., Fairclough, G., Hicks, D., Miller, J. and Schofield, J. (2004) *Change and Creation: Historic Landscape Character 1950–2000*, London, English Heritage.

Cameron, F. and Kenderdine, S. (eds) (2007) *Theorizing Digital Cultural Heritage: A Critical Discourse*, Cambridge, MA, MIT Press.

Giaccardi, E., Malcolm Champion, E. and Kalay, Y. (eds) (2008) 'Sense of place: new media, cultural heritage and place making', special issue, *International Journal of Heritage Studies*, vol. 14, no. 3.

Gorman, A. (2005) 'The cultural landscape of interplanetary space', *Journal of Social Archaeology*, vol. 5, no. 1, pp. 85–107.

Harrison, R. (2009) 'Excavating Second Life: cyber-archaeologies, heritage and virtual settlements', *Journal of Material Culture*, vol. 14, no. 1, pp. 75–106.

Harrison, R. and Schofield, J. (2010) *After Modernity: Archaeological Perspectives on the Contemporary Past*, Oxford, Oxford University Press.

Penrose, S. (ed.) (2007) *Images of Change: An Archaeology of England's Contemporary Landscape*, London, English Heritage.

Schofield, J. and Cocroft, W. (eds) (2007) *A Fearsome Heritage: Diverse Legacies of the Cold War*, Walnut Creek, CA, Left Coast Press.

Spenneman, D.H.R. (2006) 'Out of this world: issues of managing tourism and humanity's heritage on the moon', *International Journal of Heritage Studies*, vol. 12, no. 4, pp. 356–71.

Appendix: Second Life terms

avatar
: The virtual character that represents an individual Second Life resident. Avatars can change their shape, gender, species or outfit. They can also perform many actions and can move, walk, fly and teleport.

inventory
: List of all the things currently owned by an individual avatar.

in world
: Located within the virtual world rather than in a setting considered to be part of the 'real world' or 'physical reality'.

lag
: Delay in response. When residents experience lag, their real-world input only affects in-world events after a significant period of time.

Linden (name)
: Avatars all have names. Members of Linden Lab staff can be recognised because they share the surname Linden.

Linden™
: In-world currency used to acquire objects, skills or services. The Linden has a real-world value. In December 2008, 262 Linden dollars could be exchanged for US $1.

Linden Lab®
: Company that developed and currently owns Second Life.

LSL
: Linden scripting language is the programming language used within Second Life. Although knowledge of LSL is not necessary for residents, LSL scripts control the behaviour of in-world objects.

machinima
: Videos created in world.

prim
: Objects within Second Life are made up of primitives, or prims, which can be shaped, textured and combined to form complex structures.

real world
: Here considered to be an environment that is not mediated by technology. Also referred to as the physical world.

resident
: User of the Second Life virtual world (contrast the term 'player' used in other persistent online environments).

script
: Program affecting the behaviour of an avatar, object or environment.

sim
: The SL Grid and Teen Second Life are divided into a series of islands, known as simulators or sims.

SL Grid™ The Second Life world is divided into two: the SL Grid is
 accessible by people aged 18 and over.

Steam punk Counter-factual presentation of history. In Second Life,
 often refers to an apparently steam-powered Victorian-style
 setting.

Teen Second Area restricted to those aged 13–17 and to approved
Life™ educators.

Glossary

Aboriginal people see **indigenous people**

aesthetic concerned with sensory (primarily visual) judgements of beauty, taste and value.

aesthetic value defined by English Heritage as: 'the ways in which people draw sensory and intellectual stimulation from a place'.

age value the value attributed to a monument simply by virtue of its age. One of the terms coined by the Austrian historian Alois Riegl ([1902] 1982) (see also **historical value** and **commemorative value**).

antiquarian person who collects and studies antiquities, before modern disciplines and research methods.

apartheid a policy promoted in South Africa by the Afrikaner National Party in 1948 for the segregation of racial groups, leading to widespread discrimination of black and coloured people. An extreme case of a **pillar society.**

assimilatory society a society in which a dominant culture marginalises or persecutes minority cultures. One of five terms used by Ashworth, Graham and Tunbridge (2007) to describe different kinds of multicultural societies (see also **melting pot**, **core+**, **pillar**, **salad bowl society**).

battles of memory conflict between people or groups seeking to impose their interpretation of **collective memory**.

catafalque a temporary decorative structure used to represent a coffin in a funerary or commemorative ritual.

cenotaph an empty tomb; a monument designed to **commemorate** one or more bodies buried elsewhere.

cognitive landscape refers to the different layers of meaning that accrue around landscape, derived from the different ways people react to it, based on what they know about its physical and cultural history.

cognitivisation describes the way we make sense of memories, through ordering and clarifying them. One of four terms used by Michael Schudson (1995) to describes memory distortion (see also **instrumentalisation**, **distanciation**, **narrativisation**).

collective memory the way in which a society or social group recall, **commemorate** and represent their own history (as opposed to personal memory).

commemorate to honour and perpetuate the memory of someone or something in a ceremony or a **monument**.

commemorative see **commemorate**

commemorative value the value attributed to a monument which recalls the life and times of a distinguished person. One of the terms coined by the Austrian historian Alois Riegl ([1902] 1982) (see also **age value** and **historical value**).

communal value communal value is defined by English Heritage as: 'the meanings of a place for the people who relate to it, or for whom it figures in their collective experience or memory'. See also **social value**.

contemporary past term used by archaeologists to describe the recording and conservation of apparently trivial and everyday artefacts as a means of understanding contemporary society and as an alternative to exploring and conserving **antiquities**.

core+ society a society in which a dominant culture accords minority cultures freedom to conserve its heritage. One of five terms used by Ashworth, Graham and Tunbridge (2007) to describe different kinds of multicultural societies (see also **assimilatory, melting pot, pillar, salad bowl society**).

cultural heritage object, place or practice of heritage that is of human origin. The term is often used by way of contrast with **natural heritage**.

cultural landscape humanly modified landscape believed to be of importance due to the interplay of natural and cultural influences. A distinct category of cultural landscape was recognised in the revisions to the World Heritage Convention in 1992.

culturalism term proposed by Arjun Appadurai (1996) to describe the way groups of people use their heritage to advance their contemporary interests.

dissonance the potential for heritage meanings to exclude (by implication) other meanings held by other stakeholder groups.

distanciation describes the progressive blurring of memory and loss of emotional intensity in recollection that occurs with time. One of four terms used by Michael Schudson (1995) to describe memory distortion (see also **instrumentalisation, narrativisation, cognitivisation**).

embodied memory see **incorporated memory**

ethnicity in the professional literature, refers to groups of people who believe that they share a common geographic ancestry. In popular parlance, ethnicity and **race** are often confused.

evidential value defined by English Heritage as 'the potential of a place to yield evidence about past human activity'.

extrinsic describes a quality associated with a thing in people's minds, rather than **intrinsic** or **inherent** values associated with the thing's form.

fictive kinship groups term coined by Jay Winter (1995) to describe people from different localities drawn together by shared memories or experience, such as bereavement after the Great War.

heritage boom term coined by David Lowenthal (1985), to describe the rapid increase in the designation of heritage sites by official agencies and the establishment of **commercial** and **unofficial heritage** sites between the 1960s and the 1980s.

historical value the value attributed to a monument by virtue of the historical information which can be extracted from it. One of the terms coined by the Austrian historian Alois Riegl ([1902] 1982) (see also **age value** and **commemorative value**). Defined by English Heritage as 'the ways in which past people, events and aspects of life can be connected through a place to the present – it tends to be illustrative or associative'.

Holocaust destruction or slaughter on a mass scale; when capitalised, usually refers to the mass murder of Jews under the Nazi regime in Germany (especially 1941–5).

incorporated memory term used by Paul Connerton (1989) to describe ways in which the body preserves past experience in habitual actions and skills, such as reading or riding a bicycle. Connerton maintains that this principle can be extended to certain social actions, such as ceremonies and rituals, in which remembering is acted out. Sometimes referred to as **embodied memory**.

indigenous people ethnic group who occupied a geographic area prior to the arrival and subsequent occupation of migrant settlers. The term may be used in some circumstances to include groups who may not have been part of the 'original' occupation of an area, but who were part of an early historical period of occupation prior to the most recent colonisation, annexation or formation of a new nation-state. The terms 'first nation' and **Aboriginal people** are also often used.

inherent the idea that the values of a heritage object, place or practice are inseparable from its physical qualities. Close in meaning to **intrinsic.**

inscribed memory term used by Paul Connerton (1989) to describe the way memory is perpetuated in texts or physical artefacts, which he distinguished from embodied or **incorporated memory**.

instrumentalisation describes the way that 'the past is put to work' in the present, serving the needs of the present. One of four terms used by Michael Schudson (1995) to describes memory distortion (see also **distanciation, cognitivisation, narrativisation**).

intangible heritage something considered to be a part of heritage that is not a physical object or place, such as a memory, a tradition or a cultural practice, as opposed to **tangible heritage**.

intrinsic describes a quality or value which is thought to be inseparable from a thing, as opposed to its being associated with the thing in people's minds. A common distinction between 'intrinsic' and '**extrinsic**' qualities of an object would differentiate between qualities associated with the form of the object and those associated with the memories and feelings which the object prompts in the beholder by association. See also **inherent**.

melting pot society a society which attempts to blend many different cultures into a new hybrid. One of five terms used by Ashworth, Graham and Tunbridge (2007) to describe different kinds of multicultural societies (see **assimilatory**, **core+**, **pillar**, **salad bowl society**).

memorial a **monument** or other artefact intended to **commemorate** a personage or event.

memory activist one who campaigns to **commemorate** a particular group of memories and inscribe them in **collective memory**.

memory traces residue left in the mind by experience, which is then 'encoded' by the mind and built into memories we can relate to others by efforts of recall.

modernity in this context, understood as the set of ideas preceding **postmodernity**, characterised by a belief in progress brought about by material change, marked by radical change in the arts and lifestyles.

monument among the many meanings of monument is that of a structure built to **commemorate** a historical event or personage, in which case it has almost the same meaning as **memorial**. Some monuments, however, have very little or no commemorative function.

multiculturalism a term given currency in the 1970s to describe government policies intended to allow different racial and ethnic groups freedom to conserve and develop their own traditions, as opposed to the assimilatory policies adopted previously.

narrativisation describes the way memories are turned into interesting stories. One of four terms used by Michael Schudson (1995) to describes memory distortion (see also **instrumentalisation**, **distanciation**, **cognitivisation**).

natural heritage plants, animals, landscape features and biological and geological processes that are not humanly modified. The term is most often used in opposition to **cultural heritage**.

natural site a site admired and conserved for its physical beauty and rarity of its geology, flora and fauna. Used as a distinct category by UNESCO until 1992, when it was merged with the category of **cultural landscape**.

nostalgia longing for the past based on a belief that it was better than the present. Often used to describe the approach to heritage which tries to conserve buildings, objects and places without regard to contemporary attitudes and beliefs.

official heritage state-sponsored or controlled processes of heritage listing and management. The term is often used in opposition to the term **unofficial heritage**.

oral history the transmission of historical information by verbal means. Often a feature of non-literate cultures.

personal memory/memories see **private memory**. Usually contrasted with **collective memory**.

pillar society a society organised around the principle that distinct and autonomous cultures co-exist independently. One of five terms used by Ashworth, Graham and Tunbridge (2007) to describe different kinds of multicultural societies (see also **assimilatory**, **melting pot**, **core+**, **salad bowl society**).

plural society a society in which different ethnic, racial, linguistic or cultural groups coexist (see also **multiculturalism, ethnicity**, **race**)

postmodernity term designed to indicate the attitudes current after the collapse of **modernity** (around the 1960s); according to François Lyotard ([1979] 1984), postmodernity is characterised by a constant state of flux, a relativism of values and the collapse of confidence in notions of truth and historical objectivity.

private memory the memory of individuals; some authors have argued that all memories have some social element, since we rehearse and reinforce memory by interacting with others.

public memory see **collective memory**

race any group of people sharing genetic characteristics, but most usually used to distinguish groups with recognisably similar physical attributes, such as skin colour. Imprecise terms such as 'white', 'black' or 'coloured' have their origin in racial difference. Often confused with **ethnicity**.

resurrection rising again from the dead: in the Christian tradition, refers to Jesus Christ.

salad bowl society a society in which many distinct cultures find expression and where the government supports diversity. One of five terms used by Ashworth, Graham and Tunbridge (2007) to describe different kinds of multicultural societies (see also **assimilatory**, **melting pot**, **core+**, **pillar society**).

social memory see **collective memory**

social value the value of a heritage object, place or practice to society. The term is most often contrasted with other types of heritage values (e.g. **inherent** or **intrinsic** values) that are determined by experts, and is closely linked with the concepts of community value and **intangible heritage**.

subaltern subordinate or overlooked. A person or group of low social status and their cultural expression which is excluded from common representations of the nation.

tangible heritage physical heritage, such as buildings and objects, as opposed to **intangible heritage**.

time-depth in archaeological and heritage parlance, refers to the conservation of successive temporal layers of a site.

unofficial heritage objects, places or practices which are not considered to be part of the state's official heritage, but which nonetheless are used by parts of society in their creation of a sense of identity, community and/or locality. The term is often used in opposition to the term **official heritage**.

Venice Charter The International Charter for the Conservation and Restoration of Monuments and Sites, which was drafted at the Second International Congress of Architects and Technicians of Historic Monuments in Venice in 1964 and adopted by ICOMOS in 1965.

World Heritage Convention The Convention Concerning the Protection of World Cultural and Natural Heritage, adopted by the General Conference of UNESCO on 16 November 1972, which established the World Heritage List and the process for listing **World Heritage sites**.

World Heritage List list of places considered by the World Heritage Committee to have outstanding universal value. The list was established by the 1972 UNESCO **World Heritage Convention**.

World Heritage site a place listed on the **World Heritage List**.

Acknowledgements

Grateful acknowledgement is made to the following sources for permission to reproduce material in this book.

Pages 111–12: Zolkepli, F. (2008) 'In memory of war dead', *The Star*, Malaysia, reprinted with permission.

Pages 299, 303, 304, 305, 306: Second Life is a trademark of Linden Research, Inc. Certain materials have been reproduced with the permission of Linden Research, Inc.

Index

Page number in **bold** refer to illustrations.